TOKEN
SUPREMACY

TOKEN SUPREMACY

The Art of Finance, the Finance of Art, and the Great Crypto Crash of 2022

ZACHARY SMALL

ALFRED A. KNOPF NEW YORK 2024

THIS IS A BORZOI BOOK
PUBLISHED BY ALFRED A. KNOPF

www.aaknopf.com

Knopf, Borzoi Books, and the colophon are registered
trademarks of Penguin Random House LLC.

Page 333 constitutes an extension of this copyright page.

Library of Congress Cataloguing-in-Publication Data
Names: Small, Zachary, author.
Title: Token supremacy : the art of finance, the finance of art,
and the Great Crypto Crash of 2022 / Zachary Small.
Description: First edition. | New York : Alfred A. Knopf, 2024. | Includes index.
Identifiers: LCCN 2023014592 (print) | LCCN 2023014593 (ebook) |
ISBN 9780593536759 (hardcover) | ISBN 9780593536766 (ebook)
Subjects: LCSH: NFTs (Tokens) | Art—Finance.
Classification: LCC HG1710.3 .S63 2024 (print) |
LCC HG1710.3 (ebook) | DDC 332.4—dc23/eng/20231006
LC record available at https://lccn.loc.gov/2023014592
LC ebook record available at https://lccn.loc.gov/2023014593

Jacket illustration: *Satire on Tulip Mania* (detail) by Jan
Brueghel the Younger, c. 1640. Piemags Art / Alamy
Jacket design by John Gall
The Great Crypto Crash of 2022 (pages x–xi) by Mapping Specialists, Ltd.

Manufactured in the United States of America

First Edition

For Seth and Ozymandias

Enchanted by its rigor, humanity forgets over and again that it is a rigor of chess masters, not of angels.

—Jorge Luis Borges

CONTENTS

The Great Crypto Crash of 2022
January 2020–January 2023

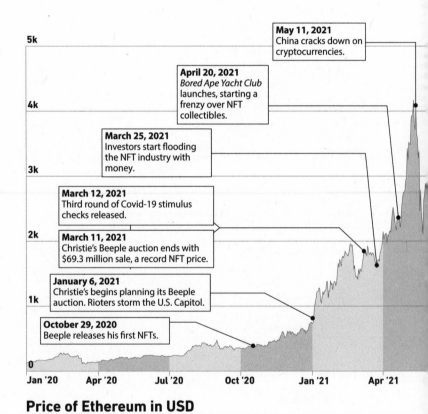

May 11, 2021
China cracks down on cryptocurrencies.

April 20, 2021
Bored Ape Yacht Club launches, starting a frenzy over NFT collectibles.

March 25, 2021
Investors start flooding the NFT industry with money.

March 12, 2021
Third round of Covid-19 stimulus checks released.

March 11, 2021
Christie's Beeple auction ends with $69.3 million sale, a record NFT price.

January 6, 2021
Christie's begins planning its Beeple auction. Rioters storm the U.S. Capitol.

October 29, 2020
Beeple releases his first NFTs.

5k

4k

3k

2k

1k

0

Jan '20 Apr '20 Jul '20 Oct '20 Jan '21 Apr '21

Price of Ethereum in USD

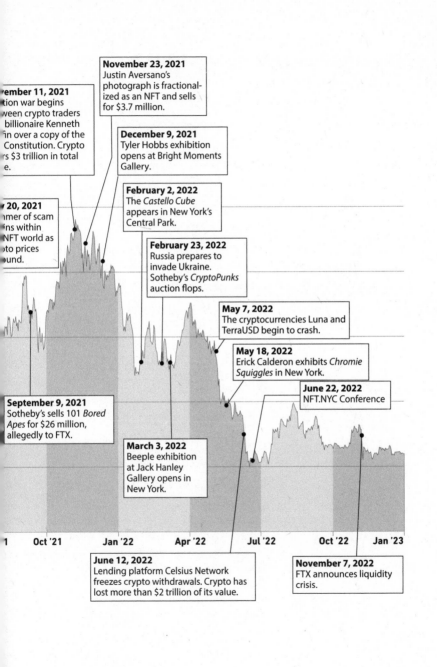

November 11, 2021
~~Bidding~~ war begins
~~bet~~ween crypto traders
~~and~~ billionaire Kenneth
~~Griffi~~n over a copy of the
~~US~~ Constitution. Crypto
~~hits~~ $3 trillion in total
~~valu~~e.

November 23, 2021
Justin Aversano's
photograph is fractional-
ized as an NFT and sells
for $3.7 million.

December 9, 2021
Tyler Hobbs exhibition
opens at Bright Moments
Gallery.

February 2, 2022
The *Castello Cube*
appears in New York's
Central Park.

February 23, 2022
Russia prepares to
invade Ukraine.
Sotheby's *CryptoPunks*
auction flops.

May 7, 2022
The cryptocurrencies Luna and
TerraUSD begin to crash.

May 18, 2022
Erick Calderon exhibits *Chromie
Squiggles* in New York.

June 22, 2022
NFT.NYC Conference

20, 2021
~~Sum~~mer of scam
~~coi~~ns within
~~the~~ NFT world as
~~cryp~~to prices
~~rebo~~und.

September 9, 2021
Sotheby's sells 101 *Bored
Apes* for $26 million,
allegedly to FTX.

March 3, 2022
Beeple exhibition
at Jack Hanley
Gallery opens in
New York.

June 12, 2022
Lending platform Celsius Network
freezes crypto withdrawals. Crypto has
lost more than $2 trillion of its value.

November 7, 2022
FTX announces liquidity
crisis.

Oct '21 Jan '22 Apr '22 Jul '22 Oct '22 Jan '23

TOKEN
SUPREMACY

INTRODUCTION

The Renaissance died four hundred years ago in the glittering light of the Dutch Golden Age, as the Netherlands became the economic and cultural center of Europe. An epoch defined by the paintings of Michelangelo, the philosophies of Montaigne, and the scientific discoveries of Copernicus had run its course by the late 1630s, when Amsterdam added a booming art market to its merchant empire. The Dutch Republic's population never exceeded two million people, but something like ten million paintings were produced during the golden age. Even butchers collected paintings, which hung in their market stalls above the meat.

But symbols of a flourishing economy gilded a wicked reality. Plague ravaged the Netherlands between 1635 and 1636, with cities losing 20 percent of their populations. Death brought new purpose to the living, and survivors found comfort in the beauty that came with money. The tulip market developed alongside the art market to satisfy that demand for beauty; however, the flower merchants were better salespeople than the visual artists, emphasizing the speculative potential of the tulip bulb. The uncertainty of the bulb's viability and the randomness of reward when it bloomed became an addictive draw for buyers. Soon, merchants were recommending that collectors purchase bulbs on contract so they could trade their stock even

before receiving any flower shipments. Prices spiked, and even a single bulb could sell for thousands of guilders or dozens of sheep—the equivalent cost of a large townhouse. Demand rose through the beginning of 1637, when buyers were acquiring their bulbs by weight. The reduction of the tulip market into what critics described as "pound goods" meant that investors no longer required any botanical knowledge to succeed; all anyone needed was a sense of the going rate. It was bad algebra from the start, and the slightest decrease in bulb prices forced the entire economy to collapse, as investors defaulted on loans they had made based on the inflated value of tulips. Everyone from the chimney sweeps to the wealthy noblemen lost their life savings. Priests who had denounced the tulips as symbols of vanity and greed used the market's demise for their fiery sermons. Artists found new subject material, caricaturing the speculators in paintings where they appeared as ill-mannered monkeys destroying palatial estates cluttered with their wilting bouquets. Jan Brueghel the Younger's 1640 interpretation of the fiasco graces the cover of this book.

Rationalism prevailed over the escapism of tulipmania, disproving the theory that one could attach value to seemingly valueless objects—though history hasn't stopped succeeding generations from retesting the hypothesis. From the prospectors of the 1848 California Gold Rush to the computer whizzes behind the 2000 Dot-Com Crash, the promise of infinite gains from the uncertainty of financial speculation has driven the decision making of powerful men and women whose failures often sprout the next generation of successes. These stories suggest that the importance of market bubbles has less to do with the economics of idiocy and more to do with the social structures that encourage their growth.

The hallmark of tulipmania reappeared only a few years ago with the arrival of NFTs. Nonfungible tokens were a relatively

simple technology for tracking ownership of digital assets, but financial speculation had transformed them into a $40-billion industry, anchoring the broader $3-trillion market for crypto-currencies in the prestigious art world. That relationship between cultural producers and the market seemed to afford NFTs another layer of value. But how special were these digital tulips? And what made them such powerful economic tools?

Years earlier, a relatively small collection of digital artists and tech entrepreneurs had conspired to improve the internet through blockchain technology. The original pitch was simple. NFTs could solve two fundamental problems with the online economy by recording transactions for digital goods and providing creators with access to resale royalties. Then it somehow morphed into an ideology of cultural renaissance and economic revolt. NFTs were about creating a decentralized society, where users traded digital artworks like money, and about bankrupting the toxic business model of social-media platforms that siphoned their personal data for profit. And, finally, NFTs reached their apotheosis as icons of an inscrutable religion. This last metamorphosis into babble—investors ranting online about how their digital collectibles had transformed them into "human gods"—demonstrated the full psychological tilt of speculation.

Had the twenty-first century simply replaced tulip bulbs with another arbitrary form of investment? Most critics said yes. It seemed obvious that the cartoons of bored apes and pixelated punks that were being traded for millions of dollars would soon wilt like the Dutch flowers. However, closer inspection revealed an elaborate financial system being developed through NFTs, which sought to capture the volatility of tulipmania, combine it with the economic potential of the art market, and create a perpetual money machine. It was a moon-shot gamble by the millennials who dominated the digi-

tal world, looking to recapture a sense of the financial security that had disappeared in the years following the 2008 financial crisis, when they were young.

A similar anxiety pervaded the Amsterdam of tulipmania, where an artist named Rembrandt Harmenszoon van Rijn walked among the wretched of Holland. He carried around his copperplate like a sketchbook, tracing the anxious anatomies of Amsterdam's vagrants with baggy clothes and hunched backs. His fortunes rose alongside the tulip's, which marked the beginning of his own personal renaissance, when he could afford to purchase a family home in the city center.

Rembrandt etched himself into the costume of beggars, replacing their features with his own unmistakably broad nose and frizzy hair. Those self-portraits seemed to foreshadow his later years of financial ruin, and history would remember this older version of the painter, who defaulted on his mortgage payments and brought ruin upon himself.

Through his fascination with poverty, Rembrandt was summoning a pathology that has been stubbornly ingrained in the cultural subconscious for centuries. He was drawing upon the paradoxical realities of pursuing an artistic life in the seventeenth century, which, as today, required artists to operate between the extremities of wealth and poverty. The decisions of a few powerful patrons could make or break careers, and the debt required to become a certified, professional artist was immense. That made an artist like Rembrandt (someone unwilling to ingratiate himself to clients, often declining their requests for better chins and bigger hands) especially vulnerable to the pitfalls of pursuing creative genius.

Cruelty bookended his career, separated by midlife accomplishments like his 1642 painting *The Night Watch*, which featured members of a civic militia responsible for patrolling Amsterdam's streets—a group that likely cleared the alleyways and canals of the beggars whom the artist once sketched.

Rembrandt shot into the stratosphere of European society after *The Night Watch*. He could have lived comfortably on the acclaim and commissions, but the artist had a money problem: Rembrandt liked spending his wealth on rarities—even bidding on his own paintings. A court arrangement in 1656 helped him narrowly avoid bankruptcy, though he needed to sell most of his paintings and antiquities, his house and printing press. The Amsterdam painters' guild was so embarrassed by the famous artist's dissolution that they instituted a new rule: nobody in Rembrandt's financial circumstances could trade as a painter.

Message received: starving artists are unwelcome, because their financial ruin could delegitimize the market. Rembrandt only stumbled after this decree, struggling in the 1660s to hold on to commissions while his romantic partner and son died. Before the end of the decade, he too had passed away and was buried in an unmarked church grave.

We love Rembrandt because of his painful story. Auctioneers are quick to mention his tortured life when pitching his portraits to their wealthy clientele, because it evokes a pity that seems to justify the insane prices that the artist's work now commands. Even during the worst months of the pandemic recession in 2020, a collector still found $18.7 million to acquire one of Rembrandt's self-portraits; it was a record price.

The contemporary art world has learned from Old Masters like Rembrandt how important mythology is to selling paintings. Artists spin their personal narratives into sales pitches that might reassure collectors that they are worth the investment. Not everyone takes the starving-artist approach, because it typically requires the artist to be dead. Jeff Koons embodies the commercialization of the art world and embraces banality. Banksy hides his identity and uses street art to make political commentary. NFT artists have workshopped their own stories, retrofitting the starving artist into a tech guru leading the next

stage of the creative economy. Even the world's richest gallerist, Larry Gagosian, dutifully practices the art of first impressions; he carefully builds mythologies around his artists and seeks to control the narrative through the museum-quality exhibitions he arranges at his dealership.

But the greatest mythology is the art market's own exceptionalism. The perception that culture is somehow above the economy has allowed the industry to exist outside the normal rules of the economy. Wealthy collectors have turned this gray market into a tax haven, an investment opportunity, and a platform for illicit activities like money laundering where their identities are easily concealed from the public record. Those backroom deals have determined so much of the culture that we consume, and the details of those financial arrangements have remained secret. Until those transactions started showing up on the blockchain.

Among the abandoned SoHo storefronts in Manhattan, a gallery lit by candles and computer screens illuminated the cobblestone streets, where a lineup of newly minted millionaires anxiously waded through the winter winds to see what their crypto fortunes could buy. The doors opened on December 9, 2021, to a cavernous space in which dozens of guests sipped champagne and devoured morsels of designer sushi as jazz musicians played. There were venture capitalists and supermodels; basketball stars and their sycophants; film scions and political lobbyists; technophobes and technocrats; technobabes and technorats.

That evening inside Bright Moments Gallery epitomized the new gods and their rituals. They spoke in strange and unfamiliar tongues. Hieroglyphs on the bathroom walls included new terms like "metaverse" and "Ethereum." Above the toilet

was philosophy: "NFTs are the bridge from conceptual art to contractual art." The messages continued deeper into the gallery, where someone had wallpapered the elevator with hacker mantras like "You can't spell culture without cult" and "Fear kills growth."

Beyond that elevator was a dark cement basement where Tyler Hobbs stood, flanked by two gallery associates: one holding an iPad and the other looking for security threats in the shadows. Clients would join the artist and enter their online wallet information into the tablet, securing the NFTs that Hobbs had coded into existence over the preceding weeks. This precious art cargo had, with the tap of a screen, turned Hobbs into one of the wealthiest artists you've never heard of.

The absurd scene inside Bright Moments Gallery made Hobbs look like a fake. He was a lanky thirty-four-year-old former software engineer from Texas, sitting in an empty cellar below a gallery full of partying supplicants and blank walls. And despite a lack of inventory, attendees upstairs had paid $7 million altogether for ninety-nine original artworks. Rembrandt he was not; Hobbs used code instead of a paintbrush. But he never cared about re-creating the past glories of art history; the romantic vision of a starving artist never held much appeal. Before cryptomania, Hobbs rarely earned money from his artworks. It was nothing more than a passion project. "Digital art was usually a sentence of poverty," he later explained to me. Nowadays, it's his bank account.

The first windfall came seven months earlier, when Hobbs started turning his creations into NFTs. He understood that tokens were traded on the blockchain, a decentralized ledger system recording ownership information to prevent thefts and forgeries. The blockchain could also classify NFTs as unique assets, deriving their price based on rarity and demand. Hobbs learned these dynamics the easy way in June 2021, selling 999 NFTs almost immediately after offering them online and earn-

ing nearly $400,000 worth of Ethereum cryptocurrency in the process. He claimed that secondary sales, which typically come with artist royalty fees of between 5 and 10 percent in the NFT world, had brought an additional $9 million into his pocket.

Hobbs was just one of dozens—if not hundreds—of amateur artists who suddenly found themselves swimming in crypto cash and struggling to understand their own success as more than a combination of hard-earned recognition and dumb luck. He wanted to believe that society's equation for determining cultural value and the price of art had changed during the pandemic, as people became more accustomed to living online. He wanted to believe that his sudden windfall was a reward for the years he had spent struggling as a starving artist. In other words, he wanted to believe in the fundamental lie that we all believe: merit equals money.

NFTs united the most conspiratorial corners of the internet: the power brokers and the power hungry, who believed that technology could change the world, one pixel at a time. In their rearview mirror: two financial crises and a raging pandemic that had already killed more than six million people worldwide. Up ahead: the capitalist fantasia of a multibillion-dollar industry summoned by artists and algorithms.

Hobbs found himself working in the zeitgeist of economic and technological forces. The same financial institutions and wealthy investors who had capitalized on the pandemic recession and the 2008 financial crisis were looking at NFTs as a technology that could perpetuate the rampant volatility and speculation that had contributed to their record profits. Selling securities as art was a guise for laundering those dynamics often found in the unregulated art market. These forces succeeded by asking questions that none of us, including government watchdogs, could answer: What is the value of art? And how do you put a price on something that is traditionally seen as priceless?

M

If tulipmania provided an outlet for the social anxieties that succeeded a devastating plague, then the NFT boom fulfilled a similar function during the Covid-19 pandemic. Lockdowns produced a strange alchemy in which virtual life became reality, and a speculative financial boom entangled the economic, political, social, and medical emergencies of the time. The framework that structured civilization nearly collapsed, and we lived between the creaking gears of recovery.

Most people were happy to see the old guard in place during this era of uncertainty. President Joseph R. Biden Jr., was the oldest person to ever win the White House, and Congress was controlled by two politicians who were older than him: House Speaker Nancy Pelosi and Senate minority leader Mitch McConnell. The top-grossing film in movie theaters starred a sixty-year-old intellectual property named Spider-Man, and the most successful song on the radio had first been released by the singer Kate Bush in the 1980s. Even the economic challenges were old, combining the stagflation crisis of the 1970s with the poor debt-to-GDP ratios of the 1940s alongside the overvalued tech companies of 2000 and the sovereign debt problems of 2009.

Life might have continued spinning around the circumference of these historical reference points if uncertainty was not such an effective crucible for change; if the young did not inevitably rise to challenge the old.

So many questions were left unanswered within their vortex of dada that I experienced inside Bright Moments Gallery and elsewhere throughout my journey of writing this book. The prattling of otherwise intelligent businessmen undermined an extensive reporting effort to outline the NFT industry seriously at the critical moment of its ascension. It made no sense. Grown men were infantilizing themselves in the

public eye, claiming that cartoon images of pothead monkeys and pixelated alien dudes would spark a new economic age of digital ownership. The claims were so immediately ridiculous that many government regulators dismissed the industry as a short-lived fad that would perish the way Beanie Babies had. And yet! Their increasingly deranged pitch had attracted nearly $30 billion in venture capital within a period of two years. Younger generations also embraced NFTs as a symbol of their own rising power in society and a definitive breaking point with older models of cultural production.

The contradictions were obvious, so my journey of discovery began with a few simple questions: Why were investors willing to debase themselves for digital collectibles? How did the economic conditions of the pandemic fuel a speculative market cycle? Who benefited from a digital culture war? And what role would artists play in determining the future of the internet?

As a reporter with *The New York Times,* I had already chronicled the market's development and realized that an even greater story was hidden beneath the headlines. But I also knew that finding the truth would require an extensive investigation unlike anything that would fit neatly into the newspaper's column inches. So from hundreds of interviews with artists, gallerists, investors, entrepreneurs, academics, fanatics, skeptics, regulators, watchdogs, and even a priest emerged this portrait of the virtual world triumphing over the physical realm.

Then everything crashed. During the succeeding summer months, when I wrote the majority of this book's twelve chapters, the cryptoeconomy shredded through nearly $2 trillion, and the once-booming market for nonfungible tokens deflated by nearly 97 percent of its record volume. Suddenly there were NFT collectors being charged with insider trading, international manhunts for crypto developers, and thousands of digital heists. I felt like I was back to where my career had

begun: tracking down money launderers and fraudsters in the art market.

My purpose recalibrated with the changing fortunes of my subjects, and a growing consensus that the tech sector was headed toward another recession. A vision of a more ambitious story emerged, one that would tell uncomfortable truths about how the wealthy enlisted the starving artists as bannermen in their battle to re-create the pre-2008 financial system, building an army of crypto Rembrandts battling for relevance and survival. Over the last forty years, the contemporary art market has served as an economic laboratory for the rich to develop a shadow banking system of alternative assets and hedged liquidity. NFTs were a by-product of those experiments, providing financial tools branded as digital art that could be monetized at lightspeed. The implication of this exchange has been wide-reaching. Even after the secondary market for NFTs imploded, the underlying technology has become a normalized part of the art world and the financial system; it has also helped innovate other industries, like gaming, music, advertising, health care, and logistics.

The results of what became a three-year investigation are now yours to read. One might consider it only a slim volume in a much longer history of cultural economics, but the story is nonetheless an enthralling case study for those curious to understand the dynamics of speculation, and how the forces of art, technology, and money once conspired to change the world.

Throughout the book, I have carefully reconstructed scenes and incorporated dialogue drawn from my own interviews and those sourced from publications, financial statements, internal documents, private recordings, investor slideshows, blockchain data, photographs, and videos. Every detail and conversation appearing in these pages has been subjected to fact-checking, and throughout my reporting I have followed the strict rules of

journalism that I learned at *The New York Times* to ensure my impartiality and credibility. I have never directly participated in the cryptoeconomy and have no financial interest in the artists mentioned here. The revelations within these pages were also shared with the appropriate people, giving them enough time and information to comment on my findings. Finally, I owe an immense debt of gratitude to the many sources who spent hours and hours speaking with me. These conversations were frequent, spread across several years, and often came during challenging life events. It's a great privilege to have gained their trust, and an immense honor that they have entrusted me to tell this story.

What follows is a largely chronological account of the NFT market's rise, fall, and reboot. There will be important side quests along the way: a discussion of NFT artworks in light of the historical reception of photography; a look at how *World of Warcraft* determined the mechanics of the cryptoeconomy; a war between the billionaire Kenneth Griffin and the crypto investors attempting to buy a copy of the United States Constitution; the time a Miami businessman set fire to a priceless Frida Kahlo drawing that he wanted to sell as a digital collectible; the role NFTs played in the fraud perpetrated by Sam Bankman-Fried and his company, FTX; and how cryptocurrencies normalized incredibly risky bets in the financial sector during the March 2023 banking crisis.

The story includes a baroque cast of characters whose entrances and exits sometimes feel like they are pulled from a nineteenth-century Russian novel. I have done my best to stage-manage their appearances without straying from the truth. But a certain amount of whiplash should be expected; these are eccentric people skilled at using misinformation and needlessly confusing jargon to convince the public of their superiority. Many use pseudonyms to evade scrutiny—yes,

there's a Vincent Van Dough and a Cozomo de' Medici. Artists have remained at the center of this story despite the noise, and there are four major artists who can tell the tale of NFTs better than anyone else: Tyler Hobbs, Mike Winkelmann, Justin Aversano, and Erick Calderon.

Each man represented a different kind of starving artist who entered the NFT bubble imagining that his career would be one thing and exited the crash realizing that it had become something entirely different. Their desires were simple at the beginning. One hungered for recognition; another craved wealth. But tokenization had already exposed the fragility of the traditional system that defined artistic value, leaving artists to strike hard bargains with greater economic forces in the technology and finance industries. The requisite struggle to bind art and money together into a single concept—the NFT—provoked the most primal feelings of greed, vanity, doubt, and revenge.

M

Those feelings were palpable inside Bright Moments Gallery as Hobbs took the stage. With every push of a button, he generated another artwork from his algorithm. The jazz band stopped playing, and the crypto hordes quietly sipped their champagne as he grabbed the microphone. He reviewed the newly minted NFTs as they appeared, laughing at the variable quality of the results but always providing his best sales pitch: *This one looks great. Now, this is truly something avant-garde. Look at the curves on that one.* The code attempts to balance unpredictability and quality, using a series of probability equations to determine the likelihood of characteristics like color, scale, and squiggle. The resulting psychedelic swirl of rectangles that Hobbs calls "flow fields" typically resemble the mod-

ernist block paintings of an artist like Piet Mondrian, only if someone dropping acid took a wet squeegee to his 1943 painting *Broadway Boogie Woogie.*

The new art slowly consumed the blank gallery walls as Hobbs kept pace, minting the NFTs, which were instantaneously assigned to collectors via the smart contracts that they had signed in the basement. The old-school artists who bore witness to the experiment were gobsmacked. "This is the art of our time," said Tom Sachs, an artist who spearheaded his own financialized art movement almost thirty years ago by incorporating luxury brands like Hermès into sculptures of McDonald's value meals. "This is the new avant-garde."

Nobody within this audience of the crypto nouveau riche remembered what had occupied the empty storefront before the Bright Moments Gallery had taken over. Maybe it had once been a traditional gallery? Or maybe it was a Prada store? A furniture store? No, a grocery store? None of that really mattered anymore. The crypto hordes had found their own Rembrandt, and the digital art renaissance was beginning—not with a bang, but with a computerized beep.

THE NEW KING OF CRYPTO

Mike Winkelmann sank into the sofa as three cameras recorded his meltdown. The dueling identities that had once structured his life were coming into conflict as his fortunes increased by the second. Unseen crypto billionaires were bidding for his soul, or at least it felt that way. His entire artistic career was being auctioned as a compilation of five thousand digital artworks, packaged by the Christie's auctioneers as a single nonfungible token. The winner would receive this NFT as an online certificate of ownership, a deed to fourteen years inside Winkelmann's mind. It was surreal watching his own coronation from the couch. The new crypto king was slack-jawed as his net worth continued to rise by the millions on the computer screen, reckoning with the transformation of his art into an ultimate use-case for blockchain technology, bringing the metaverse into the mainstream. Two documentary crews captured his euphoric stupor, memorializing the tight choreography of this historic moment.

The artist had become a multimillionaire at that moment. It was too much to bear, and suddenly he was bolting for the outdoor patio, away from the living room, where his family had gathered to celebrate his success. Winkelmann needed some air.

Once upon a time, the promise of a divided life held some

appeal. Mike owned a lucrative business turning digital graphics and animations into branded visuals for clients like Louis Vuitton, Apple, and Justin Bieber. The money he earned from those productions allowed him to live in the McMansion suburbs outside of Charleston, South Carolina. He fit comfortably there into the patterns of home, work, and hobby. He was popular with the neighbors, a plucky midwestern transplant with a wide smile, a sailor's mouth, and a heart of gold. He would sometimes rant about politics, but otherwise focused on family, sitting pretty in a large home overlooking the palmetto trees. Mike understood the value of compartmentalization, because his parents taught him midwestern manners and the importance of staying reserved in the middle-class Wisconsin village where he was born. So he kept his more libidinal thoughts inside a computer running so hot that it needed to be stored in the bathroom on a wood platform over the tub, near a jury-rigged industrial A/C unit that vented its heat into the attic.

The computer expended its vast amounts of energy trying to contain Beeple, the internet crap monster responsible for Winkelmann's cult online following. He adopted the name in 2003, after a 1980s toy that looked like the abandoned love child of Sasquatch and Chewbacca, with light sensors that triggered its blinking nose and squeaky voice whenever its eyes were covered by a hand. Winkelmann had just graduated with a computer-science degree from Purdue University in Indiana, but he found programming "boring as shit."[1] The twenty-two-year-old was more interested in shooting narrative short films through a webcam than working for a software company. The Beeple toy came to symbolize his fascination with the interplay of light and sound.

In 2007, Beeple started a project that would eventually make him famous. The *Everydays* series began as a daily drawing habit of crude little doodles that seemed to betray his more corpo-

rate, Bill Gates appearance. The drawings were the crass products of a mind feeding on internet bile (racist caricatures, nude women, penis jokes, political satire) and tutored by magical realism (family portraits, animal studies, Jesus smoking cigarettes, Hillary Clinton wearing gold teeth). A year later, Beeple switched to Cinema4D, an animation software that allowed him to manipulate three-dimensional space. For the kid who spent hours at Toys "R" Us playing a demo of *Super Mario 64* on the new Nintendo console, it was a dream come true to create realistic worlds on a computer. But it wasn't until around 2011 that he started fully utilizing the program to experiment with bright colors and blurry shapes with names like *Synthetic Bubblegum Tittufux.* Around the same time, Beeple started releasing music videos made with Cinema4D as free source material for creative professionals; the artist understood how popular his creations had become only when, on a family vacation to Hong Kong, he saw one of his works projected outside a Hard Rock Cafe.

A recognizable style finally emerged in 2017, when Beeple fully articulated his fascination with tech dystopias. Importing digital assets from other websites allowed him to create more detailed scenes in only a couple hours. His imagination exploded with skyscrapers stacked atop cargo containers, Santa Claus clones brawling to the death, and cultists worshipping an original Macintosh computer. Celebrity sightings abound in these nihilistic tales of the future: Donald Trump's head opens to reveal a burger brain; Mickey Mouse holds a machine gun; and Buzz Lightyear lactates in the park.

All that chaos was contained in Winkelmann's computer, sitting on a desk with its cables running into the bathroom hotbox. His home office was largely undecorated, with beige carpeting, Walmart bookshelves, and two sixty-five-inch-screen televisions that played CNN and Fox News on mute throughout the day. He was neither the first artist to adopt

lowbrow culture (Marcel Duchamp beat him there by nearly a century when he exhibited a signed urinal in 1917) nor the first to immerse himself in mass media (Andy Warhol and his silkscreens of Marilyn Monroe might like a word). What made Beeple special was his evangelism for digital art, his embodiment of the internet's tendency toward dark absurdism, and his eagerness to build an economy around it. He had already cultivated a network of nearly two million followers on Instagram, and artist friends were repeatedly bugging him to start releasing NFTs. Why not try something new?

Beeple had everything to gain and nothing to lose.

In late October 2020, days before the presidential election, he released three artworks on the NFT marketplace Nifty Gateway. One piece was called *Politics Is Bullshit,* featuring a diarrheic bull tattooed with an American flag with a Twitter bird perched upon its neck. The initial offer for this edition of one hundred images was just $1.00 each.

"If you need extra convincing from some BS artist's notes wether you want to spend a dollar on this i will punch you in the god damn face," Beeple wrote about the offering in the lowercase, typo-ridden idiom of internetspeak. "Smash the buy button ya jabroni."[2]

Poof. All gone. Sold. The two other NFTs offered, including one from a video series called *Crossroads,* went for $66,666.66 each. Even with such a devilish price—decided upon with the whimsy of a speculative market willing to spend whatever—Winkelmann could identify his salvation in the metaverse. The most he had ever made from his artworks was $100 for a small print. Now the artist saw a potential avenue for financial-izing his digital art, one that built upon the lucrative market for online collectibles that companies like Dapper Labs and Larva Labs had started in 2017 with the release of *Crypto-Kitty* and *CryptoPunk* NFTs. Executives behind those products had predicted that digital art would find online buyers, and

within the two-month period from November to January 2018, *CryptoKitties* made $52 million. Mack Flavelle, a founder of the CryptoKitties project, pointed out why: "There's not that much that people can do with cryptocurrency," he told the *New York Times* reporter Scott Reyburn at the time. "We gave them something fun and useful to do with their Ethereum."[3]

Winkelmann's success seemed to fulfill the prophecy that individual artists would benefit from the cryptoeconomy. But the business developers behind crypto companies were looking for the kind of legitimization that no amount of advertising could attain, and collectibles by themselves felt like little more than a bubble. They wanted the approval of legacy companies. They wanted permanence. They wanted cultural capital.

<center>𝗠</center>

Random emails popped into Meghan Doyle's inbox so frequently that she had developed a script for gently telling people that their supposed treasures were actually trash. Exceedingly few of those inquiries ever translated into credible leads, which could become the blockbuster sales needed to get promoted in the ecclesiastic world of auctions. She had been working as a cataloguer for the Post-War & Contemporary Art Department at Christie's, a research position that often meant spending 120-hour weeks inside the office during major sales, appraising the value of incoming collections, and color-checking the images of marketing materials. Monitoring the department's general email was just another one of Doyle's responsibilities, consuming time that she would rather have spent deep in a museum library's archives.

In late October 2020, dozens of crypto enthusiasts were flooding Doyle's inbox with blockheaded blockchain proposals. Earlier that month, she had been involved in Christie's first NFT auction, which came paired with a painting called *Block 21*

by the artist Ben Gentilli. Evoking the foundational text of Bitcoin, the artwork transcribes a section of the cryptocurrency's source code onto a disk-shaped canvas. More than 320,000 digits of the hexadecimal code form radiating lines of text on the arcs of the painting, which are sprinkled with thirty-two gold-encrusted digits. From a distance, the numbers and letters looked like constellations in the night sky; computer nerds might also notice a resemblance to the famous 1968 Rand Corporation diagram of the internet, which imagines decentralized networks as node clusters. The artist has described his work as a "digital fingerprint carved out of paint," which links the NFT image's display to the geographic location of the physical artwork. Depending on where the collector has housed the painting, the NFT image will be displayed in daylight or darkness. The owner can effectively control the visibility of the artwork by changing where it is located—a commentary on the resilience and secrecy of decentralized structures.

Christie's was only testing the waters with *Block 21,* and the sales team relied on Doyle to immerse herself in NFT technology to convey why the artwork might be worth a few thousand bucks. Beyond any necessary blockchain jargon, she peppered in comparisons to everything from the Magna Carta to the Rosetta Stone and Jasper Johns. Such is the logic of auction houses: if you cannot express a painting's lineage in terms of Michelangelos and sacred texts, then why bother trying to sell it?

According to insiders, Christie's executives dismissed *Block 21* as a trifle—something to sweeten the doldrums of the unpredictable pandemic market. The physical salesroom was still closed to audiences, and appetites for digital art were peaking as people continued to live and work through their computers. Collectors were already used to purchasing paintings off PDFs and PowerPoint presentations. Then the artwork arrived as Lot 443 in a long day-sale on October 7. A sur-

prise bidding war began over the livestream between anony-
mous online buyers and private clients over the phones, who
immediately catapulted the painting above its high estimate
of $18,000. A flurry of two dozen bids ricocheted around the
room; after just four minutes, the price had reached $105,000,
for a final price of $131,250 including buyer's fees.[4]

The sale raised some eyebrows at Christie's; when the com-
pany later released its $4.4-billion earnings report, it claimed
that digital innovations would remain a major driver of growth
for its business. But ultimately it was only a small success com-
pared with more traditional artworks offered in the same sale;
for example, a painting of waterfalls and forest called *Shangri-
La* by the late artist Matthew Wong sold for $4.47 million.[5]

However, crypto entrepreneurs were paying close attention
to the success of *Block 21.* When NFT prices started surging
in 2018 around *CryptoKitties* and *CryptoPunks,* Web develop-
ers had rushed into the space. MakersPlace became one of the
first marketplaces for online collectibles. The company's chief
technology officer, Yash Nelapati, had been the first employee
at Pinterest while its executive chairman, Dannie Chu, had
led growth engineering at the image-sharing platform. Ryoma
Ito, the chief marketing officer, came from a background in
e-commerce and believed that NFTs could solve many of the
problems he had faced at other startups selling digital goods.
When they pitched creators, they often tried to sidestep the
jargon about NFTs to explain more simply that the blockchain
technology helped defend against piracy by securing and dis-
playing provenance, a new ledger system that would replace
physical autographs with digital ones.

But the company had struggled to onboard customers and
creators. Ito said that he personally recruited about three
thousand artists for the website, but many left because their
artworks never sold and they were still skeptical about the
underlying technology. Then—a stroke of luck. In October

2020, around the same time that Christie's was selling *Block 21*, opportunity paid a visit to MakersPlace. The comic-book artist José Delbo released a video collaboration named *Genesis* with the crypto artist Trevor Jones that features a drawing of Batman transforming into an oil painting. A crypto investor nicknamed MaxStealth placed the winning bid of nearly $113,000 in Ethereum, a new record for the NFT marketplace.[6]

"That was an opportunity to go into the market and tell people to start paying attention," Ito later told me in an interview. "But trust and legitimacy were the things that we still needed. Working with a huge brand or an auction house could do that."

Time was of the essence. Ito created a list of companies and started cold-pitching the art world. Sotheby's, the largest auction house, was near the top of his list. No response. So he tried reaching out again through specific employees, and with little luck; finally, he was told that the idea of an NFT sale was uninteresting. He encountered similar challenges everywhere he went; most gatekeepers were unwilling to risk their own reputations on a partnership with the volatile crypto market.

Christie's was his last, best chance. Over email, Ito finally connected with Doyle in the Post-War & Contemporary Art Department. She was a sympathetic ear, having studied NFTs and blockchain technology ahead of the *Block 21* sale. And while most of her colleagues had dismissed the sale as a pleasant fluke, the young cataloguer noticed that the majority of bidders who competed for the artwork were new clients. A relationship with MakersPlace could provide a boon to future auctions if she could convince her bosses to move forward. But that was no easy task.

"The general consensus was that it was too new, and too much to wrap your head around," Doyle said. Her managers declined to include NFTs in their upcoming December sale, but she continued her advocacy campaign, until one relented: "If you want to run with this, go ahead."

Doyle liked a challenge. She had joined Christie's through the company internship program after graduating as valedictorian from Pepperdine University in 2018, where she studied Conceptual Art within view of the Malibu shore. Her passion for art history helped fuel her work at the auction house, writing essays for upcoming lots. Within two years, she was promoted three times, until reaching the cataloguer position.

"Render yourself meaningful," Doyle said, repeating the advice of senior colleagues who navigated the cutthroat environment at Christie's by becoming specialists in a specific artist, cultural movement, or medium.

Doyle might have fallen into NFTs by chance, but she recognized that the technology would become her foothold in the industry. After managers declined to include digital collectibles in the December 2020 sale, the twenty-four-year-old cataloguer started having regular conversations with Ito about plans for another collaboration.

"We were going back and forth over the holidays about our approach," Ito said. "Who do we pick to be the champion, the evangelist for NFTs?"

Thanksgiving and Christmas passed; the collaborators developed their shortlist of artists, including Winkelmann, Delbo, Jones, and an anonymous artist named Pak, who that December had raised $1.3 million in a sale on Nifty Gateway.[7] Appraisals normally begin with an examination of the artist's sales records. Good metrics include not just rising prices but the volume of sales, the stock rarity, the prestige of collectors, and the comparable data from other artists. The auctioneer's role is usually similar to that of a real-estate agent attempting to triangulate a competitive price for a Manhattan condo. But NFT artworks lacked substantial sales to outline their market or reasonable prices. The collaborators were mainly speculating on the future. They eliminated Pak from consideration because of his anonymity behind a pseudonym; whoever led

the Christie's sale would need to become a visible spokesman for the blockchain. Jones and Delbo were good options but a little too connected with the comic-book industry to establish a foothold in the world of fine art.

And then there was Winkelmann. "The guy looks like a high-school math teacher playing on his computer every single day," Doyle observed. "Buyers could respect that kind of perseverance and diligence."

Ito had unsuccessfully courted Winkelmann in the past, but this new opportunity with Christie's held appeal. He sent the artist a short, vague email about having a chance with a major auction house, keeping the company's name concealed. Hours later, they were on the phone closing the deal; meanwhile, Doyle had been waiting for the right time to approach her superiors.

Nobody was coming into the office on January 6, 2021. The holiday season was winding down, and the Covid-19 Omicron variant was still rampaging through New York's reopened offices. Christie's headquarters in Rockefeller Center were quiet, with just a few employees at their desks, and security guards manning Reception. Everyone else was glued to their televisions and phones, watching news unfold as thousands of right-wing protesters approached the United States Capitol building in Washington, D.C., with firearms.

"I sent you an email, but you probably didn't read it," Doyle said, grabbing the attention of Noah Davis, the company's online-art specialist. She explained how, over the last couple months, she had worked with MakersPlace on a new NFT sale idea that would leave behind the physical components of painting that had sweetened the *Block 21* auction. The young cataloguer then presented her research on potential artists and buyers, and asked for a slot in the upcoming February sale.

Davis hesitated. He was both curious and cautious, accustomed to the bold gambles of the auction world after nearly a

decade in the business. He had come by way of California, a teenage punk-rock wannabe from Los Angeles who spent his mornings at the prestigious Harvard-Westlake School and his evenings playing in a band with friends in Culver City. Friends described him as the golden prince of the San Fernando Valley—tall with chestnut hair and good looks. A rebellious streak took Davis across the country to New York University, where he studied English, focusing on topics like existentialism and French postwar theater.

Within the beige offices and bland bookshelves at Christie's, Davis looked like he belonged to the rigmarole of chic, attractive, but ultimately dull salesmen who lubricated their big auction deals with boozy dinners and bons mots. But underneath his tailored suit, Davis's more mischievous side revealed itself in tattoos of animals, roses, and other plants. After years of maneuvering through such a stuffy industry, he had come to see himself as an outsider. He had joined Christie's in 2016 as a lateral move from Sotheby's, becoming a cataloguer in the Post-War & Contemporary Art Department. A new auction house was his chance to establish himself, but instead he found himself passed over for promotions to the lucrative evening sales. He was mostly quarantined to digital art; the man hadn't even owned a personal computer since college. Now he was responsible for one of the smallest segments of Christie's business: First Open, an online category for contemporary art meant to woo new collectors who rarely ever appeared. Davis described the situation as a "digital garage sale."[8] The paintings and prints that he hocked were as good as goop, which he was expected to transform into a revenue-making enterprise. His goal was to feature increasingly more expensive art by partnering with cultish fashion brands like Supreme, but sales figures still hovered as low as $200,000. It was barely enough to justify his salary.

Life in the company boondocks was frosty. Davis stood

on the sidelines of major changes to the auction house as the boundaries between departments were collapsing and auctioneers became more skilled at goosing auction records.

In 2017, Christie's made a Renaissance painting the marquee lot in their November sale of postwar and contemporary art. The anachronism was supposed to convey the immediacy of the artwork's appeal, even if art historians were more skeptical about its authenticity; nevertheless, the auction house described *Salvator Mundi* as a genuine Leonardo da Vinci painting, and it sold for a record $450.3 million to Saudi crown prince Mohammed bin Salman. The price overtook the previous benchmark, set by a Picasso painting in 2015, by almost triple. Gasps from the salesroom confirmed the event as peak spectacle, made even more ridiculous in the coming years, as *Salvator Mundi* remained locked inside the crown prince's yacht; he refused to exhibit the painting publicly, allegedly because he feared that museums might downgrade the work as belonging to a Leonardo assistant instead of the master himself.

Restructuring continued in 2020, as Christie's announced that it would merge its impressionist and modern and contemporary art departments into one office. "Our clients don't think in categories anymore," Guillaume Cerutti, chief executive at the auction house, told reporters at the time.[9]

The decision came at a time when impressionist and modern sales were performing far below their postwar and contemporary competitors. Combining the departments would dump collectors into one pool, changing the dynamics of the market and pushing tastes toward the present. It suddenly seemed that the most expensive artworks had paint dripping off the canvas; the artists were oftentimes women and people of color, and they were in their thirties and forties—shocking for an industry that had exclusively prized dead white men for the majority of its existence. Sales of art sold within three years

of its creation date grew 1,000 percent over the past decade to almost $260 million.[10]

Ironically, the arrival of the ultra-contemporary market occurred around the same time that Christie's announced that its top lot for the 20th Century Evening Sale in October 2020 would be the remains of a Tyrannosaurus rex, nicknamed Stan, which ended up selling for $31.8 million, the most ever paid for a fossil at the time.

Many employees were bitter about the changes; they rolled their eyes at the little anachronisms that had become headliners. It was a successful marketing gimmick by the bigwigs to grab attention in a moment when the pandemic economy seemed on the verge of daily collapse. Those who joined the auction house to nerd out on art history hated this new approach, but others, with a sense for business, thrived in the controlled chaos.

"I have always felt like I am living in the theater of the absurd," Davis later confided in me. He relished the ridiculous nature of his industry. The auction world was a system of meaningless sales records, an illusion of competition that often boiled down to a handful of rich men who all knew one another competing over the bragging rights of ownership. Connoisseurship was dead. Provenance was a mirage. Dinosaur bones were being sold next to Rothko and Picasso paintings.

"All I know is that I know nothing," Davis said, adding that the motto was actually a paraphrase of something Socrates once said and a lyric from a song called "Knowledge" by the California punk band Operation Ivy.

So, when the salesman considered all the strange circumstances surrounding him, auctioning an NFT sounded perfectly reasonable. "It will be fun and a little weird," he predicted.

The auction was less than two months away, and everyone supporting the NFT sale had something to prove. Doyle and

Ito started working around the clock, feeling pressure to cre-
ate the perfect auction. But the most important detail was still
missing: what was Beeple going to make? The artist had origi-
nally suggested one of his *Everydays* to commemorate fourteen
years of working on the project.

"Cool, but maybe not as epic as it should be," Doyle said,
declining the proposal.

Winkelmann returned with a new idea. "I had hit this per-
fect milestone in this massive project," he remembered. "And
I had just happened to hit 5,000 days of making art."[11] Instead
of offering a single work, he decided to combine everything he
had created over the last fourteen years into a single composite,
sold as an NFT.

"He came back to us with a magnum opus," Doyle said.
"With that image in hand, we were able to rally the support
that we needed to develop content around the piece and get
advertisements in the newspaper. We had a complete story, a
complete picture."

However, Ito found the level of involvement from Christie's
Marketing Department lacking. Understanding the stakes of
this auction for his company, he started trying to make his own
luck through outreach with private collectors—"whales," as
they are called in the crypto community. Vignesh Sundaresan
was one of the first names on his list.

In January, Sundaresan could be found on the virtual disco
floor with a champagne glass floating about the head of his
digital avatar. He was partying hard in the metaverse to cel-
ebrate his $2.2-million purchase of twenty Beeple NFTs and
the opening of a gallery that he had commissioned Web archi-
tects to build in the online world of Origin City. Back then, he
was operating under a mysterious persona named MetaKovan,
which translates from his native Tamil language into "King of
Meta."

Sundaresan was a serial entrepreneur in the crypto indus-

try; he had gained his affinity for decentralized finance after a childhood in the Indian city of Chennai, where he dreamed of becoming the next Steve Jobs.[12] He was born there in 1988, and came of age alongside the World Wide Web, which had been released the following year. Then there were a series of false starts, including the creation of "Bitcoin ATMs," which enabled users to deposit physical cash and receive crypto, and a trading platform called Lendroid, which blew through its $48 million in funding within two years.[13]

In 2019, Sundaresan started investing heavily in digital properties, buying a digital representation of a diamond-studded Formula One car for an online racing game, NFT artworks, and hundreds of acres in the digital real-estate market. A year later, he started using the name MetaKovan, which he describes as his "exosuit" created for "building the metaverse."

At the virtual party in January, Sundaresan, now thirty-three, unveiled a fund called Metapurse for investing in NFTs. The twenty Beeple artworks that he had purchased were bundled into a single asset called B.20, which was then fractionalized into ten million tokens. Buyers of the tokens were told that this would denote ownership over the metaverse's first large-scale public art project.[14]

"We were inspired by the idea of not only being able to own historic artwork, like the *Mona Lisa,* but also being able to own the museum it was displayed in, and then sharing that ownership and experience with the public," the company said in its newsletter. "Making money with art is fairly simple and not very imaginative. What we want to do is to decentralize and democratize art."

Ito had been watching Sundaresan for a while; he understood how the crypto millionaire operated and that he had an affinity for the guttural sci-fi fantasies that Beeple was selling. More important, MetaKovan wanted to leverage NFTs as a financial instrument. He was exactly the kind of person who

might want to send a message about the power of digital art by spending millions on an image.

Gradually, Sundaresan was coaxed into the process. He had some initial worries about going through the Christie's "Know Your Customer" process, an anti-money-laundering rule that ensures that companies keep records on the essential facts of their buyers and sellers. He expressed his reservations to Ito, fearing that he would be unmasked as MetaKovan because of the digital identity trail. But, eventually, he came to accept that this was a risk involved in doing business with an established auction house, even if the majority of bidders remain anonymous to the public unless they choose to reveal themselves. He was joined by his cofounder at Metapurse—another Indian crypto investor, Anand Venkateswaran—who played more of a backseat advisory role in the acquisition process.

The marketing juggernaut at Christie's, which had initially been slow to support the sale, finally kicked into action. Winkelmann's NFT idea had been rebranded into an event with its own subtitle, like an *Avengers* movie—*Everydays: The First 5000 Days*. Doyle was receiving increasing numbers of emails from crypto collectors expressing their interest in placing a bid. The artwork had been published without a price range; instead, the auction house chose to write "estimate unknown," a cheeky nod to the usual "inquire for estimate" phrase implying that anyone needing to ask was too poor to buy.

"Estimate unknown." That was the truth. Winkelmann had prepared himself for the NFT to sell for somewhere near $1 million. Ito had the same gut feeling. It wasn't until a few days before the sale, as reporters started asking if they were prepared to sell for *tens of millions,* that the team realized something profound was about to happen.

"Noah looked at me and said, 'We are about to throw a grenade on the art world,'" Winkelmann recalled.

Compliance officers and executives at Christie's were still debating the financial terms of the deal. The original plan was for the house to accept cryptocurrency for the hammer price but require that its own premium fee be paid in dollars; however, sale organizers worried that such an arrangement would discourage crypto whales from participating in the auction. Success needed to be measured with the company's long-term goals for growth. Accepting cryptocurrency would invite scrutiny from the press, traditional collectors, and government regulators; it could also be a financial risk, depending on the volatile prices of Bitcoin and Ethereum. What ultimately became clear to decision makers was that nothing about this sale could be half-assed. Big money often requires big leaps of faith.

"A decision was made at the highest levels to take the whole thing in cryptocurrency," Doyle said. "The amount of cogs in the wheel for that to happen was truly mind-blowing."

The gamble worked, and the tidal waves of inquiries about the Beeple sale never stopped. Sundaresan had already confirmed his participation in the auction, but what nobody expected was another competitor willing to participate in one of the most furious online bidding wars that the auction house had ever seen.

〽

On February 25, 2021, the auction began with a $100 opening bid. Within eight minutes, the price had reached $1 million.

"I was shocked that our website could handle it," Doyle said. "I had never seen that happen."

The auction had already reached the threshold for bidders at which the prospective buyers needed to be cleared financially, often with letters of references from the crypto exchanges sup-

porting their transactions. There were nearly two dozen hopeful buyers at that point, eighteen of whom were entirely new to Christie's. Most were millennials.

"It was a psychotic amount of bidding," Davis thought as his phone started blowing up with messages.[15] His boss, Alex Rotter, head of twentieth-and-twenty-first-century art, even took to social media to brag about the sale. He posted a Beeple artwork to his Instagram featuring a superpowered Homer Simpson lobotomizing his son, Bart Simpson, with laser vision. "Beeple leads the way," Rotter captioned the image. "It's all happening."

ART IN THE TOKENIZED ECONOMY

Two centuries ago, photons collided with the plated silver salts hiding within a camera obscura to create a dark impression of daylight. This was the world's first photographic negative, a quickly fading imprint produced in 1816 that the French inventor Joseph Nicéphore Niépce called a "retina."[1] The stabilization of a positive image would take Niépce another decade, with the world's oldest surviving photograph produced on a metal plate with light-sensitive chemicals fizzling into view a desolate and shadowy landscape outside a window in Saint-Loup-de-Varennes, France.

It would take another Frenchman, Louis-Jacques-Mandé Daguerre, to refine and popularize the photographic method. This accomplished painter and scientist found the right combination of chemicals to produce permanent images affixed to metal plates in 1839. Those daguerreotypes scandalized the superstitious corners of Europe; at least one German newspaper described the images as pure blasphemy: "Man is created in the image of God and God's image cannot be captured by any human machine. Only the divine artist, divinely inspired, may be allowed in a moment of solemnity, at the higher call of his genius, to dare to reproduce the divine-human features, but never by means of a mechanical aid!"[2]

The intelligentsia were likewise upset. In an 1859 essay, the

French poet Charles Baudelaire described photography as "art's most mortal enemy" and claimed that "if photography is allowed to supplement art in some of its functions, it will soon have supplanted or corrupted it altogether."[3]

Baudelaire continued: "Are we to suppose that a people whose eyes are growing used to considering the results of a material science as though they were the products of the beautiful, will not in the course of time have singularly diminished its faculties of judging and of feeling what are among the most ethereal and immaterial aspects of creation?"

But the wealthy didn't care, and portrait photography soon became a luxury good akin to jewelry and stored behind similar glass cases; painters even used photography as a technical aid in their own processes. But as the German scholar Walter Benjamin recalled in his 1931 description of photography's history, people were still embarrassed to look at daguerreotypes, unaccustomed to seeing their own images reflected so vividly. "The human face was surrounded by a silence inside which the gaze was in repose."[4]

Widespread interest in photography meant little to the traditionalists running museums on the hierarchical ideas of high and low art. The idea of a new technology that could compete with the supremacy of painting and sculpture was absurd. Curators were quick to dismiss photography, and slow to admit their mistake. For example, the Metropolitan Museum of Art only started collecting photography in 1928, when one of the world's most famous photographers, Alfred Stieglitz, donated a significant portion of his personal collection to the institution. It would take the museum another sixty-four years to establish a dedicated photography department, in 1992.

Benjamin argued in the 1930s that photography had transformed our psychology, culture, and politics by ushering in an age of mechanical reproduction that stripped artworks of their ritual function associated with a previous age of religious art in

churches and temples. He warned that the future would need to worry not about the illiterate man who could only understand photographs, but about the illiterate photographer who could not read his own pictures.[5] Written before the outbreak of World War II, Benjamin's critique articulated a growing skepticism that modernization was bringing humanity toward the precipice.

The adoption of mass-communications technology throughout the early twentieth century raised the alarm bells of existential crisis for some critics attempting to reconcile the flattening of cultural values with the democratization of image-making. Meanwhile, painters pushed deeper into abstraction and amplified the ritualistic aura of their canvases; sculptors started experimenting with monumentality and ready-made objects; and photographers indulged in the archival impulse, defining the world through catalogues of visual information.

Curators at the Museum of Modern Art took their cues from those artists, painting their galleries like the white laboratories of a research institute. Art in the expanded field was not just an aesthetic pleasure, but also a device for expressing new ideas and systems. MoMA began collecting photographs in 1930 and four years later produced an exhibition called *Machine Art,* which included three floors of utilitarian objects like kitchen tools and scientific instruments that were put on pedestals and displayed like sculptures.

In 1968, the museum would stage *The Machine as Seen at the End of the Mechanical Age,* a major historical survey that marked an end to the machine and the beginning of the computer age. The exhibition included a section devoted to a collective called EAT (Experiments in Art and Technology) that included artists like Robert Rauschenberg and engineers from Bell Laboratories. An open call for submissions included computer-generated drawings, and films with computer graphics, a cutting-edge technology for the time. The winners were

all engineers, whose work registered the power of digital and electronic tools. There were cybernetic sculptures that converted sound into light and motion, a vitrine of red pigment that erupted in response to the viewer's heartbeat, and a ribbon spinning at a hundred miles per hour to produce an image of a mechanical fountain.[6]

The EAT collective eventually became a global network with nearly five thousand members, an astonishing scale of participation for the time period. The experiment collapsed under its own weight in the 1970s, however, and artists like Rauschenberg, Claes Oldenburg, and Robert Whitman moved on to other projects. So did the engineers. But the collaboration between these two sectors set an important precedent that would later fuel the NFT revolution. Artists could help inspire engineers to think more creatively for the public good, and they could also serve as an early-warning system for technologies that could harm society. And although artists were not as directly involved in the development of technology during the internet age, their work is critical to understanding the phenomenon of digital culture.

The year 1989 marked the fall of the Soviet Union and the rise of the World Wide Web as theories on globalization became the dominant ideology of market capitalism. Political buzzwords like "openness" and "transparency" coalesced with new telecommunications technology like satellites, which created a nonstop news cycle just in time to project footage of the violent 1990 Gulf War around the world. A little more than a decade later, in 2004, the advent of social media with Facebook's creation introduced new tools for monetizing information and visual culture. New revenue streams emerged based on viewership and interaction; the attention economy increased our tolerance for algorithmically addicting features like Twitter's infinite scroll and YouTube's Autoplay function. The hours spent online suddenly felt like minutes.

What happens when you cannibalize time? The artist Christian Marclay offered one theory with the 2010 release of *The Clock,* a delirious compilation of movie clips synced to the passage of a full day, in which nearly every second is represented by an image of a timepiece and character reaction shots. Viewers must experience the artwork in real time with a scene from Audrey Hepburn partying in *Breakfast at Tiffany's* around 6:45 p.m. and Natalie Portman watching Big Ben explode at midnight in *V for Vendetta.* The escapism of the cinema is replaced with a meditation on the time spent consuming media—or, more precisely, the inability to grasp time as it passes. Bearing witness to Marclay's lucid dream, the viewer is asked to make sense of these unrelated scenes, grasping at symbols and sounds as the brain attempts to reconcile the cacophony. Audiences caffeinated enough to stay awake until 4:30 a.m. are greeted by a torrent of blood flooding the hotel corridors of Stanley Kubrick's *The Shining.* Overrun by the speed of this scherzo choreography, the viewer is caught between the mesmerizing and horrific images of Hollywood enchantment.

"Time of the finite world is coming to an end," the theorist Paul Virilio once wrote. "We live in the beginnings of a paradoxical miniaturization, which others prefer to baptize automation."[7] The intellectual prospecting of the digital revolution has attempted to cram all knowledge into a singularity called internet time, in which even the infinitesimal processing speeds of algorithms are pinned to "epochs," a term redefined by programmers to describe how computers keep track of their internal clocks. The internet has constructed a new Library of Babel, where all information is simultaneously remembered and forgotten, created and destroyed. Art was supposed to prevent this cultural collapse by building its monuments large enough to block the looming shadows of death from our periphery.

Marclay described his own project as "capturing time, try-

ing to hold it back," recalling the unique way that images defy logical time through their own permanence, and our tendency to dissociate into the romance of cinema.[8] NFTs serve a similar function in popular culture. The tokenized economy snapshots the unceasing pace of digital life through artworks and collectibles that substantiate the internet's hierarchy of values. The camera is simply too slow to capture internet time, where transactions occur at the speed of nanoseconds, a million times faster than the shutter of a lens.[9]

NFTs visualize the seemingly endless nodes of community forming online, so there is a special irony in its members' need to rehearse the same arguments that early pioneers of photography made two hundred years earlier to accustom gatekeepers to new norms around provenance and authenticity. And perhaps the repetition of these historical arguments about technology has streamlined the feedback of rebellion and acceptance that has characterized the art world. It took photography more than a century to enter a major museum; it took NFTs a couple months.

Details of the latest coup in digital art and speculative finance traveled much faster over the internet than through the old gossip mills of the Parisian nursing home where Vera Molnár lived. The ninety-six-year-old artist had moved into the facility after the initial wave of the pandemic made independence nearly impossible. One might expect that containment and age would have slowed her creative process, but word from her longtime gallerist about the rise of cryptocurrency, the potential of nonfungible tokens, and the promise of a man named Beeple had energized a sudden reach toward her pens and papers. Her bedroom desk became the workstation where she mapped some of her first new drawings in years.

An overwhelming wave of recognition soon followed for Molnár, after she spent so many decades in the shadows of men whom she had once worked alongside. Curators from around the world were asking for permission to produce retrospectives about her career. She was going to be seen for the first time in California museums and exhibition halls at the Venice Biennale, the art-world Olympics. And whereas traditional collectors were never willing to spend more than a few thousand dollars on one of her prints, some of those supposedly craven crypto millionaires were willing to shell out six figures for one of her works, eager to legitimize their NFT holdings within a historical arc that claimed Molnár as grandma.

"I've become so used to not being known, to working in my corner," Molnár said, in an interview conducted via email because of her English skills and advanced age. She lived in disbelief for weeks, sure that all these requests for comment about the rise in NFTs were a mistake. "And then, the other day, I told myself that it's normal, that I deserve this."

She remembered a friend saying that the life of a painter was quite simple; only the first sixty years were hard. For her, it was nearly a century.

Molnár was born in Budapest, Hungary, in 1924 to parents who nurtured her creative ambitions. Her mother had provided her with a set of pastels at the age of ten, and so she began drawing. One of the first artworks that she ever drew was a sunset over Lake Balaton, which her mother gently criticized as being too plain. Molnár was unfamiliar with the concept of artistic license, and her mother suggested maybe adding a tree to the otherwise flat image of the lakeside setting sun. "I felt it was overloaded! It was too much! I didn't know what 'artistic license' was, but I decided that my mother didn't know anything about art and I should go with my own idea."[10]

Stubbornness prevailed, and Molnár found herself creating systems within her young art-making practice, rotating

through red, blue, and green pastels each day, and reducing complex portraits to their basic geometries. Even when she saw the Sistine Chapel at sixteen, she was thinking about numbers. Her mother got frustrated when Vera looked above the altar, counting the figures that flanked Jesus Christ.

Classical training at the Budapest College of Fine Arts marked her entrance into the art world, but it was her immigration to Paris in 1947 with her future husband, François Molnár, that allowed her to circle the same orbits as famous artists like Brancusi, Kandinsky, and Fernand Léger. In 1960, she helped found a cooperative named GRAV (Groupe de Recherche d'Art Visuel) with François, the Argentinian artist Julio Le Parc, and eight others. The group investigated new approaches to mechanical and kinetic art, rejecting the concept of a "solo" artist by collaboratively devising immersive experiences that foreshadowed the genres of social practice and interaction that became popular in the 1990s. Within this built environment, Molnár developed her "*machine imaginaire*," a generative method for which she handwrote procedures to create artworks.

But GRAV's collective ethos was constantly undermined by the reality of competition among the artists. The group disbanded in 1968—a troubling year for Paris, when a student revolt and general strikes shuttered campuses and halted the French economy. It was an era of hopeless naïveté, when roadblocks to sexual liberation and social equality became the barricades of a rebellion that almost toppled the Fifth French Republic.[11]

"The students were demonstrating on the Boulevard Saint-Michel," Molnár recalled, explaining how she got access to the computers at the Paris-Sorbonne University in Orsay. "The technician, who was bored to death, was only too happy to help me."

So, as politicians were preparing for disaster and French

president Charles de Gaulle was secretly checking on the troops he had stationed in Germany, Molnár was tiptoeing into the computer lab. She arrived the next morning to face the display screen of an early IBM computer, a gigantic gray machine that required an entire other room for ventilation.

"I understood that this gadget was going to be my salvation. You get flashes of insight," she said. "Before, I had to program in Fortran with punched cards, and then I had to wait several days to get the answer, which was almost always wrong or at least not exactly what I wanted. And here I thought that with this screen it would be like a conversation, or a kind of visual psychoanalysis. And it was true! This IBM gadget changed my life."

Technology became a gateway to the modernist grid; Molnár produced *Interruptions* (1968–69), a densely compact maze of alleyways drafted by computer to suggest chaos and void, which seemed like an imprint of the helter-skelter students running through the Paris streets. She tested the limits of informatics and generative algorithms, balancing randomness and redundancy to reproduce the idiosyncrasies of an artist's hand wobbling on the page. Contemporary research by another early computer artist, A. Michael Noll, an engineer at Bell Telephone Laboratories in New Jersey, confirmed that viewers enjoyed those quirks. When one hundred participants compared Xeroxed reproductions of Piet Mondrian's *Composition in Line* (1916–17) and a computer-generated version of the original painting, most subjects mistook the computer facsimile for the real thing, and also preferred it. He concluded that randomness played a key role in the aesthetic appreciation of images.

Computer artists seemed to gravitate toward the gridlike structure of Mondrian's style, which had by the 1960s become synonymous with sleek modern design—a symbol of future-forward thinking. The style also held a practical appeal for art-

ists like Noll and Molnár, whose rudimentary digital programs could more easily reproduce the artists' right angles and crisp edges than something like the swirly paints of a van Gogh. She eventually helped her husband develop a psychological study similar to Noll's that looked at how people reacted to computer drawings, producing a series of original variations on the Mondrian designs in 1974 that she playfully called *Molndrian*. Halfway around the world, in Japan, the artist Hiroshi Kawano was preparing his own algorithmic models based on Mondrian, coded in a computer language named Fortran.

(Almost fifty years later, Mondrian's modernist grid would inspire several NFT projects, including Tyler Hobbs's *Fidenza* series, Erick Calderon's *Chromie Squiggles,* and a 2019 Larva Labs series called *Autoglyphs,* which are some of the first generative artworks minted onto the blockchain. The instructions behind those 512 randomly generated artworks were also inspired by the instructions from the Conceptual artist Sol LeWitt's wall drawings, but the resulting image shared the same fractal grid pattern of lines that Mondrian believed would help him "arrive at the fundamental quality of objects," meaning the pure, abstract spirit of their geometry.)[12]

The Cambridge art historian Aline Guillermet has written about this strange obsession with Mondrian as an attempt to legitimize the characteristics of computer art within a larger legacy of modernism's exploration of randomness and error: "The visualization of imperfection, or error, was no longer exclusively associated with the human hand; rather, it had also begun to be understood as a form of creativity specific to the machine."[13]

Celebrating the glitch was a powerful counternarrative to the technological determinism of the twentieth century; however, the contemporary art world saw little financial promise in computers. By 1995, a group of artists including Molnár and Noll declared themselves as "Algorists" within a mani-

festo that sought to give an identity to their similar practices.[14] But, nearly three decades after they began their experiments, there was still virtually no market for their creations. The art world dismissed the Algorists as programmers masquerading as artists, producing work that was too derivative of modern painting and—more alarmingly—ceding the gift of human creativity to the machine. Instead, technophobic museums and galleries invested in more palatable forms of technological experimentation in the 1990s, like video art. Even as the World Wide Web started to overtake telecommunications, computer art languished. And if computer art was on the periphery of culture, then Algorists and their generative art were on the periphery of the periphery.

The prolonged lapse in recognition for digital artists befuddled some art historians, leading Claire Bishop to ask, from the pages of *Artforum* in 2012, "While many artists use digital technology, how many really confront the question of what it means to think, see, and filter affect through the digital?"[15] She predicted an eventual turning point: "At its most utopian, the digital revolution opens up a new dematerialized, deauthored, and unmarketable reality of collective culture; at its worst, it signals the impending obsolescence of visual art itself."

The rehabilitation of Molnár's career wouldn't start until 2017, when MoMA included her in an exhibition called *Thinking Machines: Art and Design in the Computer Age, 1959–1989,* which featured artists who exploited the potential of emerging technologies with plotter drawings, computer animation, and kinetic information. The exhibition was an homage to the two aforementioned, era-defining shows at the museum: *Machine Art* and *The Machine as Seen at the End of the Mechanical Age.*

MoMA would acquire several Molnár works in 2020, by which time a new generation of creative coders, like Tyler Hobbs, Erick Calderon, Dmitri Cherniak, and Sofia Crespo, were finding inspiration in her experiments. Soon enough,

curators were recontextualizing Molnár and EAT artists as historical reference points for museum trustees to understand the NFT movement and greenlight the acquisition of blockchain-based artworks. It was a clear line of causality. Generative art blossomed into a powerful genre of digital art investigating the algorithm and its rule-based systems of predictability and randomness.

But the narrative was almost too convenient, suggesting that researchers had sketched their version of history with a ruler between the past and present. Little about the underlying technology that the Algorists used connected them with the blockchain logistics of the NFT movement; however, a market built around prestige and provenance needed romantic underdog stories that were decades in the making to sell artworks. History was only a selling point, illuminated by a preponderance of museum curators and university academics who subsidized their research by writing commissioned essays for auctioneers and galleries. The brutal reality was that artists like Molnár found their limelight when market forces dictated it.

It has become a universally accepted truth that a wealthy collector in search of a good art-investment must select an artist with enough leverage to find her way into a museum. With a big enough donation, that collector can often find himself a seat on the museum board, a position that typically affords decision-making power over acquisitions and exhibitions. A good collector is already immersed in the market, with broad connections in the commercial art world of blue-chip dealers and auction honchos. And so the sweetheart deals are made under the table, delicately suggested to curators who often take a "one for them and one for me" approach to their battles over programming. It was just another careful choreography—subtle enough that it disappeared if you didn't know where to look.

The museums would deny their role in this little dance,

because any appearance of collusion would damage their status as nonprofit institutions serving the public good. After all, museums are consistently ranked among the most trustworthy institutions in the world, above science, news agencies, and government. Research has revealed another side of the industry, however, with studies showing that just 10,000 of more than 250,000 contemporary artists took priority in museum exhibitions, which totaled just 4 percent of the creative population in the period from 2017 to 2021.[16] Another study, conducted in 2015, found that almost one-third of solo museum shows went to artists represented by five of the top galleries in the world: Pace, Gagosian, David Zwirner, Marian Goodman, and Hauser & Wirth.[17]

Smart collectors understood that museums worked for them, operating as glorified credit-rating agencies that could legitimize speculative purchases in the contemporary art market by acquiring works by the same young artists. The same logic extended into the auction world, where those same collectors and museums competed over the same artists. It was an insular world with an outsized influence and limited requirements for public disclosure. Until 1975, auction houses regularly published false records that said certain paintings sold when they did not. (These "buy-ins" were acquired by the auction houses when nobody bid on their lots.) The misleading practice was only changed after newspapers realized the reported $60,000 sale of an Andy Warhol *Soup Can with Peeling Label* five years earlier was a lie.[18]

Today the best strategy for fooling wealthy people into buying art is to make them feel insecure before throwing economic data in their faces. The ideological and financial nuances of paintings have become so complex that few collectors have the academic background to select artworks constantly; instead, most loan their pocketbooks to advisers and dealers who are afforded such enormous leeway that few are even chastised

when they overspend. Any irritated collectors are provided a little chart called the Mei Moses Index, owned by Sotheby's, which analyzes the market based on more than eighty thousand repeat auction sales since 1950. The index is the main reason why many collectors and the broader public believe that blue-chip art is a better investment than stocks or gold. (For example, my top result on Google when searching this question is an article in *Investing.com* falsely stating that art outperforms the S&P 500 by 250 percent.)[19] It is an incredibly selective tool that only examines a sliver of the entire industry made visible in auction houses, where sales are tightly choreographed. The reality unaccounted for in the Mei Moses Index and other analytical engines is that most artworks are only sold once and through private dealers, meaning their sales records are mysteries omitted from the charts.

But all anyone needs to succeed in culture is the imprimatur of legitimacy. The NFT barons certainly had an interest in upholding this system; despite their promise to kill the corrupt art-market system and usurp the museums, they doubled down on its false advertising. Showcasing artists like Molnár helped bridge the gap between old institutions and the new crypto avant-garde, inculcating a new generation of wealthy elites into the big art-money lie.

Everyone seemed to benefit from these happy coincidences. The Algorists received a long-overdue retrospective, and the auction houses made revenue. Michael Bouhanna, a digital art specialist at Sotheby's, even constructed a 2022 sale around the Algorists, in which Molnár was one of the first artists on his list. One of her original drawings from 1976, called *1% of disorder*, sold for $25,200 above its high estimate of $20,000. But it was Molnár's first NFT, called *2% of disorder*, that raised her market into the six figures and broke an auction record for the artist, selling for $138,600.

The arrival of crypto in the art world also coincided with

the industry's reluctant migration to online sales during the pandemic, and an important shift in customer demographics. Millennials had become leading spenders in the art market; nearly a third of those collectors each spent more than $1 million on art in 2020, according to one study.[20] Nearly two-thirds of those young collectors also expected to buy digital art, and NFTs became the leading art form of their obsession.[21]

Or, as Amy Cappellazzo, a rainmaker in the art market, bluntly told me in an interview: "Auction houses are devoted to what is saleable. They are not devoted to anything else. They are agency-based businesses and do not take theoretical or moral positions on NFTs."

The former chairman of Sotheby's Fine Arts Division had a point. She had likely overseen the exchange of billions of dollars through paintings and sculpture during her time at Sotheby's. "If you follow market logic, more is more."

Skilled auctioneers like Noah Davis and Bouhanna understood the power of a story in the art world; they were able to slice through the needlessly complex muddle of the crypto-economy and rationalize NFTs for traditional collectors and new millennial buyers from the tech industry. But that didn't mean the stories they told were right.

The true origin story behind NFTs more likely began in a Berlin biergarten where an American artist named Jonathan Monaghan was sharing drinks with a married couple who spoke passionately about cyberspace.

In June 2013, the German capital brimmed with young artists like Monaghan, who subsidized their digital art practices with day jobs at video-game companies and design studios. People wanted paintings that could hang above their mantelpieces, not intangible objects that floated through the virtual world. Only a handful of collectors were willing to spend a couple hundred bucks on digital art; the sum total of these purchases was nothing compared with the millions of dollars

spent every year in the primary market for paintings. So, when a curator named Masha McConaghy proposed a meeting with her husband, Monaghan jumped at the chance to network.

Trent McConaghy was a tireless entrepreneur and computer engineer, the son of a Saskatchewan farmer and an art teacher who chased his dreams to Paris, where he eventually met the love of his life in a nightclub. That was Masha, a tall Latvian woman with blond hair who had immersed herself in the museum world while finishing a Ph.D. dissertation at the Sorbonne about the relationship between art and commerce. Although his career started in the 1990s with research into artificial intelligence for the semiconductor industry, Trent always had an interest in cultural production. For nearly five years, he ran a startup that attempted to produce creative machine-learning algorithms. Oftentimes, over dinner, the couple would fiercely debate whether algorithms could ever produce something as soulful as Rembrandt's portraits or as emotional as van Gogh's landscapes.

In 2010, an old colleague introduced Trent to Bitcoin, a digital currency running on a decentralized network of computers that verified transactions through an electronic ledger system called a blockchain. The concept had percolated online for nearly two years. It was the brainchild of a secretive developer code-named Satoshi Nakamoto, who sought to provide an alternative to the global banking system that had just spiraled into a deep recession. Nakamoto envisioned that cryptographic algorithms would free the international monetary system from human error and misplaced trust. The blockchain would time-stamp transactions, simultaneously archiving the information on thousands of computers around the world, which would provide users with a high degree of confidence in their trades without relying on centralized government authorities to monitor everyone. Protecting the blockchain was a consensus mechanism called "proof of work," which deterred

hackers by requiring computers to expend large amounts of energy solving complicated math problems before completing any transactions.

Bitcoin would become the first viable cryptocurrency, but its rate of adoption was slow, and Trent had only a cursory interest in the digital money game. It wasn't until three years later, when he visited a Berlin restaurant called Room 77, that he really understood the implications of a digital economy. The shop was supposed to be an example of the future, where patrons could pay for their stouts and schnitzels using Bitcoin. This was a seamless, electrifying experience for Trent; he was crypto-pilled, sold on the potential of a world running on blockchain technology.

His evening debates with Masha soon revolved around the blockchain and how it might improve the digital art market. She talked about the myriad problems that collectors experience when purchasing and preserving digital artworks, which were mostly sold through DVDs and CD-ROMs at the time. But this format was already becoming obsolete as cloud computing and online data storage revolutionized the market. Still, artists were reluctant to upgrade or replace discs that collectors had accidentally snapped or scratched. If the discs were so easily replaceable, this would imply that the artworks they contained were also replaceable. And if they were replaceable, then they were not a unique or valuable commodity.

"There was a lot of ambiguity when buying digital artwork," Trent recalled, adding that there were few mechanisms for verifying ownership and authenticity for reproducible objects like photographs and online collectibles.

On August 21, 2013, the McConaghys filed a patent in the United States for "ascribe," a blockchain-secured ledger that used Bitcoin to allow users to establish, confirm, and transfer ownership of artworks through the Web.[22] The system was similar to another project, "colored coins," an early digital asset

management infrastructure built on the Bitcoin blockchain to produce tokens that transferred ownership information and other attributes between traders.[23] One developer on colored coins was a nineteen-year-old Russian Canadian boy named Vitalik Buterin, who was later pulled onto the McConaghy project by their lead programmer, Yanislav Malahov.

The Berlin biergarten meeting had gone well enough to pull Jonathan Monaghan into the fold. As the "artist guinea pig," he offered a digital artwork called *Mothership* for the big experiment—a five-minute video in which the camera slowly zoomed into the sky, where a giant cow stood upon a UFO named after the company American Apparel.[24] There was a city upon the bovine's back, circled by the Rainbow Road track from the video game *Super Mario Kart 64*. And within that city was a skyscraper containing a chic penthouse apartment filled with contemporary art and a dentist's office.

Monaghan described *Mothership* as "absurd and whimsical," drawing on mythologies and corporate branding to comment on the relationships between technology, wealth, and power. It was registered onto the Bitcoin blockchain using the ascribe protocol on November 18, 2013, making his artwork the earliest known version of what we would today call a nonfungible token, or NFT. Like a quarter stamped with the face of George Washington, the digital artwork was "minted" when its information was stamped onto the cryptocurrency. This became the benchmark definition for later NFTs, which were distinguished by four qualities: immutability, uniqueness, scarcity, and transferability.

As envisioned by its creators, the NFT would be a modern solution to an old problem. For a half century, the art world has been developing tools to provide visual artists with royalties. One of the earliest examples is the Artist's Reserved Rights Transfer and Sale Agreement, which was developed in 1971 by the art dealer Seth Siegelaub and the lawyer Robert Projan-

sky. The contract attempted to define and protect an artist's right to profits in the secondary market, but it proved hard to enforce because of the limited rights to visual artists in the U.S. copyright legal code. In 2008, a group called WAGE (Working Artists and the Greater Economy) attempted to restart conversations about pay equity in the art world, but the topic failed to gain traction with commercial dealers and auction bigwigs.

Similarly, ascribe never reached the level of success that its founders had hoped. Some artists were still reluctant to relinquish power to the computer, user adoption rates suffered, and the company was running low on cash. Eventually, the McConaghys let their patent filing lapse. Trent built upon his experience and founded another company focused on using blockchain technology to help users package their private data as digital assets for sale to artificial-intelligence companies. Masha started overseeing the couple's other business, a blockchain database. Vitalik Buterin would go from being a freelance subcontractor with ascribe to the world's youngest billionaire after he helped create Ethereum, a cryptocurrency-and-blockchain system with smart contract functionality. And years later, through Ethereum, the NFT industry was born: first in 2017 as a minor bubble around digital collectibles, and then in 2021 as a cultural movement.

"It's nice to think that maybe we inspired him," Masha told me, declining to take any credit for Buterin's later successes. She was humble, perhaps too humble for an industry dominated by men and big personalities.

Modesty suffers in the egocentric world of business, where the market incentivizes bits of calculated amnesia to strengthen whatever story is currently being told. The strongest voices are the ones who survive the great forgetting. So, nearly a decade after *Mothership* landed on the blockchain, when there was scant knowledge of its arrival, the story of our trio in the German biergarten had faded from memory.

A bidding war constructed from overlapping economic and technological interests created a new starting point on March 11, 2021, when Beeple's *Everydays* were auctioned for $69.3 million. It was an outrageous sum for digital art—the kind of world record that raises conspiracy theories about the motives of its buyers and sellers. Suddenly the art market was on the fulcrum of decentralized finance, splitting its weight between the invading crypto billionaires and the ancien régime of traditional art collectors. But auctioneers tipped the balance in favor of the new money, scrambling to find a historical precedent for their new cash cow. Sotheby's thought it had found a winner with *Quantum* by the artist Kevin McCoy. The company announced their find with all the expected, exaggerated plaudits:

"In the long timeline of art, there are few works that serve as genesis blocks to their own chain of history. They are seismic forks in direction; forks that usher in new movements that block by block, mint by mint, usher in new art histories. These works close chapters on the art histories that came before, while anchoring a new flowering of human creativity. These prime movers occupy a singular position in art history."[25]

Mothership was replaced in the historical record with *Quantum*, another artwork that was registered onto the Namecoin blockchain five months later, on May 3, 2014, by McCoy and a tech executive named Anil Dash.

(This was about four years before anyone used the term "NFT," which was first introduced as shorthand for ERC-721 tokens, a new standard for digital assets that allowed developers to create a series of tokens identified by different numerical variables.[26] Those numbers allow users to track ownership for collectibles and establish uniqueness and immutability for digital assets. NFTs were considered "non-fungible" because each

digital asset had a distinct identity, versus "fungible" tokens, like cryptocurrencies, which were interchangeable.)

Described by its creators as "monetized graphics," *Quantum* was an undulating, pixelated octagon set against a black backdrop. From a marketing perspective, *Quantum* was a legible beginning to crypto art, because it trafficked in the familiar stereotypes of science fiction. It looked like something out of the last scenes of *2001: A Space Odyssey*, when a wormhole opens to a cosmic burst of neon lights. Selling the artwork as the first NFT also benefited McCoy, who secured his place in art history while increasing his sales record by more than a hundredfold when it sold in June 2021 for $1.47 million to a British investor named Alex Amsel.

Three months later, McCoy released a product that would help other companies create their own NFT tools. His reputation as the "inventor of NFTs," as stated on his website, became an incredible selling point. Within a year, the artist received a lifetime-achievement award and a Guinness World Record for revolutionizing digital art.[27] Over email, McCoy acknowledged that some might disagree with his definition of "inventor" when the McConaghys and other developers were experimenting with blockchain art around the same time. But those facts weren't going to change how he marketed himself.

Bouhanna, the Sotheby's digital art specialist who primed Vera Mólnar's market, was also behind the *Quantum* sale. During an interview promoting McCoy's primacy in the token narrative, he said that his role as curator was "to observe the current ecosystem of NFTs, understand intimately the history of this medium, and identify the trends, preferences, and technical innovation that indicate where the space is moving towards."

As later chapters will demonstrate, Bouhanna's poor skills of observation and historical knowledge about digital art would push the NFT market toward destruction. The *Quantum* sale was itself a wobbly victory, one that was soon undermined by

a lawsuit claiming that McCoy had let his ownership of the artwork expire on the blockchain. Around the same time that Bouhanna and the artist were promoting the auction, a Canadian holding company named Free Holdings registered itself as *Quantum*'s owner. The holding company's anonymous owner then sued Sotheby's, McCoy, and a list of other plaintiffs for title slander, deceptive and unlawful trade practices, and commercial disparagement.

"While the blockchain records are self-evident, such records cannot defend themselves in the face of concerted efforts by a formative artist and auction house to establish a false narrative concerning what is presumed to be the first NFT," the lawsuit alleged.

(I had to wonder if the McConaghys, two Canadians with enough reason to disrupt the *Quantum* sale, were behind the lawsuit. Trent denied any involvement.)

The dispute got tied up in court for months and was ultimately dismissed by a federal court judge. But the damage was already done. If blockchain technology was supposed to offer a permanent and indisputable ledger of provenance, then how could a simple question of ownership be so muddied?

Controversies like the *Quantum* affair detracted from the market frenzy, providing ample justification for critics who believed that much of the token zeitgeist was marketing bullshit. There was no such thing as NFTism, no crystalline manifesto on crypto aesthetics or ideological anchor that would unite all these disparate artists behind a single movement. There was a technology holding the promise of economic opportunity and a lens onto digital life. The old fogeys of the traditional art world—and even some young fogeys—hated what they saw through the looking glass.

NFTs cannot escape the "rapacious capitalism that has come to be at its heart," said the *New York Times* journalist Blake Gopnik.[28]

"Lately, watching the NFT boom unfold with a mixture of horror and inevitability, I've been thinking about the void in art," wrote the critic Elisabeth Nicula in an art publication called *Momus*.[29]

"Most NFT collectors seem motivated more by financial opportunity or fandom than by connoisseurship and appear unaware that digital art is an expansive field with a decades-long history," remarked the Buffalo AKG Art Museum curator Tina Rivers Ryan for *Artforum*.

Ryan was a particularly skilled hater, denouncing the collectors who falsely equated NFTs to an artistic medium rather than a delivery system for digital goods. And she was troubled that "the NFT implicitly privileges the idea of a stable, unitary artwork over the messy reality of digital projects that are dispersed, interactive, contingent, iterative, or ephemeral."

"I always wanted digital artists to prosper and digital art to make headlines, but not like this," Ryan later lamented, warning that technologies are not always neutral and decentralization is not inherently democratic.[30] Her deathblow? NFTs are "an impoverishment—and not just of digital art full stop, because it reduces art to being a frictionless commodity."[31]

Ryan was operating under the righteous assumption that good digital art counteracts the velocity of online consumption, slowing down the internet to a legible speed. However, most blockchain artists were digital natives already fluent in the manipulative tactics of social media and e-commerce. These were the children raised on the self-discovery of internet chat rooms and the dysmorphia of YouTube beauty blogs, the children who were raised learning how to type on a keyboard before they could spell their names in cursive. Frictionless commodities were a fact of life; internet culture was the beginning, not the end to exploring the limits of cyberspace.

Molnár could be important to curators like Ryan; she could lead a blue-chip auction at Sotheby's and make Bouhanna lots

of money. But Molnár's relationship to NFT artists was more a coincidence than a cause. The new crypto avant-garde was glomming onto references, and the generative art movement spurred by the Algorists was just one constellation in their inscrutable matrix of art, economics, and computers. Like the history of photography, it was paraded through the cultural discourse as a reference point that made people more comfortable with the new technology.

M

The token economy relies on the logic of optimization.

In computer programming, there is a process called "refactoring" used to improve systems without fundamentally changing their designs. Refactoring requires the neutralization of "smells," the name given to invisible bugs within code that can increase the likelihood of a program's failure. But smells reek of the flesh, with nicknames that betray the cold, utilitarian logic of algorithms such as "primitive obsession," "inappropriate intimacy," "object orgy," and "shotgun surgery." If these were the kinds of glitches that programmers sought to destroy in computers, then what was the cultural stench that NFTs were trying to destroy?

Every coder learns early in their career that algorithms require expediency. When a program runs slow, it is essentially useless. The optimization process is supposed to eliminate the speed bumps by erasing inefficiencies within the algorithm. Flawless and invisible, the code is supposed to hum behind the click of a button, imperceptible to consumers who with one click buy Amazon goods or start a movie on Netflix. There is very little tolerance for the stench of imperfection within these transactions, and companies employ thousands of computer engineers to optimize their algorithms, finding new and more creative solutions to their problems.

The programmers who have become NFT artists have extended the logic of optimization into cultural production, wanting to refactor the characteristic messiness of creativity into an efficient and measurable economic utility.

Decades of financialization and internet algorithms have led to this moment. In the 1960s, artists turned to Conceptualism in response to the curdled hopes of flower power. The senseless bloodshed of the Vietnam War undermined the principles of nonviolence and rationalism, leaving artists like Donald Judd to wonder how they could produce work when "the humanity of any individual subject had just been cast in doubt by massive demonstration of the inhumanity of the human species."[32]

Artists rejected the expressionism of their postwar peers. "There were times during Vietnam that what people were saying was not quite rational but it was totally emotional. You had no control. You were part of a country that was running away like a headless horse," recalled the artist Lawrence Weiner.[33]

The abandonment of aesthetics left artists to focus on big ideas, like challenging the economic conditions of their work. Sol LeWitt blazed new territory by offering certificates and instructions for creating his "Wall Drawings," outsourcing labor to the purchasers and asking for payment based on a suggested hourly rate that rendered the art commodity inseparable from the artist's time.[34] Impressed by the Conceptualist's "operational logic," others began to investigate the potential uses of art within the economy.[35]

As the dematerialization and abstraction of the artistic process was happening, Andy Warhol and his Pop Art posse were tutoring a young generation of collectors to admire sarcasm and conspicuous consumption. In 1973, the art historian Lucy R. Lippard observed that consumer habits were changing, suggesting that three years earlier "no one, not even a public greedy for novelty, would actually pay money . . . for a xerox sheet referring to an event past or never directly perceived."[36]

A paradigm shift occurred when artists started thinking of themselves as producers and buyers started recognizing the investment potential of art. That same year, Sotheby's held a record-breaking auction of contemporary art. The $2-million sale of the Scull family collection triggered a public frenzy and convinced New York's nouveaux riches to chip in, priming the market for an even bigger boom in the 1980s that reached a sale of nearly $100 million for a single painting.[37]

Conceptualism demonstrated how quickly artistic practices that threaten the market are absorbed into its prevailing economic system. During his lifetime, LeWitt railed against the capitalist structures that forced artists to produce objects for a living. He developed his methodology to outsource that burden to his buyers. It must have been painful for him to later realize that his approach backfired. Instead of freeing artists from the market, Conceptualism reinforced the notion that there was no escaping capitalism. Critics declared that Conceptualism had fetishized and financialized ideas; the mere signification of creativity was now a cause for investment. NFTs turn that negative into a positive, embracing Conceptualism like a cheat code and bypassing all the messy pretext about art's intrinsic value or its mission to resist the market. If artists like LeWitt could sell instructions and receipts, severing the connection between the displayed and owned forms of art, then why not completely vanquish materiality in the metaverse?[38] What remains is a marketplace of ideas that functions more like an Etsy account than a philosophical breakthrough.

The classic image of competing ideas and civil debates may have originated in the writings of the English author John Milton and the philosopher John Stuart Mill, but it was first articulated in a dissenting opinion by Justice Oliver Wendell Holmes Jr., in the 1919 case *Abrams v. United States*. "The best test of truth is the power of thought to get itself accepted in the competition of the market," the judge wrote.[39] The marketplace

doctrine soon gained popularity as shorthand to justify free speech in both economic and democratic terms. It was really a simple equation: better public debates created better govern- ments.[40] But the metaphor always failed to demonstrate any significant points of resemblance between the speech process and the economic model of unregulated markets.[41] The foun- dational myth of objective truths and rational individuals has allowed the marketplace image to survive the digital age even though so much of the internet—wild conspiracy theories, rac- ist hate speech, terrorist plots—shows otherwise.

Ignore all that noise, say the technologists who remain confi- dent in the powers of optimization. *We have found the solution.*

The social-media platforms of Web2 sought the monetiza- tion of attention; now the Web3 investors are looking to mon- etize thought. The great Conceptual project of NFTs replaces traditional financial products like securities and stocks with cultural tokens that combine monetary and ideological val- ues into a single form.[42] Artists role-play as influencers and stockbrokers tasked with building the crypto fantasy: a decen- tralized network unified by the singular purpose of remaking the world. And in that process, the financial system becomes a little more like the art world: a little more mystical, a little more speculative, a little more fun.

Was it by choice, coincidence, or destiny that artists like Vera Molnár became so instrumental to the convergence of finance and technology? Curators at the Guggenheim Museum pre- dicted as much in 2015 with the release of their first online exhibition, called *Åzone Futures Market,* a commentary on how cryptocurrency was changing the nature of financial specula- tion. (Many reviewers, including me, were surprised to see a major nonprofit institution directly engage the economy with-

out the intermediaries of artworks and artists.) The experiment provided participants with virtual money to invest in concepts sold on the futures market like algorithmic governance, communized intellectual property, identity cloaking, and bloodless wars. A leaderboard tracked the market's biggest influencers, with the number-one spot going to a fictitious shell company called ads-by-bernazone, a "bespoke hacking and advertising agency" that promised to create a "lucrative" opportunity for its clients.[43] For a small fee—paid in real dollars—the agency would place an advertisement on its website whose traffic could influence the trajectory of the futures market. Participants were left wondering how much their investments mattered when the future already seemed determined by a shadowy company whose forecasts always tipped toward a slightly brighter tomorrow.

Seven years later, architects of decentralized society identified similar problems of transparency within their own markets, in which scammers have stolen billions through phishing expeditions, wallet raids, and cyber hacks.[44]

One solution, proposed by Vitalik Buterin, a founder of Ethereum, is the conversion of NFT wallets into Souls, which trace "social provenance" through a series of nontransferable credentials stored in soulbound tokens (SBTs). The new system attempts to build a social contract for the metaverse, allowing SBT issuers to burn tokens when recipients violate their trust. "Just as the downside of having a heart is that a heart can be broken, the downside of having a Soul is it can go to hell," Buterin and his coauthors, the economist Glen Weyl and the lawyer Puja Ohlhaver, write in a white paper about finding Web3's soul.

"The downside of having a society is that societies are often animated by hatred, prejudice, violence and fear. Humanity is a great and often tragic experiment," the group poetically declares. The first step on their stairway to heaven is the artist,

who is expected to offer their soul to build a trust network with other users. "An artist could issue the NFT from their Soul. The more SBTs the artist's Soul carries, the easier it would be for buyers to identify the Soul as belonging to that artist, and thereby also confirm the NFT's legitimacy," the authors write. "Souls would thus create a verifiable, on-chain way to stake and build reputation on the provenance and scarcity of an object."[45]

(In an interview defending the paper, Weyl told me that the fire and brimstone metaphors were supposed to be whimsical, even provocative, so that readers could imagine the best and worst sides of this emerging technology.)

The recontextualization of artworks through the Soul also creates new methods of uncollateralized lending in which loan details might appear alongside other soulbound credentials, like university degrees, résumés, and mortgages to build confidence in a loan recipient. Financializing the Soul creates incentives for users to stay within the network, where the authors see an opportunity to create a more democratic platform around cryptocurrency. Beyond the authoritarianism of Web2 and the anarcho-capitalism of decentralized finance (sometimes shortened as DeFi), the Soul hopes to outrun the private equity and asset managers who are constantly seeking to recentralize the cryptoeconomy in their favor. If the NFTs can make it to heaven, then Souls will have a chance to "program futures that encode sociality" toward more cooperative systems of governance.

Buterin based this grand theory of a decentralized society on the popular video game *World of Warcraft*. Soulbound items are nontransferable items often rewarded for completing hard quests or killing very powerful monsters; they often require collaboration among dozens of players to earn and help establish a hierarchy for accomplished gamers through bragging rights.[46]

Released in 2004, *World of Warcraft* is the most successful

example of a massive multiplayer online role-playing game, with nearly forty-six million active monthly users during its peak in 2017, which is roughly the equivalent of Spain's population that year. Not only did gamers assume new identities through their warlock and paladin avatars, but they built communities through a guild system that has frequently expanded into real-world friendships. Soulbound items were like milestones for players, but the game's true economy reflects many of the defining characteristics of the tokenized economy.

Almost as soon as the game launched, there was a desperation for expensive rare goods in *World of Warcraft*. Players complained that the best skills and weapons were too expensive, and many found themselves indulging in a black market, exchanging real money for gold (the game's virtual currency) through online vendors. Gold suffered from high inflation as more companies developed the secondary market with sophisticated crime rings for accumulating the digital currency and selling it back to players for cash. Those companies—including one helmed by Donald Trump's adviser Steve Bannon—would outsource endless hours of gold-farming to extremely underpaid foreign workers who often stole account information through phishing scams to harvest valuables.

At the height of this digital gold rush, in 2007, Buterin started playing *World of Warcraft*. He was barely a teenager and had little better to do than sink hundreds of hours into his warlock. Then, in 2010, a game update nerfed the damage output of his favored Siphon Life spell. Translation? His favorite magic spell no longer went "pew pew." "I cried myself to sleep and on that day I realized what horrors centralized services can bring. I soon decided to quit," Buterin later wrote.[47]

Three years after logging off, Buterin had immersed himself in Bitcoin. The nineteen-year-old college dropout published a 2013 white paper on "colored coins" with fellow Bitcoiners Yoni Assia, Lior Hakim, Meni Rosenfeld, and Rotem Lev. It was a

roadmap for managing the ownership of digital collectibles not dissimilar, the authors argued, to the art market, where "original copies" of paintings regularly sold for millions of dollars.[48]

Disillusioned by the limitations of Bitcoin, Buterin and four other technologists launched Ethereum in 2015 with aspirations to become everything from a "smart contracts platform" to a "worldwide distributed computer."

That same year, Blizzard Entertainment, the studio behind *World of Warcraft*, introduced tokens as a legit method of converting dollars into gold. "Time is money, friend—but sometimes one is harder to come by than the other," the company advertised on its website. Originally costing $20 each, these tokens could be sold at the game's auction house, where players then purchased gold based on its market value. But rampant inflation made it impossible to determine equilibrium, causing the true value of tokens to rise and fall precipitously. For example, the purchase of a giant spider called the Bloodfang Widow, which users could ride, cost two million in virtual gold. Buying it with tokens would have cost $1,100 in August 2016; meanwhile, the price in tokens fell to less than $200 around two years later.[49]

The introduction of tokens warped everything in the *Warcraft* economy around the dollar. Players strayed from the intended gameplay loops of quests and battles, preferring the metagame of financial wagers and accumulated capital. Some users even developed algorithms that calculated the dollar value of items based on a live receipt of auction prices and token trades within *World of Warcraft*.[50] A new joy emerged from below the surface of the game's design, whereby an alternate economy based on manipulated game mechanics provided an unintended satisfaction. The routine of a daily grind became a pleasure principle, evoking the comforts of linear progression so rarely found in everyday life. Gamers forged strong bonds by sinking hundreds of hours into this endless

toil, building their own communities, subcultures, and micro-histories around the Sisyphean push toward perfection.

Software developers understand the power of the grind. Technological improvements and increased production budgets have allowed designers to build virtual worlds that rival our own, with releases from major franchises regularly taking hundreds of hours to complete. The global gaming industry now exceeds $200 billion, more than the combined markets for movies and music. In 2021, more than 3.2 billion people played video games during the pandemic lockdowns, the vast majority on their phones.[51] That's more than a third of the world's population spending countless hours in digital realms, so it would be safe to say that video games have replaced cinema as the visual spectacle of our time, marking the rise of a gamified culture.

Consulting firms like Accenture have described it as a "superplatform," with the sector adding a half-billion players within just three years.[52] Free-to-play games have become one of the most popular trends in the industry, employing a casino-like "gacha" mechanic to earn revenue. Entrance is free, but many players are willing to spend thousands of dollars to purchase costumes and weapons that mostly provide clout with their in-game communities. The thrill of winning these rare items helps keep players hooked for thousands of hours. So it is no surprise that, when it comes to reviewing games, quality is often described in the number of hours needed to complete a game. More hours indicate a better investment, incentivizing developers to create depthless sandboxes in the metaverse.

Museums produce their own kind of depthlessness. The majority of their art collections are held in offsite storage facilities where the public is forbidden from entering. Online catalogues that might host information on artworks are incomplete and glitchy. Inside the physical galleries, executives are always searching for growth hacks; recent trends involve the

hiring of management consultants and audience directors to manipulate viewership analytics. It's not just about who enters the museum, but how long they spend looking at the paintings on the walls. The museumgoer's stare—what was once called transcendence—is limited on average to just twenty-seven seconds; it's a negligible amount of time when compared with other forms of entertainment on the internet and in video games.[53]

Another common measure of quality that curators use to evaluate their collections is the slowdown effect. Good art is supposed to stop a person in their tracks; it prompts a reaction by distilling complicated emotions and ideas into a visual language. Good art can be ugly, politically uncouth; it may even smell. But it does need to push a viewer forward or backward psychologically; it cannot simply be decoration.

The crypto avant-garde requires a different analytical framework that can embrace the acceleration of internet culture. NFTs have become synonymous with a speedup effect. Artists are rewarded not for their skills with paintbrushes or chisels but for their manipulation of generative algorithms, online communities, and profit-distribution models. Changing tastes have as much to do with the public's acceptance that late capitalism cannot be stopped as with a macabre feeling that the virtual world has become more meaningful than reality. NFT artists are expected to dive headfirst into the money madness of this false techno-utopia—not necessarily to glorify the new oligarchs of the metaverse that will control public life, but to ensure that artists have a seat at the table in determining the future course of technology, as they once had during the computer revolution of the 1960s.

Great moments of destabilization allow for cultural resets, and the NFT boom presented a series of potential new beginnings for digital art. The scramble to claim firsts and make headlines lowered the collective intelligence of discourse

around blockchain technology by half, which was incredibly beneficial to the few smart wolves herding the sheep. Many scholars were complicit in allowing auction houses like Sotheby's and Christie's to rewrite the history of digital art. In background interviews, several curators and historians expressed remorse for allowing the *Quantum* auction to proceed without crediting the McConaghys for developing the first NFT prototype. Selective amnesia was a helpful tool in building one's career; besides, feeding the market cycle allowed for pleasant rediscoveries like the EAT collective and Vera Molnár.

The ninety-six-year-old artist deserved her time in the spotlight after so many decades of being overshadowed by the men around her. Why shouldn't the starving artist enjoy her newfound acclaim? Molnár's resurgence was also a convenient solution to problems that bedeviled the NFT market, such as a perceived lack of historical context and an overabundance of male artists. The construction of a grandmother for generative art was yet another optimization in a series of efforts to legitimize blockchain-based art.

CRAY CRAY CRAP

The wheels of Mike Winkelmann's private jet touched the tarmac of Charleston International Airport as cryptomania swung toward the stratosphere. Hangovers and sunburns never distracted the artist from his rituals of production, releasing his *Everydays* to the hungry crowd of collectors now willing to open their bidding wars at $1 million or more.[1] But under the glint of Miami sunshine, Beeple had drafted a blueprint for his future that included a vast studio complex for his experiments, where dozens of employees and even a couple aerospace engineers would transform his dreams into reality.

The spring of 2021 witnessed the rebirth of the digital art community as a honeypot for innovation and investment. The creative middle class who comprised this cohort of aging millennial designers and renegade software developers had loosely reorganized themselves into the crypto avant-garde. A hedge-fund philosophy trailed these interlopers from their previous lives in big tech, where growth always seemed to necessitate extreme risk.

Within the world of sports gambling, those with a tendency to stake ridiculously large amounts of money without the experience to inform their decisions are mocked as degenerates. But the crypto community celebrated its high-risk traders as "degens," and they wore the term as a badge of honor. It means

something to take a risk on the cryptoeconomy, to express one's faith in the new system by opening oneself up to the chance of destruction. It also speaks to the dynamics of intuition that ruled the market; memes, vibes, and emotions were sometimes the only tools needed to attract degen investment.

The degens terrified the traditional art market, which preferred that collectors practice a more discreet form of speculation by using the architecture of advisory firms and auction houses to veil their gambling addictions. But the rise of extreme speculation in the NFT market was a sick thrill to most, the kind that justified a deeply held belief among critics that contemporary art was all a money game. That worried curators like Tina Rivers Ryan, who saw the virus of "frictionless commodities" spreading through cyberspace. "The platforms that emerged during this time were designed to encourage people to think about artworks as assets," Ryan told me. "Even on a website design level, there was no room for dialogue or critical conversation."

It was the smart contract that made NFTs so frictionless and appealing to degens and artists. Smart contracts were the programs responsible for deploying transactions; they often came encrypted with resale royalties of 5 and 10 percent. The technology wasn't foolproof, and taking a token off the blockchain (by deleting whatever the digital asset referenced in the code) could jeopardize the functionality of its smart contract, but it was enough to attract artists. In the primary market, artists often divided the proceeds of a sale in half with their gallerists. In the secondary market, there was typically no chance of remuneration. (Unlike the broader entertainment industry, where unions have ensured that actors and writers earn residuals as long as their shows remain on the air.) Lobbyists in the United States had fought for decades against potential laws that would have allowed painters to receive compensation for works sold on the secondary market, as is customary in

many European countries, like France and Italy. Tokenization became an attractive tool for cutting out the middlemen who were eating into profits.[2] Lawyers would continue to debate the actual security and enforceability of these digital covenants, but the promise of compensation was enough to recruit artists to the crypto cause.

It was a season of sunny optimism never seen in a generation of artists before or likely since. It was a time to ignore the naysayers and create what Beeple described as "cray cray crap." People lived for a while in that fever dream, hoping that degens were more of a bug than a feature, believing that art might still build a path toward a collective internet and better future. But a harsh reality would soon interrupt their fantasy. Scammers trailed this cohort of new crypto converts into the metaverse, fueled by the industry's own false marketing that it was somehow above the law. The wake of enthusiasm that rippled from the Beeple Christie's auction became the impetus for criminals to stage unbelievable, multimillion-dollar NFT heists in plain view.

There is no greater speculator than the artist who believes their talents can improve the world. Frenzy remained a powerfully generative force in the weeks after the Christie's auction, when hundreds of artists declared themselves among the crypto faithful. Collaborations and conferences were everywhere, but the emerging NFT projects often sounded more like business proposals than creative pursuits. During an audio meeting on the Clubhouse app, one artist told listeners: "When I make work, I don't think about what's going to make me money. I think about what is going to make my collectors money." The consensus that emerged from the crypto avant-garde reversed the traditional flow of capital within the art world. Systems of

patronage were supposed to provide resources to artists, not the other way around. It became clear that the market was dominating more than news: the market was beginning to dominate culture.

The Christie's auction bookended a period of significant turbulence in American history. Planning had coincided with the January 6 Capitol insurrection, and the final Beeple bid was placed on March 11, when President Joseph R. Biden Jr.'s American Rescue Plan went into effect. The $1.9-trillion stimulus package was financed entirely through increased federal borrowing, bringing sweeping investments in vaccine deployment and school reopenings. State and local governments also received $350 billion to cover budget shortfalls; meanwhile, individuals received $1,400 direct payments that followed the earlier $600 and $2,000 checks from the Trump administration.

"During the pandemic, millions of Americans, through no fault of their own, have lost the dignity and respect that comes with a job and a paycheck," Biden said in a speech when he announced the plan. "There is a real pain overwhelming the real economy."[3]

A few weeks after the package went into effect, Federal Reserve chair Jerome Powell assured lawmakers that the plan's "effect on inflation will be neither particularly large nor persistent."[4] It was a surprising statement of confidence when so many economists agreed that large government spending caused inflation. Treasury officials countered that whatever fiscal challenges might arise would be manageable.[5]

"And part of that just is that we've been living in a world of strong disinflationary pressures—around the world really—for a quarter of a century," Powell added. "We don't think that a one time surge in spending leading to temporary price increases would disrupt that."

So many people operated under the assumption that someone as knowledgeable about the economy as the Federal

Reserve chairman would be correct. The cryptoeconomy became a frothy place for investment; polling data suggest that anywhere between 10 and 15 percent of Americans spent their stimulus checks on digital coins.[6] If those surveys are accurate, then we can modestly assume that $39 billion of government spending found its way into the digital markets—possibly more when you take into account the entire $803-billion program.[7] That money became a wonderful stimulant for outsized and unburdened magical thinking.

The NFT industry was suddenly flush with investment. In March 2021, venture capitalists at Andreessen Horowitz led a $23-million fund-raising round for the digital marketplace OpenSea, which would become the largest sales platform for NFTs; the crypto firm Dragonfly Capital invested $225 million into tokens and decentralized finance; and Dapper Labs, the creators of *CryptoKitties* and the *NBA Top Shot* collectibles, raised $305 million. By the end of the year, experts estimated that nearly $3 billion had been invested within the market, which had barely existed a year before.

Each passing month brought new curiosities. The vocabulary around the internet was changing as speculators recontextualized the past through a cocktail of hype and manifest destiny. Public discourse warped around the emerging Web3 ideology, which envisioned a middleman-free digital economy in which tokens and blockchain technology had restored power to users. Technologists fondly remembered the Web1 cycle of innovation in the 1990s as a period of static websites and message boards when users built their own decentralized, community-governed corners of cyberspace. Web2 began around 2005, when social-media platforms like Facebook, Twitter, and YouTube became aggregators of online interactions, monetizing attention through ads and data. Web3 would supposedly replace that current iteration of the internet, ending the grip that centralized corporate platforms have on digi-

tal society through NFTs and blockchain. The dream was to combine the decentralization of Web1 with the functionality of Web2, so that users could have a more customizable online experience. It was also a convenient system of organization for the major proponents of this vision—investors like Chris Dixon, a general partner at Andreessen Horowitz, who likened the triumph of a decentralized Web3 philosophy to the success of crowdsourcing systems like Wikipedia, where active communities help build content. "Decentralized systems start out half-baked but, under the right conditions, grow exponentially as they attract new contributors," he wrote in 2018.[8]

The bedrock of this new philosophy was a 2008 essay by Kevin Kelly, a founding editor of *Wired* magazine, who believed that the internet could be "a home for creatives in between poverty and stardom," by cultivating a following of "1,000 True Fans."[9] Millions of paying fans were hardly an attainable goal for most artists, but finding a thousand fans willing to pay an average of $100 annually sounded realistic.

By championing the Web3 ideology, Dixon and others lent credibility to their own investments. It helped that even the villains within this narrative were embracing the new leap forward. Centralizing corporations like Meta and Google invested in Web3 cloud technology for the management of blockchain data and the creation of metaverse spaces. The term "metaverse" was also packed with meaning, but the commonly accepted origin of the term was a 1992 Neal Stephenson novel, *Snow Crash*. As a portmanteau between "meta" and "universe," the metaverse described a virtual reality where humans could escape the dystopian horrors of the physical meatspace. And by declaring themselves creators of the metaverse, large corporations hoped to contain the spreading demand for their obsolescence. Decentralization seemed okay, as long as it stayed in one place and didn't challenge their other financial interests.

Web3 ideology was flimsy and often incoherent, but it

worked like a charm. Young talent found new purpose as thousands of recent graduates chose roles in crypto startups over traditional roles in the fintech industry. Investors found the language to rationalize their massive speculations. Artists found a new network of potential collectors. And anyone left curious about NFTs simply looked at the market and received the news: digital tokens were selling for big, stupid amounts of money.

In April, the potency of Web3 ideology became clear as the proliferation of NFTs created booming micro-economies around everything from internet memes to virtual real estate and cartoon apes.

Memes had become an incredibly popular form of communication in the early aughts, when the digital upload of photography became easier through platforms like Facebook and Instagram. The visual language spoke its sentences in absurdities and ironies, with the most famous images earning iconic status in shared cultural memory. But the subjects of these images were often ridiculed. In 2021, Zoë Roth, the four-year-old *Disaster Girl* of 2005, had aged into an adult looking to repay her student loans. She tokenized the image of her younger self devilishly smirking in front of a burning house into an NFT, which sold for $500,000.[10] Roth described the transaction as healing: she was taking back power over the image by monetizing it.

What motivated someone to pay $500,000 for a meme that could be freely accessed on the internet? NFT collectors dignified themselves as stewards of internet history in the same way that previous generations had characterized themselves as guardians of high culture whenever they purchased a famous painting. The public answer for both types of collectors often included something about democratizing art through its acquisition. Collectors pledged to donate their artworks eventually to publicly accessible museums. But the private answer was

much more intimate. Ownership of artworks retains its worth because the very idea of possessing something irreplaceable can evoke feelings of status and security.

The cannibalization of internet culture demonstrated the speculator's urge to devour earlier iterations of the Web, so it came as no surprise when investors also desired to conquer digital space with property division and parceling. The gimmicks were becoming painfully literal, as virtual realms like Decentraland and Cryptovoxels attracted millions in real-estate transactions. Investment firms like Everyrealm and Tokens .com purchased online plots like spaces on a Monopoly board, spending anywhere between $200,000 and $500,000 on vampire cathedrals, modern museums, and split-level ranches.[11] The companies also commissioned architects and video-game developers to build malls and casinos, hoping players would spend money to dress their virtual avatars and see them crank the slot machines. Around that time, venture capitalists began workshopping ideas to mint mortgages on real property into NFTs, which could then be bundled and sold on the secondary market alongside other loan tokens. Free of regular banking regulations, the system explicitly followed the blueprint for mortgage-backed securities that led to the 2008 financial crisis. But maybe this time would be different.

More record-setting auctions followed in the art world. Sotheby's made its initial push into the market in April 2021 with a three-day auction of NFTs by the anonymous artist known as Pak. A flurry of blockchain bidding pushed the total price to around $17 million—paid through the digital platform Nifty Gateway with Ethereum and credit cards—for 6,150 minted NFTs. One work, a single gray pixel, sold for more than $1.35 million after a prolonged bidding war. Phillips also sold its first NFT, by the artist Michah Dowbak, who goes by the name Mad Dog Jones, for $4.1 million to an anonymous bid-

der; it was the highest amount ever paid for a living Canadian artist.

The month ended with the launch of ten thousand monkeys into orbit. A mysterious company named Yuga Labs was selling *Bored Ape Yacht Club* NFTs, which combined the cartoon-cutesy aesthetic of Neopets with the branding savvy of Supreme. These primates in bucket hats and button-ups popularized a higher standard of utility in the nonfungible space, giving cryptocurrency an application outside of the financial market. Buyers received image rights associated with their apes for commercial purposes, access to exclusive merchandise, free additional NFTs, and membership in an owners' association. These perks helped demonstrate the power of Web3 ideology to incentivize users into creating lucrative economies for themselves.

When the apes began selling in April 2021, a floor price was set at around $200 in Ethereum; four months later, the NFTs were trading at about $137,000. The initial release brought in $2 million, but the secondary market brought more royalties. Yuga Labs earned net revenues of $137 million that year and courted investors who raised the company's valuation to $4 billion. Celebrities like Madonna, Kevin Hart, and Justin Bieber started advertising their purchases on social media. Ape-obsessed basketball players like Tyrese Haliburton, a point guard for the Indiana Pacers, drew his NFT monkey on his shoes. Others turned their apes into beer-can designs and intellectual property for television shows.

Four artists were responsible for creating *Bored Ape Yacht Club*, with a young Asian American woman nicknamed Seneca leading the project. She graduated from the Rhode Island School of Design in 2016 with hopes of becoming a freelance illustrator in New York. From the nook within her apartment, she drew fantastical creatures for marketing campaigns

in industries like health care, insurance, and finance. When a colleague approached her about a possible NFT project, she didn't know what the initialism meant. But the idea of designing some "punk apes" appealed to her. She accepted the commission, and later told *Rolling Stone* that she had imagined "an ape that's kind of jaded and tired of life but has all the money and time in the world, and hangs out at a metal bar."[12] Seneca imbued her monkeys with her own style, which often included metal chains, heavy makeup, and hair colored with neon pops of purple and blue. Some of the primates went a little further, with tattoos, gold teeth, and laser eyes. So it was a little disorienting when the twenty-six-year-old artist googled her name that summer to see what had become of her monkeys.

"It really took me some time to wrap my head around all this," Seneca said, later realizing that her compensation for the project was "definitely not ideal."

Yuga Labs eventually offered its artists more than a million dollars each for their contributions; sources close to the agreement said that the money came with a non-disparagement clause to prevent creators like Seneca from badmouthing the company. The fallout coincided with a *BuzzFeed News* report unmasking the company's founders: Greg Solano and Wylie Aronow. The men had once had literary aspirations, but had spent most of their early thirties edging toward crypto.

Solano had worked odd jobs as a freelance editor and critic, and authored a book about *World of Warcraft* with one of its game designers. He was the son of Cuban immigrants who had arrived in the United States very young. After attending New York University, he received his M.F.A. at the University of Virginia, where he met his wife. Solano was painfully shy in those days. "I wouldn't want to call to order Pizza Hut," he later told the journalist Jessica Klein in an article for *Input* magazine.[13] Solano was short and balding; he often wore circular glasses

on the bridge of his nose that made him look like a Hogwarts professor or Keith Haring's dad.

Aronow had a tougher transition into adulthood; he was a high-school dropout with a gambling problem who joked about never having had a real job. His father, Don Aronow, a leader in the powerboat industry, was murdered in 1987 by a competitor's hitman—both of whom pleaded "no contest" to charges about a decade later. But Wylie was still a baby when his father died, and grew up with speculations about what had killed him.[14] (Some conspiracies claimed he was working with the CIA or had connections to the mob. In the 2018 movie *Speed Kills,* John Travolta portrayed Don, in a performance that received only a half star from Roger Ebert's website.)[15] Aronow described his home environment as "shitty"; he said he spent much of his childhood escaping into video games like *Final Fantasy* and attending punk-rock shows.[16] By age fifteen, he was an alcoholic and a crack addict, and his mother sent him to treatment centers for help; the second one he attended was the kind of place where they kidnapped you and threw you into the desert. Aronow contracted what he described as an autoimmune disease in his twenties, which forced him to drop out of his M.F.A. program at Syracuse University. As his family supported him financially, he traveled the country looking for medical help, "living vicariously" through Twitch streamers and YouTube.[17] Aronow is now the picture-perfect archetype of a crypto bro, with thick tufts of brown hair and a sleeve of tattoos across his arm. He has a deep baritone voice and clearly works out.

A decade before founding Yuga Labs, the pair met in a Miami bar where they got into a screaming match about David Foster Wallace.[18] Solano had never read the author but reflexively hated him because so many of his UVA classmates were obsessed. After their argument, the two kept in touch, mainly through playing *World of Warcraft* together.

The founders, hoping to maintain their anonymity, installed Nicole Muniz as chief executive, the public face of the company, while they sheltered behind pseudonyms: "Gargamel" and "Gordon Goner." The idea of *Bored Apes* seemed to derive from the crypto term "apeing in," which described rashly investing in a new project without doing much research. The name of their company, Yuga Labs, came from the main villain in a Nintendo 3DS game called *Legend of Zelda: A Link Between Worlds*.

There was a time not long ago when business executives wanted to publicize themselves in the press as titans of industry, but the incentives of the cryptoeconomy and Web3 culture opposed that kind of bragging. The myth of decentralization was stronger without figureheads, whose presence might curb participation rates among traders.

Solano and Aronow begrudgingly accepted their more public roles, but not before their chief executive attempted to characterize the *BuzzFeed* reporting as "dangerous." Muniz made unsubstantiated claims that the crypto rich had become the target of kidnapping plots and extortion. She added, with all the seriousness of a stone, "The only thing that people got out of it was just knowing their real names."[19]

Cryptocurrencies and blockchain technology allow users to conduct anonymous transactions without the typical rules of disclosure needed from bank accounts and traditional financial institutions. Anonymity shields traders from the scrutiny of government authorities, as long as the data trail remains indecipherable, but it also implies that transparency is somehow bad or, as Muniz asserts, "dangerous."

The internet created this bogeyman decades ago, when usernames became the normalized mode of online communica-

tion and the hacking of personal banking information became known as "identity theft"—such neologisms conflated data security with personal security. The crucial right to privacy became muddled in the paranoia of anonymization, which at its best sought to limit digital security risks and dampen the intrusion of government surveillance.[20] But at its worst, anonymization provided cover to fraudsters who embezzled millions from the blinded speculators of the spring bull market.

When describing the conditions of speculation that contributed to the Great Crash of 1929, the economist John Kenneth Galbraith paused on the peculiar dynamics of embezzlement. "Weeks, months, or years may elapse between the commission of the crime and its discovery," he wrote. "This is a period, incidentally, when the embezzler has his gain and the man who has been embezzled, oddly enough, feels no loss. There is a net increase in psychic wealth."[21]

Anonymization seemed to extend the delusion of control among crypto speculators. Perhaps the embezzled derived a sick pleasure in realizing that someone wanted their tokens enough to steal them; others happily marched into their high-yield investment schemes convinced that the NFT revolution was coming. Artists ogled the blockchain ledger, watching as their creations transferred between wallets with randomized names like "0xcee5275B7C." Collectors celebrated their newfound interest in culture, though it often took multiple log-ins to see their acquisitions; most of the serious buyers kept multiple wallets, "for tax purposes."

The market lurched forward anyway as the spring bull market entered its first summer slump. Cryptocurrencies were liquidating capital at an astonishing rate, and Ethereum experienced nearly half of all capital losses; $236 million had evaporated by the end of May 2021. The coin had reached a record high of $4,380 earlier that month, before falling nearly 50 percent. Web3 boosters described the plummet as a correction to

the blazing NFT market. People got angry, desperate, foolish—
and so began a season of scamming.

On the morning of August 11, Bright Moments Gallery real-
ized that more than three hundred NFTs were missing from
its digital lockbox. Blockchain records indicated that it was an
inside job; someone had tapped into the company's inventory
and redistributed more than $3.4 million in collectibles to a
series of anonymous accounts, which then reposted the art-
works for sale. The betrayal played out in the marketplace as
customers buzzed the gallery's social-media channels for more
information on the attack and employees frantically worked to
delist the stolen tokens.

"This is NOT a hack. This is a heist," the gallery assured
its clients, who immediately worried whether their own col-
lections were vulnerable.[22] Embarrassed and upset, the com-
pany's associates went into overdrive to save their credibility.
Four days later, Bright Moments' founder, Seth Goldstein, had
arranged a meeting with the culprit, a former colleague, at a
beachside skatepark in the Venice neighborhood of Los Ange-
les. As he walked between the shadows of the palm trees, he
wondered if the thief was hiding a gun inside his backpack.

In decades prior, Goldstein had amassed a considerable for-
tune by digitizing the creative economy. He started an interac-
tive marketing company called SiteSpecific that helped brands
like Duracell increase their presence on the early internet in the
1990s; the business was later acquired by a large competitor for
$6.5 million, providing a nice trampoline for Goldstein's jump
into the world of venture capital. He became an entrepreneur-
in-residence and an investment principal at Flatiron Partners,
where he claims to have built and managed a $75-million port-
folio in the technology sector—until the 2000 Dot-Com Crash
wiped away most of his value and forced many companies to
close.

"It was devastating," Goldstein recalled. "I had a bunch of

money on paper that was suddenly worth nothing. And many of the people that I remember being messianic in their zeal for this new economy were the ones that had sold their stock while I held on to mine."

As other investors licked their wounds, Goldstein embraced an emerging interest in social media and Web analytics. Root Markets, for example, was a financial exchange that allowed users to sell online data about themselves. Another, called FoodFight, enticed people to throw virtual food at one another. His most successful gamble was Majestic Research, a company that sold internet data as market research to Wall Street hedge funds in $200,000 packages. In 2010, he sold the business to Investment Technology Group for $75 million. The grind continued into the 2010s as Goldstein attempted to build social-media networks around music through mildly successful companies like Turntable.fm, which allowed users to play DJ for crowds of virtual listeners.

Goldstein identified as a serial entrepreneur, recalling a childhood when his mother ran an international service for homemakers. "I was beta-testing all those different nannies as I was growing up," he once said.[23] As a child actor, he gained the communication skills to impress investors and the emotional intelligence to navigate business relationships. Those abilities were refined in his early twenties, when, after graduating from Columbia University with a degree in dramatic arts, he worked as an archivist for an avant-garde opera director and developed his own practice as a multimedia artist.

So it was a little surprising that Goldstein needed a push before getting into the blockchain game. Another technologist, Fred Wilson, kept bugging him about NFTs. Wilson had been the businessman's boss at Flatiron Partners in the 1990s, and they remained friends through the years as Wilson became known for his early investments in companies like Twitter, Tumblr, Kickstarter, and Etsy through his new firm, Union

Square Ventures. Seeking the competitive edge, Goldstein now looked for his entry point into the cryptoeconomy.

"He's got a bit of a chip on his shoulder to prove to the world that he's a top-notch entrepreneur," Wilson said about his friend to the journalist Matthew Leising, who first wrote about the Bright Moments heist.[24]

Divorced at fifty and contemplating his life choices, Goldstein returned to his own artistic practice during the pandemic. He photographed the waves breaking on Venice Beach and used a computer program to stitch the images together into a short video in which the mists splitting from the ocean dissolve into the golden sunset in a pixelated fizzle. In January 2021, Wilson encouraged him to mint the artworks as NFTs; Goldstein described it as the breakthrough that planted the seeds for building a digital art gallery. The Beeple auction would accelerate his plans, and Bright Moments Gallery opened that spring with its first physical location inside a former tattoo parlor in Los Angeles where a large electric "CRYPTO" sign flickered to life above Windward Avenue.

Leaning into the Web3 ethos, Bright Moments structured itself as a decentralized autonomous organization (DAO), internetspeak for a collaborative model of corporate governance in which smart contracts determined a system of rules for shareholders to debate and vote on decisions. These systems allowed the crypto rich to pool their resources together, amassing capital and deploying it through NFT investments. Some people compared DAOs to chat rooms with bank accounts, but it was a model that a venture capitalist like Goldstein was already comfortable with.[25] He asked that joining members either buy into the company or work off their debt by offering services like writing, coding, and marketing. Members received Bright Moments founders tokens when joining, the amount received from Goldstein equating to the amount of

weight their votes carried in decisions. The tokens could also be used to mint NFTs.

"We vote online by emoji consensus rather than sitting in a traditional boardroom," Goldstein told me.

About half of the forty original members became core builders of the company; many had abandoned their careers during the pandemic in something called the Great Resignation, a prolonged period of mass resignations during which more than four million employees voluntarily quit their jobs every month. Viewed in isolation as a phenomenon, these departures seemed to indicate that wage stagnation, high living costs, and remote-work options provided enough incentives for people to kick their toxic workplaces to the curb. But the average monthly quit rate had been rising steadily since the last recession, in 2008, by .10 percent each year.[26] The uncertainty of the early pandemic months had depressed the quit rate in 2020, but the stimulus checks provided the needed incentive for change. Junior personnel in the finance, consulting, and technology sectors reported experiencing high levels of burnout because of the spiking increase in demand for their services during lockdown. Increased hours came without the benefits of training, mentorship, and client interactions that had previously made those jobs rewarding.

The dynamics of an unrewarding job market led a twenty-six-year-old product manager named Phil Mohun to jump headfirst into the cryptoeconomy. He had studied bioengineering at Syracuse University before heading to Los Angeles in 2016 for a position as a business-technology analyst at the consulting firm Deloitte, where, in the man's own words, he "learned Python and used it to make PowerPoint slides." Around that time, he started mining Ethereum as a side hobby. The knowledge he gained from tinkering around with crypto helped land him a job at the insurance company Anthem,

where he helped put the company's data on the blockchain before heading to a small startup in 2020 that helped organize people's email inboxes.

Nothing about his day jobs seemed to excite Mohun. Then he purchased one of Goldstein's NFT artworks and started hearing about the entrepreneur's vision for a gallery that could serve as a platform for converting the crypto curious into true believers. Bright Moments would primarily make its money by selling tickets to live events where artists used generative algorithms to produce artworks that audience members could buy. These performances helped demystify the process of creating NFTs while building stronger communities between artists and their collectors.

But the gallery distinguished itself by launching its own series of collectibles, the *CryptoCitizens;* every city where Bright Moments opened a location earned its own subset of digital avatars. Goldstein had developed a vision document: just as a picture of Mickey Mouse had marked the arrival of cartoon culture, and a Nintendo icon became shorthand for video games, the *CryptoCitizens* would mark the arrival of an NFT revolution.

"Our goal was to distribute ten thousand *CryptoCitizens* around the world by 2023," Mohun said; he released the collectibles in equal proportion among the ten cities where Bright Moments wanted to establish a presence, including Los Angeles, New York, Berlin, London, and Mexico City. Those NFTs would provide collectors access to the DAO and future minting opportunities to purchase artworks from partnering artists like Tyler Hobbs.

In late June 2021, the DAO released its first batch of one thousand *CryptoVenetians*—pixelated characters who epitomized SoCal beach culture with their bathing suits, surfing gear, and skateboards. The trinkets were modestly successful as incentives, helping to bring customers into the beachside gal-

lery. A few weeks after the rollout, Robert Iger, taking a break between his two stints leading Disney as its chief executive, stopped by the gallery and minted one of the *CryptoVenetians*. He posted a video on social media about his latest acquisition, setting the Los Angeles scene abuzz and driving more celebrity influencers to purchase their own Bright Moments NFTs.

"The timing was fantastic," Mohun said. The gallery had survived the early summer's downturn and entered August as the markets were climbing; early that month, a single *Crypto-Venetian* was sold on the secondary market for more than $28,000 in Ethereum. Many of the DAO members considered themselves rich on paper, as the value of their investments skyrocketed.

There were clear indications in August that a speculative fervor had gripped the market again. The caution of a downturn disappeared as quickly as it had come. Investors were pouring more money into Web3 startups without significant knowledge about the industry. NFT projects announced that month seemed to arrive with record prices and promises of hundred-fold returns, only to disappear quietly in subsequent months. Getting bamboozled by scammers who posed as marketplace employees, or betting on collectibles whose anonymous creators were misidentifying themselves, became something like a rite of passage.

Rumor spread online that a digital art gallery on Venice Beach was giving out free NFTs worth upward of $10,000 apiece. Goldstein recalled turning people away, like the family of four that had driven hours through California's Central Valley to mint their *CryptoVenetians*.[27]

"We hadn't anticipated the emotional dynamics," the businessman told the crypto news site *DeCential* later that year. "People started to scam us."

Goldstein had originally hoped that *CryptoCitizens* would symbolize a user's loyalty to the Bright Moments brand, a

memento from their first voyage into the metaverse; now he became something of an admissions officer. Paranoid that degens were delegitimizing his company through speculation, he required that prospective minters send videos about why they wanted the NFTs.

"They don't even care about the beauty of what they are," one user by the name of @squrlmusic said in his application. "They don't understand the art." The degens were looking to make money, "but what is that worth, when you could have the coolest little dude or dudette on your phone for the rest of forever?"[28]

The argument was convincing enough, and @squrlmusic minted his *CryptoVenetian* on August 7. Two days later, the collector sold his NFT (featuring a nude woman with a boombox, space buns, sunglasses, and a surfboard) for nearly $19,000 in Ethereum. Goldstein learned that he needed to stop trying to control the speculators and keep focused on expanding the gallery through shareholder value. "We are trying to generate Ethereum to make more art, we are not making art to generate Ethereum," he declared. "There is no extraction capitalism going on here.

"On some level, those NFTs were moving from weaker hands into stronger hands. Serious collectors know that holding multiple *CryptoCitizens* will give them the best chance of minting future art drops. If you hold more *Citizens,* you move to the front of the line. The *Citizens* are membership passes to our world of generative art."

The credo of shareholder value once fueled the mass delusions of the Silicon Valley empire. When the stock prices of Web companies soared in the 1990s, executives pocketed obscene bonuses and received their appointments as the new titans of American industry. Wall Street had learned to idolize the corporate raiders of the Reagan years, when people like Carl Icahn, Henry Kravis, and Irwin Jacobs turned hostile

takeovers into an art form. The sensationalism of these tactics had an energizing effect on the business sector at a time when American companies had become paranoid about falling behind their rapidly modernizing competitors in Japan. And as the financial journalist Roger Lowenstein observed in his book about the origins of the Dot-Com Crash, shareholder value was itself a meaningless term, but it provided the linguistic jujitsu necessary for executives to dodge accusations of impropriety.

Industry boomed, and the stock market regained its allure after decades of rusting under the residual trauma of the Great Depression. Washington became gripped by the market and a seemingly endless debate about privatizing Social Security. The idea of Americans' investing their savings in the stock market sounded preposterous in the postwar years, but nearly half the country was putting their money into stocks and mutual funds by the mid-1990s. The Clinton administration had continued building upon the principles of Reaganomics by starting an era of globalization, believing that unfettered markets and technological determinism would outdo policymaking by creating more jobs, educating the poor, and democratizing access to information. But it was the corporations that reaped the financial benefits of deregulation while this pathology of American exceptionalism took its course. When the tires started spinning, it became imperative to keep the pipeline of new companies and IPOs coming. The market capitalization of the 199 internet stocks tracked by Morgan Stanley's Mary Meeker in October 1999 was worth $450 billion, while total annual sales for those companies hovered closer to $21 billion. There were no collective profits, only losses of about $6.2 billion, and so markets eventually took their tumble. The Nasdaq had lost nearly 80 percent of its value by October 2002. The average investor lost $50,000 in the stock market during the crash, with a total of $5 trillion evaporated and 70 percent of 401k's losing

at least one-fifth of their value.[29] Between 2001 and early 2004, Silicon Valley alone lost around two hundred thousand jobs.

Banish the thought. Everything was great—or at least needed to appear great. Investors used a series of financial instruments like commodities and equities derivatives to make disguised loans before the crash. "There was a general campaign to prettify the picture, to doctor the market profile," Lowenstein wrote about this era of shareholder value, concluding that "truth had become heresy" in the years preceding the crash.[30]

Of course, Goldstein had lived through the Dot-Com Crash and still trembled with its aftershock. Like many of the middle-aged investors in Web3, he relied on a mix of nostalgia and regret to fuel his ambitions, reminding himself—and anyone questioning the longevity of NFTs—that many of Web2's most successful companies had survived the crash, with Amazon and eBay as primary examples. Many companies would die when the crypto bubble burst; he just had to make sure his companies weren't among them. Bright Moments Gallery was his attempt to bring the Web1 ethos of decentralization and experimentation forward by building around the concept of shareholder value that he had become comfortable with in the dot-com era. This would be his greatest mistake.

Phil Mohun was the very first to learn about the heist on August 11, waking up to hundreds of messages on social media saying that someone had hijacked 309 *CryptoVenetians*. An emergency meeting was called to discuss what had happened. One member of the Bright Moments DAO claimed that he had been hacked. But it only took a few hours for the group to trace the blockchain transactions and learn the truth.

Bright Moments was using a "hot wallet" distribution system for minting its NFTs, which kept its assets connected to

the internet. The connection made the wallet less secure, providing an access point for the rogue DAO member to steal the remaining *CryptoVenetians* before anyone from the gallery could notice. The thief made three hundred individual wallets of his own, conducting a series of transactions that minted the remaining *CryptoVenetians,* putting them into his possession. Then he attempted to sell the collectibles through the online marketplace.

When the gallery realized that the heist was an inside job, a furious Goldstein and his colleagues wrote a thirty-five-page complaint to the Los Angeles Police Department attempting to bring embezzlement charges against their former associate. However, the allegations strained the credulity of authorities who already felt little motivation to pursue the culprits of crypto squabbles. The nature of the crime seemed to fit the legal definition of embezzlement: an associate had legally obtained the company's digital assets, which he intended to sell for fraudulent purposes. But law enforcement has a more complex algebra of priorities and publicity within the financial world; it would take another year for the Justice Department to start regulating by example, arresting wrongdoers in the NFT market for issues like wire fraud and money laundering.

Goldstein was out of luck with the authorities, so if he wanted to recoup the gallery's $3.4 million worth of stolen merchandise, he would need to do it himself. On the morning of August 15, four days after the heist occurred, the businessman walked toward the skatepark on Venice Beach. Mohun and nearly a dozen other Bright Moments members had come to film the confrontation, just as they had documented nearly every moment of the gallery's infancy before it. They hid in the bushes until the culprit spotted them and yelled, threatening to call off the meeting. Goldstein had come from brunch with his son at the Butcher's Daughter, and was carrying leftovers in a bag. He was told to put his cellphone with the food.

Only in California could a meeting like this occur among the graffitied palm trees and ambling tourists. The thief wore a brimmed straw hat and sunglasses. Goldstein wore flip-flops and surfer shorts; he looked like a West Coast dad with his tightly cropped haircut and five o'clock shadow.

According to Goldstein, the rogue DAO member wanted congratulations for exposing a flaw in the Bright Moments minting procedure. He argued that the NFTs were not stolen, because he had paid with his DAO tokens. He was frustrated that marketplaces like Art Blocks and OpenSea had delisted his *CryptoVenetians,* saying that it went against what the blockchain stood for.

Perhaps it was that whiff of technological determinism that broke Goldstein out of the moment. He had approached the culprit with a seething resentment, anger rising in his chest at the idea that his gallery—his new start—could be taken down from the inside. But it wasn't just anyone who had stolen the NFTs, it was an idealogue who embraced his role as shareholder to the extreme. There are crypto investors who studiously watch the market and react with deftness as the price of everything rises; then there are the crypto degens who seek to make their own fortunes through corporate espionage and insider trading. Goldstein envisioned himself as the former and was upset to realize that he had been working so closely with the latter. The real question, however, was just how much daylight was lost between them.

"We were born out of that heist," Goldstein would later say, attempting to turn a negative into a positive. "It showed us the limits of trust and decentralization."

There was a time in the tech business when calling someone an artist meant that he wasn't serious enough about business. The Rembrandts of this age were all fools without a sense of money, which implied that these starving artists lacked self-worth. "There are artists now, unbelievable artists, who are

also programmers, and they are capable of unlocking a huge amount of economic abundance," Goldstein said, referencing artists, like Tyler Hobbs, who refused to let themselves die penniless, as the Old Masters often did. Goldstein predicted that in a decade the legacy of NFTs would be "the continued merging of video games, stock markets, and art" into a single field of experience.

Bright Moments Gallery eventually retrieved 240 of the missing 309 NFTs. Telling me this, Goldstein paused to mention that these last couple hundred *CryptoVenetians* had become some of the rarest collectibles in the bunch, with their sundown aesthetic and twinkling stars in the sky. "Over time, that provenance will be interesting to collectors," he thought, already tallying a possible rise in financial value.

That August, Goldstein was looking eastward, as Bright Moments extended its reach with a location on the cobblestone streets of New York's SoHo neighborhood. The gallery would eventually restructure its way of doing business, creating an architecture that required customers to purchase minting passes, NFTs that could be traded on the secondary marketplace. Like golden tickets to Willy Wonka's chocolate factory, the passes offered proof of admission within the Bright Moments protocol, generating a QR code that could then be used on-site to mint a *CryptoCitizen* or an artist edition. The minted NFT was then automatically sent to the customer's wallet.

"It's all about minimizing the surface area of attack," Mohun said when describing the changes. "Stay paranoid and have conviction.

"If NFTs are going to succeed as an asset class, they need to do so on their own merit, outside of being 'the new thing,'" he added.

What happened at Bright Moments Gallery had transpired inside several other Web3 companies at the time, where dis-

agreements between investors and degens were turning into cybercrimes. Within the bubble of the boom, it looked as if the frictionless structure of the cryptoeconomy had triumphed over traditional business practices; the blockchain had optimized away the crutches of trust and authentication that typically slowed down sales in any regulated market. The DAO was just another outcropping of this optimization effort, turning traders into shareholders who voted with their emojis and argued out of self-interest from their text boxes. Grift easily burrowed into these anonymized networks of business, and the entrepreneurs running at hyperspeed to catch the market's upside had an interest in ignoring risk. With all the power and none of the guardrails, stealing digital assets seemed as immaterial as the assets themselves.

"The carefree early attitude of the DAO was gone," Bright Moments declared on its website, "replaced by a pragmatism forged by a first-hand experience of how quickly things can change on-chain."

But the most important thing was the same in this bubble as in any other: momentum. Only a few weeks after the heist, Union Square Ventures made the equivalent of a $1.6-million investment in Bright Moments in exchange for one million DAO tokens, allowing it to participate in the governance scheme and mint *CryptoCitizens*.[31] The deal happened completely on-chain, without any paperwork. Some of that money was used to repay new members, who had together spent 70 Ethereum (or about $200,000) to join the company; another tranche was used to cover the upfront costs of renting future gallery space. More investments came from the NFT world, including a powerful group called Flamingo DAO, which ended up purchasing forty *CryptoVenetians*—many of which were the nighttime NFTs that had once been stolen, the ones that Goldstein hypothesized would most increase in rarity and value.

When the Bright Moments gang arrived in New York, the

market's summer slump had already been replaced by a fever-ish autumn. Artists who had experimented with NFTs were devoting themselves to the medium, and corporations were beginning to hire twenty-somethings to explain how they might conquer Web3.

Meanwhile, Goldstein had sharpened the gallery program, turning his exhibitions into NFT minting spectacles where the performance of creating the token became a reason in itself for collectors to attend. A community formed around these ritu-als, and the entrepreneur was able to convince the artist Tyler Hobbs to join the Bright Moments outpost in Manhattan for a December show that would bring in $7 million in one eve-ning, which was split 70–30 between the artist and the gallery. But the vibe had certainly changed. Even as the crypto rich started pouring into the SoHo storefront, the DAO members were on high alert for thieves. The customer coming to buy a Hobbs original was flanked by gallery associates watching to ensure that nobody was stealing their wallet information in the secluded basement deal room. It was quite the scene for an exhibition called *Incomplete Control,* which dealt with the artist's interests in the imperfections that the algorithm behind his artworks could create.

"The forces of chaos and entropy give the natural world a certain warmth," Hobbs wrote about the series. "One prerequi-site is that the creator must, at least partially, give up control'... to allow the output to define an entire space of potential exis-tence rather than limited specifics."

His words described the exact juncture at which the NFT market stood near the end of 2021. One might assume that the new heights of a revived bubble had returned entrepreneurs to the bridge of magical thinking where new possibilities are found, but the velocity of the snapback was more evidence to speculators that their earlier bets had paid off. It was time to double down and leap into the abyss.

4

A GILDED VOID

From the stock exchange to the art market, the dueling sensations of euphoria and immorality created the perfect environment for speculation. New empires were built upon a nostalgia for old memes and pixelated graphics as NFT investors abandoned their quantitative reasoning skills and bought into a kleptocracy that masqueraded itself as populism.

The historian Edward Chancellor once described these dynamics as a carnival where games and gambling allow for the profane and anarchic to take root. "In the face of fortune, social distinction counts for nothing and everyone becomes equal."[1] The carnival also harbors what the Russian literary critic Mikhail Bakhtin called "grotesque realism," a degradation of value that transmutes everything spiritual into material dreck. The dreamlike glare of the carnival lights distorts the flow of time, marking a break point with reality. Carnival mania reverses the expectations of fairness. Visitors simply assume that the games played on the fairgrounds are rigged long shots, yet they spend money to participate in the charade anyway. It is a parody of the highest order.

Unlike a delusion, which threatens to consume the entirety of reality, the carnival distortion is fenced into a certain place and time. Revelers are not bereft of logic, but instead rely on bad information to reach their conclusions logically. The Great

Crash of 1929 had its foundations in the economic prosperity of the decade, but the distortions of late-stage debt and poor investments encouraged the public to assume that good times would last forever; similarly, the distortions of shareholder value during the Dot-Com Crash prepared traders to accept bad accounting practices, high debt, and overcapitalized markets as metrics of financial health.

The carnival distortion cultivates a decadent beauty, which always seems to arrive at moments of great economic upheaval. The ancient Romans celebrated Saturnalia as a topsy-turvy reversal of the social order, placing household slaves at the head of the family dinner table. Outrageous fashions, conspicuous consumption, and sexual revelries followed the scene, which became outlets for expression. Venetian traditions from the thirteenth century captured a similar vibe; carnival masquerades of that era involved the concealment of identity behind elaborate costumes and grotesque forms. Protruding noses, crumpled foreheads, and beaklike chins obscured identity, allowing members of different economic classes to fraternize behind their masks without fear of scorn.

Artists have a vested interest in pumping up the party. The carnival distortion rewards image makers with the kind of occult status usually reserved for pharaohs and prophets. Moments of fleeting speculation arise when the distinction between reality and representation collapses.[2] Attempts to reassemble the fractured landscape only amplify the distortion, making a return to the old world impossible. Each successive image subverts the old hierarchy, leaving the wealthy patrons buying these images in a bind. A purchase establishes ownership over the distortion, yet the purchase also symbolizes an admission of weakness: the patron lacks the skills necessary to decipher the distortion on his own. So artists gain the economic high ground, turning their creativity into currency.

But the scandalous reshuffling of the social order is per-

mitted only insofar as it can be stopped. Carnivals often end with a sudden reversal of fortunes. The festival king is dragged through the streets and shackled in the stocks while an effigy of his honor is burned in the town square. Chaos retreats into the shadows as people abandon their costumes. The old system returns stronger than ever, ending the carnival distortion with a sudden thud.

And while the NFT movement claimed it was building a new paradigm for the relationship between art and money, the old rules of the carnival remained—not that artists and entrepreneurs ever paid much attention to limits on their creativity.

The bulls never stopped running through the late summer and autumn months of 2021, dragging the world into another season of madness. Nothing seemed capable of puncturing the bubble that had formed around the metaverse. Global supply chains were falling into disarray as labor shortages slowed the cargo ports to a crawl. Vaccines that were supposed to protect against the Covid-19 pandemic failed to stop an onslaught of the more contagious Omicron variant. Labor shortages continued to threaten economic recovery as the realities of inflation were hitting the supermarket. The Consumer Price Index increased by 5.4 percent in September, faster than most economists had predicted.[3] The Federal Reserve slowed its bond purchases in hopes that inflation would start falling without more painful interventions; however, Wall Street was already bracing itself for more dramatic measures on the horizon as officials exhausted their options to curb inflation. And in the meantime, Federal Reserve chairman Jerome Powell was staying on message: any inflation that occurred was only "transitory." Most people were unimpressed by the government's calming pantomime, because they were certain of hard times ahead;

however, crypto traders were eager to use the power of magical thinking for themselves.

In late August, the thirty-one-year-old Bitcoin billionaire Justin Sun bought a rock NFT for nearly $600,000, which seemed like a bargain only a few hours later, when the floor price of *EtherRock* increased to $1.05 million. It was the kind of nihilistic showstopper that had helped raise the businessman's profile in the past when he threw around money to get attention. His recently acquired pet rock worked like a charm; Sun later justified his purchase to a *Bloomberg News* reporter by saying that, in the crypto industry, "money doesn't matter at all."[4]

On the contrary, money was everything. That same month, OpenSea became the first NFT marketplace to exceed $1 billion in monthly trading volume, with nearly twenty-six thousand users. *The New York Times* was publishing stories about how teenagers were taking advantage of the new technology to sell their artworks. And talent hawks in Hollywood were starting to diversify their portfolios of intellectual property. United Talent Agency signed *CryptoPunks* and other Larva Labs creations for representation across film, television, and video games—a signal from the entertainment giant that digital assets were the new "it" girls.

Lesley Silverman was the muscle behind UTA's cyberspace embrace. In 2015, she joined the agency to help establish its Fine Art Division and keep a roster of notables like Ai Weiwei and Judy Chicago happy. But it was her background as a lawyer that plugged her into the metaverse.

"Smart contracts were my initial spark," she said. "Anything that restores power to the original creators is really exciting to me."[5] The financial volatility never really bothered her, because she was playing the long game. "It does feel very similar to what the art world felt like in 2015, but at a much faster clip and at a much more expansive and globally buzzy level."

Perhaps that was why she liked signing artists who were also businessmen. Erick Calderon was an early client; his company, Art Blocks, had become a leading platform for generative art during the bull market, completing almost $1.2 billion in transactions within the course of two years. Silverman was also able to use her connections in the art world to boost Calderon's profile as a creator. His own NFT series, *Chromie Squiggles,* was already candy to crypto investors, but the traditional art world would take some coaxing.

Silverman was unstoppable, but she was not alone. Hollywood had largely missed the last generation of online influences found on streaming platforms like YouTube and Twitch after gatekeepers wrongly assumed that social-media platforms were a passing fad. One of the most dogged talent managers in the metaverse was Guy Oseary, who did more than anyone else to put NFTs into the pockets of celebrities like Madonna and Eva Longoria. In October 2021, he signed the *Bored Ape Yacht Club* as a client and proceeded on a series of maneuvers that someone unaccustomed with the wheeling and dealing of the entertainment industry might consider unethical. He would convince wealthy musicians and actors to purchase *Bored Ape* NFTs, lead his clients to a crypto exchange platform that he also had financed called MoonPay, and then publicize those purchases to fuel the hype cycle around digital assets.

The positive feedback loop was strong enough to keep the public curious. But there was a growing suspicion, even among investors, that something was rotten at the core. Were celebrities like Reese Witherspoon, Paris Hilton, and Kim Kardashian, who suddenly had an interest in the metaverse, helping to promote digital art? Or were they profiteering? Was there some fundamental value hiding in the center of the positive feedback loop that circled the NFT industry? Or was it a void?

ʍ

Good news continued rolling through the headlines. In September, the *Bored Ape Yacht Club* saw its profits climb when a Sotheby's auction of 101 monkey NFTs sold for nearly double its low estimate at $24.4 million. Traditionalists continued their futile protest over the sale of collectibles alongside paintings and sculptures, but an increasing number of contemporary artists were drawn into the lucrative market for digital goods by a familiar pattern of financialization. The bankers who created the booming art market in the 1980s with large infusions of cash were being replaced by young tech executives who brought a new mentality to their investments. Premium prices required premium swag. This generation of buyers expected artists to deliver the same complex storylines and plot twists found in their video games and television series. Worldbuilding was a prerequisite, and cyberspace became the new final frontier.

Tom Sachs converted his SoHo art studio into a crypto mothership. "No engineering project is more complex and pervasive than the corporate ecosystem," he wrote on his website, and the hiring of an international blockchain development team proved his thesis correct. *Rocket Factory* involved the creation of three thousand NFTs that were combined into rocket ships. Collectors assembled parts of their digital vessels from an assortment painted with the logos of corporations like Trojan condoms, Chanel, and McDonald's. The completed NFT rockets prompted the artist to create physical replicas, which he shot into the sky before recording metadata from the launch onto the blockchain. Additional phases of the project included an imagined trip to Mars in which the rockets would siphon resources from the red planet. Collectors would receive rock NFTs, which were then converted into fuel NFTs that could further power the mothership. Sachs promised buyers in private salons at his studio that the *Rocket Factory* universe was continuing to expand, that this was the most ambitious project he had ever undertaken.

Jeff Koons, a former commodities broker who became the most expensive living artist by selling stainless-steel sculptures of balloon animals, announced his own space-themed jamboree. But, despite his courtship of the world's wealthiest collectors, the sixty-six-year-old artist's market was softening, without enough new buyers to replace the old ones. Koons needed to make a leap forward and change his business model. After working with Larry Gagosian for nearly two decades, he was calling it quits on his relationship with the world's most powerful art dealer. (The artist also stopped working with another top gallerist, David Zwirner, after eight years together.) The critical fissure in their relationship appeared to be NFTs. Gagosian had been slow to embrace digital tokens and skeptical in the press about their relevance. He had allowed another artist, Urs Fischer, to partner with a competitor, Pace Gallery, on his own blockchain project. It became clear when Koons later joined Pace and announced his own NFT series that Gagosian had made an unforced error in belittling the new technology.

Koons entered the cyberspace race with the same approach that had secured his position in the traditional art world four decades earlier. He traded exclusively in what I would describe as "schlock value," objects of deadpan nostalgia that symbolized the terrifying emptiness of capitalist excess through banalities like the porcelain tchotchkes and vacuum cleaners that he placed on pedestals. *Moon Phases* epitomized the artist's obsession with delusional grandeur. The project included NFTs representing the 125 miniature lunar sculptures that he intended to plant on the moon during a voyage of Elon Musk's SpaceX Falcon 9 rocket from the Kennedy Space Center in Florida. Collectors paying to subsidize the mission would receive their digital tokens with a larger, twelve-inch stainless-steel version of their moons, which were named after aspirational figures like Leonardo da Vinci, Marilyn Monroe, and Muhammed Ali.

By October 2021, cryptocurrency seemed to invade most

aspects of celebrity culture, corporate communications, and financial infrastructure. Martha Stewart was the latest television personality and convicted felon to promise NFTs to her followers, just in time for Halloween. Dolce & Gabbana made $6 million from digital tokens depicting jewelry and outfits that would have been impossible to fabricate in reality.[6] Mastercard announced that it would allow merchants and banks on its payment network to exchange cryptocurrency, expanding the possibilities for the NFT market's growth. And Facebook closed the month by rebranding as Meta, stating the company's intention to build the Web3 ecosystem at a time when its flagship social-media platform had come under scrutiny for spreading hate speech and misinformation. Some crypto investors worried about guilt by association, knowing that the arrival of a large and troubled company might result in more oversight for their startups. But the value of cryptocurrencies reached new heights; traders declared that "Uptober" had cemented their place in history.

After a failed start in the spring, Takashi Murakami finally had the perfect timing needed for his NFT project. While his competitors were playing astronaut, the Japanese artist sought to colonize the metaverse with androids and aliens. In November, he partnered with the virtual fashion brand RTFKT on the *Clone X* collection, a series of twenty thousand randomly generated NFTs, which quickly became bestsellers in the secondary market, where a single specimen could sell for as much as $1.25 million.[7] Success transformed Murakami into an exuberant convert of the blockchain blowout, referring to the new technology as a "cognitive revolution" capable of dissolving the borders between reality and fiction. He compared his encounters in the digital world to earlier epiphanies that had shifted his artistic process, including the Koons porcelains that he witnessed in a 1988 exhibition at Sonnabend Gallery in New York.

"One depicted a gilded, white-skinned Michael Jackson

clutching his beloved chimpanzee, Bubbles," he recalled in a personal essay for *The New York Times*.[8] "Another portrayed the cartoon character Pink Panther festooned upon the shoulder of a woman modeled after the actress Jayne Mansfield, bare-chested and grinning."

He went home and read a review that described the Koons sculptures as simulationism. "I felt that I understood it: its manipulation of reality, its subversion of the familiar, its insouciance toward what we held to be true. My encounter with Mr. Koons's exhibit made me question my own judgment."

Murakami has spent decades trying to recapture that sense of destabilization within his artworks, deploying his kawaii anime designs like contagions spreading across walls, purses, canvases, and computers. *Clone X* helped extend his domain into the metaverse, where the NFTs could symbolize a new digital nation of financialized followers. He compared the purchase of his artworks to gambling, imagining himself as a collector with an addiction to the digital avatars. "It seemed extremely similar to the way dopamine erupts in your brain when you try to buy a work at an auction in person, raising the paddle in your hand," he said. "It's like, Aaaaah! My brain's exploding! Like a gambling addict, I lost all sense of money, buying *Clone* after *Clone* without thinking about the numbers. Then I'd suddenly come to my senses and get alarmed. I'd feel a refreshing sense of malaise, or perhaps despair.[9]

"I've also experienced this sense of euphoria when visiting art fairs," the artist continued. "I once went on a shopping spree at famous galleries at Art Basel, and when I got back to Japan, my company's accountant reprimanded me severely for bringing the company to the brink of bankruptcy. The sense of immorality I felt then was quite similar to what I felt when buying NFTs."

Nobody attempted to conceal their desire to prolong the carnival of speculation that surrounded the NFT bubble. The charade of good taste that protected the art market from criticism was irrelevant in a closed financial system where buyer and seller might collude on pricing. Murakami's celebration of gambling was matched by Sachs, who admitted that the smart contracts and Web3 infrastructure he was creating were really about money. "If everyone's an artist, and that includes bankers, it's the art of faith," he told *The New York Times*.

However, extreme acts of faith can unsettle bankers. In November, auctioneers at Sotheby's were offering a rare copy of the United States Constitution from the widow of a deceased appellate judge named Harry D. Goldman. The jurist had purchased the historical document for $165,000 from the auction house in 1988. More than three decades later, the founding text was expected to sell for as much as $20 million in one of the company's main evening sales dedicated to modern and contemporary art.

When offering such an expensive artifact, auction houses will often survey the field of collectors to ensure that there are enough bidders to give the lot a fighting chance of achieving its high estimate. However, the company never anticipated the arrival of ConstitutionDAO, a motley crypto collective bent on buying the founding document to prove that Web3 technology could "honor and protect the greatest historical tool for human governance: the U.S. Constitution."

An original group of about thirty core members—most of whom were barely in their twenties—soon swelled to seventeen thousand contributors, trading memes about the announcement by the character played by Nicolas Cage that he would steal the Declaration of Independence in the 2004 movie *National Treasure*. Like the offbeat Cage character swashbuckling his way through museums, the group was empowered by a similar naïveté to crowdfund millions in Ethereum to purchase

the Constitution. Nobody within the collective had experience
as a collector of historical artifacts, and most had never par-
ticipated in an auction. The DAO attempted to cover its blind
spots with informal research groups and overnight study ses-
sions. While admirable, this engineered approach to decipher-
ing the social rules of the art world was always doomed. What
ConstitutionDAO failed to understand was how devoted tradi-
tional collectors were to stopping their ascension.

The hedge-fund billionaire Kenneth Griffin was closely fol-
lowing the irrational swings of the market. Internal memos
from the investing platform Robinhood revealed that its
executives had scrambled to contact Griffin, the chief execu-
tive of Citadel Securities, during the great GameStop debacle
of January 2021. Retail investors from a Reddit forum named
WallStreetBets were targeting a firm called Melvin Capital,
which was attempting to short GameStop's descent toward
bankruptcy with tactics similar to those used by the people
who had benefited from the housing crisis of the 2008 Great
Recession.[10] The attack left Melvin Capital down by 30 per-
cent, and Griffin's company joined a $2.8-billion bailout to
save the firm, which nevertheless closed the next year because
of heavy losses. GameStop greatly benefited from the battle,
seeing its stock rise 1,500 percent over two weeks to a record
high of $483.00 per share. It appeared that Robinhood wanted
to stop the short squeeze by freezing trades on GameStop; a
class-action lawsuit in federal court later attempted to use the
company's internal memos to prove that Citadel had conspired
with the trading platform to prevent the squeeze. Both firms
denied any wrongdoing, and a judge in the District Court of
Southern Florida tossed the claims for lack of evidence.

The court's dismissal was issued on November 17; one day
later, Griffin was engaged in a battle for the U.S. Constitution
against the cryptomaniacs, whom he had earlier accused of
making "a jihadist call that we don't believe in the dollar."[11] His

opponents were shrugging off the accusations at this point. The auction world was still riding the NFT bump to the bank; only a week earlier, Christie's had sold Beeple's first physical artwork with an accompanying NFT for $28.9 million. *Human One,* a video sculpture housing an explorer walking across a digital landscape, went to the venture capitalist Ryan Zurrer, an eccentric Swiss with investments in crypto and psychedelics. There was no dearth of confidence at the time. Bitcoin had just reached its highest point at nearly $68,000, and the optimism within the market felt unstoppable.

But despite sleepless nights of study, ConstitutionDAO members failed to understand the core strategic principles of an auction, in which information is power. In about a week, the group had raised $47 million to purchase the historical document, but the organization was posting its results online, where an angry billionaire might see it. Griffin, an experienced art collector with his name on the Whitney Museum of American Art's lobby, started calculating his odds. The businessman had seen his $25.4-billion net worth increase during the pandemic; he had money to spare.

Sotheby's was already in a bind, having guaranteed a minimum estimate of $15 million to the consignor, meaning it would be responsible for coughing up the money if nobody bid to that amount. ConstitutionDAO's loud pronouncement that it had raised triple that amount also risked depressing the market, dissuading potential bids from collectors intimidated by the crypto collective's war chest. Instead of creating a competitive market, transparency was killing it.

Griffin immediately saw an opening, and offered his own guarantee to Sotheby's in the days before the auction began. He offered a winning bid of $41 million, which would seem to push the price to $47.4 million after buyer's fees. But his agreement with the auction house gave him a steep 65-percent discount on the $6.4-million premium of buyer's fees. Such deals

are usually hidden from the public, and, going into auction day, none of the competing buyers knew that Griffin already had an edge. Bidding opened at $30 million and steadily climbed; the Constitution was sold within eight minutes. Thanks to his sweetheart deal with Sotheby's, Griffin ultimately bought the document for less than the ConstitutionDAO had planned to offer: the final price was reported as $43.2 million.

The ConstitutionDAO collapsed into confusion. Many members assumed by the price that they had been victorious, and many crypto websites falsely declared another Web3 win. Others became irate when the group was slow to refund its participants. A few days later, Griffin announced that the historical document would travel for an exhibition at the Crystal Bridges Museum of American Art in Arkansas, which was owned by the Walmart heiress Alice Walton. She had been sitting in the auction salesroom as the drama unfolded, darting toward the auctioneers to offer the winner an exhibition spot in her museum, because she knew the document was "an obvious draw."[12]

Justifying his expense, Griffin later said that his son had asked him to buy the U.S. Constitution, and so he did. He even offered his competitors a "joint governance" agreement to decide on where the document would be displayed half the time, and offered to issue NFTs to everyone who had contributed money toward the DAO. Members of the collective remember the ultimatum differently. Graham Novak, a founder, said that the billionaire offered to sell the digital rights to the document "in exchange for an unspecified amount of the DAO's treasury. The proposal would leave Ken in control of the physical document." He added that the group wasn't aware of any free offer to get involved in display scheduling.[13]

"Ultimately we couldn't come to an agreement," Griffin concluded.

One might expect that such a public defeat would depress

the crypto market, but investors seemed to translate the loss into a new manifest destiny. "Okay so we didn't get the Constitution," one user wrote to DAO members. "What are we going to bid on now?"

Less than a week after its failure, core organizers behind the group announced their disbandment. Nobody seemed to care. For a couple months after the collapse, magical thinking helped elevate the value of ConstitutionDAO's membership tokens. In December 2021, the defunct $PEOPLE token reached a market capitalization of $1 billion, which by January 2022 was still floating at around $300 million—almost six times what the group had originally raised to buy the Constitution.

The zombified ConstitutionDAO served as a monument to crypto's near victory in the art market. Crypto investors had tasted the strange euphoria of collective action in the face of an overwhelming financial system, and they had suffered the immorality of a billionaire's using the art market's mechanisms against them. But the fiasco, spun positively as an example of crypto's crowdfunding potential, also onboarded thousands of people into the fantasy of decentralized finance. Constitution-DAO would become a bullet point on résumés as its organizers moved on to other projects, including NFT investment groups that used the DAO structure to fractionalize the ownership of digital collectibles.

Even skeptics like Griffin warmed to the possibilities of Web3. "Given the institutional increase in interest in cryptocurrency, I think it's reasonable to expect to see us be more involved in the crypto space providing liquidity to institutional and potentially retail investors," he later said at the Milken Institute Global Conference in Los Angeles.[14]

(This was certainly a provocative venue for such a statement; the conference was named after Michael Milken, the junk-bond king of the 1980s who was indicted for insider trading and racketeering, pled guilty to lesser charges of violations

in securities and reporting, paid $600 million in fines, and spent two years in prison. President Donald Trump pardoned Milken in 2020, calling the charges against him an example of "prosecutorial excess.")

Griffin conceded that the value of most assets was based on perception. "I also collect American abstract art," he said. "Why is a painting worth $10 million? It's oil on canvas. So value is in the eyes of the beholder."

The federal government continued waving the possible threat of regulation, releasing a memo right before Thanksgiving about a "sprint initiative" designed to build interdepartmental cooperation among the watchdog agencies responsible for installing guardrails on the runaway crypto train. The statement promised that by 2022 new rules would materialize to "promote safety and soundness, consumer protection, and compliance with applicable laws and regulations, including anti–money laundering and illicit finance statutes and rules."[15] But nothing of the sort happened.

ᙢ

In the last four decades, skeptics have howled about the dawning of a second Gilded Age. The warnings often emerge whenever a new technology disrupts an older industry. We have periodically heard these cries when junk bonds became popular in the 1980s, the internet dominated talk in the 1990s, and the collateralized debt of Enron's implosion overtook the 2000s. Leading economic writers like Thomas Piketty, Robert Reich, and Paul Krugman have spun the label into their own revelations about wealth disparities in more recent years.

Something about the second Gilded Age has lodged itself in public discourse, becoming a predestination in the ways businessmen operate their companies and governments fail

to regulate them. Mark Twain coined the phrase in the title of an 1873 novel written with his friend Charles Dudley Warner called *The Gilded Age: A Tale of Today*. Perhaps it was that idea of contemporaneity—of today—that has made the phrase such an enduring critique of economic despair. The Gilded Age was always happening, an eternal condition of American capitalism.

The turn of the twentieth century was an era marked by enthusiasm and anxiety, vaudeville and corruption. America had allowed an immense gap to emerge between the rich and the poor, which enabled tycoons to hoard their wealth in Newport mansions while immigrants lived in cramped tenement apartments on paltry wages. Activists followed Emma Goldman into the streets, where she proposed anarchism as "the theory that all forms of government rest on violence, and are therefore wrong and harmful."[16] But the governments of the period, run by two presidents who lost the popular vote (Hayes in 1876 and Harrison in 1888), lacked the political leverage to fight the economic headwinds; instead, real authority in the Gilded Age often revolved around the businessmen whose resources allowed them to exploit unregulated niches in the market, running against the public interest.

An industrialist like Andrew Carnegie could write at his desk about how the arrow of human progress bent history into an arc that landed at his feet. He could justify his obscene fortune of $350 million (worth about $11 billion today) by committing himself to charity in an 1889 essay titled "The Gospel of Wealth," arguing that "the millionaire will be but a trustee for the poor," setting the paternalistic foundations of modern philanthropy, public libraries, and prestigious museums on their course. Then, a few years later, he could brag in the newspapers that money is only earned by "the man who gets other men to do the work"; not long after, he sent a telegram from his

Scotland vacation to unleash a private army on the strikers at his steel mill in Homestead, Pennsylvania. Seven workers were killed.[17]

A bloody hypocrisy defined that economic age, projecting a grotesque realism that simmered just below its gilded surface. But today's financial hypocrisies are relatively bloodless. Our networks are not made of steel and railroad tracks but of the unseen submarine cables and satellite dishes that connect the telecommunications systems around the world. Economic value has become abstract, and the internet is a remarkably fragile infrastructure that derives its power from invisibility and intangibility. And that is why the Gilded Age metaphor fails today: we no longer have anything left to disguise in gold.

The first signs of a slowdown within the cryptoeconomy were imperceptible. Nothing seemed capable of puncturing the carnival masque, even as the imbalance between supply and demand grew. The number of NFT collectors started to plateau in February 2022, decreasing from a record high of about 550,000 monthly traders the month before to around 536,000. This was a mere 2-percent decrease in activity, which few investors cared about in relation to the $18 billion in total sales volume still flooding into the market.[18] But it would become an increasingly dangerous decline as nonfungible tokens started outnumbering buyers five to one.[19]

Around the same time, a winter storm was pummeling New York City into hibernation. Nearly eight inches of snow had blanketed Manhattan as a terrible blizzard whipped the falling ice crystals into errant lassos. February earned its dramatic opening with the kind of teetering optimism that comes when you see the snowflakes fall from a midtown skyscraper and are blissfully unaware of the frozen dogshit hidden underneath the permafrost.

Slush was melting off the sidewalks in Central Park on the morning of February 2, 2022, when a mysterious truck arrived

on the promenade just beyond the heroic statues of poets and suffragists bordering Literary Walk. A decadent scene unfolded around 9:00 a.m. for the morning joggers. Security guards tightly controlled the area, and the German artist Niclas Castello emerged from the truck with four assistants who carried his illustrious sculpture onto the snow; it was a cube containing nearly four hundred pounds of 24-karat gold.

"Did you see the newspaper this morning?" Barbara Graustark, the *New York Times* art editor, messaged me a few hours later. The artist and his production team had placed a wraparound advertisement in the paper costing around $150,000 to announce the *Castello Cube* with a mysterious photo of the sculpture and an address at the bottom of the page. That kind of investment told us that something ridiculous was about to happen.

The gold alone was worth more than $10 million at current prices, which the artist claimed to have afforded by preselling his own cryptocurrency to finance the project. Onlookers formed a circle around the cube, taking selfies with the sculpture. The surrounding puddles of melted snow complemented the artwork's glossy finish, which reflected the tree line above; however, a closer look revealed speckles of black crust, remnants of the compressed sand used when forming the cube in a Swiss foundry.

Three months earlier, Castello had released a video quietly advertising the cube as a pretext for his cryptocurrency. "Become part of art history and join the new digital era," said a narrator with the sultry baritone voice of a television infomercial. The video even included animated slides with bullet points addressing the good and bad of crypto adoption. The pros? Castello would guarantee maximum security and transparency with custody and bank-account listings through Swiss banks for institutional investors. He offered a series of use cases, including how the *Castello Cube* would become "digi-

tal gold" while promoting his artistic talent; buyers would also gain access to more exclusive artworks and NFTs. The cons? Worldwide adoption of cryptocurrency was in its early phases; the young market had trust problems and confusing technology. But none of that really mattered, because the miraculous cube would solve those problems through its digital currency. "The Castello Coin created a bridge by launching an astonishing physical artwork that serves as its brand ambassador to link the classical to the new digital world." Nearly one thousand people bought into the project, helping the artist raise $20 million from his cryptocurrency presale; it was enough to start building a real business around his expensive sculpture.

In Central Park, a production crew installed pink lights around the cube, which changed its hue from dull copper to brilliant yellow. The forty-three-year-old artist, with bright-blue glasses and long black hair, watched as his audience grew.

After having been involved in the European street-art movement of the late 1990s, Castello found success in the contemporary art world in 2016 when he developed "cube paintings," crumpling his finished canvases inside acrylic boxes like they were used tissues. The paintings themselves were completely ersatz, imitations of a style that had died with Keith Haring and Jean-Michel Basquiat. But their destruction and subsequent display created a conceptual knot for viewers to untangle.

Was the artist attempting to discard something precious, or was he trying to sell you trash?

Witnessing the *Castello Cube* excited all the same feelings of euphoria and immorality associated with the grotesque realism of speculation. To join the crowds that gathered around the gold sculpture's perimeter was to embrace the absurdity of financialization. And although it may not have been a Ponzi scheme in the strictest sense, the artwork still evoked the perverse thrill of being duped.

Over the last two decades, the wealth gap has become

unimaginable. Top households have added 33 percent to their median incomes while the middle class actually saw its net worth shrink by 20 percent, and lower-income families suffered a more extreme loss of 45 percent.[20] The scale of inequality has only grown wider; American billionaires saw their real wealth grow by more than a third within the first two years of the pandemic, adding an estimated $5 trillion to their fortunes.

That kind of wealth is unfathomable, illustrated exclusively through bad examples. I could tell you that $5 trillion is the equivalent of five hundred thousand of the most expensive yachts and just above the gross domestic product of Japan, the world's third-richest country. But no metaphor could explain that scope of economic power, which lies beyond representation.

Conceptualism mocks our desire to understand. The *Castello Cube* seemed to evoke the minimalism of Donald Judd and the shiny surfaces of Constantin Brancusi's abstracted bronze birds. But its closest ancestor is the wooden cube of similar dimensions that Robert Morris made in 1961. *Box with the Sound of Its Own Making* is a self-explanatory work that houses an audio recording of the three-plus hours needed for its construction. Listening to the soundtrack reframes the sculpture's significance as a product about process. Quiet interrupts the performance only when the artist needs to rest or retrieve more supplies. Those sounds and silences fill the box with the meaning of its own creation.

Is there a certain egotism to an artwork that tells a story about itself? Castello had advertised his sculpture as a once-in-a-lifetime event: "Never before in the history of humanity had such an enormous amount of gold been cast into a single, pure object." The precious metal was pure, but the eighteen-inch cube contained a hollow core. Forging gold into a lustrous, symmetrical volume is challenging because of the metal's softness, leaving viewers to speculate just how large the cavity

inside the cube was. But it was important for Castello to maximize the emptiness of his sculpture, engineering the thickness of its walls toward the brink of collapse. A dense cube would have measured only half as tall, and a bigger artwork would signify importance. Who cared if the metalworkers had warned that the two-inch-thick walls might collapse, leaving the cube in shambles. The risk was worth taking.

Still, witnessing the knee-high sculpture was like a sucker punch to the brain, a $10-million anticlimax perched on a puddle of melted snow. It highlighted the inability to visualize wealth, and yet the artwork built upon the tawdry financialization practiced by artists like Sachs, Koons, and Murakami.

The artist's cryptocurrency launched that spring. Castello Coin started with a value of 15 cents, then doubled in value a few days later before resting slightly above its original offer at about 15.7 cents. There were more than 128 million coins circulating the web, meaning that the artist had a market capitalization of $20.2 million. He had effectively doubled the price of making and advertising his cube, which was itself gaining value based on the price of gold.

Interviewing the artist, I wanted to know if he considered himself like the other financialized artists glomming onto cryptocurrency and NFTs. Did he consider market manipulation to be part of his art practice? What was he trying to tell the world by connecting a gold sculpture to digital coins? "I'm just the artist," Castello said. "The rest of the team is doing cryptocurrency work. I'm not, because I don't really understand how it works." Surely, it seemed that the market zeitgeist had overtaken him.

Has art encrypted money, or has money encrypted art?[21] Capitalism tends to consume whatever it touches, but what if culture has evolved into a more rapacious form of economic domination? Even for speculators, the conversion of artworks into cryptocurrency and nonfungible tokens represents a new

kind of financial hurdle. Abstractions like shareholder value and corporate purpose are literalized in a new regime of images that prevents speculators from using their old tactics to goose profits. But the new system is more volatile than anything that has come before, which means it is capable of higher gains and lower losses. Like a carnival carousel incapable of slowing down, the regime of images accelerates so quickly that life blurs at its edges into a dizzying mess of color. Passengers are trapped within the distortion as the carousel reaches its terminal velocity, threatening to dislodge from its axle and send people flying.

The mirage is everything, an unseen world at the edge of the carousel. Speculators stand on that near-death precipice as art becomes the new money, revealing the potential infinity of wealth that only something so indefinable could contain.

GENERATION MOONSHOT

When artists spoke the language of money, they conjured new apparitions of how currency might operate in a future where the traditional financial system had become irrelevant. Those prophecies were as cynical as the millennials who dreamed them. The children of the 2008 financial crisis had reached adulthood and were seeking revenge against the institutions that had allowed their parents' wealth to decline into bankruptcy.

The traditional financial system's goal had been to secure risky assets so that people didn't need to worry that their mortgages and loans might fail. Bankers packaged these debts in diversified ways that created frictionless environments in which clients trusted that the money inside their checking accounts stayed money. That was the reason why most customers never bothered to read their monthly banking statements or schedule weekly calls with their financial institutions to discuss the actual form their money took after being deposited. Trust was codified into the system to create feelings of security; even the dumbest bank depositor could feel confident about their money without knowing anything about capital requirements and liquidity thresholds. Trust was the singular element binding the whole economic system together. Then the 2008 financial crisis happened, and the trust was broken.

Much has been written about what caused the Great Recession, and the relevant parts are included here to illustrate the dangerous paradigm that NFT investors were trying to re-create when packaging their blockchain artworks with incredibly volatile financial products. Less examined has been the cultural impact of the crisis, which has been mostly told through a mosaic of depressing statistics in an attempt to triangulate some deeper meaning. Researchers have pointed to lower fertility rates and fewer home purchases as signs that people were generally pessimistic about their futures.[1] Household spending on health care also decreased during that period, particularly in families that lost health insurance because of unemployment.[2] Additionally, mental health suffered, as generalized anxiety, panic attacks, alcoholism, and substance abuse increased during the years following the crash.[3]

What lessons were the children of recession supposed to learn? Millennials, those born between 1981 and 1996, were mostly teenagers and college students during the 2008 financial crisis. They had once been considered the future engines of economic progress, the most diverse and educated generation in American history. But their formative years were marked by terrorism, a new nightmare fuel replacing their parents' Cold War fears of nuclear annihilation.

The Great Recession solidified insecurity and paranoia in American life. Perhaps it was the competitive job market that triggered a survival instinct in older generations, who began stereotyping young people as materialistic, lazy, and incompetent. Millennials were spending too much money on avocado toast.[4] Millennials were killing the National Football League, because they were too concerned about concussions.[5] Millennials were bad employees, because they were used to getting participation trophies when they played sports as little kids.[6]

It was an absurd moment to enter the echo chamber. In the 2010s, millennials were 34 percent behind wealth expecta-

tions set by the previous generation and carrying 300 percent more student loans than their parents.[7] Millennials entered the workforce with unpaid internships and lowball salaries as older employees were generally shielded from layoffs because of seniority. Magazine editors started asking if America had become a "wheezy gerontocracy" in which the average age of leaders in politics and business hovered near sixty.[8] And by 2020, most millennials were still struggling to find a place in the post-recession economy, while the number of older employees continued to display the highest growth rate in the labor force.[9]

The Obama administration had promised that a new regulatory framework based on legislation like the 2010 Dodd-Frank Act would produce a more resilient system with better consumer protections and fewer speculative investments; however, the White House failed to address the cultural shock wave of the recession. The whiplash has never stopped.

Any corrective system must, by definition, be both reductive and universal.[10] It must anticipate an infinite set of erroneous variations, and it must be universally known, valued, and implemented. Corrective systems are circulatory, producing a flow of information that builds consensus around past events. By contrast, the new regulatory framework was a recursive step backward. The reforms installed guardrails around corporate neoliberalism and the charade of meritocracy without tackling the problems of shadow banking that had preceded recession. The complexity of these financial products had masked risk from investors; meanwhile, the bank bailouts exposed the market's fragility. The narrow avoidance of a collapse like the Great Depression demonstrated the old system's resilience, but it also provided reason for a new suspicion that economic power in the twenty-first century had become unstoppable. So, while reforms adjusted the infrastructure of the prevailing system, they failed to address growing inequality, stagnant wages, and soaring house prices.

The paranoiacs who believed in the self-perpetuating economy were vindicated when the government started printing trillions of dollars for Covid-19 relief funds during the pandemic.[11] Millennials who were raised on the volatility of recession now had evidence that money was more like a concept than a tangible asset. It was abstract, like art; arbitrary, like God. The unencumbered millennial mind was released from the well-trodden path of financial stability. Life during a global pandemic was already a gamble, so moonshot speculation on cryptocurrencies and NFTs seemed a more appropriate expression of risk than retirement accounts and treasury bonds.

The crypto nouveau riche were an impressionable bunch, entering the art market bereft of its history and quirks. Justin Sun was an early convert from the NFT community; the tech entrepreneur purchased a $20-million Picasso at a Christie's auction in April 2021, then followed up with the $78.4-million purchase of a 1947 Giacometti sculpture, *Le Nez,* from a Sotheby's auction that November. Sun's art adviser, Sydney Xiong, handled the transaction by phone. "Before the auction, he didn't know anything about Giacometti," Xiong told me, explaining that she and Sun had discussed the artist for just three hours before placing a bid. "I tried to educate him and let him know how important the lot was and why we should have it."[12]

What else could the cryptoeconomy accomplish in three hours? There was a tender horizon of opportunity for the hustler wanting to take advantage of the crypto whale's ignorance and drive for legitimization. "The art market is always looking for new territory to expand into and the NFT world is like the perfect gateway drug," said Natasha Degen, chairwoman of art-market studies at the Fashion Institute of Technology. "Anyone involved in a market like NFTs that is so volatile and

speculative would have an easy time transitioning to the art world where those same dynamics occur."[13]

Without allegiance to art history and its dicta of good taste, these new collectors were more receptive to artists who existed on the fringes of the traditional art world. They were all outsiders, underdogs who needed to stick together.

Nobody understood the importance of a strong network so well as Justin Aversano, a young photographer with a talent for pulling crypto investors and venture capitalists into his orbit. He was openhearted and everywhere during the early months of cryptomania, identifiable among the sea of finance bros by his Rasputin beard and sleeves of enigmatic tattoos. A recovering introvert, he would hold your gaze and never let the conversation drop in a way that was endearingly awkward. He was a spiritualist, softly enunciating his words in a woo-woo way that made each syllable into melody. His kindness always felt genuine to me, even when it was unclear how deep his goodwill actually went. After all, this was a man who tattooed his right palm with a peace sign and the back of his hand with bones.

Aversano learned about NFTs through social media. In January 2021, he heard about a pseudonymous collector named GMoney who had spent $150,000 on a *CryptoPunk*, flipping the digital asset into collateral for a $25,000 short-term loan that was processed within minutes by a provider called NFTfi so that he could reinvest the money into Ethereum.[14] GMoney's gamble became a popular story among traders, because it showed how tokens could boost capital efficiency and outrun the comparably slow lending process of financial institutions. The calculation was simpler for Aversano: Here was a man willing to spend a significant amount of money on a digital image. What might he spend on a real photograph?

The answer was: nothing. GMoney said that he would only buy the photographs as NFTs. Aversano rolled with the sugges-

tion; even the suggestion of a purchase was enough incentive for him to start minting his backlog.

"The romantic idea of a starving artist was never something I wanted to be," Aversano later told me, sipping a matcha latte at a café outside Lincoln Center. We would spend hours together trying to unravel the story of how the Long Island son of a waitress became the fourth-most-expensive living photographer.

There were few indications of greatness from Aversano when he was a teenager staging mini-rebellions during the late 2000s in the hamlet of Holbrook, a sleepy pitstop only an hour west of the Hamptons. He was often in trouble for smoking weed and doing psychedelics. Between puffs, he would immerse himself in video games like *Champions of Norrath,* in which players attempted to save the world from a legion of mythological creatures, heading into the underworld to face orcs and vampires. Aversano liked identifying with the heroes in these role-playing games, conquering impossible odds.

Difficulties at home culminated with the seventeen-year-old artist's skipping town with his girlfriend, but that relationship slowly started to deteriorate as the couple attempted to couch-surf their way through New York City. There was a rude awakening sometime later when his roommate was robbed at gunpoint.

In 2010, he enrolled at the School of Visual Arts in Manhattan, where he studied philosophy and photography. It was a period of growth for him, but punctuated by the suffering of his mother, Gabrielle, from terminal cancer.[15] Her death, in the last semester of his college career, had an incredible effect on Aversano's approach to the world. Friends said that he became a kinder person afterward; he also became more interested in spirituality.

"I had no time to grieve or cope with her death," Aversano explained. After graduating in 2015, he cofounded a nonprofit

called SaveArtSpace, which staged public art installations in major cities to provide a platform for marginalized artists. Many of these exhibitions were plastered in billboards and telephone booths, makeshift galleries that allowed art to infiltrate the urban landscape. But there was hardly any money in nonprofit work: Aversano hustled to pay his bills by taking portraits of aspiring rappers and models.

Twin Flames was supposed to mark the rebirth of Aversano's fine-art career. In 2017, he unwound his commercial photography business to embark on the project, which required him to travel around the world to shoot different sets of twins. The artist had grand ambitions, calling the series "a lens on the magic and causality of biology" conjuring "metatextual manifestations across the astrological, the mythological, the academic, and the popular."

A clearer (but no less complicated) explanation for the project was that Aversano was still in mourning over the loss of his mother, who had also revealed that he once had a sister, a fraternal twin who died in the womb.

"I was the survivor who absorbed my twin," he explained to me at the café table. A nearby server paused in her tracks, then turned back around and headed toward the kitchen.

Aversano described *Twin Flames* as an odyssey. He was on a healing journey, mourning the death of his mother and the prenatal trauma of his dead sister. It was something that emerged from his subconscious during two separate trips to Peru, where he visited twin shamans Mark and Simon Myburgh to photograph them and partake in a San Pedro ceremony.

The Spanish conquistadors who arrived in South America during the sixteenth century viewed Peruvian rituals using a hallucinogenic cactus called huachuma as a form of devil worship; however, the indigenous population had used the plant in spiritual ceremonies for centuries, as early as 200 B.C.E., according to archaeological research.[16] Shamans only rebranded

the plant as San Pedro to appease their Christian colonizers, adopting Saint Peter, guardian of heaven's gates, to preserve their own religious practice.

Today's ceremonies often last an entire day and start with the distribution of "medicine," a brew called cimora that includes properties of the San Pedro cactus, which contains alkaloid mescaline, the psychoactive compound that inspired the British psychologist Humphry Osmond to coin the term "psychedelic" in a short poem from the 1950s about the "mind-manifesting" drug: "To fathom hell or soar angelic / Just take a pinch of psychedelic."[17]

Aversano must have taken more than a pinch.

"From the second San Pedro ceremony, it was clear what I was doing," the artist said. A psychic medium had also been present for the ritual, he told me. "I was talking to my twin, and her name was Alessia and her nickname was Butterfly, and there was a psychic medium there, and she was channeling her. And there was an exorcism that happened there as well. Crazy shit happened that week in Peru.

"I had always felt like I had a spiritual guardian protecting me from near-death experiences," Aversano added. "I just didn't know what or who it was, but it was my twin in the spirit world."

Twin Flames might have soothed the artist's soul, but it was a disastrous financial failure. Aversano had accumulated more than $100,000 in debt from putting every expense—plane tickets, rental cars, hotels, food, camera film—onto credit cards. American Express was trying to sue him. Efforts to sell the photography series, which ended up containing a hundred portraits of twins, had flatlined.

"Nobody cared about the physicals in 2019, when I tried to sell them. It wasn't connecting in the art world," Aversano explained, adding that many of the museums he begged to acquire the images never even responded to his emails.

So it was a lifeline when GMoney suggested, two years later, that Aversano should tokenize his photographs. The artist was unlucky when it came to betting on technology. In 2017, he had invested $20,000 in Bitcoin and "got wrecked," losing most of his investment.

(Clearly, he was a risk taker. That money could have gone toward paying off his credit card debt. But the amount he owed was so high that gambling on Bitcoin seemed like a chance to grow his nest egg.)

When the artist released his NFTs in February 2021, something clicked. GMoney purchased five images, each selling for 0.55 Ethereum, or roughly $1,000 at the time. Within two days, the entire series of a hundred photographs had sold. A secondary market soon emerged, and Aversano quickly made an additional $400,000 off his 10-percent royalties.

"Making a name for yourself is the ultimate move," Aversano gloated. "Prior to that, nobody gave a fuck about me or my work. The numbers justified why they should care. Once they saw my numbers—"

A tall, athletic man wearing gym shorts interrupted Aversano mid-sentence. He apologized for intruding on our conversation at the café, explaining that he was part of a DAO that had just collected one of the artist's NFTs. They shook hands, and the gym bro walked away.

"That man—I know him." Aversano was distracted. "That man fucked my girlfriend in the darkroom. I just remembered."

We were getting a little off-topic. I suggested that a handshake from his lover's lover might show how NFTs had changed his reputation.

"Right," the photographer said. "Once people saw my numbers, they really started to change their minds about me."

Aversano's network went beyond GMoney. He made sure ahead of the sale that influential NFT collectors were ready to pull the trigger. For instance, the investor William Savas

reportedly introduced the film producer Julie Pacino (daughter of the actor Al Pacino) to blockchain technology through the photographer's work.[18] She would become one of the many interlocutors in Hollywood for crypto, selling her own NFTs based on snapshots of actors rehearsing scenes from her movies. That money could be used to fund more films.

Meanwhile, Aversano had directed his network to overtake the auction houses. He won a community vote to decide which artist would be included in the June 2021 Sotheby's NFT sale. The final price for the *Twin Flames* photograph *Alyson & Courtney Aliano* was nearly $35,000.[19] Two months later, the anonymous buyer fractionalized the photograph, creating a shareholder system around its ownership. The owner was quickly overtaken by another collector, who purchased the majority of shares and then established a DAO investing group to purchase more works by crypto photographers like Aversano.[20]

Having become central to the NFT marketplace, Aversano saw his fortunes skyrocket. In August 2021, *Twin Flames* collectors were regularly trading his photographs for the Ethereum equivalent of $300,000 per image. Noah Davis, the digital specialist at Christie's, took notice and placed Aversano in the auction house's fall lineup: the first major test of the NFT market in the five months since Beeple's triumph.

Around the same time, Aversano realized that he needed to recoup some of the photographs that he had sold; however, collectors demanded compensation at market rates. So the artist ended up paying nearly nine times the original prices, sometimes throwing in extra NFTs to sweeten the deal. His returns included *Bahareh & Farzaneh Safarani,* which the artist wanted to use for the Christie's auction, and *Erica & Nicole Buffett.* That last image was especially important to Aversano, because it portrayed his fiancée, the artist Nicole Buffett. The couple had met through the photo shoot and considered them-

selves soulmates. Despite being the granddaughter of the bil-
lionaire investing wizard (and vocal crypto skeptic) Warren
Buffett, Nicole was also turning her attention to making NFTs.

The frothy fall market allowed Aversano to consolidate his
collector base and parade his power through the crypto com-
munity. The Christie's auction in October 2021 would be a
culminating moment for the *Twin Flames* journey. And one
day before the sale, the artist decided to photograph his new
friend, Noah Davis.

Davis appeared shirtless in a black-and-white photo-
graph for the artist's *Smoke and Mirrors* series, a project in
which subjects resemble characters from a tarot card deck. It
seemed appropriate for Aversano to explore the occult pow-
ers of fortune-telling at a moment when his own influence in
another speculative market of make-believe was cresting. And
Davis was game, willing to push the envelope on the relation-
ship between auctioneer and artist. He held a rapier over his
tattooed shoulder; his eyes, half open and directed at the cam-
era, were both sultry and malevolent. Davis was supposed to
symbolize the Page of Swords card, which represented a deter-
mination bordering on defiance. A card reader who revealed
an upright Page of Swords would say that it indicated curiosity,
enterprise, and ambition; however, a reverse image forewarned
of arguments, uncertainty, and financial stress.

But these artists and their entourages knew how to make
their own luck. The Davis photograph became an NFT, which
ended up selling for more than $32,000 to Rahilla Zafar, a
friend of both the auctioneer and the photographer. An even
greater fortune awaited Aversano at the Christie's auction,
where he offered the *Bahareh & Farzaneh Safarani* NFT and
a physical collection of the full *Twin Flames* series. That sale
closed at $1.1 million, nearly ten times its estimate. And the
buyer was not a crypto degen, but the heir of a French antiques
dealership named Cedric Lebert.

Aversano's success was always qualified by his ability to onboard people like Lebert, and that skill would eventually make him one of the highest-selling photographers in history. His approach to photography was nothing special, following the outline of much earlier and more famous projects, including Diane Arbus's portraits of twins in the 1960s and Nan Goldin's intimate Polaroids of friends in the 1980s. Critics often belittled his work as derivative, and even the Sotheby's catalogue promoting him described his style as being "reminiscent" of the two photographers. It wasn't exactly a stunning sales pitch.

But through his cult of personality, Aversano had forced his way into the establishment. It didn't matter what his critics wrote, because his followers didn't read the reviews; most would have been surprised to learn that art magazines existed. The promises of shareholder value, community, and vesting roadmaps were enough incentive. And it helped that Aversano seemed devoted to the cause, even using his nonprofit SaveArtSpace to post *CryptoPunks* on signs around Miami, London, and Florida—including the digital avatar for his greatest patron, GMoney.[21] Within a normal environment, someone might have warned Aversano that using the nonprofit to promote his own collector was ethically murky. But this was the metaverse, and rules were being rewritten daily. After all, nobody seemed to notice that Aversano had lifted his description of *Smoke and Mirrors* directly from his own website's description of *Twin Flames,* with only a few words changed between them.[22]

Aversano became the crypto evangelist that Beeple never was, although he hesitated to admit it. "I don't see myself as an ego cult leader," he told me. Then there was a long pause, during which he was adjusting to the reality of his situation. "But my actions do create waves."

Having emerged from debt and relocated to Los Angeles

with his *Twin Flames* profits, Aversano visited the NFT exhibi-
tions at Bright Moments Gallery and spoke with its founder,
Seth Goldstein. He went home and developed what became an
impromptu proposal to Flamingo DAO. The investing group
had asked Aversano about what other photographers the col-
lective should be acquiring.

"I said, forget what we should be buying, let's talk about
what we should be building," Aversano recalled. That sentence
became the mission statement of Quantum Art, an enterprise
wanting to become the Apple Store of NFTs, with locations
around the world. The business was publicly announced in
November 2021 after a round of funding provided Quantum
with about $7.5 million. The angel investors and venture capi-
talists who supported the company were predominantly col-
lectors of the *Twin Flames* series. Flamingo DAO, which was
already financing their competitors at Bright Moments Gal-
lery, also backed the startup. One of its members, Jonas Lamis,
became a cofounder of the company.

Aversano used the capital to start renting property in Los
Angeles, which was converted into physical storefronts for
Quantum Art. He described the layout as being divided into
thirds, between a shop, a gallery, and a clubhouse. With another
round of funding—he hoped to raise close to $40 million—
Aversano planned on opening at least fifty galleries around the
world.

I asked if that would make him the next Larry Gagosian,
the bogeyman of the commercial art world who, with around
fifteen locations, had the largest gallery footprint on the map.
Gagosian was more than a symbol of how the contemporary
art market had inflated into a secretive, multibillion-dollar
industry. He was the industry, selling to the rich and bidding
against them at auction. "I'm just trying to be me," Aversano
responded. "I don't want to become a mafia boss of art like

him. I don't care about being the richest or coolest guy in the room. I'm just an artist."

A shadow of consensus defined the luxury art market, in which a relatively small group of about ten thousand collectors had the financial resources to buy and sell expensive paintings. It was a closed system of advisers, gallerists, and auctioneers who defined the rules of engagement, taking great pains to establish their legitimacy despite relying on increasingly abstract signals of value, like rumor and gossip. The tolerance for speculation was unprecedented. The art market grew in the tailwinds of the decade-long bull run that followed the 2008 financial crisis, bouncing back faster than any other industry in 2010 thanks to the new Chinese collectors who were flooding the market. And the rich who were spared by the Great Recession expanded their collections with the pawned-off paintings of their bankrupt compadres. At the time, Aversano was just starting college, while savvy businessmen like Gagosian were positioning themselves to make a fortune in the fallout.

Such a freewheeling economy would mystify any sane investor, but the art market is special. It is one of the last major unregulated markets in the world, operating by its own rules. Unlike other commodities, which are guaranteed to depreciate, cultural capital is regenerative, because tastes in the market always shift, and objects tend to accumulate historical importance. The availability of tactics that would be off-limits in traditional finance also lured investors into the sector. For example, it is not uncommon for a gallerist to purchase paintings from one of his artists ahead of announcing a major exhibition, which would increase the artist's price point. Longtime clients are often invited to join the buying spree, allowing the

group to increase their profit margins artificially by anticipating demand and suffocating supply. When this is done in the financial world, it's called insider trading. The art world calls it business as usual.

But it was the gradual financialization of artworks into alternative assets that appealed to new collectors. It was "the next stage of any marketplace once it starts to attract big capital," said Amy Cappellazzo, the former chairman of Sotheby's Fine Arts Division, describing it as "an inevitability that comes with growth."[23] Fractional ownership of art was becoming more common, and collectors were increasingly coming to bid with borrowed capital. The introduction of new financial products didn't bother her.

"There is a lot of talk about the rise of NFTs, but I feel like I've been in the crypto business for about 20 years. Jeff Koons is an alternative currency, so is Andy Warhol and Mark Bradford. It's just a case of reading each market."[24]

No surprise, then, that the topside of the market was experiencing its strongest growth: dealers with sales between $5 million and $10 million saw their business increase by 35 percent year-on-year in 2021. It was not uncommon in those days for a blue-chip dealer to complain privately that it was easier to sell a $500,000 painting than something priced at a couple thousand bucks.[25]

Throughout the 2021 bull market, critics questioned the traditional art world's ability to woo the digital interlopers. Artists like Tom Sachs and Takashi Murakami glommed onto the cryptoeconomy like bankers to balance sheets, methodically recruiting software developers and product managers to convert their studios into NFT startups capable of turning a quick profit within the bull market's lifespan.

One artist who connected the lessons of 2008 with the emergence of decentralized finance was Damien Hirst. He always excelled at branding; the man turned dead butterflies and

painted dots into symbols of cultural elitism. No respectable financier could host a dinner party without having the framed insects hanging in his dining room; no museum collection was complete without the dots, even as curators snickered about their banality.

Hirst was a beneficiary of a vigorous partnership between the dealer Larry Gagosian and the advertising kingpin Charles Saatchi, who identified the British artist's talents in the 1988 *Freeze* exhibition, which was staged in an abandoned London fire station. Saatchi became a patron willing to commission the artist for outrageous sums of money and disclose his expensive acquisitions through Gagosian's showroom; after all, he was a marketer. The publicity worked in convincing other wealthy people to purchase Hirst's art, which allowed him to increase prices. But Hirst's acrimonious split with Saatchi in 2003 over details of a retrospective triggered a great spectacle. The spurned advertiser ended up selling a commissioned artwork of a shark injected with formaldehyde to another millionaire, Steve Cohen, for an estimated $12 million. It was a staggering amount to spend on contemporary art.

More astonishing was Hirst's $200-million auction at Sotheby's, which he personally arranged. It was a final gasp of decadence, presented over the course of two sales on September 15, 2008—the day when Lehman Brothers collapsed and the Great Recession began. The auction was still a roaring success, despite the beginnings of a financial apocalypse. Hirst personally made $172 million from 223 artworks purchased by collectors, a third of whom had never purchased contemporary art before. But it soon became clear that flooding one's market with supply can have a disastrous effect: within two years, his average auction price had fallen by more than 80 percent, from $831,000 to $136,000. "The perception of collecting Damien did suffer," one Sotheby's official later mourned.[26]

Another collector, Jose Mugrabi, told *The New York Times*

shortly after the sale that it demonstrated an important shift in culture heading into a recession: "Today more people believe more in art than the stock market. At least it's something you can enjoy."[27]

Clawing back into the market's good graces has not been easy, and Hirst has had more than a decade of false starts, including rejoining Gagosian Gallery, releasing a series of fake ancient statues, and designing a $100,000-per-night suite for a Las Vegas casino.

Arguably, Hirst's most successful attempt at reinvention has been through *The Currency,* a collection of ten thousand NFTs that correspond to ten thousand original artworks of his painted dots. The sale began in July 2021, and collectors were given an entire year to decide between keeping the digital artwork or the physical one. If owners did not exchange their NFTs during that period, the physical artwork would be set on fire and destroyed in a ceremony beginning in August 2022. People spoke about the artworks, which sold for $89 million, as a referendum on the importance of physical artworks and digital artworks. And giving it a name like *The Currency* made it clear that Hirst wanted to embrace financialized art regardless of what form it took. Investors from the world of decentralized finance loved the idea, because it valorized their industry and the concept that anything could become an economic tool.

So experiencing the highs and lows of the 2008 financial crisis was instructive. Hirst learned that speculation, when timed correctly and executed with bluster, generated enough profits to withstand a decade-long attention drought. He secured enough cushion so that he could hop from risk to risk, softening the blows of his failures with the last big fortune. Contrary to the short-term thinking that dominated most investors during the NFT boom, Hirst had cultivated a bullish long-term

strategy around volatility. The approach was a little jaded, but an artist of his reputation could get away with it.

∿

Only a handful of traditional artists who embraced crypto-mania were handsomely rewarded; however, true allegiance within the metaverse belonged to an underclass of hustlers like Justin Aversano, who were willing to do whatever necessary to establish themselves. Hirst had accomplished much the same by becoming his own art dealer in the lead-up to 2008; now Aversano would update his strategy for the new economy. He became a venture capitalist.

The artist talked about investing back into the community like it was charitable work, but oftentimes his efforts merely buoyed the emerging market for NFT photography. In November 2021, Aversano collaborated with Raw DAO, the group that had scooped up fractionalized shares of his *Twin Flames* photograph earlier that summer. The collective said that it had goals of uplifting thousands of photographers; what that meant was buying their artworks as investments. The DAO wanted to be aggressive in their approach, onboarding artists into the cryptoeconomy and purchasing a significant portion of their initial drops, which they described as helping to "bootstrap the early community" while "providing the market with a strong signal: people with great taste and skin in the game vouch for this particular artist."[28]

Raw DAO transformed *Alyson & Courtney Aliano* into a membership token for their organization, allowing investors to purchase shares of the Aversano photograph through a startup called Fractional (later renamed Tessera), which would grant buyers voting rights within the crypto collective. Nearly seven hundred people participated in the auction, driv-

ing the photograph far beyond its Sotheby's benchmark to a new record: $3.8 million.[29] It was this sale that made Aversano the fourth-most-expensive photographer in history at the time, after better-known artists like Cindy Sherman and Richard Prince.

There was a trade-off to this kind of transaction. Aversano's community was growing, but he could not profit financially from the crowdfunding, because Fractional worked around the provisions in the NFT smart contract for royalties. Moreover, the fractionalization of artworks highlighted a growing problem in the crypto ecosystem: the anonymity that had attracted investors was making it difficult for artists to know who actually owned their work.

But it wasn't just Aversano pushing these questions to the back of his brain. An artist like Tyler Hobbs was unprepared and unmotivated to question where his money was coming from. When speaking about his rise in the NFT market, he often drew a straight line between perseverance and success. Like other members of the crypto avant-garde, he simply believed that blockchain technology had exposed a new audience to his practice. And it was hard to challenge Hobbs. He spent seven years developing his algorithms to create generative art, detailing his journey in more than two dozen essays on his website. Hobbs approached creativity like a software engineer, sketching out his artistry on graphs where elements like randomness and control become variables in a calculation of quality.[30]

Hobbs modestly described his windfall as "a pleasant surprise." And, like Aversano and Mike Winkelmann, he stressed that success was the by-product of his long-term efforts to build a fan base. When I asked him to name some collectors of his successful *Fidenza* series, the artist started listing online aliases like Cozomo de' Medici and investing groups like Starry

Night Capital, but he could not name the real people behind those usernames.

Long before NFTs gained popularity, blockchain developers marketed their technology as a foolproof network of authentication. Like any ledger system, however, it was only as good as the recorded information. And the ability to follow transactions between online wallets could never replace the due diligence of knowing the actual names of customers. So I continued to push the point with Hobbs, who was made increasingly uncomfortable by my line of questioning.

"Anonymity feels like a very twenty-first-century thing," he said, admitting that selling to shadowy buyers was a little unusual. "But, honestly, I don't think about it that often. I came from online communities where people go by usernames and pseudonyms. I would be curious to see if it really has any effect on the market."

It would have a catastrophic effect on the market. Starry Night Capital was one of the largest collectors of the Hobbs *Fidenza* series of algorithmically generated designs. In August 2021, the company was announced as a partnership between the founders of Three Arrows Capital, a crypto hedge fund, and a mysterious NFT collector named, of course, Vincent Van Dough. "Our thesis is simple," Van Dough said on Twitter, announcing the project. "We believe the best way to gain exposure to the cultural paradigm shift being ushered in by NFTs is owning the top pieces from the most desired sets."[31] The collector managed the fund, saying that he planned to raise $100 million to invest in digital artworks and later open a physical gallery.

Starry Night Capital went on a $21-million buying spree on August 1, acquiring works from the same series that Van Dough had bought for his private collection only a few days earlier.[32] The fund ended up spending nearly a quarter of its budget on

Fidenzas, sending the floor price of the series skyrocketing in a single day to nearly double its value, at $95,000.[33] By the end of August, the floor price of a single *Fidenza* was about $900,000.

Van Dough, a self-described "purveyor of shitcoins and fine art," had nearly succeeded in delivering upon his goal. Choking supply within the blue-chip market had artificially boosted the value of his collection of seventy NFTs by twofold to more than $42 million.[34] Seeing their fortunes rise, the artists were happy and didn't ask questions about responsible stewardship. It would only become a problem when Three Arrows Capital was liquidated nearly a year later, after defaulting on nearly $2.3 billion in debt obligations. The hedge fund was as much the victim of speculation as it was the bullheaded instigator of market frenzy, betting heavily on credit and overleveraging itself on a reserve-asset cryptocurrency called Luna, which collapsed in May 2022. The 3AC founders, Su Zhu and Kyle Davies, disappeared for five weeks before emerging in Dubai, which was becoming a safe haven for the crypto industry. Van Dough stayed silent through the chaos, and his identity remained a secret; meanwhile, Starry Night Capital moved its collection into a single wallet as the market worried about a fire sale. But the assets were low-priority for liquidators, who held on to the NFTs as they depreciated. When 3AC filed for bankruptcy in July 2022, the collection was worth $7.5 million. By the time liquidators were ready to sell, three months later, it had fallen from its high to just $846,000.[35] Throughout the process, many artists from the collection struggled to sell their work; it was clear that the stench of a liquidation scandal extended into the cultural realm.

Other artists, like Tyler Hobbs, had received enough money and attention from the Starry Night spending spree that it didn't matter when everything fell apart in bankruptcy court. Hobbs had a golden parachute to glide through the upcoming bear market and many years after that. He was living mod-

estly for a multimillionaire artist with a studio of five full-time employees, and estimated that the money could last him for decades. And as for what happened to his *Fidenzas* caught in a liquidation sale? He didn't care.

"I don't lose sleep at night thinking about who owns my artwork," Hobbs explained to me, rolling his eyes a little at the question. "Someone in the traditional art world is probably used to working closely with a gallery and exerting control over who collects their work. A fact of life with NFTs is that you don't have that kind of control. It's much more open to the market, for better or worse."

Within a bull market, investors and artists like to pretend that they have swapped roles. It's through the act of collecting that everyone gets to play pretend. The businessman is applauded for his bravery and creativity; he attends swanky museum galas and debauched studio dinners where he is assured by the artist that he has saved culture—the very fabric of society—through his patronage. In exchange, the artist receives assurances that his work is visionary and groundbreaking; he develops a relationship with venture capitalists and corporate philanthropists who promise that the creative economy will build a utopian society around art. And though the cliché might be true—there are no small parts, only small actors—the roles of investor and artist were not equal within the cryptoeconomy. Artists like Hobbs had a limited chance of making themselves indispensable to the crypto whales.

Writing about the importance of generative art, Hobbs asked, "How do we take a fresh look at this new, core material of modern society?" He was talking about the importance of algorithms, saying that artists who program are "forced to speak the language of the computer—to meet it on its own terms. Here, the artist will struggle with and come to fully know the same forces that influence all software. The viewer will have the opportunity to intuitively sense what is possible,

what is desirable, and what is undesirable with software, just as past artists widened views of what it meant to work with steel, concrete, and glass, and changed our conceptions of the role they could play in our lives."[36]

The same could be said for NFTs, which turned money into an animistic power, deciphered through the tremors of the Bitcoin index: we questioned what it wanted, what it hated. Someone like Hobbs was expected to translate the index into visual form, so that it could be studied and unleashed upon the world.

Why investors expected artists to have mastered some control over money was beyond reason, especially when artists like Hobbs and Aversano were newcomers to the market. How they spent money was a gesture of rebellion, a moonshot prayer that artists thinking outside the box might jump-start a new economic order. The problem was that most NFT artists were inculcated into that same system. Money was the goal, and money corrupted the plan.

Understanding the motivations of these millennial investors and artists requires a broader historical context on the 2008 financial crisis, starting with the collapse of the 1944 Bretton Woods system. The postwar agreement had created an international monetary regime around the gold standard. Three decades later, the Nixon administration reneged on the agreement, primarily because of rising domestic inflation, and abandoned the gold standard in 1971. Most of the industrialized world followed, and for the first time since the advent of an organized financial system, in the sixteenth century, no major currency was tied to precious metal.[37]

By separating the dollar from its gold reserves, the president had turned money into an abstraction. Changes to the material and philosophical structures of the economy followed, as financiers attempted to fill the void with meaning,

with the architecture of structured finance and securitization. Government-sponsored enterprises like Fannie Mae and Freddie Mac developed systems for packaging mortgages into pools that could be sold as securities. Instead of taking the idiosyncratic risk of each individual mortgage, investors could more evenly distribute risk through their holdings; meanwhile, securitization allowed the collective market to haggle on funding costs.

In the 1980s, mortgage-backed securities and collateralized mortgage obligations created a tranched tier system that required rating agencies like Moody's Investors Service to provide a risk assessment. Those agencies attempted to optimize the process for quantifying risk through a calculation that was a more or less subjective take on a loan's prospects. Established default rates helped render a quicker judgment, so that tens of thousands of asset-backed securities could earn an ultrasafe AAA rating without much scrutiny. By the turn of the twenty-first century, mortgage debt stood at 50 percent of American gross domestic product, and rose to almost 65 percent in just four years. This was the highest rate of acceleration since the Federal Reserve started keeping track in the 1950s.[38]

Subprime mortgages became a popular way of issuing loans to home buyers with low credit scores. There were about $738 billion of these mortgages in 2005, many with ballooning interest rates that would rapidly increase after a waiting period of two or three years.[39] (The crypto industry would use similar financial products with digital assets, bundling NFTs into subprime loans that were supposed to unlock more liquidity in the market. And they did, until the market tumbled and the value of the *Bored Apes* and other collectibles went sub-subprime.) Adjustable interest rates were also set to rise in 2007 from around 7 percent to 10 percent. In March, Federal Reserve chairman Ben Bernanke reassured the public that a

looming mortgage-lending crisis would not spread into the wider economy. A year later, the investment bank Bear Stearns had collapsed under the weight of subprime mortgages, and JPMorgan Chase acquired the company in a deal orchestrated and backed by the federal government. Meanwhile, a credit crunch ripped through Europe; the International Monetary Fund estimated in the spring that potential losses could go upward of $1 trillion.[40]

The emerging crisis revealed the danger of "shadow banking," a name given to the unregulated intermediaries of the financial world, which included hedge funds, mortgage brokers, and more esoteric instruments like asset-backed securities and collateralized debt obligations. These financial products were needlessly complex and inscrutable to the average investor, masking what would soon be revealed as an incredibly fragile architecture.

By September 2008, the financial crisis had swollen to overtake the global economy. Lehman Brothers was heavily invested in subprime mortgages. It was a gamble that once paid billions of dollars in profits every day, but when the bubble burst, so did the global financial-services firm. This was the largest bankruptcy in United States history, $639 billion in assets. When the Asian stock markets opened in the following days, trading plummeted and the entire world entered a tailspin later coined as the Great Recession.

After the major events of the 2008 financial crisis, the Federal Reserve established itself as the liquidity provider of last resort for the global banking system through currency-swap agreements, pumping trillions of dollars into the European system.[41] Bernanke arrived in Congress to ask for a bank bailout of $700 billion, arguing that such a plan would "restore confidence in our financial markets." This decision was deeply unpopular with the majority of Americans, who believed that banks should have fallen on their own swords. Presi-

dent Barack Obama never used the full amount; his administration distributed about $619.5 billion to restore confidence in the financial market. But the results of this decision are contested.

A 2019 study by Deborah J. Lucas, a finance professor at the Massachusetts Institute of Technology and director of the university's Golub Center for Finance and Policy, attempted to calculate the real cost of the bailout after subtracting dividends, interest, returns, and other proceeds from the deal. In 2012, President Obama claimed that the government had retrieved "every dime used to rescue the banks," and the nonprofit newsroom ProPublica found that the government made a profit of $96.6 billion from the bailout. By contrast, other economists claimed that the ultimate price was astronomical, between $4.6 trillion and $16.8 trillion. According to an August 2018 study by the Federal Reserve Board, the financial crisis had cost every American nearly $70,000, 40 percent more than the average investor lost during the Dot-Com Crash.[42]

Most politicians were ready to leave austerity behind when the Federal Reserve Board's study was released to the public. A bipartisan group of congressmen had already passed a law weakening the Dodd-Frank Act, loosening oversight for thousands of banks with under $250 billion in assets each. Deregulation allowed institutions like Silicon Valley Bank—a darling of the venture capital crowd—to make riskier bets with uninsured deposits. The cryptoeconomy was a natural partner for Silicon Valley and its competitors, Signature and Silvergate, who saw deposits swell during the 2020 bull market. And when all three regional banks collapsed during the 2023 bear market, the moral hazard of saving banks that indulged in speculation was a nonissue. The Federal Deposit Insurance Corporation moved swiftly to restore confidence in the markets, President Biden assured the public that no losses would be borne by the taxpayer, and cryptocurrencies rallied on the volatility of tradi-

tional finance. The old debates around "too big to fail" banking and the preferential treatment of Wall Street over Main Street barely reached the public discourse. But the entrepreneurial ignorance and regulatory blindness of March 2023 seemed to echo the preconditions of September 2008, leaving some to question the motives of those who continued pushing the modern economy back toward the brink of a meltdown.

Having struggled to accumulate wealth by traditional means over the last decade, millennials embraced riskier financial markets in defiance of a system that limited their prosperity. Those who purchased cryptocurrencies and NFTs were standing against the establishment. They were aware of their powerlessness, even as they held on to an illusion of control. It was an elaborate performance of self-denial, like a character in one of Aversano's video games attempting to defy its programming and leap beyond the boundaries of hell. Failure only reinforced the importance of trying to escape.

From outside the metaverse, it was difficult for older generations to understand why so many millennials were willing to spend billions on that thing called the internet. Blockchains, cryptocurrencies, and NFTs were technological solutions in search of a problem. Critics reduced the logic of these young investors to a simple sentence: If you take a risk, at least you have a chance. But doesn't everyone like to occasionally bet against the odds?

Millennials were attracted to decentralized finance because it seemed like a better alternative to the prevailing model; however, some experts worried that DeFi was simply magnifying the worst characteristics of shadow banking by building another needlessly complex financial system upon a needlessly complex technical system.

Hilary J. Allen had devoted her career to studying financial-stability regulations. The American University law professor had testified before the House Financial Services Committee and written a book about the dangers of fintech.[43] She believed that crypto was re-creating the pre-2008 financial system, using Bitcoin's initial promise of decentralization as marketing materials to push new financial products and intermediaries that would undermine its own founding vision.[44]

"There are striking similarities," she told the journalist Charlie Warzel in an interview. "With subprime mortgages, the line was that it increased the opportunity for more people to own homes. But that rhetoric is sometimes used to hide predatory practices."[45] She noted a similar incoherency in the promises of credit default swaps in the 1990s, which created a new and unlimited way of producing leverage in a single underlying bond.

"What's being constructed is essentially the unlimited ability to create financial products and borrow against them," Allen said. "We are increasing the amount of risk—because the assets are essentially anything that somebody with programming knowledge who can mint a new coin can make up. You don't necessarily have to tie these assets to something physical: like, say, a house somewhere in the world."

Allen feared the coming storms of a crypto winter. She worried that the entanglement of decentralized finance with the real economy would have a disastrous effect. Could cryptocurrencies become too-big-to-fail? Within an academic paper that she wrote at the beginning of 2022, the law professor noted that Congress has the authority to "tax competitors of [the U.S. dollar] out of existence," suggesting that lawmakers use that power to force cryptocurrencies to prove themselves as good fiduciaries under a new licensing regime.[46]

However, few regulators at that moment respected Allen's clarion call. Oversight looked unlikely, especially from the

Securities and Exchange Commission. In October 2021, Hester M. Peirce, a commissioner for the agency, made a speech at the Texas Blockchain Summit in which she praised decentralized finance's ability to "collectively figure out how to deal with unanticipated problems." She was a cautious employer of the agency's powers, even suggesting that a lack of regulatory clarity helped prevent Americans from participating in speculation. And although Peirce agreed that NFTs needed better guidelines, she admitted that the SEC had "simply not allowed staff the latitude to consider the hard questions around how crypto can operate within the securities framework."[47]

"The way forward is not to drag entities into the commission through enforcement actions and brute force them into a regulatory regime that is not actually well-suited for them," she told the blockchain conference. "Rather, we should take a methodical approach, one that provides answers to the key questions to which market participants need answers."

NFTs were flying under the radar, excused by some lawmakers as nothing more than an online certificate of authenticity.[48] Even regulatory hawks like Allen overlooked the application of nonfungible tokens as financial products, although these digital assets provided the strongest example of how the cryptoeconomy had constructed an environment of unlimited leverage and risk.

If decentralized finance was an indecipherable knot of technical and financial systems, then NFTs were the clever packaging used to conceal all that risky mess behind a polished image. It was the logical conclusion of President Nixon's decision nearly a half century ago to end the gold standard, turning the global consensus on dollar value into an article of faith. The tokenized artwork heralded the pure abstraction of money: an embrace of the financial ambiguities that helped the unregulated art market flourish through speculation, volatility, and fraud. Art was the back door into a laxer regulatory environ-

ment. All investors needed to do was pretend to be collectors, stump the philistine regulators about the indefinable nature of art, and earn profits off the degens convinced that buying NFTs would provide an alternative asset class with cultural clout. It was a closed system, a perfect loop.

Artists were happy just to be included within an economic system that valued their work. It didn't matter if their digital creations were being treated as highly volatile investments. "I know that the people buying my photographs aren't just art appreciators," Aversano told me. "You always need degens flipping things for money."

It was a foregone conclusion. So what if investors had fractionalized one of his *Twin Flame* photographs, splitting its ownership between millions of tokens? It was just another hustle for the starving artist in a world where opportunities for economic mobility felt increasingly rare for millennials like Aversano, who were exiting their twenties with little savings. He certainly wasn't waiting on museums and galleries to provide him with self-worth.

"The art world is not trustworthy. I like when the computer fucking dictates what it gives you," Aversano said, leaning across the table. "For me, money is the vehicle for getting to create."

THE RUG PULL

Somebody was having a chuckle in the Treasury Department when Scott Rembrandt received his assignment to study the presence of money laundering and terror financing in the art market. The deputy assistant secretary for strategic policy had no relation to the old Dutch master of the same last name, but his career would become similarly entwined with the circulation of high-priced paintings.

Rembrandt the younger had started out as a consultant in China before heading into corporate law. In 2009, he joined the Treasury Department's Office of Terrorist Financing and Financial Crimes as a policy adviser. He worked on financial esoterica like hawalas, informal systems of money transferring that were popular with criminal networks like Al Qaeda.[1] Gradually, he rose through the ranks of the agency, becoming a specialist in drafting due diligence rules on anti–money laundering. So, when Congress commissioned a report addressing concerns that the art market had become a safe haven for a number of financial crimes, the responsibility fell upon Rembrandt's shoulders to evaluate the truth.

For more than a decade, lawmakers had struggled to pass a bill that addressed the opacity of the art market, where buyers and sellers were seldom identified even to parties within the same transaction. But the revelation—that terrorists affili-

ated with the Islamic State had been selling artifacts through the 2010s from the ancient sites they destroyed in Syria and Iraq to raise millions of dollars for their caliphate—had created enough momentum in Congress to override the multimillion-dollar lobbying effort against new regulations. The legislative package finally arrived on New Year's Day 2021, with the top priority of extending the 1970 Bank Secrecy Act, a law designed to monitor financial institutions, into the antiquities trade.

The Bank Secrecy Act provided the bare minimum of increasing federal scrutiny on financial transactions. The law required banks to report cash transactions of more than $10,000; highlight suspicious activity; and understand the identity of their customers and where their wealth came from. The Treasury Department's Financial Crimes Enforcement Network (FinCEN) was responsible for putting those rules into practice for the antiquities market after a consultation period with the industry, as they had already done in years prior with jewelry and coin collectors.

A second priority of the 2021 legislation was to commission Rembrandt's study, which some lawmakers hoped would provide enough reason to extend the Bank Secrecy Act across the entire art market.

Deal makers were on the defensive, already adjusting to previous regulations in the European Union and the United Kingdom that had abolished straw-man purchases (when someone makes a purchase on behalf of someone else) and required galleries to implement new screening policies for clients, holding executives accountable should anything go wrong. Given the global circulation of the art market, it was reasonable to assume that the United States would cooperate with its friends across the pond—especially given the scandals emerging from the industry at the time.

In 2020, Senate investigators found that auction houses and dealers had allowed two sanctioned Russian oligarchs, Arkady

and Boris Rotenberg, to buy and sell art using shell companies fronted by an art adviser. The report concluded that brokers went through with the sale even though they had failed to determine the true identities of their clients.[2] It was just one example of the $6-billion underground art market, where Pollocks and Picassos became vehicles for looting, theft, fraud, money laundering, and other financial crimes.[3] But there were several other high-profile cases that also alarmed lawmakers, such as when ISIS terrorists began selling looted antiquities for millions, or when a respected gallerist in Philadelphia admitted to laundering money for drug dealers.[4]

For Senator Rob Portman, the Ohio Republican who co-sponsored the report, such reports damned an industry that promoted its voluntary compliance program as a safeguard against criminal activity. "The art industry cannot be trusted to self-police," he told *The New York Times*. "While the auction houses claimed to have robust anti–money laundering programs, we found that the actual employees who facilitated the transactions never asked who the art intermediary was buying the painting for or where the money was coming from."[5]

Anxiety rolled into the next year as the New York Attorney General's Office made mincemeat of an alleged tax-fraud scheme at Sotheby's in which more than a dozen clients obtained false resale certificates to pose as dealers and avoid paying millions in tax revenue on their purchases. A judge allowed the investigation to proceed, saying there was enough evidence that senior members of the auction house "willfully turned a blind eye" to the scheme.[6]

However, the industry continued to deflect scrutiny when posed with more regulations by the federal government, arguing that their traditions of secrecy were more about discretion than duplicity. "Our expectation is that the cost of compliance will far outweigh the cost of criminal activity," Andrew Schoel-kopf, then president of the Art Dealers Association of Amer-

ica, told me in an interview. His trade organization had spent $260,000 on lobbyists to advise congressional committees and executive-branch agencies on the potential regulations.

Schoelkopf liked to project confidence to reporters; however, his tone was decidedly more apocalyptic at the 2021 Art Basel panel, where he discussed potential regulations with gallerists. "We are in the paranoid-terrified phase of what's going to come down the pike," he said, adding, "It's going to be a whole lot of paperwork and a whole lot of compliance and I don't think we will extinguish much of a problem."

Tight-lipped dealers were not afraid of getting loud when their profits were threatened; galleries and auction houses had spent nearly $1 million over the last two years on lobbying federal officials in Washington about regulatory issues, with a more immediate focus on influencing Rembrandt's final report. (The crypto industry was also building its own lobbying offense during this time, spending more than $4.6 million in 2021 and nearly $4 million in just the first six months of the following year to influence government officials.)[7]

So it should not have been as surprising as it was when the Treasury Department released its highly anticipated study on February 4, 2022, with a top-line recommendation that immediate government intervention was unneeded, despite clear evidence of criminal activity.

"We have found that while certain aspects of the high-value art market are vulnerable to money laundering, it's often the case that there are larger underlying issues at play, like the abuse of shell companies or the participation of complicit professionals," Rembrandt said, implying that art crime was more a by-product of a flawed financial system than a characteristic of the industry.

"Once we've tackled more systemic issues, like creating a beneficial ownership registry to crack down on shell companies, we will look at what else might be needed to address

money laundering risks specific to other industries, including the art industry," the Treasury official added, alluding to his agency's priorities in the real-estate sector.

Lobbyists had certainly earned their high fees, because the art market went from having an existential crisis to having champagne. Rembrandt's decision would usher in a short period of deregulation for commercial art, which pumped more suspicious activity into the NFT market as the worlds of culture, technology, and finance continued to converge. And if you dig deeper into the Treasury's report, it only becomes more confusing why regulators had backed down.

It was a strange trade-off of bureaucratic time and resources when available data indicated that the art market had a bigger problem. Estimating the scope of financial crimes within any industry is difficult, because of the concealed nature of schemes, so price ranges on misdeeds can get fanciful; for example, a conservative analysis of known money-laundering cases in American real estate revealed an annual average of $460 million in illicit funds between 2015 and 2020. However, the Treasury's own report cited evidence of $3 billion in money laundering and other financial crimes flowing through the art market every year. But even that number was a laugh.

Allow me to bring you down the rabbit hole of bad research. Rembrandt cited his number from a 2016 study by the United Nations Office on Drugs and Crime,[8] which itself cited a 2000 report from the British government on the illicit trade of cultural property,[9] which had quoted research by the Museums Association that year,[10] which had referenced a 1990 article from *The Independent* about the global antiquities trade by the journalist Geraldine Norman.[11]

And, having procured an archived version of that article, I can confirm that Norman never included a dollar figure on antiquities trafficking in her report. The closest she got was stating, without attribution, that "80 percent of all antiqui-

ties coming onto the market have been illegally excavated and smuggled from their countries of origin," which contradicts the Treasury's assertion that art crime is small fry compared with other industries.

But let's suppose that $3 billion was the correct figure. Adjusted for inflation, that would put the estimated price of illicit activity within the antiquities market at nearly $6.8 billion per year. This would leave Rembrandt with a thirty-year-old statistic for only some portion of an art market that has quintupled in size since 1990.[12] Publishing that number would likely have forced the Treasury Department's hand toward regulation: $6.8 billion was equivalent to roughly 10 percent of the global market for arts and antiquities in 2022.[13]

Nobody could say to what extent money laundering had infested the art market, and Treasury officials had not produced an original analysis upon which the federal government could make an informed decision. When contacted through a Treasury Department spokesperson, Rembrandt did not respond to a list of questions about the methodology behind his report.

What did concern the agency, however, was the rise of art-finance companies that were collateralizing paintings into personal loans. Like other shadow banking systems, collateralization did not require businesses to collect information on the ultimate owner of art or the source of funds originally used to acquire the work.[14] The speed and secrecy of these loans was a selling point, as Dewey Burke, the chief executive of one such firm, Luxury Asset Capital, alluded to in an interview: "Because we are solely focused on the value of luxury assets and collateralizing them at a certain percentage, we don't need the deep level of personal documentation and disclosure that the banks do."[15]

Curiously, Rembrandt devoted a significant section of his art-market study to NFTs, writing that the speed and volume

of blockchain transactions could outpace the companies trying to conduct due diligence, offering criminals an opportunity to launder illicit funds by creating false sales records of NFTs and fooling prospective buyers.

"The incentive to transact can potentially be higher than the incentive to verify the identity of the buyer of the work or even can create a situation where it is not possible to conduct due diligence," the authors wrote, adding that the traditional art world may lack the technical understanding to track those customers effectively. "No single platform operates the same way or has the same standards or due diligence protocols."[16]

Of course, regulators wouldn't have needed to look very hard to find dozens of startups run by twenty-something millennials who put the risky techniques of art-finance companies on steroids. Wash trading had emerged as a particularly nefarious hallmark of the NFT trade during its bull run. It was an illegal practice whereby users bought and sold their own tokens to inflate sales records, hoping someone gullible would make a genuine offer based on the transaction ehistory.

One of the largest NFT marketplaces, LooksRare, had built its business around wash trading by incentivizing users with Ethereum-based tokens that were proportional to the transaction volume made on their site. Blockchain analytics tools revealed that wash trading accounted for 95 percent of the company's transactions.[17]

Wash trading had been illegal in traditional finance for the better part of a century, since the passage of the 1936 Commodity Exchange Act. The federal government needed little more reason to start regulating the industry if it wanted. On the same day that Rembrandt released his report, LooksRare had done $626 million in trading volume, upon which the company earned nearly $11.4 million in fees; only 10 percent of that trading volume was genuine, according to the blockchain data. For buyers fooled into a wash trade, there was little chance for

accountability; even LooksRare's founders were anonymous, going by the names Zodd and Guts, characters from a Japanese manga series called *Berserk*.

The Treasury Department's decision to include NFTs within its art-market report sent mixed messages. It implied that the government wanted to include tokens as another type of artistic medium; after all, the Internal Revenue Service's definition of an artwork already encompassed things like carpets, coins, and collectibles. (The IRS maintains this de facto definition through its administration of the Art Appraisal Services unit in the Independent Office of Appeals.) However, the report also attempted to make a distinction between NFTs that simply hung digital art on the blockchain and tokens used for investment purposes. Rembrandt's error was attempting to create such a distinction where the market operationally had none.

Frivolity was the perfect cloak for ambition. The art market had successfully evaded scrutiny for decades by packaging its financial products in paint; now the industry's crypto companions were using a similar playbook to befuddle regulators. Art: Who could define it? Who could assign a price to something that was at once so illusory and so central to our understanding of the soul? It was an impossible task for bureaucrats to decipher such an incalculable value system—made even more ludicrous with the arrival of NFTs. How could anyone expect the serious men of the Treasury Department to regard *Crypto-Kitties* and *Bored Apes* as threats to global financial stability?

When Rembrandt published his report, in February 2022, the marriage between art and NFTs was being consummated over evening champagne and milquetoast conversation inside Sotheby's New York headquarters. The auction house was pressing its luck with a marquee sale showcasing a collection

of 104 *CryptoPunks* as a single lot estimated to fetch between $20 million and $30 million.

The occasion received all the marketing gusto that a company serving billionaires and their baubles could muster. Sotheby's had described their *Punk It!* event as "an unprecedented showcase for NFTs and digital art with a presentation on par with the most significant and high-profile sales for contemporary and modern art." Buyers could pay for the holy grail of online collectibles in Ethereum, Bitcoin, USD coin, and fiat currencies. A panel preceding the sale included Kenny Schachter, a rabble-rousing art critic who became cryptopilled when his own NFT project gained a following. From his brownstone on the Upper East Side, Schachter had situated himself as a communicator between the degens and the dealers. A bulldog for the digital art movement, he even managed to corner Max Hollein one evening in Central Park, recalling that the Metropolitan Museum of Art director said that his curators were too scared of the new technology to partake.

Speaking to the VIP attendees at the Sotheby's auction, Schachter waxed poetic about the promises of NFTs: "They've become a paradigm shift in the history of culture, something which is a hybrid between fine art and collectibles. They have changed the history of art without even intending to be an art piece in the first place."

An audience that included celebrity influencers like the rapper Ja Rule and Snoop Dogg's son Cordell Broadus clapped for the holy platitudes; meanwhile, employees were scrambling behind the scenes to salvage what was supposed to be a historic sale.

According to three insiders close to the sale, there were signs of trouble from the beginning of the auction house's relationship with the consignor, who operated from behind the username 0x650d. Sotheby's had been the collector's second

choice to sell his *CryptoPunks,* after initially failing to secure a deal at Christie's. "That was the easiest piece of business that I ever declined, because it was an obvious train wreck," said a senior Christie's manager, speaking anonymously to discuss private business. Beyond the consignor's own eccentricities, there was a lack of enthusiasm for this particular collection of *CryptoPunks.* The 104 NFTs were considered "floor Punks," lacking any of the rare attributes that gave other artworks in the series their high prices. So there was little incentive for a serious collector to buy this suite of tokens, especially at a time when purchasing a single *CryptoPunk* at floor price would have cost about $150,000. Such a simple calculation made clear that Sotheby's digital art specialist, Michael Bouhanna, had overestimated the total value of his lot by nearly double what a retail trader could find online without needing to go through the hoo-ha pageantry of an auction. And there was the matter of poor timing. Cryptocurrencies had just taken a nosedive with the news that Russia had invaded Ukraine; there was still an appetite for speculation, but perhaps not so much when everyone's wallets had suddenly depreciated in value. Risk needed some promise of reward.

But the looming war in Europe had not punctured the celebratory feeling in the salesroom, where attendees held on to their bidding paddles and booze. Among the metaverse natives were older clients of the auction house, the daring crypto-curious few who were eager to jump into this new age of digital art. They were traditional collectors like Holly Peterson, an author, who arrived at the event hoping to purchase her first NFT. She was the daughter of the Blackstone founder Peter G. Peterson, a commerce secretary for the Nixon administration turned private equity billionaire and MoMA trustee.

Holly came to Sotheby's with Rahilla Zafar, a crypto investor and documentarian interested in the philanthropic appli-

cations of blockchain, like money transfers to communities in impoverished countries with little banking infrastructure. That night, however, Zafar was focused on her friend.

"I wanted to demystify the NFT space for her," Zafar said. "Until that auction, Holly was really intrigued by the blockchain."

Having a wealthy philanthropist like Peterson as an ally could open doors. She was a significant influence in the art world as a trustee of the Studio Museum in Harlem and a member of several acquisition committees for organizations like the Whitney Museum of American Art, the Brooklyn Museum, the Centre Pompidou, and the Tate.

And when Peterson entered Sotheby's that night, she was initially won over by the absurdity of the scene. It was nothing like she had experienced in years of coming to the auction house to buy paintings. "It was just an amazing, fantastic moment," she recalled in an interview. "I started looking around and saw all these little shits with paddles. What's going on? I'm a Park Avenue woman with a fancy art collection and I couldn't even get a paddle."

Behind the scenes, there was trouble. Even with nearly three hundred people in the salesroom, the actual purchase power of clients in the room was low. It was rumored by Kenny Schachter and the consignor that someone acting on behalf of Yale University's endowment made the opening bid that night at 7:00 p.m., promising $14 million on what could have become the cornerstone of its digital art collection and the most legitimizing purchase to date for the NFT industry. It seemed like another tall tale concocted by the degens to goose the market. Anyway, the offer would have been far behind the collection's low estimate of $20 million, which represented the lower threshold of what the consignor was willing to accept. The salesroom hung in a state of suspense; employees flanked the stage like palace guards.

"They were all standing there, staring into space," said Kent Charugundla, a telecom investor and NFT collector who attended the event. "Nothing was happening."

"There was still a lot of positive energy, but it always felt delayed," said Alexandra Peers, a retired *Wall Street Journal* reporter who came to the auction with Charugundla. "There was tremendous confusion."

Awkward chatter pervaded the Sotheby's salesroom for twenty-five minutes as the seated crowds looked toward the empty altar, where an auctioneer should have been gaveling in the *CryptoPunks* sale. Suddenly it was announced that the consignor had withdrawn the lot; everyone was still welcome to enjoy the after-party and listen to the sick beats of DJ Seedphrase, but the sale was shot.

Having invested thousands into a goose egg, Sotheby's was not especially forthcoming about the details of its failure, saying that the "lot was withdrawn prior to the sale following discussion with the consignor." It was a specious claim, implying that the company was happy to let its valued customers sit on their thumbs for nearly a half hour. The real fiasco came only moments before the sale, when 0x650d, analyzing the depressed market for *CryptoPunks,* decided he could find a better deal elsewhere.

Quite simply, it was a scandal.

"The whole evening was totally surreal," said Peterson. "The auction definitely made me think that something was rotten."

"I knew it was very damaging to the movement," she added. "These kids were too excited, too ignorant. And I don't believe in their idealism anymore." Peterson, like many other seasoned collectors, was out.

For market rainmakers like Amy Cappellazzo, the former Sotheby's executive, it was the nail in the coffin. "They withdrew it," she said. "It was an early sign that the crypto market was in trouble."

NFT collectors needed strong sales to continue their momentum. A catastrophe like the Sotheby's auction broadcast on the grandest scale possible that the industry's best days were behind it. Traditional collectors who may have joined the digital art collectathon like Peterson were now backing away while the skeptics celebrated proof of the blockchain's impotence.

"Collectors from the old economy are afraid that their marketplace will be disrupted by these crazy, wacky forces," Cappellazzo explained, "and there is nothing more tried and true than owning a hard asset like a painting and putting it on the wall. But anything that softens a hard asset will make them feel uneasy."

The anonymous consignor, 0x650d, attempted to salvage his reputation. He posted on Twitter at 7:41 p.m. to announce his decision to "hodl," cryptospeak for holding on to digital assets. About an hour later, he shared a meme featuring the musician Drake, claiming he was "taking punks mainstream by rugging Sotheby's."

Of all the nefarious crypto scams that deflated the NFT market, rug pulling was the most notorious, because it transformed goodwill into a liability. More generally, the ploy described programmers who intentionally siphoned investor funds before abandoning their projects. It was the internet's answer to the pump-and-dump schemes that dominated the 1990s, which snapped back into the cultural consciousness in 2013, when Martin Scorsese released *The Wolf of Wall Street*, a film that chronicled the Quaaluded lifestyle of Jordan Belfort, who spent nearly two years in jail for his financial crimes.

Rug pulling became one of the most lucrative and fraudulent outlets for creativity within the unregulated NFT industry, because scammers tended to replicate the marketplace's top collectibles with nearly identical projects that promised ridiculously high returns without having concrete plans for success. For example, at least four major scams riffed on the *Bored*

Ape Yacht Club, which totaled more than $11 million in lost investments. (These included *The Baller Ape Club,* $2.6 million; *Superlative Apes,* $2.9 million; *Evolved Ape,* $2.7 million; and *Mutant Ape Planet,* $2.9 million.) And between just two *Pokémon* rip-offs, degens stole more than $9.8 million from collectors after promising to turn the tokens into a play-to-earn game.

As a prelude to money laundering, rug pulls abused the trust of gullible investors and obscured the deliverability of their promises. And in the absence of rules, the government only played referee in a small number of cases, still preferring to regulate by example in the hopes that they could achieve deterrence by sending a few people to jail. That left online watchdogs like the crypto sleuth ZachXBT to investigate scams, following the trail of crypto capital through "chain hopping," a DeFi version of money laundering that converts stolen funds from one cryptocurrency to another before trackers can blacklist the funds on the blockchain.

Although 0x650d's decision to withdraw the 104 *CryptoPunks* made financial sense when it became clear that Sotheby's lacked the clientele needed to push the digital tokens above the low estimate of $20 million, there was very little strategic benefit in the consignor's publicly mocking the world's largest auction house. His miscalculation illustrated the growing divide between the degens seeking to destabilize traditional institutions and a growing segment of the NFT community that sought their acceptance.

The rug pull on Sotheby's coincided with the end of the cryptoeconomy's bull market, announcing a new season of hell for investors who were keeping their wealth in cryptocurrencies. It was the beginning of a crypto winter unlike anything that traders had experienced in the history of digital money, when Bitcoin lost nearly $2 trillion in value and online communities started advertising the suicide prevention hotline.

There was desperation everywhere, denialism, and even a morbid acceptance of the volatility that was ruining a once-profitable market.

But the bad omens were not so apparent to NFT traders accustomed to online rug pulls. For a period of four months after the auction, Ethereum was relatively stable, and the NFT market attempted to save itself; trading volume was still relatively high.

ʍ

After the auction fiasco, 0x650d's accounts on social media went silent for a month, until April 1, 2022, when he announced that his *CryptoPunks* collection would be used as collateral for an $8.32-million loan, thanking "the chads at MetaStreet" for unlocking the liquidity of his NFTs while allowing him to "retain upside exposure" through the collectibles.[18]

It was almost beguiling that the crypto degen would reveal the latest episode in his *CryptoPunk* melodrama on April Fools' Day, but this was no joke. Blockchain records verified that the ill-tempered consignor had used his collection as collateral for a short-term loan facilitated by MetaStreet Labs through the marketplace called NFTfi.

MetaStreet defined itself as a decentralized interest-rate protocol for the metaverse, but the company specialized in bridge loans that helped traders make margin calls on their tokens. The startup had raised nearly $14 million during the bull market from venture capitalists with the promise that NFTs could replace the existing infrastructure around lending. Two of its young founders, Conor Moore and David Choi, had met as investment banking analysts within the division of real estate, gaming, lodging, and leisure at Deutsche Bank in 2017—the same year when the bank agreed to pay the United States gov-

ernment $7.2 billion for misleading investors about mortgage-backed securities before the 2008 financial crisis.[19]

Three years earlier, Choi had started his career doing market research for ArtAssure, a financial firm specializing in asset-based lending. The collateralization of art had become a $20-billion industry with a potential for $400 billion in market capitalization; private banking units of Citigroup, JPMorgan Chase, and Bank of America were backing billions in loans based on 50 percent of the appraised value of artworks. (Those appraisals were typically done by auction houses, so it's no surprise that both Christie's and Sotheby's would become financiers themselves, offering clients loans greater than $1 million against their fine-art collections.)[20] And although the vast majority, about 80 percent, of collateralization occurred in the United States, it had become an appealing option for collectors in other countries who wanted to monetize their off-shore assets. The Turkish investor Yomi Rodrig, for example, has borrowed against at least nine works by artists like Anselm Kiefer, Takashi Murakami, and Jean Dubuffet through Athena Fine Art Financing, part of the Carlyle Group.[21]

Moore, who was twenty-five when he founded MetaStreet in 2021, wanted to combine the lessons that he had learned working in real estate with Choi's background in art collateralization. NFTs were a perfect fit. "It was an inefficient debt market with all peer-to-peer financing," Moore explained to me. "And NFT smart contracts could be built like escrow contracts while eliminating counterparty risk."

The MetaStreet protocol allowed a lender to take possession of an NFT for the duration of the bridge loan. If the borrower failed to meet his financial obligation by the deadline, the smart contract would automatically execute and allow the lender to take permanent ownership of the collateral, which the lender could instantaneously sell on the marketplace to pay off the

remainder of the debt, potentially earning a large return. Volatility was built into the system; Moore calculated loans based on historic fluctuations in price over a monthlong period.

(The financial machinations that were possible in the NFT industry were beyond the wildest nightmares of Rembrandt and other regulators. Companies like MetaStreet demonstrated a grave challenge to authorities who struggled to wrap their minds around the crytpoeconomy. By the time these bureaucrats had finished editing their reports, their findings were outdated.)

In an interview, Moore told me that his company reached out to 0x650d immediately following the Sotheby's fiasco. "We said, Hey, if you are trying to get liquidity, you can get liquidity with a loan without the taxes. I think the auction wasn't the best possible execution for him."

And it just so happened that the value of the *CryptoPunks* loan was approximately 40 percent of Sotheby's $20-million low estimate of the collection, indicating that 0x650d was able to use the resources of the auction house to legitimize the value of his NFTs for use with another vendor, taking the auction house's assessment as valuation.

Once the loan terms were settled, Moore needed to find a platform to conduct the trade. He approached NFTfi, which had been founded by a South African fintech consultant named Stephen Young, to facilitate peer-to-peer lending. The forty-one-year-old entrepreneur combined his knowledge of programming with an interest in art collateralization to support "the seamless financialization of NFT based economies."[22]

"If you want a loan against a painting, it needs to be something expensive," Young told me in an interview. "If you default on the loan, someone has to come and get it. There's a whole physical system that needs to work around the loan. The cost of doing that transaction is super-high, and it only makes sense to do multimillion-dollar collateralizations. Because we are on

the blockchain, we can move assets into smart contracts. If you don't pay, I can immediately take the asset. I don't have to come to your house to repossess it."

Young framed his vision for NFTfi as a financial tool for the average person to access art collateralization without needing to own a Picasso painting. NFTfi would not underwrite loans, but would provide liquidity based on a preapproved list of hot tokens like *CryptoPunks* and *Bored Ape Yacht Club*. Because of how volatile the market was, these loans were limited to short windows of time; for example, the 0x650d loan period was just ninety days.

"All the due diligence happens at that stage," he said. "We check correct contacts, scan for malicious coding, examine the secondary volume."

Then I asked about basic vetting procedures required of traditional lending institutions to deter money laundering. Would NFTfi determine the identities of its users?

"We don't know the identity of the persons involved in the loan," Young said. "Our business wouldn't exist today if we had required them to do it up-front."

And it was a lucrative operation. Young said that in 2021 he did $14 million in loans. Within the first four months of 2022, he had overseen more than $104 million in business.

"It has gotten so big so quickly," he said. Young added that the loan default rates by count were almost 11 percent, while the default rate by volume was 6.5 percent. By comparison, the total annual default rate in the United States for 2021 was 0.4 percent.[23] The NFT market was clearly still a volatile and unwieldy financial system, so wasn't he worried that American regulators could still charge him for failing to abide by the anti-money-laundering rules that applied in traditional finance?

"We have lots of lawyers who are making sure we adhere to the rules we know about," Young explained, unbothered by the question. "It's a risk you take when you are in the crypto space."

Even applicants who had proved themselves to be untrustworthy actors in the traditional financial market could get a second chance when cloaked in the anonymity of the NFT market. An investor like 0x650d never had to reveal his true identity—not to NFTfi and not to MetaStreet.

"Everything is anonymous and trustless," Moore added. "That's what gives us an instant global scale."

And though Moore believed that the art market was a lucrative playground for financialized NFTs, he was also looking at how blockchain technology could bleed into other sectors, like the housing market. The dream was to turn mortgages into digital tokens. Smart contracts that executed a MetaStreet loan were already NFTs, meaning that the loan itself could be tokenized and sold on the secondary market next to a *Crypto-Punk*, but it was also possible to bundle loans together into a single NFT package, like a mortgage-backed security.

The goal was to demonstrate the flexibility of NFTs as smart contracts that could use alternative assets as a workaround for the regulatory ecosystem established after the 2008 financial crisis. Proponents of this technological back door saw the blockchain as a liberating force in the economy that provided a chance for people with bad credit scores to find liquidity and better their circumstances. Critics viewed the tokenized economy as the ultimate gamification of the financial markets, in which investing was truly akin to gambling. It was Shadow Banking 2.0, just as the law professor Hilary J. Allen had expected from the decentralized finance industry.

"DeFi's proponents speak of a future where sending money is as easy as sending a photograph,"[24] Allen, the regulatory hound, wrote in her February 2022 article on the topic, speaking of money a bit larger than what you might trade on Venmo and regular banking apps. "But money is not the same as a photograph. The stakes are much higher when money is involved."

What Allen and so many other concerned parties failed to

understand was that these distinctions between money and photographs and mortgages and art were dissolving before their eyes. Young generations were burned on the very idea of investing, and short-term gains looked better than long-term worries about heightened leverage and market rigidity. Simply put, it was payback for a system that had killed the American Dream, as Moore pointed out to me.

"People that are younger don't have any love or respect for financial institutions," he said. "This is sort of the ultimate fuck-you to everything."

0x650d eventually succeeded in paying back his bridge loan, meaning he retained the 104 *CryptoPunks* by using the liquidity from MetaStreet to leverage himself better as the NFT marketplace was tumbling into oblivion. It was a moment of feast and famine in the digital art world—what some degens called a "flight to quality," when the façade of speculation dropped and the idiocy of collectibles started to reveal itself. And as the bear market emerged and the crypto winter depressed trading volume, it was clear that degen collectors like 0x650d had the capital to keep the market afloat. MetaStreet data indicated that nearly a third of all transactions for Yuga Labs brands like *Bored Apes* were managed through the company's lending protocol.[25] For artists who had affixed their fates to the NFT boom, that meant it was time to prove their value to the mighty but sinking cryptoeconomy.

CLOWN FROWNS

"Are they gone yet?"

Jack Hanley had scurried toward the back room as hundreds of crypto enthusiasts approached the security guards outside his gallery storefront, eager for a chance to meet their online art messiah in the flesh. Beeple had officially arrived in the art world with the March 2022 exhibition, *Uncertain Future*, a title contradicting all the assurances he had already gained from the uncanny circus of celebrities, anxious collectors, and tech wallflowers now storming the traditional art world.

Hiding behind his desk in the back room, Hanley was struggling to process the embarrassment of riches that seemed to have fallen into his lap nine months earlier, when Mike Winkelmann first called him on the phone. The NFT upstart was still basking in the early glow of his $69.3-million auction success at Christie's when there were suddenly new friends from the art, finance, and technology sectors offering to serve as informal advisers. Since then, creating a foothold within the traditional art world had become an obsession in Winkelmann's digital art crusade. But the artist had never attended a gallery opening until his own, and he wondered if he would be treated as a savior or an invader by the TriBeCa culturati. How would the Beeple critics react when faced with the artist they had accused of killing high culture?

The gambit would require a steady hand, and Winkelmann's counsel nominated Hanley as their unlikely general. Taking a deep breath before our interview, the art dealer relaxed into an avuncular patter. "Why did I like him?" Hanley asked, repeating my question with a smile. "I just thought his work was funny and weird."

The gallerist had quietly built a career for himself over the last thirty-five years by embracing the starving artists. He enjoyed "weird," and repeatedly staked his own credibility on the slow success of outsiders with interests in comic books, music posters, and psychedelic drugs. He had originally set out in the 1970s to become a musician, working as a roadie with the Grateful Dead, tuning guitars for Bob Weir. During the 1980s, he opened his first gallery, in Austin, Texas, and then relocated to San Francisco. Hanley soon became a supporter of West Coast hippiedom, exhibiting artists like Raymond Pettibon and Peter Saul—degenerates to the postwar art establishment whose trippy caricatures of right-wing figures from Ronald Reagan to Donald Trump have in recent years become the toast of museum curators and auction bigwigs.

But through the decades, Hanley had also learned how to balance artistry with business acumen. The wild lion's mane of his Deadhead era had whitened into a respectable haircut like the one that Donald Sutherland sported as the dictatorial President Snow in the *Hunger Games* movies. But Hanley was no tyrant. In most decisions surrounding the Beeple exhibition, he deferred to the artist and his advisers, taking an unusual backseat role for a dealer who had spent much of his career turning outsiders into insiders.

"All these collectors are getting pissed on pricing," he said at one point during our interview, throwing up his hands. Only a few days before the opening, prices increased to as much as $300,000 for a single artwork. "What's $25,000 between friends?" Hanley laughed.

The gallerist's joke was interrupted by three men in gray business suits who stumbled into the back room, then retreated when they realized that the office was already occupied. The roar of opening night popped our little interview bubble. Hanley seemed a bit shaken by the degens at the door. A normal art reception never buzzed above polite conversation; this was a rager, and new clients had no clue about the rules Hanley had been playing by all his life.

"We have been trying to find a price that everyone is comfortable with," Hanley continued. "I probably have the least say out of everyone involved about what the prices are and who gets what."

Finding the right price for artworks is more crystal ball than calculus. A painting is only worth what somebody is willing to pay, and having such a limited pool of collectors makes it impossible to normalize prices. What a dealer often relies on is a combination of supply, demand, speculation, and gossip. But there were a few more confounding variables at play for Winkelmann. One year after he broke records at Christie's, the artist was still making his *Everydays*. Dozens of collectors from his inner circle were eager to buy a genuine Beeple, but the artist had grown increasingly reluctant to sell anything from the series; less than 2 percent of the five-thousand-plus images minted were available for purchase. A similar choke on his physical market would ensure that his paintings were secured by collectors who agreed not to flip the artworks for a quick profit.

The thirteen paintings and prints were already reserved before the gallery doors ever opened; the artist and his family members had negotiated sales of the works and their accompanying NFTs to longtime faithfuls. Outside the metaverse, it would take more than proof of ownership to establish legitimacy. Collectors needed those physical artworks to secure his reputation—and their investments—in museum collections and history books.

(Another back room, in the Italian city of Turin: Ryan Zurrer, a venture capitalist in crypto, was negotiating details of an exhibition with Castello di Rivoli Museo d'Arte Contemporanea, one of the few museums at the time willing to platform the artist. Zurrer had purchased Beeple's first physical sculpture, *Human One*, for $28.9 million during another ferocious Christie's auction in November 2021. The sculpture, an arrangement of rotating monitors that houses an explorer walking through a digital terrain, would end up across the museum's exhibition hall from a portrait by Francis Bacon, one of the most respected and expensive artists from the last century. Winkelmann and his supporters couldn't find a better statement on the value of his work unless it had been situated in Michelangelo's Sistine Chapel.)

Winkelmann's successful New York debut required precise choreography to match the changing tempo of the crypto-economy. NFT sales were fading fast in March 2022; ownership data from the year before revealed that 80 percent of the market's value was held by only 9 percent of accounts, meaning just 32,400 wallets were responsible for generating nearly $25 billion in sales.[1] The knockoffs and clutter once purchased by speculators were now languishing in the market and bringing the sales data down; however, many investors saw the downturn as an opportunity to consolidate their holdings. A great recentralization of value was beginning; venture capitalists spent $900 million in the first three months of 2022 on companies selling NFT technology as the future of financial transactions. The year before, investors had spent $4.6 billion on the industry. It was open season for financial firms like Andreessen Horowitz (which participated in a $450-million deal with *Bored Ape Yacht Club*), Accel (which participated in a $2.02-billion deal for a trading platform called Koodos), and SoftBank Group (which participated in a $738-million deal with Sorare, a sports NFT company).[2]

Beeple's reception in the art market was a litmus test. If the snootiest of culture vultures could accept an NFT alien within their ranks, then perhaps those same billionaire collectors would respond favorably when the same technology became integrated into mortgages, restaurants, securities, and loans.

M

Hanley admitted that he had trouble understanding the Beeple industrial complex that now seemed to include his own business. The partnership had already come at a high cost: at least six artists threatened to find a new gallerist in protest of Winkelmann's arrival; one sculptor, Emily Mullin, followed through and demanded that her name be removed from the gallery's roster before opening night. "They didn't even see the show!" Hanley told another reporter, Katya Kazakina. "These aren't even NFTs!"[3]

There was good reason for many gallerists to refuse to open their doors to digital artists like Winkelmann, even if they could have made a killing in the NFT market. Mutiny was a top concern, according to several gallery executives. Megadealers like Larry Gagosian would also have recognized the impossible task of familiarizing old collectors with new art. And although some artists from his roster were allowed to experiment with blockchain technology, he wasn't interested in having crypto natives join his dealership. Many gallerists assumed that critics would do their jobs and eviscerate the crypto artists as charlatans. Some gatekeepers in the traditional art world described the exhibition as "betrayal," hoping that Hanley and Winkelmann would be so unsuccessful that neither could show their faces in New York City ever again.

But threats from the old guard mattered little on opening night. The backroom opened onto a bacchanalia of celebrants applauding the artist's paintings of an apocalyptic future in

which companies like Facebook and Amazon are reduced to rubble, their founders' vessels of vanity and greed. The gallery had promoted these visions of zombified Zuckerbergs and beheaded Bezoses as grand political gestures warning about the disastrous omnipotence of our tech overlords, articulated through dusty cargo containers bearing the Netflix insignia and hemorrhaging animatronic representations of Silicon Valley chieftains.

Winkelmann had warned before the show, "Things are gonna get weird."[4]

Toward the back of the gallery, a young artist named Julia Sinelnikova was admiring a large painting of Jeff Bezos quarantined within an area the artist called an "excess testosterone dump" with phalluses emerging from his face and the surrounding landscape. She appreciated that Winkelmann was willing to critique the leaders of an industry that had supported him.

"I had been looking at Beeple's work for a long time just as entertainment," Sinelnikova said, squinting at the artist's penis-filled portrait of the Amazon founder. "But the works here in the gallery are much more beautiful and detailed than I expected."

The stunning quality of these paintings was of little credit to Winkelmann, who had recently transitioned from working in a home office to a fifty-thousand-square-foot complex in Charleston, South Carolina, where more than a dozen employees and even more freelancers around the world helped turn his ideas into digital and physical artworks. Some of these craftsmen had previously been employed by artists like Jeff Koons. Others came from the realm of video games; Rafael Grassetti, art director for the successful *God of War* title on Playstation 4, even helped model Bezos's head for the penis painting.[5]

Sinelnikova was unbothered by the artist's distance from the paintbrush. Italian Renaissance greats like Michelangelo

and Raphael managed large workshops to handle commissions from popes and the preposterously wealthy. Studios of more recent history have blossomed into thriving businesses because artists have outsourced their talents. Andy Warhol made himself famous by cultivating an entourage of artists, socialites, drug addicts, and drag queens inside his Factory, which between 1962 and 1984 produced thousands of his paintings, drawings, and prints. Later artists, like Damien Hirst, Jeff Koons, and Takashi Murakami, would professionalize that model, employing dozens of assistants on their assembly lines. But though these production protocols were widely accepted in the art world, the public received little information about the practice; assistants are rarely credited for their work, even when their bosses never make a brushstroke, so that the myth of artistic genius lives on.

Something other than labor dynamics was stumping Sinelnikova, and others inside the gallery, who struggled to find deeper meaning in the deserted Bezos wasteland of leaky phalluses. The artworks had characteristics of quality painting worthy of a prestigious gallery show, but the message of tech machismo was a foregone conclusion in 2022, one that placed toxic masculinity within the comfy echo chamber of chief-executive gamesmanship and dank memes. Beeple had proved capable of causing audiences to rethink their relationship with technology and finance, but something more fundamental was preventing the establishment from taking him seriously.

Warhol once said, "I want to be a machine," and Winkelmann was happy to oblige. The perfunctory pace of the internet manifested in his daily practice of making an NFT within a couple hours, usually in response to current events and politics. Everything was about output: commentary without contemplation. For many editors at the major newspapers and magazines, hating the Beeple exhibition was such a foregone conclusion that they never sent critics to see it. There were no

reviews published in *The New York Times*, *The Wall Street Journal*, or *The New Yorker*. Glamorized by the spectacle, the gate-keepers seemed to have ceded their authority and bitten their tongues. The gallery's gambit was working.

"It speaks for itself," Sinelnikova offered in compromise. Those words seemed to haunt the exhibition. I heard it from the twenty-one-year-old fashion designer wearing a *Bored Ape* NFT on the back of her neon-pink suit; from the thirty-year-old recently incarcerated entrepreneur trying to network with attendees; from a vaunted New York art critic followed by a crowd of fans; and from myself, dodging requests for my own professional opinion as I attempted to keep my distance from the unfolding chaos.

ᴗᴧ

It was becoming increasingly difficult not to get pulled into the Beeple orbit. The frenzied evening had involved a revolving cast of billionaire scions and Hollywood stars coming to pay homage to their new court painter. The comedian Jimmy Fallon stopped by for photographs, as did the film director Darren Aronofsky and members of Elon Musk's clan: his brother, Kimbal, and his mother, Maye. The celebrity crowd mingled as New York's greatest passed the bouncers: an acrobat walking on his hands, a stoner laughing at himself taking selfies, and bucket-hat bros in sunglasses with their crypto soapboxes strapped to their ankles. The clamoring crowd morphed into a long, snaking line through the gallery, filled with the dozens who waited for a chance to meet Winkelmann for a short conversation and picture in front of *Zuckerborg V12 (2021–22),* which featured the Facebook founder as a cyborg with bloody, leaking brains.

A star was born. Winkelmann stood under the blighted gaze of a felled Silicon Valley god as he shook hands with strangers.

For someone holding the mantle of guru, the artist rejected much of the pomp and circumstance associated with the contemporary art scene. There were no Warhol wigs, no black monochrome outfits, no spiffy suits or funky jewelry. He came dressed as an everyman, wearing a buttoned shirt under a half-zip sweater with wire-framed glasses, sensible leather shoes, and a Corona beer in hand.

"I'm kind of in a weird position," Winkelmann had told me in an interview earlier that night. "I'm an outsider in the traditional art world."

An outsider? Winkelmann was quick to acknowledge how ridiculous the suggestion sounded nearly a year after he became the most expensive millennial artist in the world, flying on a private jet to Miami, and amassing the kind of entourage that most insiders would covet. But from his perspective, the laurels were a sudden gift after nearly fourteen years of making digital art with little fanfare. The traditional art collectors and curators who now crowded into the corners of his first exhibition—pushed into the periphery by the artist's boisterous crypto fans—would have to wait in line with everybody else to kiss the ring after badmouthing him.

"Artists, pornographers, and criminals are always the first to exploit new technologies for implementation before going mainstream," Jehan Chu, a crypto entrepreneur who had previously worked in the auction world, told me. He was a rainmaker within the NFT market, onboarding artists and introducing new collectors to the industry. "Right now it's all a circus."

Chu had a talent for networking between art and technology. He had gifted the Ethereum founder Vitalik Buterin with his first *CryptoKitty* NFT and later, in 2018, introduced the inventor to the curator Hans Ulrich Obrist. The chichi Swiss curator and artistic director of London's prestigious Serpentine Pavilion had been hooked on the blockchain ever since,

as part of his fascination with how technology (and its wealthy oligarchs) might impact cultural development.

However, Winkelmann was easily Chu's greatest investment yet. The auction geek turned venture capitalist had purchased nearly a dozen NFTs from the artist in 2018, when he identified that Beeple would become a disrupter in the art world.

"We are all working in the service of Mike, to give him the network, insight, experience, and expertise that we collectively have," Chu said. "We really believe that this is a digital movement, and that it's the next chapter in contemporary art."

The truth was that Winkelmann had much more in common with the traditional art world than with many of the degens who loved him. There was a disconnect with some investors, including his most famous one: Vignesh Sundaresan. The Indian crypto investor dematerialized in the months following his purchase of *Everydays: The First 5000 Days,* and so did his promises to build a virtual museum around his groundbreaking acquisition. The artist found it increasingly difficult to reach the man, who receded from public view and rarely responded to press requests for comment. There were indications that Sundaresan was having money problems. His B.20 coins, made by fractionalizing twenty Beeple NFTs, were essentially worthless by March 2022, having plummeted in value by 70 percent from their initial coin offering at $1.26 to just 40 cents per share.

"I never get money from that," Winkelmann noted, because the fractionalization overwrote the royalty fee in his NFT smart contract. But the artist felt powerless to stop Sundaresan. "Well, he bought it."

The artist felt increasingly burned by the men like Sundaresan who used his artwork to sell the cryptoeconomy to speculators. Despite the art market's own murkiness, its ability to build him a legacy through museums and exhibitions held a greater appeal for him at this point than money. And even

if the attendees at his art opening seemed to stay on opposite sides of the gallery—degens to the left and artists to the right—Winkelmann was trying to unite these different sides of his practice into his own powerful alliance.

Despite the violent scenes of exploding tech tycoons and their hairy scrotums, the artist somehow managed to ooze midwestern charm. He stayed smiling throughout the night as he autographed postcards for the hundreds of adoring fans, rarely leaving his corner position in the gallery. And behind his never-ending procession of Bitcoin bros and crypto nuts were his family members: mother, wife, father, brother. All of them had abandoned their own careers to work under the Beeple name, establishing a family office within the artist's vast laboratory in Charleston.

Dottie Winkelmann had once dismissed her son's artistic abilities and remained slightly confused if overwhelmingly supportive of his rise through the digital ranks. She had worked in their hometown of North Fond du Lac as director of the local senior center while her husband, Peter, earned a living as an electrical engineer. The Beeple largesse meant that she was able to retire and leave Wisconsin, opting for the sunshine of South Carolina, proximity to her sons, and a chance to write her family's history, which now revolved around the NFT market. She believed that the journalists writing about her son were missing this key component to his story, which was also her story. But she had also grown suspicious of the attention, burned after a local reporter—a supposed friend named Sharon Roznik—printed her unvarnished truth.

"Growing up, Mike loved to draw but he still isn't good at drawing," Dottie had apparently said, sparking a minor drama within the family and her hometown.[6] She claimed the comment was taken out of context, but she had learned her lesson about speaking a little too honestly, although the matriarch still admitted to not fully understanding the hype surrounding

her son's artworks or the crypto community that now vener-
ated him as a god.

"It's just unreal," Dottie told me, watching her son greet
his followers from across the room. "Chills go straight up my
spine."

Dottie was there when the Christie's auction timer reached
zero and the number $69.3 million flickered onto the screen,
standing behind her son in shock. All she could do was cover
her mouth with her hands.

"I went over to his office a couple of days later, sat down,
and just started crying," Dottie said. Winkelmann responded,
assuring her that nothing would change. "So this is all good,
it's good, and we are going to do good things. I just think God
has a plan, but I'm wondering exactly where this is all going."

Dottie was not a particularly religious woman; her prayer
invoked the same articles of faith you might expect from some-
one who won the lottery, survived a plane crash, dodged a bul-
let, or outran a cheetah. She suddenly belonged to a family
of cyberpunks, and the NFT zeitgeist seemed to have irrevo-
cably changed their status in society. The midwestern charm
remained, but the stakes were higher than ever for these new
apostles of the crypto cult.

Two hundred years ago, the promise of Manifest Destiny
had energized a legion of speculators to head for the western
hills in search of gold. Those three hundred thousand pros-
pectors arrived in California and staked their claims to the
riverbanks and silt deposits rumored to hold untold riches.[7]
Violence swept across the rugged Sierra Nevada mountains
as government officials in the newly formed state encouraged
white settlers to scalp Native Americans into near extinction.[8]
Thousands of miners would leave the ravines as penniless as
when they came in 1848. The true victors were often inves-
tors like Samuel Brannan, an excommunicated member of the
Mormon Church who stayed in California when his prophet,

Brigham Young, decided that he preferred the desolation of the Great Salt Lake in Utah. When the businessman heard rumors of gold deposits, he traveled to San Francisco with a quinine bottle stuffed with gold. He stepped off the ferry, swung his hat, and waved the bottle around. "Gold! Gold! Gold! Gold from the American River!" By the middle of June, three-quarters of the male population had left for the mines where Brannan had created a series of supply stores that made as much as $5,000 a day, about $182,000 in 2022.

Although he never touched a shovel, he became one of the richest men in California and the largest landowner in Sacramento. But he also seemed cursed by good fortune, plunging into a series of questionable choices that would make even today's billionaires blush. He once sailed to Hawaii to overthrow the king, but his coup failed; he bought three thousand acres in Napa Valley and hired Japanese gardeners to create a new Eden for his eight hundred horses to roam; and he was violent, getting into at least one fight with an employee that left him with eight bullet holes. Brannan's wife eventually divorced him after a series of infidelities, forcing the tycoon to transfer his considerable paper fortune into cash during the economic lull of 1870. Within the next decade, his empire collapsed, leaving him with less than what he came to California with. In 1887, Brannan was selling pencils door to door to raise money for a trip to San Francisco. A reporter described him as "old, gray, broken in strength, able only to get about with the aid of a cane. The old keenness of the eye alone shows that his spirit has survived the decay of his body."[9] Two years later, he died on a small fruit farm with only a few dollars to his name.

As the mother of a crypto millionaire, Dottie Winkelmann worried that her son might be staking his legacy on this generation's version of a gold rush. Was he just another Brannan, indulging in the mad boom times before the inevitable bust?

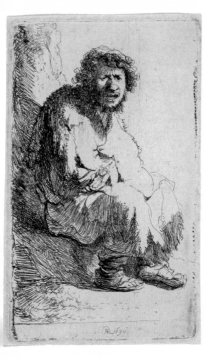

Rembrandt's *Beggar Seated on a Bank* is representative of the artist's interest in depictions of poverty. By etching his own face into the portrait, he is empathizing with the poor. Perhaps he is telling us that he himself is a "starving artist."

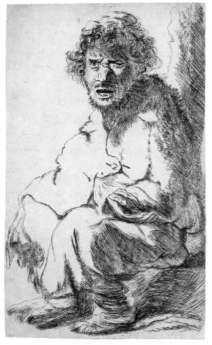

Think of this artwork as a primitive meme. It was created by the artist Jan Lievens, one of Rembrandt's competitors. Lievens took the original etching and caricatured Rembrandt's portrait to make him look like a drunken clown. What's fascinating is that he used an early form of mechanical reproduction to accomplish his task, disseminating his satirical portrait of the artist around the European continent.

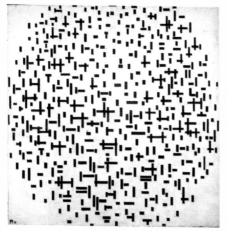

Piet Mondrian's *Composition with Lines* exemplifies modernism's fascination with the formal elements of pictorial space, like the grid. Working only on vertical and horizontal axes, Mondrian builds his lines into an orb-like cloud of pluses and minuses. The style was especially influential for Algorists like Vera Molnár and A. Michael Noll because their computers had an easier time drawing straight lines. Later NFT artists like Tyler Hobbs and the Larva Labs creators of the *Autoglyphs* series would also adopt the style.

QQL was released by Tyler Hobbs and another artist-coder named Dandelion Wist Mané in 2022. The project allowed collectors to indirectly tweak Hobbs's algorithm, perfecting the artwork before minting it. A financial element was added to the interactive design; collectors received a 2 percent royalty for secondary sales of their *QQLs*, which seemed to imply that NFT projects always need a crypto component to succeed.

Tyler Hobbs became a famous NFT artist because of his *Fidenza* project, which attempted to balance unpredictability and quality through a generative algorithm that produces artworks like this one. It places Mondrian's pure grids into a blender and releases a tornado of geometries onto the page.

An early example from Mike Winkelmann's *Everydays* series, *Cap'n Bitch* exhibits the kind of puerile *Family Guy* humor that runs through much of his early works.

Everydays: The First 5,000 Days was the artwork that started the NFT boom and characterized the Great Crypto Crash of 2022. From a distance, the five thousand images create a beautiful waterfall of pixelated creations. Look closer and you will see experiments, successes, failures, offenses, and indeterminate futures that Mike Winkelmann created over the previous fourteen years.

Winkelmann has frequently expressed his disdain for Silicon Valley—by turning Mark Zuckerberg into a decapitated and hemorrhaging head, he's making his feelings obvious. This is complicated, however, by the artist's symbiotic relationship with social media. As an artist who gets most of his inspiration for *Everydays* from the internet, Beeple is also bound to the achievements of these tech titans.

Another artwork included in the first Beeple exhibition, *Metaverse* has a ritualistic quality that the artist often scatters throughout his science-fiction scenes. Other artworks have nuns or robed monks, often bowing to technology.

The first sculpture that Mike Winkelmann created, *Human One* consists of a rotating series of monitors that creates the illusion of three-dimension space "inside" the monitors. It was purchased by the crypto investor Ryan Zurrer at a Christie's auction, which cemented the businessman's relationship with Winkelmann.

Based on a short-lived TikTok meme, *Vibe City* represents what Mike Winkelmann does best. His *Everydays* are like a performance of the social media algorithms that define our lives in absurd yet profound ways.

As an example of Justin Aversano's photography, *Bahareh & Farzaneh Safarani* shows his interest in the supernatural. He was also inspired to create the larger series, *Twin Flames*, because of his unborn twin sister who died in the womb.

Within this photograph of Noah Davis, the auctioneer turned NFT evangelist, the photographer Justin Aversano creates a haunting atmosphere. The series, *Smoke and Mirrors,* was based on tarot cards. Here, Davis becomes an avatar for the Page of Swords, which can represent ambition, but also uncertainty and financial stress.

Justin Aversano's *Cognition* series was created after the artist's mother's death. He was using art as therapy, and often depicting themes of spirituality, sexuality, and occultism in his mixed-media collages. He later repurposed the series as NFTs, selling the physical and digital copies together.

In Central Park, the *Castello Cube* followed an intense blizzard that covered New York City in snow. As the ice melted, the cube's reflection was cast over the puddles. Inside the golden cube was a hollow core. Crowds gathered and took pictures.

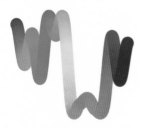

The most recognizable version of Erick Calderon's *Chromie Squiggles* is the standard rainbow version. The artwork is similar to a corporate logo, but its zigzag formation, randomized by the generative algorithm, also recalls the tremors of a heartbeat or the stock market.

This *Chromie Squiggle* is one of the rarest versions—a "Pipe," which represents only 1.91 percent of the 10,000 NFTs in the collection. The six variations incentivize buyers to collect a complete set of the artworks, much like trading cards.

One undervalued aspect of digital art is how it's contained. The whacky and vibrant world of Jonathan Monaghan's *Mothership* is reduced to a discreetly packaged computer plug—a reminder that everything digital, even NFTs, must have some physical component.

Jonathan Monaghan's *Mothership,* with a *Mario Kart* rainbow road spiraling through an imagined cityscape, is arguably the first NFT. It was registered on the blockchain several months before Kevin McCoy's *Quantum* but has received far less attention.

In retrospect, Refik Anadol's exhibition at the Museum of Modern Art represented the bridge between the NFT community, the art world, and the growing fascination with AI. It's telling that Anadol, previously an artist-in-residence at Google, would create that bridge. The exhibition was immensely popular, with MoMA extending its run several times.

And now that he was doubling down on the speculation and spectacle of the art market, was he multiplying his inevitable misery? Only time would tell if Beeple's prospects belonged with the prospectors of yore, but he had clearly become a cultural phenomenon in his own right—a cult of personality for the generations raised in virtual worlds and video games who believed their online hobbies could become real careers.

ᴍ

A prayer, no matter how genuine, never saved anyone from a critic's pen, and Winkelmann had everyone writing about his "bad" art, even if they never came to his exhibition. "It's a very boring sort of outsider art, made by nerds for other nerds," quipped Dean Kissick ahead of the show in an extended essay about how Beeplemania represented everything rotten in culture.[10] "Lately artworks have begun to look more like memes, while memes have begun to look more like artworks. The memes look nicer, and offer more hope." The critic regarded Winkelmann's success as a failure of the traditional art world. "The old gatekeepers have been losing their power for a while now," he wrote. "With NFTs, we've made the leap from art that's easy to post, to art that simply is the post."

Diminished as the old gatekeepers were, there would be retribution for collectors who legitimized Winkelmann by purchasing his artworks. There were long-standing rumors that directors at megagalleries like Gagosian would automatically move any collectors who owned "bad artists" down their waitlists.[11] Critics assumed that Beeple owners had simply joined the blacklist.

These rumors had the opposite effect to what was intended, encouraging NFT collectors, triggered by the smallest suggestion of gatekeeping, to purchase more *Everydays*. It seemed like no amount of critique would break the Beeple spell. What

started as genuine compassion for an ignored creator was starting to look like a crusade, which seemed appropriate for a man of messianic qualities in the blockchain ecosystem.

Cryptocurrency was itself the first true religion of the twenty-first century, with its own saints and sinners.[12] The digital dollar has become godlike; its foremost prophet, the anonymous Satoshi Nakamoto, spread the gospel of decentralization through a sacred text before disappearing from the world. "What is needed is an electronic payment system based on cryptographic proof instead of trust," he wrote in a 2008 white paper. "We have proposed a system for electronic transactions without relying on trust."[13] So it was written, so it was done.

Early apostles developed their own Talmudic guidelines based on the white paper; the message boards are still studied today to understand the origins of blockchain and how to keep the system kosher. Then came Bitcoin Block 0, the first of the crypto coins, which became known as the Genesis Block, whose strength was the religion's founding miracle. Momentous leaps forward in adoption became holidays. May 22, for instance, marked the day in 2010 when a man named Laszlo Hanyecz bought two pizzas from Papa John's for ten thousand Bitcoins, which totaled about $41 in those days. (At the time of Winkelmann's exhibition, Hanyecz would have been spending the equivalent of $28.3 million on pizza.) But it wasn't all celebrations. Schisms and apostasy abounded. The splintering of cryptocurrencies birthed new theocracies, like Ethereum, Gemini, and Dogecoin. Outsiders became known as nocoiners, and those who abandoned the religion were ostracized as heretics.

A religion of the faithless appealed to the children of recession. Trust was simply an analogue of the old, corrupt system. The speculative fantasies of decentralized finance were more appealing than any alternative promised by the banks. Sure, it could have all been a Ponzi scheme, but what wasn't?

And just as the Catholic Church once relied on paintings and sculpture to attract a largely illiterate society into its cathedrals, crypto investors have welcomed new parishioners into the metaverse through NFTs promoting a new mysticism of moon birds, pixelated zombies, and mutant monkeys. Winkelmann positioned himself at the center of this new cyber cosmology by producing artworks that wedged NFTs into a broader cultural context. He was the perfect symbol for a religion that was struggling to outgrow its secretive founder. Satoshi's anonymity might have allowed cryptocurrency to evolve beyond him, but his later disappearance created a power vacuum and accountability issues. With honest midwestern mannerisms and an appetite for merino wool sweaters, Beeple championed transparency and community within the NFT space. He was the charismatic leader in Ned Flanders cosplay, capable of rehabilitating crypto's image problem.

"I am still bullish on NFTs," Winkelmann insisted after my pestering about the money laundering, thefts, and scams that were squeezing through the blockchain's supposedly flawless security protocols. One hacker with the very creative pseudonym Monsieur Personne was determined to show the system's vulnerabilities, producing a "second edition" of Beeple's record-selling *Everydays: The First 5000 Days* and registering the forgery on the blockchain as though the artist had minted it himself.[14]

I might have been the thousandth person to ask the question, and Winkelmann refused to budge. "There were all kinds of problems—all kinds of bullshit, for lack of a better term—when the internet was created," he explained. "But we didn't just stop using the internet and say it's all crap. It's just up to people to recognize that things are wrong with the ecosystem and make solutions for it being better."

ᙡ

Having taken in the bizarre scenes at opening night, I had forgotten about my plans to meet a friend during the party. She arrived late, with enough luck to slip past the large queue still waiting outside.

"Has there ever been a gallery opening with security guards and a line down the block?" Grace asked, peering through the window at the crowds of young people craning their necks to see Winkelmann, who was now surrounded by ecstatic fans in his corner of the room. As someone who had worked between the art and tech industries, she could recognize a winner. Kissick was right: the old gatekeepers had lost their power. There was nothing that Gagosian, or anyone else from the traditional art market, could threaten to stop Beeple from becoming one of the most famous living artists in the world.

As the evening inside Jack Hanley Gallery ended, the partygoers became louder and messier. Winkelmann was surrounded by adulation. His parents stood behind him, and his brother, Scott, was floating around the room with Chu, who seemed to be orchestrating the backroom meetings with collectors.

Hanley, now ejected from his safe space, anxiously roamed through the crowded hallways of his venue in a daze. What had he done? What had he allowed to be done in his gallery? Scenes of science fiction surrounded him, portending a future in which Silicon Valley would crumble. He passed by a painting called *You Got Mail*, which featured Jeff Bezos's severed head as a vessel for Amazon cargo containers. It was a terrible omen for what was about to happen. In the painting, a worker wearing a hazmat suit roams the surrounding wasteland looking for dead bodies as other crewmates look upon their leader's rusting face, whose lips are painted with the company logo like a clown's exaggerated frown.

TRANSCENDENTAL SQUIGGLE MEDITATIONS

In the high scrublands of Texas, just north of the limestone canyons where the coyotes of Big Bend National Park hunt their prey, was an improbable art town of fewer than two thousand residents—now hostages in a standoff between the national press and the crypto entrepreneur Erick Calderon, who believed himself to be the inheritor of a cultural dynasty guarded within the dusty outpost. He had arrived to hitch the town's future to the cryptoeconomy, which was about to collapse.

Southern Pacific Railroad ran through here in the 1880s, set-tling the expanse into a county of cowboys and soldiers. Back then, it was nothing more than a fortified pit stop for the steam trains, somewhere to replenish water supplies quickly before Butch Cassidy and his stickup gang appeared on the horizon. Hanna Maria Strobridge experienced one of those first jour-neys along the tracks with her husband, the railroad's chief engineer, who granted her naming rights.[1] A constant reader, Strobridge looked warmly upon the wasteland outside her window and back at the 1876 Jules Verne novel upon her lap, *Michael Strogoff: The Courier of the Czar;* she ultimately dedi-cated the barren vista to a minor character within the story: Marfa.

And, like its namesake, the town of Marfa remained on the

periphery of importance for most of its existence. Residents had big hopes in 1911, when the federal government constructed a nearby army airfield to monitor the growing turbulence across the border during the Mexican Revolution; a generation later, the site was rechristened as an officer-training school during World War II. But in 1945, when the conflict ended and the military slowly started to withdraw from the area, the mayor predicted a looming economic crisis. The townspeople cried, their knees buckling with fear. It seemed Marfa was destined to become just another dead-end ghost town in the Wild West.

Donald Judd missed those last dying gasps of old Marfa when he traveled through West Texas in 1946 en route to California, where he would embark on a mission with the U.S. Army Corps of Engineers in Korea to help build an airbase and a boiler plant.[2] He was an army brat who had spent much of his adolescence in Missouri before later enrolling at Columbia University to study art history and philosophy after his own military service concluded. Judd had dreams of becoming an artist once he graduated from the Ivy League school, but the starving artist supported himself through the 1950s as a writer.

One might expect such a résumé to produce a snobbish critic, and Judd certainly occupied the stereotype. He was a scrupulous crank on everything from Dallas ("very disagreeable") to psychology ("the astrology of the mind") and his contemporaries ("one of the worst paintings I've ever seen in all respects is one by Anselm Keifer").[3] However, Judd was no hypocrite; he pushed his own practice toward a spartan efficiency that stripped art of its kooky mysticism. He sought a purity of new forms. Painting was kaput, because of its reliance on illusionism and rationalism. Sculpture wasn't much better, since it often lapsed into figuration, but Judd still favored three-dimensional space. Eliminating sentimentality from the equation, the artist described his sculptures as *objects*. He embraced

new industrial technologies and outsourced the fabrication of his works in 1963, sometimes enlisting a commercial sheet-metal workshop in Queens called Bernstein Brothers Sheet Metal Specialties.

It was the turning point he needed. Judd soon became an international art star with an acclaimed exhibition at the Whitney Museum of American Art in 1968. He had refined many elements of his work by then, showcasing "stacks," identical shelves set on a wall at regular intervals from floor to ceiling. There was a harmony to Judd's work. "The order is not rationalistic," he always insisted. "[It] is simply order, like that of continuity, one thing after another."[4]

Judd seemed to fetishize the industrialization of postwar America, searching for an artistic language that replicated the characteristics of a manufacturing plant. His disillusionment with the art world came in 1971, when he decided to leave the "harsh and glib situation in New York" for another life, in Marfa. He bought sixteen dilapidated buildings, the decommissioned army base, and three ranches spread across forty thousand acres. The artist's liberalism spilled into libertarianism; Judd wanted to assert his own autonomy through a permanent art installation spread across the desert he owned. He wanted to build something that would last forever, a monument to his vision of pure art.

"Marfa is a company town and the company is Judd," the novelist Jim Lewis once wrote, observing that the artist had destroyed and rejuvenated the former military settlement into a colony of the avant-garde.[5] He was a godlike figure to some residents, who affixed bumper stickers to their pickup trucks asking, "What would Donald Judd do?"[6]

When the artist unexpectedly died from lymphoma in 1994, at the age of sixty-five, he left behind a family and dozens of supporters committed to maintaining his vision through the

Chinati Foundation, a nonprofit that stewards his collection and guards what is arguably Judd's greatest achievement: *100 Untitled Works in Mill Aluminum.*

Judd had spent four years in the early 1980s converting two run-down artillery sheds into galleries that housed a hundred boxes of identical dimensions (forty-one by fifty-one by seventy-two inches) with slight variations, such as vertical dividers, horizontal cutouts, and diagonal slashes. The aluminum forms shimmered in the light, reflecting the desert landscape outside as if the surrounding environment had become pure essence, trapped inside the objects like images on a television screen. See the boxes at sundown and their power becomes manifest, with surfaces ignited by the dusk-red sky, their flames dimming in the black void of night.

"I intend my pieces to be hollow," Judd once commented. Not because of some negative desire to illustrate emptiness, but to encourage people to become more conscious of the world around them. Judd, a grump with a fondness for Bach and bagpipes, sought an artistic style that could resist interpretation, achieve objectivity, and last forever. It was really that simple. Not minimalist, a name Judd loathed: simple. "One thing I wanted to do with art is to be able to see it," he would often explain. "It is something you look at."[7]

America has little use for empty altars, however, and today's Marfa has become a tourist destination for elites who have turned this desert bohemia into a vacation town with a housing crisis. The artists who followed Judd into the outlands were constantly besieged by magazine reporters and wealthy collectors. It had become a land of great ironies, where a self-avowed communist sells midcentury modern lamps for $500, an abstract painter wins the mayoral election, and an underclass of workers live in mobile homes to serve the jet-set patrons on pilgrimage to the Chinati Foundation.

Erick Calderon was one of those tourists when he visited

Marfa on a family vacation in 2016 in search of Judd and his own unfulfilled dreams of becoming an artist. He was a thirty-five-year-old businessman from Houston, a mildly successful entrepreneur who resembled the actor Seth Rogen, down to the white streak running through his beard. Maybe it was from stress: Calderon was a charming hustler who spent his mornings selling imported ceramic tiles from Europe and his evenings tinkering around with computer programs. There was nothing within his biography that would indicate a man capable of starting a billion-dollar NFT business. And yet Calderon had navigated the heights of the bull market with an unusual grace. Nobody within the crypto industry had a bad thing to say about him. Marfa was another story. Calderon and his company, Art Blocks, managed to alienate residents with a botched rollout of their new NFT gallery in town, which the businessman had purchased for "a third of a *CryptoPunk.*" Housing records indicated that it cost about $600,000.

ᴍ

The response from Marfan tastemakers was overwhelmingly negative. Calderon seemed like yet another opportunist attempting to capitalize on the town's cultural cache. There was something defensive in the announcement of his gallery. "Even though it wasn't coded in JavaScript and rendered on a computer, Judd captured the ideas of permanency and variability," the company wrote in October 2021.[8] Calderon saw himself and the generative artists he supported through his NFT marketplace as the next generation of Donald Judds, but transposing his themes into the digital realm. When asked about his artistic background, however, Calderon was noticeably uncomfortable. He could barely hold a paintbrush, and had frankly done little research into Judd before buying real estate in the artist's company town.

Digital tokens and metaverse money were foreign concepts in a place like Marfa, where the shaky internet usually failed in a rainstorm. During a town-hall meeting that month held in the backyard of the Art Blocks gallery, Calderon described NFTs with words like "revolution" and "movement." Rachel Monroe, a magazine writer and local resident, chronicled the standoff in sumptuous detail for *The New Yorker*.[9] Artists described the meeting as super-depressing, and Monroe observed that Calderon was edging toward desperation, surprised by the amount of pushback he was now receiving from guests in his own backyard.

"Art's not a commodity, and everybody should fight that idea," Judd once said, in a 1985 interview. His followers in Marfa tended to espouse those beliefs, even if many, like Christopher Wool, traveled there in private jets and sold their paintings for millions of dollars.[10] Not that their own hypocrisies were up for debate that afternoon.

"It sounds like you're talking about art without aesthetics," Wool told Calderon, who now wished he hadn't invited an angry mob into his own backyard.

Until that year, Calderon had identified more as an entrepreneur than an artist. During the 2008 financial recession, his tile business almost went bankrupt alongside the collapsed housing market. There were times when a single invoice was the difference between survival and bankruptcy, which helped Calderon develop a tolerance for speculation. Later, he dived into riskier markets and new technologies, like projection mapping and 3D printing—all of which failed to make a profit.

"Part of the reason I don't feel like I can officially call myself an artist is that once I make something that I think looks cool, I immediately try to find ways to make it faster and more efficiently so that it can appeal to a broader market," Calderon said in a 2015 interview.[11]

The businessman acquired his first *CryptoPunks* in 2017,

paying $35 in transaction fees to acquire thirty-four of these rare collectibles. The marriage between digital commodities and artworks clicked for Calderon, who then bought land in the metaverse and even minted a Tweet announcing his purchase onto the blockchain for safekeeping. He was obsessed, going out of his way to pawn his *CryptoPunk* zombies for $200 each to pay the developers who were building Art Blocks, an NFT marketplace for generative artists. Originally, buyers could visit the website and choose from a series of artist-generated algorithms. Their selections were minted and recorded on the blockchain.

Calderon had only a limited background in coding, however, and the Art Blocks prototype kept failing. The project was shelved for several years until the pandemic, when Calderon had some extra time. The tile industry was experiencing another drag as homeowners sheltered in place, so Calderon used his extra time to learn Javascript.

"My original idea was to host artworks on their own individual smart contracts. The smart contract would be connected to a hash on the Ethereum blockchain that triggered a visual output. It was kind of like a slideshow that would produce visuals forever," Calderon explained to me. "Customers would purchase a token for about 0.001 ETH, which would allow their visual to be displayed for one minute. The more Ether a customer spent, the longer their image would be displayed.

"We thought of it as a tipping system for digital art, something akin to the buckets in front of street performers in the park where you pay five dollars, and they start moving around like living statues."

But the concept was difficult for investors and artists to wrap their heads around in 2018, when he registered the company in Texas.

Art Blocks relaunched in November 2020, positioning the company to benefit from the upcoming year's bull market and

even benefit from the industry's great recentralization that happened later during the crypto crash. Sure enough, Calderon experienced an unfathomable windfall over the next summer. In August 2021 alone, the business saw nearly $600 million in primary and secondary sales across fifty-one thousand transactions. Traffic skyrocketed on August 23, when degens produced $69 million worth of transactions in a single day through the rapid buying and selling of their NFTs. Art Blocks received 10 percent of every primary sale and another 2.5 percent on the secondary market, profits that helped the company hire thirty employees and establish its presence as a premium brand. Calderon struggled to keep up with demand. Some collections sold out before even he could place an order. So Art Blocks began minting a new generation of art celebrities, with creators like Tyler Hobbs and Dmitri Cherniak owing their millions to the website. Hobbs was so appreciative that he even hand-painted a custom *Fidenza* mural onto the side of the company's Marfa gallery.

The company's success legitimized Calderon as both a businessman and an artist. He had inaugurated the platform with *Chromie Squiggles,* a generative art series released under his Snowfro username, a callback to the entrepreneur's college days selling snow cones.

Calderon had originally used the *Chromie Squiggles* as proof-of-concept for Art Blocks, distributing the NFTs to clients across the design industry as a demonstration of how his company was revolutionizing the tokenized economy. There were six versions that the algorithm could produce within its limited set of ten thousand collectibles: standard, slinky, fuzzy, ribbed, bold, and pipe. Additional characteristics like color and height helped individualize the artworks, which danced in collector wallets like vibrating Technicolor scribbles.

Collectors renamed themselves as squigglers, organizing DAOs and fan-made websites that hailed Calderon as "a really

good guy," "a very chill dude," and "the unquestioned king."[12] The businessman became a member of the exclusive Flamingo DAO group, which invested in Art Blocks, as did venture capitalists like Galaxy Digital, an influential firm run by the billionaire Michael Novogratz, a former Goldman Sachs executive turned crypto evangelist.

Even though he had run aground in Marfa, the contemporary art market lavished praise on Calderon, their new middleman between culture and the tokenized economy. Marc Glimcher was one of the first voices in the Texan's inbox. The chief executive of Pace Gallery wanted to get ahead of the crypto curve, but he took a less aggressive route with Calderon, spending a full year courting him with stories about Donald Judd and James Turrell. Another shark circling the squiggler was Adam Lindemann, an investor interested in exhibiting the *Chromie Squiggles* at his Upper East Side gallery. Even the staunchest of NFT critics took an interest, including the museum curator Tina Rivers Ryan, who held frequent conversations with Calderon about the art world.

"My fear is that what comes next could be worse than what we have now," Ryan said, explaining why she had started to engage with people like Calderon. "This is a prelude of what comes next, and I want to make sure we have people in the room to help shape those conversations while the future is still being drafted."

Calderon became the consequential figure that Ryan hoped he would become. He was an outspoken critic of financialization, attempting to dampen speculation within the Art Blocks ecosystem. He benefited from the role, as *Squiggles* became a part of licensing deals that brought the colorful doodles to larger audiences. And instead of retreating from Marfa after Rachel Monroe's *New Yorker* article made him a laughingstock, he dug deeper into the community with new exhibitions, charitable donations, and partnerships across town. Besides, the

Juddites who mocked him in *The New Yorker* never came to his gallery openings; instead, most guests came from the local Hispanic community, he said, a source of pride for a man whose parents had emigrated from Mexico. And despite being roasted in a highbrow magazine, the Chinati Foundation still accepted Calderon's personal donations and those from his company.

"I felt rugged by that journalist," Calderon told me nearly a year after the article had been published, clearly still upset about an ordeal that he described as the darkest point of his career. Nobody had gentrified Marfa more than Donald Judd when he bought most of the town in the 1970s; however, Monroe's essay portrayed Calderon as an idiot flaneur, a bearish multimillionaire intent on destroying her neighborhood with digital art. "She turned me into some arrogant tech person."

Still, he rarely shied away from a good business opportunity, especially as the cryptoeconomy started its slump in the aftermath of the ill-fated Sotheby's *Punk It!* auction. In the succeeding months, Calderon announced a collaboration with Pace Gallery, informally advised Samsung on bringing NFTs into millions of living rooms through its smart televisions, and earned a lucrative sponsorship deal with a British soccer team owned by degens who wanted to put the *Chromie Squiggles* on their Adidas jerseys.

It was a matter of historical coincidence that Calderon's big exhibition opened in the same week that the cryptoeconomy as we knew it ended. The Great Crypto Crash began in May 2022 with the collapse of two cryptocurrencies called Luna and TerraUSD. The Terra blockchain had been created in 2018 by a trash-talking South Korean businessman named Do Kwon, a Stanford University graduate who taunted his critics by saying things like "I don't debate the poor." Arrogance helped

endear the twenty-seven-year-old firebrand to the men run-
ning investment firms, such as Galaxy Digital and Coinbase
Ventures, who gave the young degen more than $200 million
for his company, Terraform Labs, which announced TerraUSD
in 2020 as a stablecoin designed to maintain its value as a reli-
able means of exchange with fiat currencies.

But "stablecoin" was a misnomer for TerraUSD, which relied
on an algorithm that linked its value to Luna; thus, the dual
cryptocurrencies had become inextricably paired. This ben-
efited investors during the bull market, as the price of Luna
rocketed from $1 in early 2021 to nearly $116 in April 2022.
Kwon became a cult hero to retail traders and his wealthy
investors. Michael Novogratz, chief executive of Galaxy Digi-
tal, was so enthralled by the crypto architect that he got himself
a Luna-themed tattoo of a wolf howling at the moon on his left
arm. "I'm officially a Lunatic!!!" the fifty-seven-year-old wrote
on Twitter.[13]

On May 3, Kwon joked in an interview that 95 percent of
cryptocurrencies were going to die, "but there's also entertain-
ment in watching companies die, too."[14] Six days later, Terra-
USD dislodged from its peg to the dollar, and the price of Luna
plummeted to close to zero. Overleveraged investors incurred
heavy losses as the combined market value sank into oblivion
from its high point of $60 billion. Everyone else panicked, and
the digital equivalent of a bank run started to drain the market
of its wealth; by the end of the week, nearly $300 billion was
wiped from the cryptoeconomy.[15] It was an embarrassing rout
for the financiers and academics who had championed Kwon's
leadership. Harvard Business School's Marco Di Maggio had
even partnered with Terraform's head of research, Nicholas
Platias, to claim the dollar peg would prove "highly robust . . .
based on one million years' worth of simulation data."[16]

Kwon had finally changed his tone by May 13, a few weeks
before South Korean officials announced an investigation into

his company. "I am heartbroken about the pain my invention has brought on all of you," he wrote on Twitter.[17] Investors who lost everything in the crash were posting suicide hotline numbers in online forums.

Five days later, I was shaking Calderon's hand as he joked about the end-times. We were at a show at Lindemann's gallery, Venus Over Manhattan, where monitors displaying *Chromie Squiggles* covered the walls of the dealer's brownstone mansion. A spring breeze cooled the room packed with investment bankers, scraggly digital artists, and Park Avenue princesses. The people were noticeably different from those who attended Beeple's opening. The guests were older and richer, which made them calm. After accumulating their wealth over the last few decades, they belonged to an income bracket impervious to economic doom. Guests joked that they had dressed in their recession-chic best for the evening, which on the Upper East Side meant wearing only one diamond necklace to cocktail hour.

Falling numbers in the stock market painted a bleak picture for the fiscal year, as economists reported that the S&P 500 was approaching bear-market territory; meanwhile, inflation had caused the prices of food and gas to increase, which Treasury secretary Janet Yellen described as the "stagflationary effects" of Russia's invasion of Ukraine and its continued chokehold on natural resources. The more conservative banks on Wall Street, restrained from directly investing in cryptocurrencies thanks to rules created after the 2008 financial crisis, had instead chosen to bet against the digital economy. BNP Paribas, for example, arranged what analysts described as a "cappuccino basket" of some fifty stocks that they thought were overpriced. The French bank had its clients betting against the basket in autumn, and by spring their fortunes were rising as crypto crashed. Of course, the retail investors—average people who had stashed their life savings in digital currencies and NFTs

after being bombarded by advertisements promising umpteen returns on their portfolios—lost everything. In May 2022, sales of digital assets had fallen by 92 percent from their September values.[18] The value of major NFT collections like the *Bored Apes* had decreased by half.[19]

"In the great cryptocurrency bloodbath of 2022, Wall Street is winning," proclaimed Emily Flitter, a banking reporter for *The New York Times*.[20]

It was a surreal experience to witness the cryptoeconomy freefall from inside a brownstone mansion on the Upper East Side where the occupants remained blissfully in denial, surrounded by rainbow *Chromie Squiggles*. The challenging economic outlook was simply a blip in time to people whose careers were made by riding the waves of uncertainty.

Outside the gallery, sitting on the stoop, was a German economist named Magnus Resch, a specialist in the art market who had recently started teaching classes at Yale University on the subject. He had the charming good looks of the European aristocrats who typically attended these things—almost all wearing navy-blue suits and crisp white shirts. Resch expanded on the thesis of his upcoming self-published book assuring readers that "Nostradamus-like predictions of the gradual decline of the art world" were premature, as were the mumblings about NFTs being a fad. As he lectured a growing crowd of onlookers—most simply trying to enter the gallery doors behind him—Robert De Niro briefly stopped in a car outside the exhibition to meet a friend inside. Earlier in the year, the actor had been photographed for an NFT project programmed to match his facial expressions to the real-time price of Ethereum.[21] He certainly looked displeased, both in the metaverse and in real life. His car scooted away from the scene.

Inside, guests crowded around Calderon, who seemed unable to move from his corner in the dimly lit backroom. *Chromie Squiggles* reflected from the artist's glasses as he shook

the hands of his adherents. Near the doorway, I recognized the silhouette of Justin Aversano, schmoozing with the out-of-place degens who clung to the perimeter of the white-cube room. The photographer was there to secure his own exhibition with Lindemann, the gallery proprietor, to be staged in September. Despite owning his own NFT gallery, Aversano still wanted his formal debut in the art world, like Calderon and Beeple.

Lindemann, a blue-eyed businessman with the talents of a Greenwich bon vivant, happily welcomed this new crowd of artists and prospective clients who had found his brownstone through the blockchain. He had spent years trying to make crypto happen in the traditional art world, even organizing a chaotic blockchain conference at Art Basel Miami Beach in 2018, which *New York* magazine described as a mixture of "Bitcoin and Basquiat" that included speakers like Pace Gallery's chief executive, Marc Glimcher; New Museum's director, Lisa Phillips; and the billionaire tech entrepreneur Jim McKelvey.

"The world of tokenization of different asset classes is on its way here," Lindemann declared, about three years too early.[22]

Phillips responded with a skepticism that has now become commonplace in the arts: "We've heard a lot about value," she said, "but not a lot about *values*."[23]

McKelvey, who founded Block, Inc., with the Twitter co-creator Jack Dorsey, epitomized the tech sector's awkward entry into the art world. He stumbled over a bad joke, telling the audience that an artist is "somebody who sells something no one else needs," before monologuing about blockchain's importance and his own glass-blowing hobby.[24]

Lindemann loved that kind of drama, though. He was the son of the Connecticut billionaire George Lindemann, a tycoon of contact lenses, cable television, and cellphones. Adam made his own fortunes in Spanish radio broadcasting, but during his rebellious twenties, in the 1980s, the business

scion palled around with artists like Andy Warhol and Jean-Michel Basquiat in downtown hovels like the Mudd Club and CBGB. He had since mellowed out, opening his own gallery in 2012 just a floor above Larry Gagosian. The idea was that a young financier not quite ready to spend big on a Jeff Koons sculpture from the famed dealer might climb the flight of stairs to buy a cheaper Warhol print.[25]

In 2018, Lindemann attempted to build a cryptocurrency around art, but other dealers, including Gagosian, turned him down. Now he could celebrate being on the vanguard of a cultural movement, building his own NFT collection with examples from artists like Aversano, Beeple, and Calderon. He was much more suspicious of the tech investors encroaching into the gallery world, however, seeing experiments like Bright Moments Gallery as bland. "It's a party where some guy with an iPad reveals art on a computer screen. We are supposed to get excited about that?" he said, laughing. "The NFT world is two years old. The art world is more than a century old. It's not comparable. The idea that every NFT is an artwork is a joke. It's absurd."

Nevertheless, Lindemann had invested in a series of crypto companies, including Yuga Labs. By staking his credibility to the *Bored Apes* and *Chromie Squiggles*, the gallerist stood a chance of carving himself a profitable niche in the market.

"The venture capitalists worship squiggles," he explained in an interview. "The NFTs don't have to be judged alongside Picasso's *Les Demoiselles d'Avignon* to have value. The squiggles are a way for people with crypto to diversify their portfolio and get into collecting."

"NFTs are money," Lindemann concluded. "They are gold coins with images on them."

He was saying the quiet part out loud, admitting to what the crypto industry dared not confess. Tokenized artworks were little more than financial products for the majority of inves-

tors buying NFTs. How much could the original intentions of
the artist matter when faced with the armature of the crypto-
economy? The reality was that these digital images were both
symbols and tools of financialization.

ᗰ

Whatever happened to democratizing art and decentralizing
the banking system? The espoused goals of Web3 took a back
seat to large-scale recentralization during the crypto meltdown
as the bull market's biggest winners consolidated their gains.
In March, Yuga Labs had purchased the *CryptoPunks* fran-
chise for more than $100 million, bringing the lucrative col-
lectibles under the same roof as the *Bored Ape* series, which
was undergoing its own transformation. That same month, a
group of token holders that included Alexis Ohanian, a Red-
dit cofounder, and Amy Wu, leader of the crypto exchange
FTX's venture division, created ApeCoin, a digital currency
that would supposedly be used for activities and merchandise
inside the *Bored Ape* universe. There was a frenzy of nearly
$9.2 billion in trading within a twenty-four-hour period when
ApeCoin launched; some people "borrowed" other users' apes
to fool the system into letting them acquire the coin. Venture
capitalists who helped with the launch—including Andrees-
sen Horowitz and Animoca Brands—received 14 percent, or
140 million tokens from the billion-token supply, granting
them substantial influence over the project.[26] Yuga Labs would
receive an even greater supply, 160 million tokens.

Critics often compared ApeCoin to special-purpose acqui-
sition companies (SPACs), which had increased in popularity
during the pandemic as mechanisms to raise capital quickly
without going through the traditional process of an initial pub-
lic offering (IPO). SPACs are essentially blank-check compa-
nies used for mergers, when investors blindly give their money

toward some end goal without knowing the details of how executives would get there.[27] ApeCoin had a similar proposal, but with no regulations and a smaller group of people running the show.

Andreessen Horowitz stood to benefit. The firm was already in talks with Yuga Labs for a $450-million fund-raising round, which FTX also participated in, bringing the company's valuation to $4 billion. This raised some alarms from crypto analysts who had tracked blockchain transactions and believed that FTX had been the secret purchaser behind the 101 *Bored Ape* NFTs offered at Sotheby's the previous September, although the auctioneer, Michael Bouhanna, claimed that the buyer was a legacy art collector.

ApeCoin operated like a financial derivative of *Bored Ape* NFTs, which were themselves a financial derivative of the company. It made for some weird economics, in which ape holders rushed to secure their windfalls, pumping the price higher in a speculative burst that seemed to contradict the bear market's sagging fortunes. The notion that FTX might have artificially created demand for *Bored Apes* to inflate the value of Yuga Labs before one of the exchange's executives created *another* form of leverage from the brand seemed like a conflict of interest. The payoff seemed obvious: Yuga Labs became the strongest NFT brand in the world and pushed recentralization as it gathered some of the most expensive collectibles under its name. But the company was also chaining the NFT market to FTX, a crypto exchange whose downfall would become one of the most infamous bankruptcies in American history.

Recentralization was turning the token economy into an ouroboros, snaking NFTs back into the crypto market as a new financial derivative; the industry was entering Washington by brute force. Political donations from the sector topped more than $26 million during 2021 and the first three months of 2022, funneling more cash into Capitol Hill than internet companies,

drug companies, or defense manufacturers.[28] Spending from individual donors from the crypto industry was also mushrooming. Sam Bankman-Fried, the thirty-year-old billionaire and chief executive of FTX, contributed $16 million in April. He was the second-biggest individual donor since the start of 2021, according to data from the Federal Election Commission, behind only George Soros. Up till then, the FTX founder had poured his money into Democratic coffers; however, another company executive, Ryan Salame, was quietly giving money to Republicans. Disclosure forms released in 2022 indicated that Bankman-Fried had donated nearly $45 million to Democratic groups, and Salame donated $24 million to Republicans.

Crypto cash was flowing both ways, toward anyone with a sympathetic ear for the industry. In a May 2022 interview with *Bloomberg*, Bankman-Fried said that, while he was unlikely to reach that level of spending, he would potentially donate nearly $1 billion during the 2024 presidential election.[29]

That amount of money would be necessary to overcome all the negative press on crypto. Everyone was getting scammed in the spring of 2022. Arts leaders and cultural critics were victims of an April phishing attack by an NFT bot selling phony *Moonbirds,* a hot collectible of the time. Even a Florida gubernatorial candidate, Nikki Fried, had her Twitter account compromised in a phishing attack by someone trying to pawn *Skulltoons.*[30]

There were also critical efficiency problems within the sector as the price for NFT minting, nicknamed a "gas fee," dramatically increased. Meanwhile, a series of investors had filed lawsuits against marketplaces like OpenSea for failing to prevent cyber culprits from stealing *Bored Apes.*[31] (OpenSea claimed that thefts happened off its platform, because it does not control or custody any NFTs.) Customers were about done with the shoddy infrastructure of the cryptoeconomy; meanwhile,

attorneys were happily accumulating millions in billable hours from their hapless clients.

Then the Federal Bureau of Investigation revealed that one of the largest crypto hacks in history had been perpetrated by North Korean agents. *Axie Infinity* had become a popular NFT-enabled video game in which users could trade their axolotl-inspired digital pets for crypto dollars. A Vietnamese studio called Sky Mavis had designed it as a "play-to-earn" game: users generated revenue directly from playing the video game, harvested the digital assets, and traded them. Transactions had peaked during the bull market, when average monthly sales reached as high as $848 million.

Behind those profits was a more sinister economy, which some critics described as "digital colonialism."[32] Like the gold-farming plantations in *World of Warcraft*, the serfdoms of *Axie Infinity* outsourced its gameplay labor to unpaid workers in the Philippines, who rented powerful avatars from other players, who received a cut of profits anywhere from 30 to 75 percent. Internally, studio developers referred to the workers as "scholars" and the managers as "bosses." In one example cited by Edward Ongweso Jr., a reporter with *Vice,* the game had become popular in countries like Venezuela, where hyperinflation and political instability made decentralized banking more appealing.[33] A boss by the name of Iguano employed scholars, splitting proceeds in half so that workers received about $20 every two weeks. On a larger scale, a YouTuber named SavageStudiosFBG said he ran a team of two hundred scholars, and pulled in $20,000 a month at his peak.

According to the FBI, North Korean hackers known as the Lazarus Group infiltrated *Axie Infinity* through Ronin, the game's underlying blockchain, siphoning more than $620 million in cryptocurrency.[34] Employees at Sky Mavis were supposedly under constant advanced spear-phishing attacks through

social channels, but a hacker eventually got through with a fake job application. A senior engineer downloaded the Word document, allowing the Lazarus Group access into the company system.[35]

News about the attack tanked the *Axie Infinity* economy as players realized that the blockchain had failed to safeguard their wallets. There was a growing awareness that the risk of engaging in the crypto economy had become untenable. The industry had poured the majority of its resources into financialization without much thought to security, or how the lie of blockchain permanence opened users to phishing attacks and malware. Nobody could evade these scams.

In May 2022, Seth Green announced that his *Bored Ape* nicknamed Fred Simian had been stolen with three other NFTs in a phishing scheme that sent him scrambling. The *Austin Powers* actor had developed a television show around his monkey's intellectual property. Simian would be an animated New York City bartender, a brooding schmuck working at the White Horse Tavern in the West Village. But without the digital asset, there were technically no intellectual-property rights. The ape eventually reemerged in a wallet connected with the alleged abductor known as "Mr Cheese," who brokered the ape's return for a $300,000 payday. Green paid the price and used a crypto escrow platform called NFT Trader to complete the handoff.[36]

Mike Winkelmann was the next victim. In the early morning of May 22, a scammer accessed the artist's social media and posted two Tweets advertising a raffle for a fraudulent NFT partnership with Louis Vuitton. Winkelmann removed the links about five hours later, but the damage was already done. The hacker drained nearly $400,000 from Beeple fans.

This unholy trinity of scams did not go unnoticed. The NFT industry was accused of being a massive Ponzi scheme from the very beginning, and now critics had three major examples

and hundreds of other rug pulls to prove their point. Companies and figureheads were starting to pull back their promises to Web3.

It was around this time that I started receiving messages on social media and email from a press agent for Camila Russo, a former *Bloomberg* financial blogger turned blockchain booster, who claimed to have a movie deal with the award-winning filmmaker Ridley Scott about the Ethereum founder, Vitalik Buterin.

Within an urgent email, the press agent said that Russo was "meeting the Pope at the Vatican for round table discussions on Thursday this week and will discuss NFTs, films and decentralization." Needless to say, my interest was piqued. What would his holiness Pope Francis say about cryptocurrencies and digital assets? Could the metaverse help steer the soul toward a greater good?

Earlier in May, the Vatican had said it would open an NFT gallery within the next year, presumably featuring the priceless works from its collection, like Michelangelo's Sistine Chapel and Raphael's Apostolic Palace. The program—called Humanity 2.0—was an exceedingly strange idea from such an old institution. For starters, the initiative was the brainchild of Father Philip Larrey, the dean of philosophy at the church's Pontifical Lateran University in Rome. The Vatican's partner on the program was Sensorium, a tech company founded by Mikhail Prokhorov—one of the few Russian oligarchs not sanctioned by the United States and European Union after Russia's invasion of Ukraine.

Jokes about the Catholic Church transubstantiating its art collection into digital assets were good. "The Catholic Church is now selling indulgences as NFTs," posted a Twitter account called God.[37]

When I followed up with the press agent a week later,

her tone had changed. She claimed that reporting about the Church's NFT project had displeased the Vatican. Pope Francis was not feeling particularly bullish.

However, the public-relations flack assured me that the pontiff "blessed everyone at the event," in which Russo was apparently able to explain how blockchain and crypto could improve life in South America. Photographs from the event told another story: it seemed that Russo had spoken with the Pope during a short meet-and-greet at which she placed her crypto book in his hand and His Eminence quickly returned it to her. Not exactly the kind of divine backing that Russo and her ilk needed as they faced an economic precipice.

Calderon took the ridiculousness of these publicity stunts for what they were: attempts to revive the cryptoeconomy from its recession. "Everyone is acting normal. But nothing about this is fucking normal," he said. We were supposed to be mingling at the *Chromie Squiggles* after-party inside Melody's Piano Bar on Lexington Avenue. Bartenders were serving tropical cocktails to the tangle of glitterati who had followed the artist from the gallery about a mile south; however, Calderon's mind was thousands of miles away, with Donald Judd in Marfa.

The sculptor's masterpieces were buckling and bleached under the Texan sun. Rainwater was slowly leaking through the roofs above *100 Untitled Works in Mill Aluminum,* where the artist's attempts to improve drainage had failed. The metal boxes groaned from the intense heat, unable to enjoy air-conditioning, which the Chinati Foundation considered too intrusive to the experience of Judd's divine assembly. It would cost an estimated $70 million to save the art installation.[38]

I must admit that there was a sick pleasure in watching Calderon embrace and befoul Judd's artistic legacy at the precise moment when environmental and economic factors had undone the sculptor's treatise on permanent art. The *Chromie*

Squiggles were an unintended perversion of minimalist prin-
ciples, revealing the fragility of Judd's autonomous and pure
sculptures.

Calderon's rainbow doodles were reflections of their own
erratic market value, anemic signals of volatility sketched as
anxious heartbeats across a monitor. He had replaced Judd's
imperial strength with a vision of vulnerability. After all, the
businessman had invested everything in his *Chromie Squiggles,*
one hundred of which were placed in a trust fund for his two
small boys. The numbers had to work for their sake; Calderon
was reliant on the market in a way that Judd had always self-
ishly denied, even as the artist grew so capable of articulating
what was wrong with the ecosystem around him.

In 1991, three years before his death, Donald Judd wrote
about how the Gulf War had changed the relationships between
technology, culture, and money: "The consequence of a fake
economy, which is the military economy, is a fake society. . . .
As the enforcing bureaucracy grows omnipresent and omni-
scient, real art and architecture shrinks. . . . The art museum
becomes exquisitely pointless, a fake for fakes, a double fake,
the inner sanctum of a fake society."[39]

Calderon wasn't about to argue with a heavyweight. His life
had become an absurdity. It was a life beyond control, a farcical
series of episodes that launched him deeper into the inanities
of capitalism. He was now the kind of guy who entered a ritzy
cocktail lounge and was handed a Rubik's Cube by a stranger
who claimed to hold the puzzle's intellectual property rights
and asked whether the businessman-artist would consider
tokenizing the toy. Calderon laughed, holding the cube to my
face. But it was a dark laugh of bewilderment; the cryptoecon-
omy was dying. The zeitgeist might have taken his wallet, but it
hadn't taken his mind.

WE'RE ALL GONNA DIE

Optimism sputtered into despair in the weeks following Erick Calderon's *Chromie Squiggles* exhibition. If the NFT market boom was defined by the "cray cray crap" of Beeplemania, then the bust was illustrated by the hellacious monsters that appeared the following summer as investors slowly realized they were damned.

June 2022 marked the beginning of the Justice Department's crackdown on NFT marketers and the end of decentralized finance as we once knew it. The cryptoeconomy lost more than $2 trillion of its value that month, a 70-percent decline from its highest point, in November 2021. The prices of Ethereum and Bitcoin hovered close to what investors would have paid in 2018, erasing gains made over the previous four years and punishing longtime holders.

The effervescent heights of speculation were replaced with melancholia as degens changed their motto from WAGMI ("We're all gonna make it") to the gloomier epitaph of WAG-DIE ("We're all gonna die"). A grotesque legion of some ten thousand disfigured potato heads emerged from an NFT project called *Goblintown* to embrace this new philosophy, wearing shirts with the names of bankrupt cryptocurrencies like TerraUSD/Luna and other scams. The series was a wickedly smart satire of the market crash. On social media, *Goblintown*

advertised itself with jokes about the ugly monsters pissing on *Bored Apes* and collecting coins in dung piles. During audio conferences on Twitter, with eighty-six thousand people listening, the goblins spent more than three hours babbling in gibberish to the infuriated investors, who missed the joke. And when the *Goblintown* NFTs were finally offered in a free mint, collectors were explicitly promised nothing. No roadmap. No Discord. No utility. Only words of caution: "Don't be fucking greedy, that's how we got ourselves here."

Goblintown was incredibly successful as performance art, staging the dada absurdity of what the NFT industry had become—a swarm of drooling prospectors—into a successful digital art collection. Investors returned to the carnival of speculation, only this time painfully aware that feelings of euphoria and immorality were fueling their acquisitions. *Goblintown* visitors wanted to perform their own crucifixions, eager to participate in a ritualistic burning of money that symbolized the cryptoeconomy's death. You could only laugh as professionals attempted to take the downcycle seriously by praising the goblins for their "calculated ugliness," telling prospective buyers that it was hard to create something so consistently repulsive.[1] And you could only cry when the sales pitch worked; *Goblintown* made more than $60 million on the secondary market within its first month.

June belonged to the metaverse monsters devouring the last morsels of profitability in a flagging market, so it was unfortunate timing that a conference celebrating the industry would take place that same month. NFT.NYC had epitomized the highest heights of the bull market in November 2021, when degens spent lavishly on midnight raves and yacht excursions. It was invariably described as "Woodstock" and "Crypto Coachella" by the collectors who fanboyed over sightings of artists like Beeple, celebrities like the filmmaker Quentin Tarantino, and even the Wikipedia founder, Jimmy Wales.[2] Within

its heyday, the conference demonstrated the potency of NFTs as tools for building community. Record attendance of some five thousand people demonstrated that all the shitposters hiding behind usernames and pixelated profile pictures were actually eager for human connection, and would step beyond their computer screens and into the electrical glow of Times Square to hug their fellow *CryptoPunks*. Organizers wanted to build upon their success by staging another conference within six months, never imagining that such a frigid crypto winter could occur in the dead of summer.

The newest edition of NFT.NYC had tripled in size, with over fifteen thousand attendees paying between $599 and $1,999 each to hear speakers describe the digital recession as a "build market" while eating their boxed lunches inside the New York Marriott Marquis hotel in Times Square, where the majority of events were held. It was an incredibly bloated affair; the registration line took hours, snaking through seven floors of the building, with each level containing different NFT sub-genres, including art, finance, sports, gaming, and legal. I navigated through the crowds with a press agent for the conference who described it as "a clusterfuck." Moments later, a Snoop Dogg impersonator passed us with a pretend security guard; apparently, they had been hired by a crypto company to generate press for the event. Meanwhile, protesters marched through town carrying signs reading "God Hates NFTs," "Crypto Is a Sin," and "Make Fiat Great Again." It was another ruse, staged by a fashion designer who said he wanted to exploit the line between skeptics and enthusiasts.[3]

In 2019, when the conference was founded, it was nothing more than a small gathering of a few dozen blockchain fanatics interested in capitalizing upon the breakthrough sale of

CryptoKitties. NFT.NYC was the brainchild of a sixty-two-year-old Australian businessman named Jodee Rich, whom I grabbed coffee with to better understand his vision of the NFT industry a decade into the future.

Rich was a very tall, very bald man with whiskers protruding from his earlobes that made him look much older than his actual age. His propensity for formal business attire and crisp shirts made him an outlier among the millennials in hoodies who populated the conference.

But his path into the blockchain world was similar to that of Seth Goldstein and other tech industry veterans who had been burned during the 2000 Dot-Com Crash. Rich started his career in the 1980s, selling financial software to merchant bankers, and became one of Australia's most notable entrepreneurs a decade later when he founded One.Tel, which became the country's fourth-largest telecommunications provider, with a market capitalization of A\$3.8 billion in 1999.[4] Two years later, regulators blamed Rich, then the chief executive of the company, for overspending and accumulating reported losses of A\$291 million. He ultimately resigned, One.Tel dissolved, and the Australian Securities & Investments Commission sued him for A\$92 million over the company's collapse. The implosion of his career was so spectacular that some business-school professors use the One.Tel disaster as an example of poor corporate governance.[5] Rich battled the government for eight years until, in 2009, the court finally exonerated him of the charges.

In the 2010s, Rich had reemerged as a thorn in the side of social-media websites. Through another company, People-Browsr, he sued Twitter in 2012 to stop the platform from cutting his access to the Twitter Firehose, an information stream that gives companies detailed insight on user activity. Rich eventually settled with the corporation outside of court, but his conviction grew that Web2 companies had too much control over personal data.

With the right amount of investment and infrastructure, he believed, NFTs would be the next social network. "NFTs are objects that allow people to express their identities," he told me, explaining that PeopleBrowsr had contracts with luxury brands like Coach and consulting firms like Pricewaterhouse-Coopers (PwC) to build a blockchain system around corporate swag. It sounded trivial, but those NFTs were like little black boxes of data that placed consumers and clients into a network.

After interviews with dozens of crypto artists and venture capitalists, I had come to expect a certain level of panache to their presentations on the digital utopia known as Web3. But here was one of the most influential men in the NFT industry, calmly sipping his coffee and explaining that blockchain represented the next chapter of corporate hegemony. Rich owned very little cryptocurrency and discouraged his staff from investing in coins; he never engaged in the secondary market for digital assets, and he owned no NFT artworks.

So, when I asked the businessman about the prevalence of crime within the cryptoeconomy, he simply shrugged. "Your concerns about trading and someone being prosecuted have very little to do with the NFTs used for the redemption of rewards or our work with PwC and Coach."

Rich represented the interests of large corporations that invested in NFTs as branding tools for developing unique social networks among their consumers and as mining tools to extract larger data sets from users than social-media companies would supply. He was especially keen on the gradual implementation of NFTs by event promoters like Live Nation and its subsidiary Ticketmaster, which had started to sell the digital assets with ticket purchases. This was a side of the industry that most journalists ignored, because there was ostensibly no money trading hands. But the companies didn't need a thriving secondary market to justify the business; within a few

months of the program, Live Nation had more than 126,000 owners of NFT *Live Stubs,* and a wealth of data connecting fans with their favorite musicians.[6]

"I have a laser focus on building a company in a space that is evolving, and I have never seen a market evolve as quickly as this," Rich said. "And what I love about this space is that the blockchain makes the user data completely open."

The businessman predicted that, in a decade, NFTs would become integrated into the fabric of internet commerce and culture. Users wouldn't think twice about the smart contracts underlying their purchases, because companies like Live Nation and Coach wouldn't talk about the technology. It would just be a purchase like any other, probably hidden within the terms of service agreement that most internet users already zoom past.

"Who would have thought in the 1990s that domain names for websites would become such an important part of our lives?" Rich observed.

"So will NFTs become part of the internet's infrastructure?" I asked.

"It will become the internet," Rich answered.

During the downcycle, Web3 entrepreneurs shied away from bombastic speeches about democratizing art and destroying gatekeepers. More pragmatic goals were forged in the crypto recession that sought to replace existing digital infrastructure with NFT technology.

There were glimmers of potential far outside the art world in unsexy industries like health care, in which doctors and block-chain developers were creating NFT programs to authenticate medical records that patients could store in their digital wallets. A dermatologist named Usama Syed had become a consultant

for health-care companies looking into such Web3 tools, and he believed NFTs could solve the logistical challenges that he and other medical professionals faced.

"It's all the boring stuff," Syed said, underselling the potential. From authenticating antibiotics and Botox injections to simplifying the transfer of medical records and lab results between clinicians, he believed that NFTs could streamline patient care. Tokens could also improve recruitment efforts in medical research, the dermatologist added. "You can envision a future in which people can opt into an application layered on the blockchain to enroll in clinical trials," he said. "Health care is an industry where the data is already financialized, so let's make a future where patients are in control."

A California startup called TransCrypts was already testing these use cases in Europe and Asia. During the pandemic, the company had partnered with Doctors Without Borders to register Covid-19 vaccinations in India and Afghanistan. Patients without reliable access to medical institutions could be assured that their records were being stored on the blockchain. TransCrypts also helped refugees fleeing Russia's war in Ukraine, uploading the medical records of more than five hundred families onto their network and providing patients with NFTs that served as portals to that information.

"Families that are fleeing persecution often don't have time to bring their medical records with them," explained Zain Zaidi, the company's founders. "Maybe you bring a birth certificate if you are lucky. So, when you come to a new country, your health-care records usually start at zero. Immigrants will often get misdiagnosed or given prescriptions that trigger allergic reactions."

However, given the reluctance of the medical industry to embrace new record-keeping systems—it took nearly twenty years for doctors to transition to electronic files—experts like Zaidi and Syed estimated that it would be another decade or

so before progress was made on the blockchain. They were less worried about these systems receiving HIPAA certification than they were with the powerful companies running the oligopoly that held medical records. Two companies, Epic and Cerner, controlled more than half of the entire $25.8-billion industry, and neither organization was ready to forfeit power over health-care documents to patients.[7]

But there was no industry with more potential for NFT adoption than the video-game industry, though attempts to convert players into token traders had mixed results. *Axie Infinity's* disastrous hack cratered the "play-to-earn" model that became popular during the bull market, and gamers were aggressively outspoken against traditional developers who attempted to tokenize content. But that didn't stop many gaming studios from pushing ahead. Square Enix, the developers behind franchises like *Final Fantasy* and *Kingdom Hearts,* even sold a large amount of its subsidiary studios and intellectual property, including the *Tomb Raider* series, for $300 million with aims to invest in blockchain projects.[8]

One of the stranger events that I attended during NFT.NYC intended to bridge the gap between video games and art. During a private event at the Explorers Club on East Seventieth Street, I witnessed the intermingling of distinguished museum curators and gamer bros in bucket hats who schmoozed between the wood-paneled walls, an intricately carved stone fireplace, and a taxidermied polar bear. On display were several ancient weapons that a private collector hoped to monetize as NFTs used in a future game called *The Knights Who Say Nah.* The weapons master was an affable man with a chest tattoo named Nick Richey, who provided an overview of the items on display, including the genuinely famous Harriet Dean Alexandria Sword and a Viking Ulfberht Sword from the ninth century.

"People light up when they see the objects," Richey said,

reminiscing about how often he had geeked out about the ancient arms collection. "When the stories aren't told, the cultures die."

Above the weapons display is a cartoony advertisement for the NFT video game, which includes characters who might wield the digital re-creations of the swords on display, including a Viking, a samurai, a skeleton, and a medieval knight.

Richey spoke very quickly as he walked me around the exhibition, emphasizing how video games like this could improve public access to private collections of antiquities. I asked if he was tired, having made all the preparations for the event.

"I'm running on fumes right now," he said, admitting that he had just come from a film premiere. In addition to being a weapons master, Richey was attempting to conquer Hollywood with an autobiographical film called *1-800-Hot-Nite*. Online, the movie's synopsis read: "When 13-year-old Tommy loses his parents to a drug raid he turns to a phone sex operator (his fairy godmother) for help as he embarks on an urban odyssey to escape foster care with his two best friends."[9]

The evening transitioned into a series of speeches meant to provide context and credibility to *The Knights Who Say Nah*. Besides Richey, a curator from the Worcester Museum of Art named Jeffrey Forgeng praised the project for creating precise digital replicas of the ancient arms using photogrammetry and 3D modeling. (A $10,000 donation to Forgeng's museum on behalf of the NFT project seemed to imply that Forgeng's words of praise came at a cost.) Also in the crowd was the Metropolitan Museum of Art's own arms-and-armor curator, Pierre Terjanian, who said that he admired the project's ability to reach new audiences. (Of course, he was also there as a courtesy; the private collector was offering one of the weapons on display, a medieval war hammer, to the Met department as a loan after the event ended. So, although the museum employees might

have been resistant to acquiring NFTs, they were certainly not above humoring their donors.)

Terjanian and I got into a deeper conversation about the authenticity of presenting ancient weapons in digital space and the limitations of technology in translating the experience of holding a sword. But both of us landed on the idea that there was massive appeal in the concept. Almost one hundred million people have played games from the *Assassin's Creed* franchise, for example, which takes place in historical settings like Viking England and Ancient Egypt. Wouldn't a sizable portion of that audience pay money to handle authentic weapons from the eras they were visiting?

By the time I left the Explorers Club, I had witnessed a woman fainting in the middle of the exhibition hall, I had held a Dresden Rapier in my right hand, and I had contracted coronavirus. It was an eventful and exceedingly strange night, but one that left me convinced that, in the long term, projects like this might enhance the gaming experience.

Elsewhere in the NFT market, the novelty of blockchain-based artworks was wearing thin, and the marketplaces that catered to digital art were racing to consolidate their gains in the traditional art world to achieve stability. To hear more about the digital art market's chances of survival, I headed downtown to Chelsea, where Erick Calderon was staying for the conference. The crypto industry had taken over a futuristic-looking hotel, recognized on the skyline by its porthole windows and metal exterior resembling the hull of a cruise ship.

Calderon's star was ascending that summer. His efforts to distance himself from speculation and brand himself as a connoisseur of quality in the NFT market had opened doors in

the traditional art world. After touring the European art fairs and exhibitions, the businessman arrived home with a partnership deal between Art Blocks and Pace Gallery. The announcement that a Web3 startup would share resources with one of the world's largest art emporiums helped buoy the company through turbulent times. Separately, both companies had started to develop their own white-glove services for collectors who didn't want to sully their wallets with crypto transactions. These buyers would pay a premium in dollars to have their dealers complete NFT purchases on their behalf. Of course, it undermined the blockchain's record-keeping system to have the transactions occur offline, but the value of provenance was always secondary to a sale.

Not long after the partnership was announced, *Chromie Squiggles* increased in value: their floor prices nearly doubled in value, to $15,000.[10] Calderon joked that his NFTs were better than stablecoins: his collectors held on to their squiggles, and the prices only seemed to increase. Yet the businessman insisted that he was entirely serious about shifting the conversation away from market mayhem. He predicted that we were entering the next phase of the metaverse, when NFT technology would become a feature and not a focus of the digital economy.

"The technology must take a back seat," Calderon said, arguing that generative art stood the best chance of surviving, because such works demonstrated the cultural impact of algorithms rather than the economic promises of the blockchain. "I think we are finally getting to a place where the technology has been normalized in the public. NFTs can invisibly flow underneath the artwork without drawing our attention."

And NFT technology's hogging the spotlight was not the only problem. Another was that cryptocurrencies would alienate potential collectors from his product. Calderon said he was looking for a way to leave Ethereum behind.

"But is it even possible to untether the NFT artworks from the Ethereum payments?" I asked.

"Yes, but we are terrified," Calderon responded. "Who are our main supporters? Crypto people. They are the reason we even have the funds to run a company, so we need to balance our desire to leave cryptocurrencies behind with an effort to make Art Blocks bigger than its tech."

Still, Calderon admitted that it was "borderline hypocritical" to talk about moving beyond the technology when he was still charging customers in Ethereum. And he was not entirely correct to claim (as many other businessmen had claimed) that the NFT ecosystem could operate without the exchange of cryptocurrencies. Blockchain experts laughed when I suggested that NFTs could leave crypto behind, assuring me that it would simply become a digitally authenticated file no better than a JPEG. Nonfungible tokens and their smart contracts lived on the blockchain, and the blockchain ran on cryptocurrency, a foundational aspect of the entire system. Businesses that accepted credit cards and fiat currencies often used intermediaries to hold their clients' digital assets and process payments. It was not an elegant solution in the backend, and some technologists worried that buyers were only getting a mirage of ownership, since these wallets and NFTs were not exclusively controlled by them.

Unless they wanted to lose their fortunes, NFT investors could no longer ignore the legal questions plaguing their industry as the federal government increased its capacity for prosecuting financial crimes in the metaverse. The Trump administration had expressed very little interest in regulating the crypto industry during its four years in power, meaning that officials within the Justice Department and Treasury had done very little casework. President Joseph R. Biden Jr. promised more regulations would come, but the Senate took three months after his January 2021 inauguration to confirm Gary

Gensler as chairman of the Securities and Exchange Commission. It took Gensler more than a year to build capacity and develop a semi-coherent crypto strategy.

During a June 2022 interview with *The Wall Street Journal,* Gensler outlined his desire to bring the cryptoeconomy under existing regulations. "If you want to raise money for the public, you are supposed to make certain disclosures," the SEC chairman said, adding that thousands of tokens were being traded as highly speculative assets.[11]

Regulatory hawks were frustrated that Gensler was dragging his feet on applying rules to the crypto industry. Watchdog organizations had noted that the sector was spending millions on its efforts to lobby Congress at a crucial moment: making its way through the Senate Banking Committee was a significant package of regulatory legislation that would establish a regulatory framework around digital assets. Its bipartisan sponsors, Senator Kirsten Gillibrand (Democrat of New York) and Cynthia Lummis (Republican of Wyoming), both of whom had received donations from FTX and Sam Bankman-Fried, released a draft of the bill that left some experts perplexed.

"It's terrible," said the law professor Hilary J. Allen after reading a draft. "The bill would create a new special regulatory regime for digital assets by carving them out of securities. And if you look at digital assets, which could be any computer file traded on a database, that could be any financial product these days. If crypto companies were unsure about whether they were securities or not, they always had the option of registering as securities. What they wanted was clarification that they didn't have to comply with security laws."

The Lummis-Gillibrand bill threatened to curtail the SEC's authority by cutting the agency out of the digital economy and classifying the bulk of crypto products as commodities—a definition that would put NFTs on par with gasoline, grains, and gold. It was the latest jab in a battle between the SEC and the

Commodity Futures Trading Commission (CFTC) for control over the cryptoeconomy; Bankman-Fried was attempting to influence lawmakers toward the latter because of its laxer regulatory regime. In February 2022, the CFTC had already asked the Senate for an expanded role in the digital asset industry, which would have curtailed the SEC's power. Gensler needed to assert himself and the SEC's rule more proactively if he wanted to persuade lawmakers that decentralized finance belonged within the existing framework of securities.

Traditionally, the government had defined a security under the "Howey Test," which referred to a 1946 Supreme Court case involving a citrus farm in Florida. This flawed historic measurement defined securities as "investment contracts" made through the exchange of currency to engage in a "common enterprise" with the reasonable expectation of making profit. The clunky logic of these rules provided ample opportunity for NFT investors to excuse themselves from the conversation. Unlike stock units, which were indistinguishable from one another, nonfungible tokens were defined as unique assets and marketed as collectible artworks. And although there was a yawning gap of difference between the expected use of NFTs and the reality of their deployment as financial products, their bright colors and weird designs made them look trivial to legislators. Was a *Chromie Squiggle* or a drooling uggo from *Goblintown* really worth a senator's time?

"NFTs are among the mysteries to me," Senator Lummis said in an interview with *Decrypt*, a crypto news site. "I'm learning about this from Senator Gillibrand, because she has children who have NFTs, and she's the one who is teaching me about how they are used."[12]

The senators were looking to regulate cryptocurrencies, which left NFTs on the advantageous periphery of the conversation. Although traders were languishing in the bear market, smart entrepreneurs like Erick Calderon and Jodee Rich were

finding new ways to propagate blockchain technology into every corner of the economy under the noses of regulators.

Just as the Treasury Department had dismissed evidence of illicit trading within the art market as being too small-fry without deeply studying the problem, other bureaucratic agencies took a superficial look at NFTs, noticed something was wrong, but failed to identify the root issue. At the beginning of June 2022, for example, the Justice Department announced an indictment of a former product manager at OpenSea, Nathaniel Chastain. This was the government's first insider-trading case to involve digital assets, and it had been percolating since September 2021, when a group of nearly seventeen hundred collectors joined a discussion on Twitter called "investigation allegations" to follow the blockchain money trail. One user, named 0xZuwu, found that Chastain had allegedly sent $17,000 in Ethereum from his known wallet to an anonymous wallet, which forwarded the payment to a third account.[13] Sleuths were able to identify the wallet because it held the same *CryptoPunk* that Chastain used as his Twitter avatar. What they claimed to have found was that the product manager used his foreknowledge of which NFTs would be featured on OpenSea's homepage to purchase the tokens before exposure on the website boosted their value.

Before the government intervened, OpenSea seemed to confirm the investigation's findings. Devin Finzer, a founder and chief executive of that marketplace, said it was "incredibly disappointing" in a statement. The company hired a third party to review the alleged misconduct, and Chastain resigned from his position.

It was a turning point for the entire NFT industry, which had debated whether such practices were illegal given a widespread perception that crypto operated by different rules, or no rules at all. But the fact that some traders defined Chastain's alleged maneuvers as insider trading analogized his actions to those

of a malicious stockbroker; tellingly, they were not comparing him to the art dealer who purchases paintings from artists knowing they will have major exhibitions announced to the public in the near future. It was a clear indication that, within the industry, collectors viewed NFTs as being much closer to securities than to art.

With nearly $100 million worth of NFTs stolen within the first seven months of the year, it was strange that the Justice Department was targeting a man whose alleged misconduct earned him around $67,000.[14] Chastain's arrest was more of a deterrent than a demonstration of the government's probing of the industry. And yet, when the agency brought its accusations of insider trading against the former product manager, the specific charges were money laundering and wire fraud—not security fraud.[15] Wire-fraud charges were much broader than security fraud, giving the government more leeway to prosecute Chastain while leaving regulatory questions about the status of NFTs as securities or commodities unresolved. And despite those ambiguities, Chastain was ultimately convicted in May 2023 of insider trading.

It should not have been so surprising that an industry named after cryptography had trouble deciphering its own identity. Ambiguity was baked into the system by design, and the masks that its financial products wore functioned as safeguards against regulation. NFT technology hid behind art, resisting the scrutiny of bureaucrats who had neither the expertise nor the resources to determine the boundaries between artistic creation and artistic collateral. It seemed like a dependable strategy, because the disguise shifted with every micro-movement in cultural trends. However, other attempts to misguide consumers within the cryptoeconomy lacked staying power.

Several major lending platforms characterized themselves to consumers as banks—or better than banks. Celsius Network made its fortune on such promises, promoting itself with pre-

posterously high yield rates of 18.63 percent and providing large
loans backed with little collateral. The calculations worked in a
bull market, when the firm was managing $25 billion in assets
for nearly 1.7 million users.[16] But shock waves from the crypto
winter obliterated the company's toothpick foundations, leav-
ing its investments exposed to the market. And when Celsius
was unable to satisfy the withdrawal requests from customers
attempting to recover their own positions in the sagging cryp-
toeconomy after Luna/TerraUSD's crash, the firm decided to
freeze withdrawals and other transactions. It was the closest
that decentralized finance had come to a bank run—too close
for many regulators.

A former investment manager with the company, Jason
Stone, later filed a lawsuit accusing the company of running
a Ponzi scheme by artificially inflating its value with client
money and then failing to pay investors nearly $200 million.[17]
(Celsius later fired back with a countersuit, claiming that Stone
stole from investor funds to buy hundreds of NFTs. As of this
writing, neither case is resolved.) State securities regulators
in Alabama, Kentucky, New Jersey, Texas, and Washington
announced that they would investigate the crypto lender for
suspending customer transactions. Privately, agents with the
SEC also contacted the firm's representatives.[18]

Without a mechanism for pausing the crypto market, inves-
tors panicked through the weekends and evenings. Celsius
Network declared bankruptcy on June 13, 2022, and within a
few days the price of Ethereum dropped below $1,000 for the
first time in four years—a stunning 80-percent decline from its
highest point, in November 2021. The nouveau riche suffered
from financial whiplash; people like Calderon who had stored
their newfound wealth in NFTs now had little to show for their
investments. The *Chromie Squiggles* king estimated that during
NFT.NYC his net worth had dropped by nearly 95 percent; the
value of his children's trust fund had also tanked.

A normal person would have at least mourned the loss of their nest egg to a financial rout that was roughly equivalent to what traders experienced during the Stock Market Crash of 1929, but Calderon and his ilk were comfortable with volatility. When I needled the subject with him, he took a deep, serious pause. A wide smile grew as he whispered, "It's amazing." Calderon felt that the cryptoeconomy's collapse had freed him from the expectations of degens looking to make their fortunes on Art Blocks.

Not everyone was so happy. The timing of events was such that most investors had paid for their NFT.NYC plans in the weeks before the crash, when spending a few hundred thousand dollars on luxury hotels, private dinners, and pop-star performances was a no-brainer. Suffering through this glitzy parade of NFT marketing lingo in a theater named after Coinbase, a crypto company that had just laid off 18 percent of its employees, was something else. It was like arriving at a Michelin-star restaurant on a full stomach and forcing oneself to eat through nine courses of steak tartare and salmon roe.

And even fancy dinners and cocktail hours weren't enough to pull crowds. A champagne event in SoHo for MakersPlace, the NFT platform that had brokered the Christie's Beeple auction, was so sparsely attended that the waiters congregated around the unopened bottles of wine. Mike Winkelmann was in town, but he had long ceased contact with the company executives over frustration with his cut of the profits from the legendary sale; instead, he was attending the *Bored Ape Yacht Club*'s concert series downtown with the Yuga Lab founders, one of whom, Wylie Aronow, had just moved to Charleston, South Carolina, not far from the artist's new studio.

ApeFest was token-gated. It was a collectors-only event,

serving burgers and coffees stamped with little monkeys to the partiers at Pier 17 as musicians like Timbaland, Eminem, and (the real) Snoop Dogg performed. Even at such an exclusive party for owners of the top-selling NFT collection, there were still ranks. Artists like Winkelmann were roped into their own VIP section with celebrities like Jimmy Fallon and models paid by the concert producers to dance around the venue. Many attendees felt like this was their last hurrah, a dance for the end-times with a branded crypto burger in hand. And it wasn't the only branded crypto burger in town. *Goblintown* had rented a food truck staffed by actors dressed like the deranged gnomes to throw McGoblin Burgers at passersby. One middle-aged man wearing the McGoblin costume even posted a photo of himself urinating on the grounds of the ApeFest venue.[19] "It's a really nice time to piss and poop," a fellow Goblino later suggested online, speaking with a poor affectation, as if Gandalf were giving the Hobbits potty lessons.

Artists who once believed that NFTs would revolutionize the cultural economy were caught unawares by the changing taste of collectors. Conference visitors walked around Times Square with shirts reading "Bank on Culture" and "Tokenize the World," but their definition of art was looser than their wallets had been during the bull market.

Justin Aversano was having a hard time acclimating. He had once been a guru in these parts, a short-lived shaman of the blockchain avant-garde who had courted millions in venture capital through the force of his charisma. The photographer became a quick crypto convert when his successful entry into the NFT market released him from $100,000 in debt, but his success sacked him with a different kind of bondage. Collectors expected a return on their investments. He had recently started his own line of galleries, Quantum Art, opening a flagship location in Los Angeles with plans for another spot in Manhattan across the street from the New Museum, clearly

positioning his brand as the future of contemporary art. But the Los Angeles store had opened with little fanfare. Business was apparently so slow that its manager could take a weeklong vacation right after the grand opening to attend NFT.NYC with colleagues. And at a private dinner for collectors and investors at a chic restaurant named Upland in the city's Flatiron District, two tables of about ten remained completely empty; other tickets were raffled off to Quantum Art customers.

Aversano looked tired. He arrived late to his own party, with large caffeinated eyes. The artist had earlier visited Times Square to see his work displayed on a billboard, a collaboration with the artist Nicole Buffett. The couple had recently broken their engagement; it was a sore subject, and Aversano came to the Quantum Art dinner with another woman on his arm.

This was Angela del Sol Varela. She had a fondness for floral dresses and often styled her hair in long, brown curls. As we got to know each other, she explained how she had been born in Colombia but was raised in the United States and abroad. After graduating from college, she had danced across Southeast Asia, coming to see Bali, Indonesia, as a second home. These days, however, she was focusing on climate activism and the ways blockchain technology might redistribute wealth toward green initiatives like carbon offsetting. "I am so interested in oil and pollution," she explained, "because nature is the one thing that is nonfungible, you know?"

One of the greatest arguments against the NFT market was its energy consumption. The Ethereum blockchain operated on a system called "proof of work," which requires computers to expend significant amounts of energy solving mathematical puzzles to deter malefactors from abusing the system. Researchers attempting to calculate the energy uses of the blockchain have claimed that mining Bitcoin, for example, used more electricity than entire countries like Argentina, Sweden, or Pakistan.[20] There were certainly efforts to reduce

the blockchain's energy consumption, including a plan called "The Merge" that would successfully transition Ethereum to a more efficient system of validating transactions without using so much computer-processing power.[21] But the gargantuan environmental costs of the existing system were a serious concern to many artists, some of whom had canceled their NFT projects out of concern for the environmental impact; Varela, by comparison, was selling NFTs to fund her environmental initiatives, which seemed like a circuitous route toward green peace.

According to Varela, she and Aversano had met years ago, when she "was living with a drug dealer, a healer, and a venture capitalist in Williamsburg." The photographer would sometimes stop by the apartment for healing sessions, and the couple stayed in touch, bumping into each other at parties. Both ended up relocating to California, where they went on a hike together in 2021 and connected on a deep spiritual level.

But her appearance at the dinner and the absence of Nicole left investors who had financially supported Aversano because of his proximity to the Buffett name at a loss. If he couldn't keep influential people around him, how would he become the next Larry Gagosian?

Aversano was now operating in a very different space from the DIY art scene that he had spent most of his career building. Managing the expectations and paranoias of tech investors looking to capitalize on the cultural phenomenon of NFTs was not something within his skill set. And, unlike artists like Winkelmann or Calderon, he didn't have a strong business background that might help steer him through tricky situations. That much was clear when we started talking about Noah Davis at the dinner.

About a dozen of us were seated around an oblong table, enjoying the first courses of the evening. Large burrata salads, wine, and mojitos filled the placemats. We were talking about

the lead-up to NFT.NYC and the shocking news that Davis had resigned from his position leading digital art sales at Christie's to oversee the *CryptoPunks* brand at Yuga Labs, which had acquired rights to the NFT series from Larva Labs in March for more than $100 million.[22]

"I wasn't so shocked," Aversano said off the cuff, explaining to the table that Davis had informed him he was taking the new job about two weeks before it was publicly announced. "And I'll admit it, I told some people." He went on to explain that those people bought and sold their *CryptoPunks* in the days before everyone else found out about the news.

Aversano was suggesting that his friends had committed something akin to insider trading based on his access to confidential information. It was a stomach-dropping admission, especially in the wake of Chastain's arrest, but one that Aversano had made on the record in a crowded room of NFT collectors, who mostly laughed and awkwardly nodded along to their host's reasoning that he was not directly culpable because he had never personally acted upon the information.

The photographer turned toward me and said, with a laugh, "I probably shouldn't be talking about this around you."

It was obviously something that I shouldn't have heard. I awkwardly smiled back and averted my eyes to below the table, as I typed his statement into my phone.

Aversano was supposed to be one of the good guys, but had he crossed a red line? In the days before it was publicly announced that Davis would take over the *CryptoPunks* brand, the NFTs experienced a sudden spike in popularity. Trading volume spiked over 957 percent, and 115 transactions were placed on June 18, for a total trading volume of $8.1 million; within the previous three months, there had been an average of 8 transactions per day.[23]

NFT speculators might have been foolish, but they weren't dumb. The *CryptoPunks* pump left many collectors feeling

frustrated by what they perceived as market manipulation. "If you're OK with this, you're hurting the NFT space," one investor wrote on Twitter. "You're going to get the thing you hate the most: State regulation instead of decentralized governance."[24]

According to blockchain records, several of the investors who bought into the pump had connections with Aversano. That included Gary Vaynerchuk, a prominent guru in the Web3 space with more than three million followers on Twitter and a penchant for evangelizing NFTs. He was also a collector of Aversano's *Twin Flames* series, an early supporter of Winkelmann, and an investor in Yuga Labs. But he dismissed the accusations of wrongdoing on social media: "No insight just always buy punks when I can and want to."[25]

ᙡ

The environment around the cryptoeconomy was rapidly changing during the downcycle, and no number of parties and private dinners could obscure that fact. The glamour of speculation and an earth-shattering auction had dissipated over the last two years, leaving some businessmen, like Calderon, to get serious while others, including Aversano, soldiered forth into a fantasy of an unregulated market run by artists.

Sitting in a taxicab headed back uptown, I couldn't stop thinking about how ill-equipped a starving artist like Aversano was to handle such a ruthless financial system. He had seen his photography fractionalized into tokens and monetized into venture-capital bucks. It reminded me of something the photographer had said earlier in an interview: "We want to change the language around monetization, because we are not trying to monetize, we are trying to have a livelihood."

Looking for answers during my long ride home, I started scrolling through Aversano's Instagram. A post from May 22, 2020, provided a window into the artist's thoughts about the

economy before he was consumed by it. This was nearly a year before he tokenized *Twin Flames* and earned his millions. There were two images. One was a photograph of a Jim Morrison lookalike posing in the branches of a tree in California. The other depicted the artist's uncle, sitting on the stump of a tree in Italy. Aversano was thinking about the role that nature played in defining people and their surroundings, and how money had disrupted those relationships.

"Money is instrumental and it cannot buy you intelligence or happiness," he wrote in the caption. "Life was made to be simple. But, at some point we swayed from the natural path and found ourselves trapped in an economic loop of depression and anxiety. Living paycheck to paycheck instead of fruit to tree. Does technology serve us, or do we serve technology?"[26]

THE ESCAPE PLAN

Deep in the swampland suburbs of Charleston, South Carolina, a road wound through the palmetto trees and culminated at an unmarked industrial complex wedged between distribution centers for Budweiser and Walmart. Inside was a fifty-thousand-square-foot production studio with museum-quality galleries where more than a dozen employees tinkered with doodads and dark hallways were illuminated by almost 150 television monitors. Ambient music piped through the speakers as the boss, Mike Winkelmann, sat in his office, his back to six cable-news channels playing on mute. The adjacent wall was decorated with a framed portrait of Super Mario undergoing a bloody Cesarean section with a green 1-UP mushroom emerging from his womb.

"It's one of my favorites," the artist said, patting the dead plumber's bare chest before turning around to gauge my surprise.

Winkelmann was finally letting loose in July 2022. He had grown comfortable enough to joke about his twisted creations on the second day of my visit to his mad laboratory. After nearly eighteen months of nonstop travel, crypto parties, and media interviews to secure his place in pop culture, Beeple had returned home. Relaxed in his studio, how would he respond to my own observations about his journey over the last two

years? And could we finally settle the question: Was this artist more than his market?

"I am focused on legacy now," he said. "It's about the real shit that people will give a fuck about two hundred years from now. Who cares about a stupid auction anymore? I don't care."

His studio was unlike anything that I had seen in the ramshackle lofts and cramped Brooklyn quarters of his classically trained counterparts. Most professional artists inhabited the public's romantic ideal of cluttered paint canisters and stacked canvases. Even the wealthy ones who could afford several assistants preferred working in a fire hazard. A chaotic environment was thought to stimulate the creative genius; besides, collectors were impressed by bohemian squalor. It reminded them of Rembrandt and other starving artists. Winkelmann, however, was going in a completely different direction by mimicking the grayscale corporate offices found inside video-game companies and tech startups.

It hadn't taken long for the artist to realize that the beige home office where he completed many of his *Everydays* was not a suitable workspace for the world's richest digital artist. The room was a bland reminder of his days shilling for concert promoters and corporate events; he chafed at the memories of being told what to do by marketing executives. So Winkelmann ordered a redo shortly after receiving his earnings from the $69.3-million Christie's auction. Like so many tech entrepreneurs, he moved into a garage.

"For some reason, we thought that we would be there for years," Winkelmann said, fondly recalling the 450-square-foot garage at his brother Scott's house that had served as a launchpad for the next phase of Beeple's career as a fine artist.

Becoming a celebrity had been difficult for Winkelmann, a self-professed "control freak" who found himself powerless to stop the metaverse maniacs from worshipping him and the snobbish critics from panning his artworks as glorified JPEGs.

It was difficult for a man to become a symbol. It was unnerving to receive suspicious packages on your doorstep at strange hours from the crypto sleuths who had tracked down your address. It was uncomfortable explaining to your wife and young children that an armed guard would be stationed nearby for their own safety.

Sometimes, those feelings of insecurity that Winkelmann inherited from NFT mania made it all feel pointless, as if his rise to token supremacy had come as a Pyrrhic victory: one that brought wealth at the cost of his own identity. He needed to prove his worth as an artist. He needed to show that he wasn't just some one-hit wonder propped up by the crypto industry. So, however contrived it was for a millionaire to move into his brother's garage, Winkelmann needed a fresh start to push forward.

The garage quickly filled with 3D printers and electrical components required to create the artist's first sculpture, the rotating video installation called *Human One,* which Beeple had envisioned as his new employees wheeled a shipment of flatscreen TVs around the cramped studio.

"Then I was like: *We should roll them into a little box unit,*" the artist had said in promotional material ahead of the sculpture's sale at Christie's. "And so we did that and, oh man, it was just fucking insane. We immediately realized that this configuration of screens was a powerful canvas."[1]

Human One used four ultra-high-resolution monitors to produce an optical illusion that blurred the distinctions between digital space and reality. The sculpture housed an explorer walking across an imagined world on a twenty-four-hour loop that would be continuously updated by the artist throughout his lifetime. The first update was a political statement against Russia's war in Ukraine, placing the explorer (a Beeple avatar) in a bombed-out battle zone.

Ryan Zurrer, the crypto venture capitalist who ultimately

purchased *Human One* for $28.9 million at a November 2021 Christie's auction, understood that he was buying into the Beeple mythos. He reasoned that art collecting should be approached just like buying Bitcoin, in a philosophy he described as "Proof of Art Work." When investing, he calculated value by adding capital expenditures and operational expenditures. Zurrer claimed to have adopted that same cold algebra for evaluating *Human One,* believing that Winkelmann stood the best chance of surviving the NFT market crunch in the years ahead.

"We ask ourselves how much time, effort, collaboration, innovation, artistic merit and training went into the piece at hand," he wrote in an article justifying the purchase. "I ask myself, is it rare? Is it culturally important? Is it innovative either technically or in the story it tells and the emotions it evokes?"[2]

Winkelmann was doing everything within his power to survive the oncoming slaughter, and his campaign to convert the traditional art world into believers in digital art was paying off. While tinkering on *Human One* in his brother's garage, the artist had cultivated a friendship with a firebrand curator named Carolyn Christov-Bakargiev, director of the Castello di Rivoli Museum of Contemporary Art in Turin, Italy.

Even for an industry filled with eccentric personalities, Christov-Bakargiev was a cut above the rest. She was an American expat from New Jersey who briefly dominated the European art scene in 2012, when she curated *Documenta,* a quinquennial art exhibition in Germany known for its tastemaking prowess. That year, she became the first woman named as the most powerful person in the art world by the magazine *ArtReview,* listed above the mighty gallerist Larry Gagosian.

Over the next decade, she cultivated a reputation as a risk taker willing to take bets on the future when other museum directors preferred to let history divide cultural value from cultural fluff. And, despite losing some support by taking those risks, she had remained a fixture on the European art-party circuit, omnipresent at gallery openings with a champagne flute in hand.

Even though she had a chokehold on the art world, Beeple's breakout success caught the curator by surprise. "Carolyn reached out shortly after the auction. She thought I was an algorithm," Winkelmann recalled with a laugh. "Immediately, we clicked."

She became his guru, tutoring the artist with near-monthly sessions about important art-historical figures like El Greco and Rembrandt. Winkelmann started incorporating these lessons into his work; imagery from iconic paintings like Francisco Goya's *Saturn Devouring His Son* appeared in his *Everydays*. Before long, Christov-Bakargiev had become Beeple's greatest ally in the traditional art world; the curator even initiated plans to exhibit *Human One* at her museum in Turin opposite the Francis Bacon painting *Study for Portrait IX*. She thought the works contrasted nicely. "Bacon's man is tormented in his Cold War, post–atomic bomb era, and you get the feeling he can't do anything," she said, "and then there is Beeple's character, constantly moving but in its box."[3]

When the exhibition closed, Christov-Bakargiev helped arrange a world tour for *Human One*. The sculpture's first stop was in Florence, at the Fondazione Palazzo Strozzi. That museum, located only steps away from where the Medici family developed cultural patronage into an expression of political power during the Renaissance, used Beeple's artwork as the prime example of digital art's triumph. *Human One* was given pride of place in the show, situated one floor above an exhibition on the Renaissance artist Donatello, widely considered the

greatest sculptor to have ever lived. The curators had made an extraordinary juxtaposition, implying that Winkelmann had inherited one of art history's greatest legacies.

But the artist still had much to learn. And that summer, while the crypto industry braced itself, Winkelmann was getting his honorary degree in art history as Christov-Bakargiev's arm candy to the world's most exclusive cultural events. The pair were spotted together at the Venice Biennale, a citywide exhibition that is considered the art world's version of the Olympics. Though Winkelmann couldn't name a single artwork that he saw during the show; most of his time was spent schmoozing alongside his curator at the private parties held in the marble palazzos along the Grand Canal. Honestly, ignorance was a badge of pride among the culturati. Traveling to far-flung destinations with the goal of seeing art, only to spend most of your time nursing a hangover, was an honored tradition, and Winkelmann seemed well acquainted with the custom.

However, he did manage to attend the Decentral Art Pavilion, a satellite exhibition produced by crypto companies to promote NFTs with digital works by Erick Calderon, Justin Aversano, and others. Beeple was a centerpiece of the exhibition, which included an immersive installation of his *Everydays* within the seventeenth-century palazzo where the show took place. The exhibition was well attended but poorly reviewed. Sebastian Smee, an art critic for *The Washington Post*, described the artworks as "tasteless and pointlessly surreal" while "the ambiance was somewhere between that of a particularly bad high school art exhibition and a video game expo."[4]

Curators were much more forgiving than the critics, who still eagerly awaited the demise of NFTs. Many, like Smee, were crouched for the kill, waiting to declare the blockchain technology as an outlier of a longer historical relationship between artists and technology. The Venice Biennale's main exhibi-

tion, *The Milk of Dreams,* gestured toward that relationship throughout its halls, and the curator, Cecilia Alemani, devoted an entire gallery to Vera Molnár's computer plotter drawings. The ninety-eight-year-old's experiments in generative art during the 1970s had laid the groundwork for NFT artists like Erick Calderon and Tyler Hobbs to explore the boundaries of algorithmic chaos, as previously explained in chapter 2, and it was clear that Molnár was finally getting an international stage because of her financially successful heirs.

After his celebratory reception in Italy, Winkelmann traveled with Christov-Bakargiev to the latest edition of *Documenta* in Kassel, Germany. The exhibition put the artist outside of his comfort zone. For many years, Beeple had styled himself as an outsider working toward recognition from an establishment that hated new ideas. *Documenta* was the establishment in many ways, yet the exhibition showed the art world's capacity for novelties. The exhibition was organized by an Indonesian collective of ten core members called Ruangrupa who believed that anything could be art. Accordingly, the show included vegetable plots, a plywood sauna, a skateboarding halfpipe, Britney Spears karaoke, and a kink-friendly nightclub.[5]

Winkelmann was out-weirded by the selection of socially conscious installations and playtime experiments at *Documenta.* "I didn't see a lot of work that I connected with," he explained to me. Only one sculpture captured his attention, a small contraption made by the Nhà Sàn Collective from Hanoi, Vietnam, that periodically raised a pole and slammed it on the ground. The terrifying *thwack* shocked viewers, causing many of them to yelp in surprise. Winkelmann loved this literal slapstick comedy, which I suppose was unsurprising from a man who made millions by doodling penis jokes about tech executives.

The artist returned from Europe with a renewed sense of purpose and the confidence that nothing he produced would

ever be as strange as what he had witnessed in Germany. And after a quick schmooze through Art Basel in Switzerland and the goblin-ransacked remains of the NFT.NYC conference, Winkelmann finally returned to Charleston as construction workers put the finishing touches on his studio.

ᚠ

Upgrading from a garage to a large industrial complex outfitted with all the desired bells and whistles had cost Beeple about $10 million for renovations and capital improvement in the seven months since he started renting the location. Nearly a decade ago, the building contained offices for a Swiss company offering sterilized medical equipment. Then it had a short life as an oversized Mandarin school for the few Chinese families living in the surrounding area. And, more recently, the venue had served as a location for the filming of a Netflix series called *Outer Banks*. Each owner had retrofitted the building according to their own purposes, and now it was Winkelmann's turn. He turned the medical-equipment company's drab offices into workshops where his assistants developed new digital tools and welded together experimental versions of the rotating sculpture that contained *Human One*. A classroom from the Mandarin school was retrofitted into a conference room decorated with a collaged vinyl printout of Beeple's *Everydays*. And the warehouse used for filming the television show was converted into two massive exhibition halls designed to rival the galleries at MoMA, providing the artist with the capacity to produce his own museum-caliber exhibitions. There was also a cluster of family offices nestled in the studio's west wing, where the artist's mother, Dottie Winkelmann, sat at her desk writing the story of her family's history and her son's miraculous fortune.

There was an intense effort among the Winkelmanns to rationalize and repackage the Beeple name into a prestige

brand. Scott became his brother's chief technology-and-operating officer, responsible for most of the sales, logistics, and hiring decisions that occurred inside the studio. He had joined the family business shortly before the Christie's auction in March 2021, turning his back on a decade-long career as an engineering manager at Boeing. The connection between airplane manufacturing and art making was not immediately apparent, but Scott did his best at turning corporate knowhow into a plan for cultural domination by investing the family fortune into a studio that would allow his older brother to operate independently of gallerists and other middlemen.

Europe had clearly changed the scope of Winkelmann's ambition. A man once accustomed to the instant gratification of the NFT market was now thinking about legacy—not what his career would look like a couple years from now, but for centuries.

"Hundreds of years from now, artists will only have one or two things that stand the test of time. And I think that I have made only two things that are actually good," Winkelmann said, referencing his two highest-selling artworks: *The First 5000 Days* and *Human One*.

He made his point without any emotion behind the words, like it wasn't up for debate. As if the scorn of his detractors had seeped into his veins and become biology. It was a simple fact that the artist hated almost everything that he had created before becoming famous.

I held my tongue, believing that the artist was wrong about his own legacy. Without the *Everydays*, there would be no career worth discussing. The *Everydays* were like portals into a subconscious overloaded by mass media and nurtured in the junkyard of a YouTube animation studio. The people and objects that occupied this digital netherworld were composed of ready-made assets stashed away in the filing cabinets of a search engine. Beeple explored these abandoned stockpiles like

a scavenger, redistributing their odds and ends into a gutter harvest of digital culture.

Were the resulting images crap? Yes. And so what if they were? Other artists got famous on the stuff. Christopher Ofili painted his portrait of the Virgin Mary using elephant dung; Piero Manzoni sold cans of his own shit to collectors; and Andy Warhol made his *Oxidation Paintings* by urinating on copper-painted canvases.

Most contemporary art critics had learned to tolerate excrement when it was confined to painting or sculpture. However, Beeple trafficked in the sewers of the digital world and built monuments to the worst aspects of popular culture: its amnesiac and memefied mess of short-lived references and shitposts; its aesthetic of battery-acid colors, Digimon landscapes, and sex gags; its mental prolapse, an epistemological abyss where the internet, the greatest library of human knowledge ever to exist, collapsed under the weight of its own bookshelves. All that remained in the debris was a cyborg impulse called the present. Despite the everyday internet crap and decaying logic of search-engine optimization that clouded his vision, Winkelmann created art.

Though it wasn't an especially common interpretation, I had come to view Beeple as the internet's answer to Claes Oldenburg, a Swedish-born American artist whose oversized sculptures of everyday objects made him into a leader of the Pop Art movement during the 1960s. Around the same time that Warhol was elevating soup cans and Brillo boxes into cultural icons, Oldenburg was meticulously transforming everything else in the corner store (cigarettes, lingerie, hamburgers) into sculptural curiosities. If art was doomed to become a commodity, he reasoned that commodities could become art.

Oldenburg devised experiments that tested his hypothesis. In March 1960, the artist stepped into the basement gallery of Judson House in lower Manhattan to install *The Street,* a

constructed environment made from cardboard, burlap, and newspaper that together create an immersive panorama of a bustling city.[6] These sculptures were scenery for a performance called *Ray Gun Show,* a satire of the art market in which Oldenburg offered audiences large sums of imaginary money in bills ranging from $1,000 to $7,000.[7] Viewers used their Ray Gun currency to purchase objects from *The Street,* leaving the stage almost barren. The experience proved to Oldenburg that art had currency in the political economy, that it could be compared to and exchanged with other notional stores of value.

A year later, his "Ray Gun Manufacturing Company" opened a location in the East Village called *The Store,* which replicated the cheap look and inventory of the neighboring dime shops. The goods were mostly made from cloth soaked in plaster, shaped into ugly clumps that were garishly colored to resemble baked potatoes, ice cream, blue shirts, yellow dresses, and other knickknacks. It delighted Oldenburg to see his storefront circumvent the traditional process of selling art through a gallery. Now he had a front-row seat to the visitors straining their eyes trying to identify the sculpted blobs near the register. "It's a lady's handbag . . . No, it's an iron. No, a typewriter. No, a toaster. No, it's a piece of pie."[8]

Contemporary art was like an inkblot in a Rorschach Test, changing its appearance depending on the viewer. Anything could be anything else within its political economy, and artists had the freedom to explore new roles within the system. It just so happened that Oldenburg enjoyed the role of shopkeeper. And, with his hypothesis proved true by *The Store,* the artist started scribbling more surreal comparisons in his notebooks:

cock and balls equals tie collar
equals leg and bra
equals stars and stripes

flag equals cigarette package and cigarettes heart equals
 balls and triangle
equals (upside down) girdle and stockings

Obviously, the artist had a passion for Freudian slips and psychoanalysis, which led him to conclude that the origins of American consumerism could be traced back to the human libido. He had once described *The Store* as "fragments of the field of seeing" that could have "an unbridled intense satanic vulgarity unsurpassable, and yet be art." More than a decade before young financiers discovered that contemporary art could become a battleground for their egos, Oldenburg sought to manipulate the value system of collectors by inuring them to especially ugly sculptures. It was devilish. It was genius. It conceded that art buying was really no different from buying a chocolate bar.

As his sculptures grew to monumental heights, Oldenburg retained his fascination with the mundane and a desire to mess with the audience's expectations of highbrow art. Critics alleged he was from "the cuckoo school of art"[9] for putting a giant clothespin across from Philadelphia's City Hall in 1976. But even funnier than the backlash against Oldenburg was the praise he received decades later for his massive creations. In 2009, the Whitney Museum of American Art opened a retrospective honoring the artist. Installing the exhibition required three employees to reassemble one of his sculptures: *Giant BLT (Bacon, Lettuce, and Tomato Sandwich).* In a video advertising the show, art handlers wearing latex gloves delicately placed the painted bacon on a bed of vinyl lettuce as the curator Dana Miller remarked on the meat's "curvy and sensuous form."

"I have never looked at a BLT sandwich the same," Miller said as the sandwich's white bread was placed atop the bacon. "It makes you look at your world with fresh eyes."[10]

Any artist who forced highly educated curators to speak like that was worth their salt in fake bacon. Such was the power of Oldenburg. He fooled elites into revering the mundane as art, clowning them into admitting that just about anything could have artistic value.

"I am for an art that embroils itself with the everyday crap and still comes out on top," Oldenburg wrote in 1961. "I am for an art that imitates the human, that is comic, if necessary, or violent, or whatever is necessary. I am for an art that takes its form from the lines of life itself, that twists and extends and accumulates and spits and rips, and is heavy and coarse and blunt and sweet and stupid as life itself."

Winkelmann said much the same thing during my studio visit. And if he were a better art-history student, I might have accused him of ripping a page from Oldenburg's notebook. Through his *Everydays,* the digital artist had stumbled upon the same fundamental curiosities that turned Oldenburg into one of the greatest sculptors of the modern age. Like his predecessor, Winkelmann played with imaginary currencies and mundane objects, taking the seemingly insignificant crap on the internet (today's dime store) and glorying it through a computer program that allowed him to rearrange digital assets like scenery on a stage.

Beeple is like a performance. He is an avatar of the information economy that has replaced the manufacturing economy of Oldenburg's heyday. In this new environment, where originality is long dead and artistic value has been hijacked by capitalism, Beeple intuitively understands that the artist's role is to mark time through the shreds of imagery and inside jokes posted on social media. Like the predictive algorithm of a social-media company that determines the addicting contents of your newsfeed, Beeple preselects viral memes from the dreck of online chatter and corporate IP. The strongest *Everydays* synthesize the flotsam of digital culture into pictures like *Vice City,* where

Ocean Spray containers tower above an imaginary city skyline in homage to a briefly viral TikTok starring an Idahoan swigging cranberry juice while skateboarding down a road. *The First Emoji,* another example, presents the winky-face emoji as a fifteen-story-high wooden structure constructed by medieval townsfolk in a desert. Like Oldenburg's *Clothespin,* Winkelmann's *Everydays* are immediately recognizable for the general public. They are totems of internet time, symbols of banality in a society happy to spend its days online and its nights exploring a dreamless virtual world.

From behind his desk and only a few inches from his face, six televisions aired the muted dribble of 24/7 cable news channels, which Winkelmann scrutinized like a stockbroker reading his Bloomberg Terminal. What he gained from watching these programs on CNN and Fox News likely amounted to only a few minutes' advantage before it filtered into the Twitterverse, but it was enough time to start imagining his next *Everyday.*

"I have always been a big news junkie," Winkelmann said, justifying his addiction.

During my studio visit, Boris Johnson announced that he was stepping down as the U.K. prime minister. "I thought, Hmmm, maybe I want to make a cross out of somebody's head," the artist said. So he constructed a crucifix on a grassy plain composed of about five dozen versions of Johnson's face. *Pray for Bojo* became the title, referencing a *Simpsons* episode in which Homer gets a monkey helper named Mojo that becomes lazy and overweight. It was classic Beeple, both bracing and a little on the nose.

The next morning, we reconvened in the artist's office, where another shocking chiron appeared across the television screens: someone had assassinated Japan's former prime minister Shinzo Abe. The politician was shot in broad daylight while campaigning for an ally's upcoming election. Through

Winkelmann's eyes, it was yet another example of the world going to shit. He paced around the office, debating which was worse: gun violence, government surveillance, or the spread of misinformation by extremist groups.

So I had assumed the next *Everyday* would reference the assassination; instead, Beeple released an image of a muscular Elon Musk fighting a Twitter bird. There were two major reasons why the artist might have avoided mentioning Abe's murder: pragmatism and impatience.

Technological limitations often restrained Winkelmann's imagination. If nobody else had gone through the trouble of creating a 3D model of Japan's former prime minister and uploading the ready-made onto a website hosting free digital assets, the artist lacked the necessary tools to illustrate his vision. The absence of models would also indicate to Beeple that his chosen subject was not especially popular. That was a warning sign for an artist who paid close attention to which *Everydays* triggered the largest response from his three million followers on social media. Winkelmann already knew that his audience had a limited taste for politics; doubling down on the same subject matter was not a winning formula in the metaverse, which preferred to idolize a tech overlord like Elon Musk instead of an elected official like Shinzo Abe. The artist's instinct was eventually proved right by the metrics of social media. His interpretation of the Tesla executive received nearly five times the amount of engagement on Twitter than his send-up of Johnson from the previous day.[11]

That summer, Winkelmann was careful about what he posted on social media. Investors who lost everything in the crash were eager to blame someone. Who better than the NFT poster boy? Conspiracy theories flooded the internet about how he was responsible for dozens of rug pulls; how he had forsaken the digital art community to become friends with celeb-

rities like Madonna; and how he secretly created *Goblintown* to squeeze the last ounces of profitability from a dying market.

$$\mathsf{M}$$

All the contradictions of speculation and volatility that fueled the bull run were starting to look hideous in the unforgiving spotlight of a market correction. NFTs were headed toward the bonfire in July 2022, as OpenSea announced layoffs for a fifth of its employees, and trading volume on its website declined by nearly 99 percent within a three-month period. (The company said these two facts were not causally related.) A number of smaller crypto startups fell like dominoes in the subsequent weeks; they went into hibernation, with enough funds from their venture capitalists to keep a skeleton crew going for the next five years without revenue. Executives, however, still wanting to project confidence to the public, released cookie-cutter statements about optimizing their "product-market fit" and "increasing utility." Meanwhile, the industry was shedding thousands of workers.

"The reality is that we have entered an unprecedented combination of crypto winter and broad macroeconomic instability, and we need to prepare the company for the possibility of a prolonged downturn," said Devin Finzer, a founder and chief executive at OpenSea.[12] Sure, his company had a $13-billion valuation and a market share of nearly 80 percent, but Finzer recognized the considerable challenges the NFT industry was facing.

Within the course of a year, OpenSea had experienced technical difficulties, plagiarism complaints, customer lawsuits, federal probes, and a hemorrhage in the supply of daily active users. Those were expensive problems for a five-year-old company to have; however, Finzer often reminded the press

he accused of writing sensationalist headlines that OpenSea had started doing business during the last crash, in 2017, when Ethereum went from $1,300 to $90.[13] This was nothing. More concerning to him was the larger economic picture. For example, the personal savings rate had fallen from a 33-percent high during the pandemic, when Americans were hoarding cash and receiving stimulus checks, to nearly 5 percent, its lowest level since the 2008 Great Recession.[14] When paired with rising interest rates and high inflation, the numbers indicated lower consumer spending in the immediate future.

Contractions in the real economy provided the perfect cover for why OpenSea and other NFT exchanges needed to downsize their workforces. Executives could dismiss the volatility of cryptocurrencies as a feature (not a bug) of their industry; they could blame the outside world; and they could encourage traders to keep buying the dip. No need to investigate who was responsible for the industry's dangerous rate of growth, anyway, because profitability was right around the corner.

But no economic principle beyond greed could explain why so many businessmen had damaged the fundamental values of their core product. Ever since the McConaghys had invented the prototype, in 2013, nonfungible tokens were supposed to have been immutable, unique, scarce, and transferable. How many of these attributes still existed in the tokenized economy? The fractionalization and flipping of top series like *Crypto-Punks*, *Bored Apes*, and *Everydays* undermined the premise that tokens were indivisible or unique. The imbalance of supply and demand—there were five NFTs for every buyer—exemplified overabundance, not scarcity. And although transferability was embedded in the market infrastructure, it relied on fee-extracting middlemen like OpenSea.

Consumers and regulators had given the industry nearly two years to understand what it was selling, but the frenzied

failure to develop a consensus around the technology only caused whiplash. Even though NFTs were supposed to fill artist pockets with money, many collectors looked to sidestep the royalty clauses of their smart contracts.[15] NFTs were supposed to improve gender parity in the art market, yet more than three-quarters of all sales benefited men.[16] NFTs were supposed to democratize art collecting, yet a small group of insiders with access to presale discounts were reaping the bulk of trading profits.

As everyone who has ever worked with Winkelmann told me, he was a shrewd businessman. The artist had called bullshit early in the hype cycle and planned, accordingly, to ignore the misdirections of NFT entrepreneurs and use the speculative market to slingshot into the upper echelons of the art world. He had succeeded, surviving impact with enough common sense to renounce the floundering market that launched his career.

"I was never an NFT evangelist," Winkelmann insisted. "What I am is an evangelist for digital art. The selling aspect is a means to an end. I would love not to sell, because that is the least fun part, even though it's necessary. But I am not some crypto bro, because there is actually substance to what I have been doing."

For a man who had become synonymous with NFTs, he had sold shockingly little of his artworks through the blockchain. Practically none of his *Everydays* had gone on sale since his March 2022 exhibition at the Jack Hanley Gallery. He had also purchased fewer than a dozen NFT artworks from other artists.

"Most of my art will not be available in my lifetime, but all will eventually be released after I die," Winkelmann said, adding that he intentionally limited the supply of *Everydays* onto the market so that existing collectors were not "fucked over" by lower demand. And he still owned what would likely become

the most expensive *Everyday,* his first doodle in the series, a crude portrait of his uncle Jim from 2007, which was secured in a bank vault.

Few artists have had sufficient foresight to extend their willpower from beyond the grave. Andy Warhol was one such exception, pioneering the artist-foundation relationship through a very controlled and gradual release of artworks from his collection onto the market. Upon his death, the Andy Warhol Foundation for the Visual Arts reportedly acquired 4,010 paintings and sculptures.

The foundation releases more than $15 million of work every year to auction houses and galleries like Gagosian that cater to the ultrarich. The foundation's leadership decides on what emerges from the vault based on market trends. The digital art boom in early 2021 presented an opportunity to clear the archives of some of the most obscure works in the Warhol backlog. The foundation ultimately released five works created by the artist in the 1980s on his personal computer, an early prototype of the Commodore Amiga 1000. The images had been digitally excavated from floppy discs in 2014; under the advice of their Christie's colleagues in 2021, the foundation registered the digital artworks on the blockchain as NFTs. Bidding started at $10,000 for each of the lots and ended with a total sale of $3.4 million.

Although the precise number is unclear, Warhol created approximately twenty-one thousand paintings, sculptures, and drawings during his lifetime. The majority of those works are now in museums and private collections that are unlikely to consign them on the secondary market. Stock is limited. The artist is dead. So are many of his contemporaries, like Jean-Michel Basquiat and Claes Oldenburg. The auction houses needed to circulate fresh blood in their evening sales to keep business healthy. Beeple offered more than a semblance of con-

tinuity of the Pop Art generation; he offered a stable business partnership built for longevity with a growing catalogue of artworks for collectors to snag.

Every year, Winkelmann is guaranteed to add 365 artworks to his portfolio. Barring some unexpected catastrophe, he has about fifty more years to create work, which would result in 18,250 new images that could be slowly introduced to the market over the succeeding decades. Excluding any additional projects undertaken by the artist, his output would exceed the Warhol Foundation's stock and have the chance to last for more than just decades—indeed, for centuries.

I realized the scope of Winkelmann's ambition as he guided me deeper into the bowels of his studio complex, where a dark hallway bent toward a storage closet where he kept dozens of physical *Everydays*. They were attempts by the artist's global network of studio assistants to re-create the magic of his digital creations for canvas and paper. Not everything translated from the metaverse into the "meatspace," and Winkelmann rummaged through his pile of botched prototypes, saying he was unsure of how to dispose of them. He was still trying to understand the process—why, for example, his mechanized SpongeBob SquarePants BattleBot image succeeded as a print but his android doused in the refracted rainbow prisms of an oil spill failed as a painting.

Charleston was the incubation site for these projects. During my visit, there were at least five sculptures comparable to *Human One* floating around the office, as well as a physical re-creation of *The First Emoji* chained to a wooden pallet and a rubber baby pickled inside a large jar.

For the time being, Winkelmann remained focused on realizing the kind of monumental projects that only an artist with unlimited resources could imagine. The enormous hangar in his studio complex would become the stage for immersive art

installations. These projects were about getting back to his roots as a concert designer fascinated by the interplay of light and sound.

"I would love the room to feel like you're stepping into a video game," Beeple said, as he brought me through the empty warehouse where his digital dreamscapes might one day flourish. "What would the room look like if it was hell? If you were to walk in and there were piles of bodies on the screens? Then you could immediately flip a switch and make it feel like heaven."

If only there was a switch that could be flipped. The summer dip never rebounded, and the NFT market found itself bereft of buyers and overridden by crime. With the collapse of secondary sales, investors faced an economic and existential crisis. The brunt of financial capital had altered the very boundaries of human imagination and triggered the beginnings of a cultural reset—but could the digital artists and tech revolutionaries see their project through to the end? A multimillionaire artist like Winkelmann could survive the hunger pangs of a crypto winter, but there were hundreds of other artists who had uprooted their studio practices for cyberspace. The time for desperation and denialism had passed. Acceptance and scavengery were on the agenda.

INFORMATION-PROCESSING ERROR

The future of the cryptoeconomy was pinned to a software update.

It was all anyone could discuss at Justin Aversano's packed exhibition opening at Venus Over Manhattan. The gallerist Adam Lindemann had staged the show in his un-air-conditioned venue near Bowery Street; hundreds of the photographer's admirers had poured onto the sidewalk to escape the sticky heat of the white-walled venue. Many arrived at the September 2022 event to claim their physical artworks from Aversano's *Cognition* series, which they had purchased as NFTs a month earlier for about $1,600 each in an online sale that raised above $584,000 in a matter of hours, a bright light in the dank basement of the bear market.

"Do you think it's enough to pump another bull cycle?" one attendee asked, overshooting my own question about whether he liked the artwork he had just purchased. Collectors didn't have time for silly chatter about aesthetics. A change was fast approaching, and any wrong move could obliterate what was left of the NFT market.

Eight years of developer conferences and speculative roadmapping was about to culminate in the Merge, the largest upgrade of the Ethereum blockchain ever attempted. The backbone of the NFT market was prepped for adjustments

that would significantly reduce its energy consumption, and dash concerns about the blockchain's negative impact on the environment. The blockchain would switch its "proof of work" model to a "proof of stake" model, turning its verification system from an exhaustive series of algorithms solved by super-computers to a network of randomly selected validators. The "proof of stake" validators would confirm transactions and ensure that information on the blockchain was correct. The industry stalled itself for months ahead of that upgrade, praying that a successful relaunch of Ethereum could stimulate its faltering economy. Spending was down. Trading volumes were down. Public interest was down. The only thing going up was the consensus among economists that a tech recession was inevitable, which would also drive future sales down. It became obvious that the transition to Ethereum 2.0 needed to happen seamlessly or the entire market would collapse.

Not that Aversano was pleased with the tenor of conversation during his opening night. Sometime over the summer, he had decided that technology was a necessary poison best survived in small doses. The crypto collapse had damaged his aspirations, maybe even his spirit. A dream to become the Larry Gagosian of the digital art world had quickly disintegrated as his gallery, Quantum Art, struggled to cultivate a user base. His physical location in Los Angeles had become a glorified co-working space, and the New York plans were quashed, he said, by a greedy landlord who wanted to upcharge him for a venue in Chinatown. Aversano needed to save his pennies; after all, the bear market had dried the wellspring of venture capital.

What I got from conversations with his collectors was an unvarnished image of the starving-artist pathology. "I have never seen hustling at this scale," said one investor, who said they became estranged after Aversano asked them to delist a *Twin Flame* that would have brought the floor price of the art-

ist's collection below a hundred Ethereum. "He engineers the sales and regulates how collectors list the artworks."

But the artist's chokehold on the market was alienating some collectors and limiting his reach. "The community keeps growing," the investor said. "But nobody in the newer crowd has any idea what a *Twin Flame* even is." Aversano had lost the goodwill of his biggest supporters.

"Last year, everyone was throwing money around like candy; this year, it is hard to get on the phone with investors," Aversano said, explaining his difficulties at fund-raising a Series B round. In separate conversations, three employees confided in me that the company was having staffing problems and firing personnel; two artists said that their NFT projects were indefinitely delayed on Quantum's platform. So whether his business troubles were the result of macroeconomic pains, decreased support from investors, management problems, or just personal exhaustion was anyone's guess. Likely, it was a combination of all four factors.

Somewhere down the line, Aversano had decided to take a break. He traveled to the Amazon rain forest a month before his exhibition to plant trees with his girlfriend, Angela del Sol Varela. When he returned to New York, he was engaged, again.

"What can I say? I love to love," he told me in an interview, explaining that he was high on ayahuasca when they decided to marry. The couple had dated for only four months, after his breakup with his last fiancée.

Aversano said his new engagement was a spur-of-the-moment decision while the couple swung in a hammock under the jungle canopy. That literal breath of fresh air convinced Aversano that he needed to step back from the metaverse. Nature gave him balance that his business could not provide. "Last year was more about quantity," he ruminated. "But is that the culture we really want for the future?"

A saxophonist played on the sidewalk outside his exhibition

opening, under the watch of a pink *Bored Ape* on a billboard with the bromidic slogan "We're bored of celebrity brands." The monkey looked unamused; its eyes barely open, it was sleepy or lulled into a high from the smoking pipe it puffed. A friend who joined me for the *Cognition* opening joked that the *Bored Ape* reminded her of a passage from *The Great Gatsby* when the narrator, Nick Carraway, spotted a large billboard in the valley of ashes. The advertisement must have been for an optometrist. It was a blue background with a pair of enormous yellow spectacles floating over the wide eyes of an invisible face. Those unblinking eyes seemed to pierce through the polluted landscape, casting judgment on the crass commercialism that had symbolized the corruption of the American Dream in the early twentieth century. My friend suggested that maybe these new eyes of the *Bored Ape,* barely open, represented the near eclipse of judgment in contemporary life. The preemptive critique of celebrity brands by a celebrity brand seemed like a good indicator that this cartoonish form of zombified capitalism was here to stay. I hoped my friend was wrong.

The gallery slowly emptied as collectors grabbed artworks from a display. *Cognition* included 365 painted collages, which Aversano created in the aftermath of his mother's death in 2014. The small square canvases of magazine clippings were filled with naked bodies, self-portraits, and occult symbols like the Illuminati eye. Because of the intense humidity, some of these elements were peeling off the artworks' surfaces.

"The beauty of NFTs is that they're permanent," Aversano told a colleague. So what if his artworks had been damaged? "The physical dies or degrades, whereas the digital twin gets better over time on the blockchain. They meet in the middle and then go their separate ways. It's death and life."[1]

It was an elegant if pessimistic approach that characterized tokenization as a talisman against death. Aversano played on the old trope of artworks as monuments of immortality for

their patrons and the people who painted them, positioning digital art as a life force that bled money. But the photographer didn't really seem to believe his own words anymore, and he certainly took a more skeptical approach to the technology that had turned him into one of the world's most expensive living artists. Even with the Merge around the corner, he downplayed its importance simply as "news" that might energize some degens but would ultimately land with a thud. And on this point, Aversano was correct.

The Merge occurred on September 15, 2022, within the course of fifteen meetings—a success that spoke to the capabilities of developers and the technological resilience of cryptocurrencies. But the upgrade also led to a precipitous drop in Ethereum, from around $1,700 to about $1,300, where it remained for the next two months—the first evidence of price stability since the last crypto winter, which had started in 2018. Looking for excuses, the degens said that smart investors had already predicted a successful Merge during a small price rally toward the end of August. Optimists would have to look elsewhere for their silver lining, or surrender hope.

$$\mathcal{M}$$

While the goalpost kept changing in the secondary market, the strategy remained the same in business. Companies that used the art world as a laboratory for their NFT experiments saw a profitable future in the fringe benefits of blockchain technology, though it wasn't necessarily a faith in nonfungible tokens that drove their decision making.

The arts and entertainment industries finally had access to tech money. Providing a funnel for the new capital, auction houses like Christie's created their own venture-capital firms to seed startups with technology that might help collectors trade artworks. United Talent Agency translated the lessons it

learned from the Web3 world into a venture arm for investing in the crypto communities and startups. The direction of capital was clear, even from the agency's press release: "As content creators and entertainers recognize the opportunity to monetize their influence in shaping consumer behavior and culture, we believe that UTA has a robust pipeline of investment ideas and a clear vision for the future."[2]

Cultural influencers were not alone. Venture capitalists had poured a record $33.8 billion into crypto-and-blockchain-related startups by the fall of 2022, outpacing the year-end sums of 2021 and defying expectations of a crypto winter.[3] Monetization of the cryptoeconomy needed to take these more legitimized channels of commerce if it wanted to survive regulation. The battle between the Securities Exchange Commission and the Commodity Futures Trading Commission was intensifying after the Merge; threats and legal action were driving the NFT market into a panic.

SEC chairman Gary Gensler released a statement on the same day as the Ethereum upgrade, arguing that new services from exchanges offering the cryptocurrency looked "very similar—with some changes of labeling—to lending."[4] Meanwhile, the agency attempted to assert its own jurisdiction over all Ethereum transactions because around 46 percent of nodes registering trades on the blockchain were based in the United States.[5] This claim was buried in a lawsuit against a crypto influencer accused of making unregistered offerings of a token with an investing pool he had formed in 2018.[6] Then the SEC went further, unveiling a $1.26-million settlement with the celebrity Kim Kardashian, who was charged with promoting tokens without disclosing that she had received about $250,000 to advertise the digital assets.

"This case is a reminder that, when celebrities or influencers endorse investment opportunities, including crypto asset securities, it doesn't mean that those investment products are

right for all investors," said Gensler, who took the opportunity of such a high-profile charge to star in his own public-service YouTube announcement against celebrity endorsements.[7]

Gensler was smart to heavily publicize the charges against Kardashian if he wanted to win the regulatory battle. The settlement included conclusory allegations that the token she had promoted was a security without requiring the SEC to bring any formal claims, which helped push consensus among government officials that the agency should control the crypto markets because of the security-like characteristics of most tokens. Even the few regulatory skeptics within the SEC were dialing back on pro-industry rhetoric at a time when the agency was doubling its enforcement team.

Commissioner Hester M. Peirce, the SEC's senior Republican member, even admitted that some NFTs could be regulated like stocks or bonds. "If an NFT were a security and someone did make misrepresentations about it, then they've got a securities fraud kind of issue," Peirce told the *Financial Times*.[8] Only a year earlier she was on the stage of a blockchain conference in Texas championing the industry's capacity for self-regulation.

The SEC's territorial dispute with the CFTC would continue through a legislative logjam in Congress, where nearly seventy crypto bills were introduced in 2022 and died before the term ended. That hadn't stopped CFTC chairman Rostin Behnam from advocating for his agency through his contacts in the Senate by reminding them that more than $140 million in enforcement actions on crypto companies had been brought in by his office. The commission also started pursuing DAOs for illegal trading activities in September 2022, which put many of these wealthy crypto collectives on ice. DAOs were an important life raft during the bear market, spending on NFT projects with pooled resources; however, their shareholder structures and use of tokens to vote on financial decisions required more

disclosure and regulations, according to the commission. (A suggestion for increased regulations appeared within Scott Rembrandt's February 2022 Treasury report on the art market, one of that document's few successes.) Many DAOs unceremoniously shuttered their operations to avoid fines; others lawyered up and registered as corporations to join the existing regulatory market framework.

Some of the greatest blows to the crypto industry were happening in the NFT market, where the SEC outshined all other regulatory agencies. By October 2022, the commission was investigating Yuga Labs for possibly violating securities law with its *Bored Ape Yacht Club* franchise. There were several good reasons for the inquiry, including how the company portrayed itself as providing collectors with shareholder value, and the frequent liquidity crises in the marketplace that involved millions in unpaid debts on *Bored Ape* NFTs. But the most likely answer was Yuga Labs' participation in the Ape-Coin cryptocurrency based on their brand. Only thirty minutes after newspapers reported on the SEC inquiry, the price of ApeCoin took a nosedive: investors sold their positions and drained about $200 million from the market.[9]

The industry's response to the investigation was predictably strange, as investors attempted to recapture some of their bullish grandstanding from years past. Greg Solano, one of the founders of Yuga Labs, leaned into the investigation as if it were a popularity contest: "It's not that surprising, given everything else that's going on, that NFTs are getting looked at."

On social media, degens were characterizing the federal agency as a washed-up celebrity appearing on reality television. "The SEC is desperate to stay relevant. That's all this is," wrote one crypto influencer, Heidi Chakos. "The SEC is OWNED by Wall Street and completely funded by them. They HATE crypto and it shows."[10]

Nevertheless, dominoes continued falling in the commis-

sion's favor. The agency had a string of wins that autumn, which coincided with the decline of the crypto lobby's influence in Washington. Sam Bankman-Fried, the billionaire boy wonder in charge of FTX, was having money issues. The thirty-year-old executive was responsible for the bulk of lobbying dollars that went toward convincing legislators to give CFTC the regulatory power; he also dangled the carrot of more than a billion dollars in donations to Democrats ahead of the upcoming 2024 presidential election.

Those were hollow promises. But suffice it to say here that Bankman-Fried became responsible for one of the largest bankruptcies in history, a calamity that mixed the insanity of Theranos with the speed of Lehman and the scale of Enron. His net worth decreased by 94 percent during the fallout, dropping $15 billion in a single day. Later, as federal officials were preparing to charge the failed Svengali for defrauding customers, he texted with reporters about his motivations. Bankman-Fried, the son of two Stanford professors, admitted that his championing of regulations was a stunt.

"There's no one really out there making sure good things happen and bad things don't," he texted a Vox Media reporter.[11] Bankman-Fried continued by describing how all of finance was corrupt and that his public image, just like his balance sheet, was a lie.

"Fuck regulators," he wrote. "They make everything worse."

The real financial winners of the meltdown were on the sidelines of the action. Andreessen Horowitz, the venture firm largely credited with amplifying the cryptoeconomy into a speculative juggernaut, had sold a portion of its tokens in the days before the downturn started. According to internal documents, the firm quintupled their initial investment in the process, and now had $356 million in assets under management. They had played the chutes-and-ladders game of volatility and won.[12] Even if their other crypto bets went to zero,

investors would still get five times their initial investments. And although Andreessen had passed on investing in FTX, they had spent lavishly on a competing exchange, Coinbase, and large NFT companies like OpenSea and Yuga Labs.

Attorneys and digital security experts were also reaping the rewards of malfeasance. Increasingly, these consultants were needed by NFT investors and crypto exchanges to oppose the federal government in court. Most such legal actions were misguided attempts at publicity, as when Coinbase funded a lawsuit challenging the U.S. Treasury Department's sanctions on Tornado Cash, a program that allowed users to scramble their online wallet addresses when withdrawing and depositing assets. Tornado Cash helped fraudsters hide their identities by obscuring the digital paper trail; it had already been used to launder about $7 billion, which included $455 million by North Korean hackers.

A need to trace money launderers through the blockchain had also birthed a cottage industry of consultancies that helped authorities, businesses, and individuals decrypt the data shields of their hackers. The blockchain analytics firm Chainalysis, for instance, grew exponentially to meet demand, employing nearly 850 people with many specialists coming from public sector jobs in regulation. The firm worked both sides of the fence, aiding investors but also frequently consulting law enforcement on investigations.

Federal regulators grew more and more confident of their skeptical position on digital assets, which produced a chilling effect in the cryptoeconomy. Rising interest rates and rampant inflation in the global markets—the prelude to a recession— were causing investors to think twice about speculation. The influx of venture capital and the adoption of cryptocurrencies into the accounts of major financial institutions also damaged the core promise of decentralized finance, which left some investors with an identity crisis that only worsened as the gap

between fluctuations in crypto prices and the stock market closed. If cryptocurrencies could not be used as alternative assets or hedges, then what was the point?

Exhaustion peaked, and investors quietly forfeited their positions in the autumn of 2022, when the transaction volumes in the NFT market lingered at 97 percent below record highs; they would stay at this level for the remainder of the year. The few hangers-on were pushed to extremes, and my reporting on the dramatic blood-sport known as the bear market put me into contact with some of the shadiest people I had ever met in the industry.

ᴧᴧ

Martin Mobarak was the most genial member of that ruthless crowd. The fifty-seven-year-old Mexican businessman was remarkably soft-spoken for someone who publicized himself on social media holding an assault rifle and traveling on private jets. And perhaps it was because he was surrounded by other bombastic millionaires living in Miami that his own eccentricities went undetected. For example, nobody knew that he owned a priceless artwork by Frida Kahlo until he burned it during an NFT publicity stunt.

In 1945, the artist had drawn a surreal parade of animalistic monsters on a page in her personal diary and called it *Fantasmones Siniestros (Sinister Ghosts)*, which she later gifted to the Venezuelan art critic Juan Röhl. The decades passed and Kahlo died, but her celebrity grew alongside her sales figures. She had only produced about 150 paintings and a limited number of drawings; collectors were willing to pay almost anything for her work. So the critic's heir decided to sell the nine-by-six-inch drawing in watercolors, crayon, pencil, pen, and sepia ink. In 2004, a gallerist named Mary-Anne Martin brokered a deal with the Vergel Foundation, which consigned the artwork

back to the dealer nine years later, when she sold it to a private collector. The drawing's new owner loaned the artwork for a touring museum exhibition, which ended in 2014. Only a year later, Mobarak had *Fantasmones Siniestros* secured in a lockbox. He refused to disclose how much he had paid or who the private collector was. All he would say was that he reckoned *Fantasmones Siniestros* was worth $10 million—maybe more if he destroyed the original and replaced it with ten thousand digital copies.

Mobarak opened his summer spectacle with a mariachi band, a flame-juggling dancer, and models wearing bathing suits and ball gowns sauntering beside the pool of a Miami mansion. An event planner named Gabrielle Pelicci arranged the soirée with only two weeks' notice, describing her vision as "the ice bucket challenge, but with fire."

Wearing a sequined blazer with the artist's portrait on his back, Mobarak pinned the picture to a martini glass filled with blue rubbing alcohol. A security guard wearing a bulletproof vest surveyed the crowd, who gathered at a distance near the opposite side of the pool. The artwork was set aflame and quickly reduced to ashes. A promotional video of the evening was later released online, describing the drawing as having been "transformed to live eternally in the digital realm."

The metaverse was just his latest fascination; Mobarak had built a career on speculative technologies. His first major business venture came during the 1990s ascent of Web companies. After selling one of the first internet service providers in the Anchorage region before the dot-com bubble burst, he reinvented himself as an aircraft tycoon and then developed an interest in prospecting. A potential silver mine in Mexico never turned a profit. Bitcoin did. The money he made in cryptocurrencies was then used to purchase the Kahlo drawing, which became a symbol of how gambling brought him financial success. And then he read a *New York Times* article that I

had written in 2021 about the results of a $34.9-million auction that made Kahlo the most expensive Latin American artist in history.

"Wow. This has some good value," Mobarak recalled thinking about the record. Then came his idea of holding a virtual auction with NFTs. Burning the drawing was just a ploy to get noticed. "I had to do something drastic to get attention," he admitted.

Destroying an artist's work in the name of crypto had become so trendy that it was nearly passé. An original Banksy screenprint, called *Morons,* was purchased by a DeFi company for about $95,000 and was then burned ahead of the company offering an NFT representing the artwork for $380,000, in a publicity stunt that helped the business raise $8 million from investors.

Around the same time, Damien Hirst was culminating his *Currency* project with a bonfire inside a London gallery. The artist forced collectors to choose between retaining a physical copy of his dot paintings or burning them in favor of an NFT representation. A slight majority of his ten thousand buyers chose to retain physical copies, which meant the remaining 4,851 artworks were cremated.

"It's a bit like the reverse of signing," Hirst told audiences while dressed in silver fire-resistant dungarees. One spectator remarked that the artist stoked the flames like a suburban father absently tending to his barbecue while thinking about his pension plan.[13] "It's kind of nuts to be burning art, but I think it's more like transformation really."

But the transformation resembled one of Hirst's old magic tricks, using the same tactics he had deployed in the 2008 Sotheby's auction that made him synonymous with the Lehman Brothers collapse and the beginning of the Great Recession. Again, his poor timing was immaculate. The embers of *Currency* were still smoldering as cryptocurrency prices flatlined

after the multibillion-dollar collapse of FTX. The fools who burned their paintings were left with NFTs whose value dropped by nearly 13 percent in the immediate aftermath.

What compelled these wealthy men to burn everything down when the ashes only created anguish? The cycle repeated itself with Mobarak, who incurred such immense and utterly predictable consequences for destroying a priceless Kahlo drawing that no amount of financial jujitsu could justify the scheme. If he had consulted an attorney, he would have learned that burning the artwork violated Mexico's cultural-heritage laws, which carried a potential decade-long prison sentence and hefty fines; instead, the businessman had, somewhat reasonably, assumed that purchasing the artwork proffered full ownership rights.

And what if the businessman had lied? What if the Kahlo drawing was fake? He refused to disclose who had sold him the artwork, because that would have killed the speculation driving all the free publicity. It was a shortsighted gamble, according to Leila Amineddoleh, an attorney specializing in art law. "If he did actually burn it, he is breaking one law," she said. "And if he didn't, if it was a reproduction, then he might have violated copyright law. And if he copied the original with an intent to deceive, it could be fraud."

The art critic Ben Davis summarized the pandemonium: "From one angle, Frida.NFT is a brazen scam, from the other it looks like a crime against art history. I am not sure which is worse." The Mexican government seemed to agree; soon enough, officials announced they would investigate Mobarak for destroying the Kahlo artwork.

The businessman refused to apologize. "If Frida Kahlo were alive today," he told me, "I would bet my life that if I asked to burn a small piece of her diary to bring some smiles and better quality of life to children, then she would say: 'Go ahead and do it. I'll light the fire.'"

However, the spectacle failed to convince buyers. Mobarak claimed to have sold four NFTs from his collection immediately after his summer party; however, blockchain records made that seem unlikely. Those four sales were all transactions with the same wallet and half were at steeply discounted rates, equivalent to a few dollars. And though he denied it, the most likely scenario was that Mobarak had sold those NFTs to himself. It certainly didn't help that the Frida.NFT website was innavigable, with broken links and grammatical errors. Altogether, the tokens sold for less than $11,200.

When asked if he regretted burning Kahlo's drawing, Mobarak took a long pause, sighed, and said, "I like to say that I don't regret it."

Only a nihilist would destroy art; however, Mobarak had twisted the logic of his destructive act into a symbol of rebirth. The colors of *Fantasmones Siniestros* were destined to fade. The paper on which Kahlo illustrated her nightmares would degrade. Attempts to conserve the artwork would only delay the inevitable. A photographer like Justin Aversano might see something poetic in the fragility of the physical artwork and the permanence of its digital twin, but Mobarak saw weakness and financial opportunity. The physical artwork needed to die so that the NFT could live.

Culture will always find reasons to celebrate its ability to deploy logics that subvert and eventually replace old belief systems. We close ranks and ostracize the nonbelievers, declaring war on their old truths. *Make it make sense.* We rehearse our arguments until they become iron cages. Our fragile egos remain safe there from harm, allowing enough space between the bars to eject all contrary evidence from our minds while we hoard those new affirmations close to our chests. The result of this grisly process is sometimes called iconoclasm, a violence erupting from our penchant for conflating images with ideas.

Many investors turned into iconoclasts during the NFT

bubble, when digital artworks became a more efficient vehicle for financial speculation than physical artworks. Their decision to embrace the blockchain was not the instigation of a paradigm shift within culture but the result of a slower process of capitalism.

The conflation of artistic merit and economic value within the last fifty years has changed the definition of the word "priceless." The dictionaries have not been updated and still use the arcane definition explaining that something so precious cannot have its value determined. Belonging to this category was a burden, because the value of pricelessness was zero. It has become unthinkable, but priceless artworks like the Picasso paintings hanging in the Metropolitan Museum and the Bernini sculptures inside the Vatican were traditionally thought of as functionally worthless, unlikely and in some cases unable to be sold by their institutions. Masterpieces were supposedly incomparable, and therefore incapable of being judged within the economic terms of the marketplace.

A paradigm shift began when collectors started asking insurance companies to protect their investments, which required an impossible calculation. Pricelessness was an aberration to appraisers, whose jobs required them to correct this information-processing error with numbers despite a lack of reference points. The appraisers could scour the artist's catalogue raisonné for price listings, or contact the previous owner for purchase documentation and auction records. If authentication was required, they could pay an expert for their services or request assistance from the artist's estate. But for the majority of artworks, sparse documentation and sales histories left appraisers to rely on even more abstract algebra. The historical movements that once helped us make sense of cultural history became sales departments within the great auction houses, which offered antiquities, Old Masters, impressionism, and postwar art in their own siloed categories. Those limitations

became obsolete with financialization, which incentivized collectors to buy everything from dinosaur fossils to jewelry and NFTs. The aggrandizement of auctions created the appearance of a market; however, there was often more to their sales statistics than what was published. A glint of suspicion was raised in 2001, when the former chairmen of Sotheby's and Christie's were indicted by the U.S. Department of Justice for an internal price-fixing conspiracy that lasted for six years and resulted in $400 million in commissions.[14] The duopoly survived its scandal and continued increasing its profit margins as wealthy collectors remained unflinchingly loyal.

An expectation of endless profits has effectively changed the definition of a "priceless" artwork from something with zero value to something with infinite value. The economic potential of the artwork has finally eclipsed other important criteria, like technical skill, emotional resonance, and political commentary. Whether one is discussing a Frida Kahlo drawing or a Jean-Michel Basquiat painting or a Banksy screenprint, the appreciation of an artwork inevitably returns to price.

The preference for numbers over feelings is an information-processing error; human reason no longer feels adequate enough to judge artistic merit, so we rely on increasingly complex systems of meaningless algorithms to make incredibly subjective decisions like ascribing value to an artwork. But as crypto investors have taught the market, the financial potential of artworks can be "unlocked" by shedding the physical form and digitizing the concept. What good are pigments and porphyry, anyway, in a culture that values credentialism, optimization, and greed above all else?

Burn, baby, burn.

A SLEEPLESS NIGHT

When rich collectors want to celebrate exhibition openings at the Museum of Modern Art, they rent a back room at the museum's Michelin two-star restaurant, where the windows look onto a marble courtyard of priceless Giacometti statues and whatever else the curators have decided to rotate through the acid rain.

One might describe the sound of clinking champagne glasses that emanated from the back room as heraldry. November 18, 2022, was close to the two-year anniversary of the NFT boom, and those assembled at the restaurant were as happy celebrating their own survival through the crypto crash as they were toasting the artist who had convinced the establishment to destroy the last barrier between culture and nonfungible tokens.

Refik Anadol had emerged from the same digital art communities that had nurtured the careers of artists like Mike Winkelmann; however, the Turkish American artist had three fine-art degrees and a thriving studio practice with a dozen employees by the time he started selling NFTs. His early successes came from public art installations in airports and shopping malls, where he installed swirling datascapes of colorful abstraction. The artwork would change in real time based on a machine-learning algorithm developed by the thirty-seven-

year-old artist and refined during his 2016 residency with Google's Artist and Machine Intelligence project. Two years later, he staged one of his *Machine Hallucinations,* feeding an artificial-intelligence program more than 300 million images and 113 million other data points so that it could draw its own images of New York City. Anadol described the experiment as entering a "dream" inside the "mind of a machine." Visitors found the results absurdly moving, like a long supercut of memories stitched together from the internet's archive of tourist photography.[1]

His first NFT project, in December 2020, applied the *Machine Hallucinations* model to Renaissance art. The results were lackluster: melting imitations of marble statues you might expect to find among the wax candles at the Vatican Museum. Crypto investors bought the artworks for a couple hundred dollars apiece, anyway, which was enough to keep Anadol interested in the blockchain. A year later the artist had become a modest success in terms of the NFT boom, his artworks selling for several million dollars each. He didn't have the same name recognition as Mike Winkelmann or Tyler Hobbs, and he didn't have the same corporate backing as Justin Aversano or Erick Calderon. But he had the hunched posture of a traditional artist and spoke in a language that the art world understood.

MoMA stayed quiet during the NFT boom cycle, although behind closed doors the real-estate tycoons and gonzo financiers on its board were interested in the crypto market. A secret task force was assembled not long after the 2021 Christie's Beeple sale, including the museum's chief financial officer, Jan Postma, and the curators Michelle Kuo and Paola Antonelli.

The museum struggled through Covid-19, like most cultural institutions, arduously attempting to recover its high attendance records and financial support from before the pandemic. The same conditions that had fomented the digital

art renaissance were killing art nonprofits. MoMA's director, Glenn Lowry, talked about taking a "chainsaw" to his budget. The museum had its $180-million budget slashed by a quarter, its workforce reduced by 160 employees, and its dozens of free-lance educators fired.[2] Things were not looking good in early 2021.

The NFT task force was searching for a savior and found one in Anadol, who then produced a *Machine Hallucinations* series based on 138,000 images and text materials from the museum's archive. The hundreds of resulting images—living vortexes of swirling colors and undulating forms—were sold as NFTs for $1.8 million; at least one artwork was purchased for $200,000. And although MoMA never formally announced its partici-pation, the museum received nearly 17 percent of all primary sales and 5 percent of all secondary sales.

Receiving more than $300,000 from the NFT sale without expending any of its own resources had convinced MoMA executives to embrace the crypto communities and their cho-sen artists. Kuo and Antonelli were empowered to continue expanding the museum's digital footprint by hiring a Web3 associate and developing an exhibition for Anadol in the insti-tution's public lobby—an honor typically reserved for the most prestigious artists in the world.

"Being open to new technology is part of our responsibility," Antonelli, the museum's senior curator for the Department of Architecture and Design, said in an interview. She was best known for guiding MoMA's acquisitions of historical video games like Pac-Man and computer typography like the @ sym-bol. "We are never jumping on new technologies, but, rather, realizing that we need to keep pace with the world."

An outsider looking at the arrangement might accuse MoMA of trading its credibility for crypto, but that would ignore the finesse with which payola is handled in the art world. In a museum that typically needed five years to plan its exhibitions,

this one happened within only a year. *Refik Anadol: Unsuper-vised* opened in November 2022, using an updated version of the *Machine Hallucinations* algorithm that created the NFT series, which provided a good reason for the curators to start relationships with some of Anadol's crypto patrons.

This is how Pablo Rodriguez-Fraile and Ryan Zurrer were finally welcomed into the traditional art world. These business-men had become two of the most prominent NFT collectors, thanks to their association with Beeple. Rodriguez-Fraile was an early collector and bought one of the artist's first releases, *Crypto Is Bullshit,* in 2020, before turning into one of the high-est bidders for digital artworks at the auction houses. Zurrer offered close competition. Not only was his $29-million pur-chase, *Human One,* still touring museums around the globe, but he had recently discussed commissioning Winkelmann for a forty-two-foot-tall version of his *Dick Milking Factory* NFT, which featured an erect penis the size of a skyscraper with ele-phants stimulating the testicles to increase semen production. The new version would be plopped in a Brazilian city.

From a mutual respect came a partnership. The business-men split the cost of the most expensive *Machine Hallucination* from Anadol's MoMA series and soon struck a friendship with one of the most influential trustees at the museum, Pamela Joyner, a wealthy collector specializing in African American art whose venture-capitalist husband, Fred Giuffrida, also dab-bled in the crypto markets.

"Pamela had a concept early on that we could be new taste-makers," Zurrer said. "There was an opportunity for tastemak-ing with NFTs, just like she had done for African American art."

So the push to legitimize NFTs became a lot more respect-able with powerful allies running the museums. Those tradi-tionalists learned to ignore crazy ideas like a Brazilian Beeple penis the size of a three-story house, which never material-

ized, and focus on more palatable expressions of digital art, like Anadol's algorithmic experiments, which meditated on the art-historical canon inside MoMA.

Winkelmann was left feeling a little frustrated, although he still attended Anadol's opening, as did Kimbal Musk and a horde of new tech investors previously unknown to MoMA's fund-raising department. The artist had his own meetings with the museum's trustees, but left those chats empty-handed. "More than anything, my work is about continual growth," Winkelmann told me, explaining why he was done waiting for cultural institutions to recognize his work. "If they don't care about shaping visual culture anymore, then that's fine. People like me will shape visual culture, because I'm reaching many more people, and it will be what it is."

Zurrer remained steadfast about building his relationship with MoMA. The big dick could wait. During one of our conversations, the venture capitalist said he was interested in donating his Anadol NFT to MoMA's permanent collection. When I asked Kuo about the offer, she declined to discuss specifics. For the moment, she remained focused on the Anadol exhibition and the crowds of young people entering the museum to gaze deeply into the pixelated hurricane of colors.

"Refik is bending data—which we normally associate with rational systems—into a realm of surrealism and irrationality," Kuo said. "His interpretation of MoMA's data set is essentially a transformation of the history of modern art."

It had taken two years for a curator as powerful as Kuo to speak publicly in support of NFTs, but once she did there was little reason for others to resist the new technology. *Refik Anadol: Unsupervised* marked a watershed moment in the history of digital art, when the speculative tremors of the NFT boom had dissipated and the tokens were simply rebranded as "digital collectibles" no stranger than paintings and sculptures occupying MoMA's galleries.

A simple change in the language and tenor of the NFT industry had opened the floodgates. The major museums who stayed silent about the blockchain bonanza were suddenly eager to talk.

"We have hit a critical point where the technology that's available to artists has far outpaced what museums can offer in terms of resources. So we have to beef up," Naomi Beckwith, deputy director and chief curator of the Guggenheim Museum, told me in an interview for *The New York Times.* "If artists are working with technology, then we have to be able to hold it."[3]

Financial support from LG, the electronics company, had shifted priorities at the museum, which announced a new assistant curator for digital art and a $100,000 annual award for artists making "groundbreaking achievements in technology-based art." Conservators were also exploring the possibility of uploading ownership records to the blockchain, which could help art historians researching the collection.

Around the same time in November 2022, Tina Rivers Ryan was organizing the first survey of blockchain art by a major American institution. She had convinced the Buffalo AKG Art Museum to run the exhibition as an online auction called *Peer to Peer,* which would raise money for the museum. More than a dozen digital artists participated in the show, including Rhea Myers, LaTurbo Avedon, and Itzel Yard (known online as IX Shells).

Ryan was exceptionally careful to avoid using the NFT initialism when describing the exhibition, preferring to define its offerings as "digital artworks by artists who are engaged with blockchain technologies." This awkward phrasing was an inelegant solution to an inconvenient problem. The curator needed to explain how she had gone from being one of the NFT market's strongest critics to becoming a cheerleader for the crypto avant-garde that had earned her a platform and a promotion.

She had attacked NFTs as turning all art into "frictionless commodities" and now talked about how these culture bombs should be placed near Picassos.

"I think a number of people in the NFT space have expressed relief over the market crashing because it allowed for different conversations," Ryan reasoned, "including conversations that are a little more about the art and less about money."

Nobody has ever celebrated losing so much money in such a short period of time as NFT collectors; however, the next-best thing would be gaining cultural capital. Investors who once lambasted curators for being "cultural gatekeepers" were learning museumspeak through Ryan, who always packaged her blockchain projects through art history. She made NFTs sound like an inevitability, relaying how it took nearly a century after photography was invented for the artistic medium to receive its first museum exhibition in the United States. That 1910 show at the Albright Art Gallery was arranged to demonstrate that photography could be a visual form of artistic expression during an era when most people regarded cameras as documentary tools. So why wouldn't the gallery, now called the Buffalo AKG Art Museum, host the first NFT exhibition?

"Digital art will arguably be central to the contemporary art story in the decades to come," Ryan argued. "Digital technology is already one of the determining factors of contemporary life, whether or not you even use it."

And although it didn't receive the fanfare of a big museum exhibition, other structural changes were afoot that secured the position of NFTs within the art market.

Perhaps the most influential decision came from the Artist Rights Society, the industry's de facto authority on copyright protection and licensing matters, with more than 122,000 members worldwide. The organization released its own NFT platform, Arsnl (pronounced "arsenal") in September 2022 with a collection by the eighty-six-year-old minimalist Frank

Stella, called *Geometries*. The project gave collectors the right to 3D-print the artist's digital creations.

"NFTs are exciting," Stella told journalists. "We can build in resale rights; that's something we've worked, rather fruitlessly, on for decades. It will be wonderful if technology can give us what the government never would."[4]

The Artist Rights Society was sending a clear message to the industry that NFTs would be an important part of the art market in the future; meanwhile, artist estates were demonstrating that NFTs would also be an important part of remembering the past. Foundations representing deceased artists like Leonora Carrington and Alexander Calder released their own tokens, which provided a new revenue source for their cash-strapped operations. Other groups tapped talent within the NFT community to produce original works. The estate for László Moholy-Nagy even commissioned the generative artist Dmitri Cherniak to develop new works inspired by the Bauhaus master of machine experimentation.

The sale allowed Cherniak to flex his deep understanding of art history. "Tech people always appreciated my work, because they understood the tools I was using to make it," the generative artist said. "Others would think that it was boring, mundane, and robotic." His *Light Years* project was devoted to Moholy-Nagy as a public plea that artists start taking ownership of technology.

"Tech is something we accept, but we don't own culturally," Cherniak explained. "It's used as an economic and political tool. But if we could harness that power for creativity, the world could become a lot more interesting."

〜

Outside the insular world of art politics, determining which NFT investors were winners and losers was more complicated.

The attitude shift among collectors was abrupt; one might charitably describe the crash as having a humiliating effect on these millionaires, but it would be more accurate to suggest that the cataclysm had been ennobling. The man-children who once traded *DickleButts* and openly mocked the contemporary art world now emulated the professionalism of the old fogeys.

Perhaps it was because the markets had become so boring. The price of cryptocurrencies was plateauing, and Morgan Stanley estimated in October 2022 that 78 percent of all Bitcoin units had not been used for any transaction within the past six months, a record slump, indicating that traders were entering hibernation for the crypto winter.[5] A liquidity failure was also pulling *Bored Apes* from the market, where millions in unpaid short-term loans on the collectibles were being repossessed by Web3 lending groups. The investors who had spent lavishly during the bull market had drained their accounts, leading to embarrassing situations when these crypto "millionaires" who pledged generous donations in exchange for seats on acquisition committees at museums like the Whitney and the Los Angeles County Museum of Art were booted after failing to pay their dues.

Other embarrassments followed, like when the NFT artist Claire Silver announced in *Vanity Fair* that she would have an exhibition at the Louvre Museum in Paris. That seemed immediately preposterous, because the museum rarely displayed *any* contemporary work, let alone something digital. After speaking with a museum spokesperson, I realized that Silver had mistaken the Louvre Museum for the Louvre Mall, an underground shopping center with a similar name. The artist later retracted her statement, blamed the fiasco on the exhibition organizers, and asked critics to "leave [her] the fuck out of it."[6]

The rare businessman who managed to avoid complete disgrace was elevated, by comparison; the washout helped strengthen the industry around a few core NFT projects. Smart

influencers distanced themselves from the fools and criminals, pivoting toward something that appeared like sanity as the lights dimmed on the carnival of speculation and that brief glimmer of anarchy faded over the financial world.

But the festivities wouldn't end until the carnival named its king. Someone needed to take responsibility for the mayhem. Demand for sacrifice was growing as regulators settled their internal disputes and crypto investors anxiously called their lawyers for reassurances. Opposition research into competitors became a valuable currency; entrepreneurs were bloodthirsty. The carnival king would be a scapegoat for the sins of the community—a guilty man upgraded into a capitalist anti-Christ who would be stripped of his wealth and imprisoned: the quintessence of speculation and its reinforcement of economic inequality.

The thrashing of carnival kings in the public square is highly symbolic. Bloodless crimes like embezzlement are dramatized as financial terrorism, and the prison sentences can extend several lifetimes. Bernie Madoff received 150 years for defrauding his hedge-fund investors of nearly $65 billion after being arrested in the early months of the 2008 financial crisis. Though the seventy-one-year-old financier had no chance of spending that much time behind bars, his court case became a referendum on the runaway greed of American capitalism.

Nobody leaves the carnival fully satisfied; the costumes worn are purposefully titillating and grotesque; the theater is predictable—a cheap and indulgent striptease. What the ritual does supply, however, is a conclusion. Madoff, who died while incarcerated, was only the latest speculator crowned. Previous examples include John Law of the Mississippi Company, who stoked the 1720 South Sea Bubble around shipping routes, an event from which the term "millionaire" originated; Richard Whitney, whose embezzlement of the New York Stock Exchange precipitated the 1929 Great Crash; and Michael

Milken, the junk-bond king of the 1980s. Crypto needed its own fall guy if the industry wanted to survive the downturn.

On November 2, 2022, crypto investors found their king of fools. Sam Bankman-Fried was dragged through online forums and pilloried with insults and accusations of causing the largest bankruptcy in the industry's history at the precise moment when the mainstream was warming toward its cause.

The billionaire founder of the crypto exchange FTX also owned the trading firm Alameda Research, which he operated from a lavish apartment complex in the Bahamas in company with many of his top employees, who, if you believed the industry rumors, treated the compound like a cocaine-filled sex dungeon with video games. And although Bankman-Fried denied knowledge of a problem, his companies were so heavily intertwined that Alameda Research held $14.6 billion in assets, with nearly $3.7 billion in FTTs, tokens issued by the exchange. Unlike NFTs, the FTTs were supposed to provide utility to owners. They were semi-fungible and encouraged investors to keep their assets on the FTX exchange by providing holders with discounts on trading fees in its marketplace. The problem was that Alameda was using a token that its sister company invented as its main asset, and FTX was using that same token as collateral on its balance sheet. The revelations came from financial documents leaked to the publication *CoinDesk*, which characterized Bankman-Fried as concealing a folding house of cards.

"It's fascinating to see that the majority of the net equity in the Alameda business is actually FTX's own centrally controlled and printed-out-of-thin-air token," Cory Klippsten, chief executive of the investment platform Swan Bitcoin, told the publication.[7]

So traders panicked and started rapidly withdrawing money from the exchange. Binance, a competing exchange that had previously invested in FTX, announced on November 6, 2022,

that it would offload hundreds of millions of dollars in FTX tokens. There were nearly $10 billion in transactions within two days, significantly more than the company could process. Rumors of an imminent collapse spread on social media. On November 9, Binance reneged on a deal to save FTX, as word leaked in *The Wall Street Journal* that the troubled exchange was being investigated by the Justice Department and the Securities and Exchange Commission.

"We will continue to do our job as a cop on the beat," SEC chairman Gary Gensler said earlier that day, in an event hosted by the Healthy Markets Association. "The runway is getting shorter for some of these intermediaries, I have to say."[8]

Agents would have their hands full with Bankman-Fried. On November 10, sources from within the company said that he had allegedly used customer funds held by FTX to support risky trades at Alameda Research. On November 11, the same day that FTX filed for bankruptcy, analytics firms reported that anywhere from $500 million to $2 billion in "unauthorized transfers" had vanished from the company's accounts.

The financial brush fire decimated many of the companies that Bankman-Fried had supported through other shocking bankruptcies earlier that summer. At least eight companies that had received investments from FTX needed to pause withdrawals in the aftermath. BlockFi, a large crypto lender, declared bankruptcy. Even the crypto-obsessed government officials in Miami were looking to dissociate from Bankman-Fried by stripping FTX from the NBA basketball arena, where its logo cornered the courts.[9] Brush fires are supposed to clear the land for new growth, but many investors saw the ashes as smothering a potential crypto comeback and mummifying what was already there.

The hulking institutions that had planned to embrace NFTs long before the crash started were now hamstrung by their decisions. Innovations that once held promise looked

embarrassing, such as a Starbucks loyalty program organized through tokens. Even initiatives that would have changed the market trajectory a few months earlier were now duds, like Instagram allowing creators to sell digital collectibles through its marketplace.

It was textbook disillusionment. "Learned my lesson" was the phrase I commonly heard toward the end of 2022. The number of serious traders who remained in the market was a mystery obscured by the prevalence of wash-trading accounts and duplicate wallets that allowed investors to evade taxes. Generously, one might say that the global phenomenon of the NFT market had been reduced to about five thousand people. But one might reasonably cut that number in half and still be overshooting the truth, based on my interviews with data scientists and anecdotal evidence I found by attending lavish Web3 parties and seeing the same faces no matter where the gatherings occurred.

However, a decrease in real collectors was not the category killer that NFT critics wanted; rather, it demonstrated a shift in demand from a general public interested in speculating on collectibles to niche audiences looking for specific uses from their digital assets. The most lucrative demographic for the time being was in the art world, where traditional collectors had buoyed the system. A report published in November 2022 by Art Basel and the investment bank UBS found that NFTs now constituted 9 percent of all collections, outstripping film, video, and photography in popularity.[10] The study indicated that NFTs also had a greater appeal for global collectors; nearly 65 percent of Brazilian collectors said they planned on buying NFTs in the coming year. Though it wasn't a scientific study, the numbers indicated that NFTs had had a profound impact on culture by displacing more traditional mediums within the market. Additionally, photographers like Aversano may have

unintentionally weakened their own markets by convincing buyers that the digital versions of their images were more valuable.

The numbers reinforced what the death of FTX suggested about the token economy: decentralization provided a limited horizon upon which the next generation of tech oligarchs plotted their future; recentralization allowed them to amass capital and resources from weaker companies; and the market cycle's ending was just the beginning of something new.

〰

On the same day that Sam Bankman-Fried resigned as chief executive and his companies filed for bankruptcy, more than five hundred of the most powerful NFT collectors and artists traveled to Marfa, Texas, for the second annual retreat organized by Erick Calderon. The happily captive audience experienced one of the worst weekends of their professional lives, in a desert with spotty cell reception and a local population that resented their presence.

Time passed slowly here, sixty miles east of the Rio Grande, where tumbleweeds caught on the thorny underbrush pixelating the landscape. A three-hour trip from the closest airport, in El Paso, could feel about four times as long on Route 90, a wilderness theater where brutal sunsets cindered the purple clouds. One minute the embers glowed a deep red, and then they disappeared into an ashen dusk. Critters emerged from the scrublands, howled, and departed. Then what scientists had determined was the darkest sky in the United States filled the night with a million stars. Marfa was that way: a beautiful and desolate town where the environment was set against civilization, where arid winds cracked its adobe houses and brushed its pale lawns with layers of dust.

So how was Erick Calderon, crypto's kindest person, getting along in what one might reasonably describe as the country's most inhospitable town?

"Marfa is a difficult place to live," said one woman, a tour guide overwhelmed that weekend by crypto visitors. She had moved here from Massachusetts nearly a decade ago to live hermetically sealed in her painting studio. And, like many residents who remembered last year's backyard brouhaha, she remained unconvinced that Calderon, his investors, or the NFTs that covered his casita would become permanent fixtures in Marfa. "People come here. They get obsessed. They buy a house or a storefront. They last three years and then move somewhere more hospitable. That *Chromie Squiggles* guy has been here for two years. We can re-evaluate him in another eight."

That *Chromie Squiggles* guy had returned to his backyard, where he addressed the hundreds who had followed him into the desert. "Art Blocks has continued to grow, even in a tough market," Calderon said, explaining that he had doubted even a year earlier that his company would still be around. "We have contributed toward a redirection in the evolution of digital art and a creator's ability to pursue art full-time."

The crowd hollered and applauded. Among them were employees from other crypto companies, like OpenSea and ConsenSys; dealers, like Adam Lindemann from Venus Over Manhattan, Ariel Hudes from Pace Gallery, and Philip Mohun of Bright Moments Gallery; Justin Aversano's Quantum Art cofounder, Jonas Lamis; and the artists Dmitri Cherniak, Tom Sachs, and Tyler Hobbs.

Seeing everyone together was a reminder of how small the circle of influence actually was in the NFT market, and how the power rankings had changed astonishingly little despite the crash. Calderon tried explaining that most investors within his circle hadn't stored their cryptocurrencies with exchanges

like FTX, because they worried about losing control over their assets. So, while most consumers never got the memo, investors more familiar with the cryptoeconomy saved their bags. Calderon optimistically estimated that the FTX bankruptcy would only impact about 20 percent of NFT collectors, though I'm not sure that was accurate.

People chatted loudly over their kale salads and cold-pressed juices at Marfa's boutique lunch spots. Word spread that NFTs had become one of the primary vehicles for investors to withdraw money from FTX despite its freeze on transactions. Bankman-Fried left behind a large loophole during bankruptcy that allowed users registered in the Bahamas to continue their withdrawals from the Nassau-based company.[11] (He claimed that the island government had requested an exception; public officials denied ever asking, and then started their own investigation into FTX.)[12] The trading window that immediately followed bankruptcy saw otherwise worthless NFTs held by Bahamian accounts going for millions of dollars. One collectible, a *Bored Ape* knockoff, even went for $10 million.

The Twitter discourse was predictably bold and stupid. "If anyone helps me on KYC on FTX im giving 100k," wrote an anonymous user named Algod. "I already submitted everything, i need someone from FTX to process it."

In the pandemonium of a collapse, most of these NFT collectors successfully laundered their money without legal repercussions. Bankman-Fried was not as lucky. In November 2023, he was convicted in federal court on fraud charges. The jury only took a few hours to decide on what would likely be a life sentence for someone who was once the world's youngest billionaire.

Gossip from the Marfa visitors and the Twitter posters was essentially the same. Traders were committing fraud by violating Know Your Customer laws and expected the remaining employees at FTX to process their requests using the company's

own NFT marketplace. This was one of the last magic tricks that showed the potential dangers of implementing tokens into the financial world as part of decentralized finance's new shadow banking system. But the gambit worked, and millions of dollars in cryptocurrencies were withdrawn from FTX, probably by some of the same people trying on the cowboy hats in the Marfa clothing shops.

Playing dress-up was one method of relieving anxiety, and getting drunk was another. A combination of the desert's high altitude and the dehydrating climate meant that Marfa was the perfect environment for a boozy party. Investors who had seen their wealth decrease by 75 percent over the last year were taking it out on the dance floor of a beer brewery, where a sound-activated *Chromie Squiggle* thumped like a heartbeat as the British musician Jamie xx performed.

I had missed most of the revelry because of a dinner with the traditional art crowd who had come into town for the opening of a museum exhibition at Ballroom Marfa. Those dignitaries were laughing at the stiffness of the crypto crowd.

"There's an NFT conference here and people are dancing," remarked Kibum Kim, a Los Angeles gallerist. "We're not in the metaverse; you can move your limbs."

"A complete shit show," said Jenny Laird, one of the most important art collectors in Texas and a trustee at Ballroom Marfa. She had previously attended the opening of a new digital art space in town called Glitch Gallery, founded by members of a venture fund that also supported Calderon.

"Three screens and a pizza party," said the Chinati Foundation curator Ingrid Schaffner, dismissing Glitch Gallery as a gaffe. She wasn't wrong. The opening night featured just three screens, which alternated between different NFT artworks and collectibles like *CryptoPunks* and *Meebits*. The owners didn't even bother to add wall labels featuring the artists' names.

When I finally arrived at the brewery, most people were downing beers at the adjoining bar. One young man—I never caught his name—was stumbling toward the Hotel Saint George, a few blocks away, and needed help walking.

"It's gone," he kept saying. "It's gone. It's gone. It's gone."

What he meant, he wouldn't say. Clouds were swallowing the night sky, blotting out the stars, and making the darkest place in the country feel even darker, save for the electric candles lighting the sidewalk between the brewery and the hotel.

"It's gone. It's gone."

There was no point in asking what had gone; his responses to further questions were only murmurs. By the time he reached the hotel lobby, he seemed to have sobered up enough to return to his room alone. He stepped into the elevator, pressed a button to the third floor, and said thank you before the doors closed.

The next morning, I headed for my interview with Tyler Hobbs at the Art Blocks house. The adobe building was also the site of a new exhibition curated by the company's artistic director, Jordan Kantor, who had recently joined the company after messaging Calderon that he was a big fan. His shift into NFTs came as a surprise to most of his colleagues, including Michelle Kuo, who was a student at Harvard University when Kantor was completing his Ph.D. dissertation on Jackson Pollock's late paintings under the scholar Yves-Alain Bois, who helped author one of the definitive textbooks on modern art.

Kantor's pedigree helped amplify the role Art Blocks played in championing digital art and owning the cryptoeconomy around it. His debut exhibition included an essay in which he compared NFT artists to stalwarts like Marcel Duchamp, quoting the late artist as saying, "The creative act is not performed by the artist alone," because "the spectator brings the work in contact with the external world by deciphering and

interpreting. . . ." The exhibition was masterfully organized, as one might expect from a former MoMA curator; the realities of wiring a century-old adobe house to accommodate nearly a dozen monitors and live algorithms were clear. The windows of the showrooms were blocked by large walls holding the screens; electrical boxes were stashed in the six-inch crevice behind it.

In conversation, Kantor was willing to go further back. He said that the idea of NFTs was as ancient as Albrecht Dürer, an artist of the German Renaissance in the early sixteenth century who became one of the most respected printmakers in history, arguably the first person to create work using mechanical reproduction that still retained its value.

So what was Kantor implying about members of the crypto avant-garde like Hobbs?

The artist had undergone a transformation since we first spoke, nearly two years earlier. He was more confident and sociable. The computer nerd had grown into a celebrity, walking through Marfa while trailed by the young men who jokingly called themselves his groupies. He looked kind of like a Backstreet Boy. He wore a wide-brimmed hat, wire-framed glasses, and a sweater featuring Raymond Pettibon's artwork for Sonic Youth's 1990 *Goo* album.

Some buyers, like a man named Andrew Badr, described collecting the artist's work as an obsession. He had lost his software engineering job during the pandemic. "I found myself with all this time and energy that ended up going into the world of NFTs," he told me.

An episode of the crypto investor Kevin Rose's podcast had spoken about the token boom, and Badr, who had tinkered with digital art in the past, started paying attention. Hobbs was a clear standout, so the new collector bought into his work. Badr owned more than twenty *Fidenzas,* having sold a handful during the bubble. His collection grew to more than five

hundred NFTs, including works by Calderon and Cherniak, among others. The collector also became a creator, producing a generative art series of typographic NFTs in collaboration with two other artists.

One might say that Hobbs has had a generative effect on collectors like Badr, inspiring them to create their own artworks. That impact attracted investments from Pace Gallery, which decided to feature Hobbs in a solo exhibition in March 2023 with nearly a dozen paintings based on his recent series *QQL,* a collaboration with another artist named Dandelion Wist Mané, which allowed buyers to tweak the algorithm indirectly until they were satisfied with the randomly generated results. Collectors who mint artworks also received a 2-percent royalty on secondary sales, which Hobbs said was his way of recognizing their contributions to the creative process.

"Tyler represents an upper tier of the NFT market that is similar to what a Pace Gallery artist represents in the physical art market," said Ariel Hudes, the dealership's digital stratego, explaining why she thought Hobbs was ready for his debut with the megadealer. "He is the one defining this space."

The *QQL* release defied expectations of the bear market; collectors spent $17 million on nearly a thousand minting passes. A month later and buyers had built a $28-million secondary market, a shocking statistic that defied the market slump. Collectors gradually used their minting passes to produce artworks, which Hobbs liked to comment on through social media.

"The thin lines really allow the colors to blend, creating a nice richness in perceptual color," he wrote about a purple *QQL* made by Thomas Lin Pedersen, another generative artist.

Hobbs chose to release the *QQL* series on Archipelago, an NFT marketplace that closed soon afterward, demonstrating how difficult it had become to survive in the digital economy, even with star power.

"This has been the longest year of my life," Hobbs said. "But, thankfully, it has been almost entirely positive."

But his presence in Marfa was also something of a stressor to the Art Blocks crowd. Hobbs had not released a project with the company since *Fidenza*, and celebrity meant that he no longer needed to rely on any NFT marketplace to make his fortune.

That had become a common theme in the industry, as marketplaces lost their power and continually ran on thinner margins. The public had lost interest in NFTs as speculative juggernauts. Now the technology had to live as art. But could it? The crypto exchanges were folding, and the marketplaces were losing their leverage. Calderon seemed a little nervous when asked why many artists like Hobbs, who became famous through his platform, hadn't used Art Blocks for their next projects.

"Would we love to retain all the major artists that have come through our platform? Yes. But the concept of decentralization in the crypto world is about getting rid of middlemen. We need to stop being so possessive over other humans," Calderon said. "Listen, I would love Tyler Hobbs to come back and release more work, but not because we have a contract making him."

But the NFT market was facing a much larger crisis around royalties, which was occupying most of Calderon's private meetings in Marfa. The bear market had incentivized traders to find workarounds to avoid paying the secondary royalties encoded in the token smart contracts, which were the main reason why artists had joined the market during the boom. Thinner wallets incentivized wash-trading platforms like LooksRare to announce that they would no longer honor artist royalties, to attract a diminishing pool of traders. It was clear evidence that the priorities of the crypto maximalists no longer aligned with the NFT world.

OpenSea was losing its market share to royalty-free exchanges, and executives had the impossible task of creating policies that might appease both creators and collectors. Their shifting stance on royalties ended up fracturing the market into unrecoverable shrapnel. The company eventually said that it was "an existential imperative to preserve creator's fees," yet their policy was implemented through a code that would effectively prevent NFTs from being traded on other marketplaces; the rules also timed out royalties for some new projects, meaning that artists lost thousands of dollars.[13]

Calderon took a public stance against the marketplace.

"When you start programming royalty restrictions into the smart contract, you might also encourage people to trade off-chain instead of using the trustless systems of the blockchain that are made to protect people from getting screwed over," he said. "I believe that a person who wants to sell an NFT without paying for royalties will find a way. Our problem is making those people feel defiant about the marketplace and looking for less secure ways of conducting business that can get them hacked or manipulated. So it's a difficult problem to solve within the code."[14]

This was a vendetta for Calderon, who had already seen *Chromie Squiggle* collectors trading his artworks on platforms allowing them to avoid paying his royalty fee. Behind the scenes, he and other businessmen—like Jonas Lamis, who served as the chief operating officer for Justin Aversano's Quantum Art company—were threatening to cancel their contracts with OpenSea because of the fiasco.

The leadership structure at NFT startups like Quantum Art was becoming incredibly fragile in the meantime. Aversano would spend the next few months attempting to oust Lamis and other executives, whom the photographer accused during an investor meeting of siphoning the company's intellectual

property for a rival startup. Aversano was eventually left to his own devices in 2023, when he closed Quantum Art's physical location and swerved away from the highly financialized products that Lamis had been developing. Recognizing the whirlwind that his life had become over the last two years, he ended his short-lived engagement with Angela del Sol Varela and refocused his business on photography. It was unclear how much longer investors would support him. "I've had a lot of turbulence," Aversano explained, "because I'm an artist dealing with people trying to take advantage of my community."

He wasn't the only one feeling used. Artists were starting to chafe against the demands of their entrepreneurial overlords. Even an artist-businessman like Calderon reached his limit with how demanding and centralized the NFT marketplace had become.

"Last year was wild, getting shit flung on us by people angry that we were not creating the ideal environment for them to play poker with our art," he said, explaining that OpenSea's royalties policy was "an attempt at futile protectionism."

ᴍ

I thought about those words long after leaving Marfa. The NFT explosion had begun with a deadly symmetry exposing culture's worst tendencies: toward trustlessness, toward scarcity, toward desperation and sycophancy. All that might have been logically expected had come to pass from the speculative market cycle; criminals took advantage of the zeitgeist and errant entrepreneurs played at expertise. But it ended with artists asserting their power in the new economy and challenging the status quo in a system that has devalued them since it began four centuries ago.

These half victories reminded me of something Vera Molnár had written in the 1980s, when she was still experiment-

ing with early algorithmic technologies. "The computer frees the painter from the weight of a sclerotic artistic legacy," she wrote. "By ridding the artist's head of clichés, or cultural 'mental ready-mades,' it enables the production of assemblages of shapes and colors never seen in nature or in museums. Pictures that we never could have imagined, pictures unimaginable." Her words were an aspirational reminder that computer technology was supposed to expand our vision instead of merely reflecting what we have already seen.

But there was good reason to suspect that artistic power had reached its limit. It was not because the NFT market was poorly developed, or that the artists were untalented; on the contrary, several had demonstrated the importance of digital art in the continuum of human expression. Even those businessmen who failed would likely reemerge in the industry, one way or another, just as they had after the Dot-Com Crash. But getting there required sacrifice, and though many would continue denying the truth, the illusion of art's independence from money was finally dead. What replaced the illusion was a more cynical view of how culture operated in the twenty-first century as the disbursement of capital.

There were moments when I questioned whether what I had witnessed was only the prelude to some greater calamity. The March 2023 collapse of regional banks associated with cryptocurrencies was evidence of how volatility born within the art and tech industries was leaking into the traditional financial system. Even large institutions like First Republic struggled during the bank run, sending clients four emails within hours of one another to quell the panic; their stock still plummeted by 62 percent in a single day. The United States government's decision to insure the billions that tech investors had placed with the banks might have boosted the market's confidence, but it raised a moral hazard about the industry's ability to take responsibility for its risky investments. The trade-off was

enough to send billionaires like Kenneth Griffin into a tailspin. He accused American capitalism of "breaking down before our very eyes."[15]

"There's been a loss of financial discipline with the government bailing out depositors in full," he opined in an interview with the *Financial Times*. "The regulator was the definition of being asleep at the wheel." He would certainly know the definition, after playing within the practically lawless bounds of the art market for years and outsmarting his crypto competitors in the auction world.

Art once aspired to become money, and now money aspires to become art. Art that once reproduced financialized society through history paintings and royal portraits now shapes the economy through its delirium of increasingly fractionalized images, subdivided into numbers and assigned positions on the blockchain—a perpetual machine that will never sleep until humanity dies or someone turns off the internet. There in the digital filing cabinet is a sleepless delirium, an insomnia that turns the art money into a parade of hallucinations that dance on the fence posts dividing perception and imagination. The body cripples itself with tension, spasming as the balancing between anabolic and catabolic hormones push the brain into a black hole of anxiety. A breakdown begins as muscle repair stalls; the bones ache as the mind collapses.

Back there in Marfa, under the darkest sky, with the hundreds of sleepless investors refreshing their bank accounts, I thought about what it meant to live in a culture of insomniacs. From that point forward, it didn't really matter anymore what happened to the market, because NFTs had already changed the logic of cultural production from a messy outpouring of human emotion to an algorithmically optimized series of bets. It was not an end, but the beginning of a new paradigm: the tokenization of dreams.

ACKNOWLEDGMENTS

On a cold, wintry night in New York's East Village, a friend named Jenny Xu gently suggested that maybe something book-worthy was buried in the articles that I was writing about the NFT market. Her encouragement sparked an engine within me that powered a handful of sleepless nights as I raced to document the changing economic environment and write a crypto book worth reading.

There was certainly no lack of evidence that something exhilarating was happening in the digital art world; however, the greater challenge was finding an editorial team who recognized the significance of this story. I credit my literary agent, Howard Yoon, with assembling that team. From the earliest drafts of my book proposal, he challenged me to think more ambitiously about the narrative I wanted to tell. The project ultimately landed with Knopf Doubleday Publishing Group, where Reagan Arthur, the imprint's publisher, dared to step into the crypto quagmire when it was still uncertain if the industry would boom or bust. She was undoubtedly convinced by my editor, Todd Portnowitz, a man of immense passion and conviction who shepherded this book to heights that I could never have achieved by myself. His steady guidance went beyond the norm, even as he welcomed his son Nico into the world. (I am only a little hurt that Todd decided against the name "Ethe-

reum," but you cannot win every argument.) When he went on parental leave, Tiara Sharma helped move this book through its final stages. I am also thankful for the guidance of Linda Friedner, an attorney with Penguin Random House's general counsel, the support of Andrew Miller, senior editor at Knopf, and the advice of Terry Zaroff-Evans, who did the painstaking work of copyediting and fact checking, and Nora Reichard, my production editor.

This book would not have been possible without earlier support. There was my high school English teacher Tasia Kimball, who advised her students to speak plainly ("sign" not "signage") and avoid writing clichés; my art history professor Monica McTighe, who allowed me to stay enrolled in her graduate-level course on postmodernism although I was a college freshman without any experience in visual art or philosophy; and one of my first bosses, Francesca Wilmott, then a curatorial assistant at the Museum of Modern Art who hired me as an intern despite me saying that I probably didn't belong at such a prestigious institution. My career as a journalist would have also ended years ago if it wasn't for the support of my colleagues at *The New York Times,* in particular editors like Barbara Graustark, Kevin Flynn, Jason Baily, Michael Cooper, and Sia Michel, who've entertained my hunches, challenged me to find more evidence, and always center the stories of real people in my writing.

A special thanks is due to the friends who read drafts and provided suggestions for improvements: Ellie Beckman, Gabrielle Cella, Emily Feng, Julia Halperin, Grace Hoyt, Julia Jacobs, Brenna Lilley, and Stephen Malina. But I would be nowhere without Seth Bishop. It's hard putting into words what it means to have such a supportive partner who helps without question and loves without fear. Seth was a gracious bystander during the entire process of researching and writing this book; like me, it would have been a poorer version of itself without him.

NOTES

Chapter 1: The New King of Crypto

1. Kyle Chayka, "How Beeple Crashed the Art World," *New Yorker*, March 22, 2021.
2. Mike Winkelmann, *Politics Is Bullshit* description, OpenSea.
3. Scott Reyburn, "Will Cryptocurrencies Be the Art Market's Next Big Thing?," *New York Times*, Jan. 13, 2018.
4. "Robert Alice Lot Essay," 2020, https://www.christies.com/en/lot /lot-6283759.
5. "*Shangri-La* by Matthew Wong," 2020, https://www.christies.com /lot/lot-6283522.
6. Robert Stevens, "Rare Batman NFT Art Raises $200,000 in Sale Led by Mystery Collector," *Decrypt*, Oct. 17, 2020.
7. Liam Frost, "Cryptocurrency Artist Becomes the First to Earn $1 Million," *Decrypt*, Dec. 8, 2020.
8. Noah Davis, "How Christie's Learned to Love NFTs with Noah Davis," NFT Now Podcast, Aug. 11, 2021, YouTube.
9. Eileen Kinsella, "In a Profound Shift, Christie's Is Eliminating Its Standalone Impressionist and Modern Art Department, Shedding a Significant Amount of Staff in the Process," *Artnet News*, June 26, 2020.
10. Julia Halperin, "Artnet News Intelligence Report," *Artnet News*, Oct. 27, 2022.
11. Mike Winkelmann, "Beeple in Conversation with Glenn Fuhrman," interview, 92NY, May 4, 2022.
12. Angus Berwick and Elizabeth Howcroft, "From Crypto to Christie's:

How an Indian Metaverse King Made His Fortune," *Reuters,* Nov. 17, 2021.

13. Ibid.

14. Metapurse, "Announcing B.20 and Metapalooza: The Most Epic NFT Bundle and Event in the Metaverse," *Substack,* Jan. 13, 2021.

15. Noah Davis, NFT Now Podcast, Aug. 11, 2021, YouTube.

Chapter 2: Art in the Tokenized Economy

1. "Niépce and the Invention of Photography," *Maison Nicéphore Niépce.*

2. Walter Benjamin, "A Short History of Photography," *Screen* 13, no. 1 (Spring 1972): 5–26; originally published in 1931.

3. Charles Baudelaire, "On Photography," in *"The Salon of 1859," Révue Française,* July 10–20, 1859.

4. Benjamin, "Short History of Photography."

5. Ibid.

6. Michelle Kuo, "To Avoid the Waste of a Cultural Revolution: Experiments in Art and Technology," Harvard University Doctoral Dissertation, 2018, p. 223.

7. Paul Virilio, *Speed and Politics* (Los Angeles: Semiotext(e), 2006), p. 156.

8. Roland Barthes, "The Third Meaning," in *Image—Music—Text* (New York: Hill and Wang, 1978), p. 68.

9. Colin Scott, "Latency Numbers Every Programmer Should Know," in GitHub, 2020.

10. Jo Lawson-Tancred, "Meet Vera Molnár, the 98-Year-Old Art Pioneer Who Is Enjoying New Relevance at the Venice Biennale," *Artnet News,* April 19, 2022.

11. Kate Keller, "Fifty Years Later, France Is Still Debating the Legacy of Its 1968 Protests," *Smithsonian Magazine,* May 4, 2018.

12. Piet Mondrian, *Pier and Ocean 5 (Sea and Starry Sky),* Museum of Modern Art online collection.

13. Aline Guillermet, "Binding and Unbinding the Mondrian Stimulus," *British Journal of Aesthetics* 58, no. 4 (Dec. 2018): 449–67.

14. Roman Verostko, "The Algorists," http://www.verostko.com/algorist .html.

15. Claire Bishop, "Digital Divide: Contemporary Art and New Media," *Artforum,* Sept. 2012.

16. Clare McAndrew, "The Role of Cities in the US Art Ecosystem," UBS, 2022.
17. Julia Halperin, "Almost One Third of Solo Shows in US Museums Go to Artists Represented by Five Galleries," *Art Newspaper,* April 1, 2015.
18. Don Thompson, *The $12 Million Stuffed Shark: The Curious Economics of Contemporary Art* (New York: St. Martin's Griffin, 2010), p. 133.
19. "Blue Chip Art Has Beaten the S&P by over 250%—but How Do You Invest?," *Investing.com.*
20. Clare McAndrew, "The Art Market 2021," UBS, 2021.
21. Clare McAndrew, "The Art Market 2022," UBS, 2022.
22. Trent McConaghy and Maria McConaghy, "Method to Securely Establish, Affirm, and Transfer Ownership of Artworks," US Patent PCT/CA2014/050805, 2014; filed Aug. 21, 2013.
23. Meni Rosenfeld, "Overview of Colored Coins," Dec. 4, 2012, https://allquantor.at/blockchainbib/pdf/rosenfeld2012overview .pdf.
24. Jonathan Monaghan, *Mothership,* 2013.
25. "Kevin McCoy: Quantum," *Natively Digital: A Curated NFT Sale,* Sotheby's, 2021.
26. Paul Wackerow, "ERC-721 Non-Fungible Token Standard," *Ethereum.org,* Aug. 15, 2022.
27. Shanti Escalante-De Mattei, "Takashi Murakami, NFT Creators Win Big at Webby Awards," *ARTnews,* April 27, 2022.
28. Blake Gopnik, "One Year After Beeple, the NFT Has Changed Artists. Has It Changed Art?," *New York Times,* March 3, 2022.
29. Elisabeth Nicula, "The Artist Is the Void," *Momus,* May 10, 2022.
30. Tina Rivers Ryan, "Will the Artworld's NFT Wars End in Utopia or Dystopia?," *ArtReview,* Dec. 2, 2021.
31. Gopnik, "One Year After Beeple."
32. Michael King, "Art Is a Symbol: Conceptualism and the Vietnam War," *Lehigh Preserve,* vol. 16, 2008.
33. Liza Zapol, Oral history interview with Lawrence Weiner, *Smithsonian Archives of American Art,* March 25–28, 2019.
34. Kirsten Swenson, *Irrational Judgments: Eva Hesse, Sol LeWitt, and 1960s New York* (New Haven: Yale University Press, 2015).
35. Martin Hartung, "Under Control: Sol LeWitt and the Market for Conceptual Art," *Journal for Art Market Studies* 2, no. 4 (2018).

36. Lucy R. Lippard, *Six Years: The Dematerialization of the Art Object* (New York: Praeger, 1973), p. 263.

37. Fred Ferretti, "Scull's U.S. Art Brings Record $2 Million," *New York Times,* Oct. 19, 1973.

38. Mitchell Chan, "NFTs, Generative Art, and Sol LeWitt," *Medium,* July 26, 2021.

39. *Abrams v. United States,* 250 U.S. 616 (1919).

40. Stanley Ingber, "The Marketplace of Ideas: A Legitimizing Myth," *Duke Law Journal* 33, no. 1 (Feb. 1984).

41. Paul H. Brietzke, "How and Why the Marketplace of Ideas Fails," *Valparaiso University Law Review* 31, no. 3 (Summer 1997).

42. Aaron Wright (@awrigh01), Twitter post, Feb. 19, 2021, 6:27 p.m.

43. Zachary Small, "Guggenheim Ventures into the Future with Its Own Cryptocurrency," *Hyperallergic,* July 6, 2016.

44. MacKenzie Sigalos, "Crypto Scammers Took a Record $14 Billion in 2021," *CNBC,* Jan. 6, 2022.

45. E. Glen Weyl, Puja Olhaver, and Vitalik Buterin, "Decentralized Society: Finding Web3's Soul," *SSRN,* May 10, 2022.

46. Vitalik Buterin, "Soulbound," *Vitalik.ca,* Jan. 26, 2022.

47. Owen S. Good, "NFT Mastermind Says He Created Ethereum Because Warcraft Nerfed His Character," *Polygon,* Oct. 4, 2021.

48. Yoni Assia, Vitalik Buterin, Lior Hakim, Meni Rosenfeld, and Rotem Lev, "Colored Coins Whitepaper," 2015.

49. Daniel Friedman, "World of Warcraft's Inflation Problem Could Finally Be Hitting Regular Players," *Polygon,* Aug. 22, 2018.

50. Stephen Winson, "A History of World of Warcraft's Gold Economy," *Memory Insufficient,* Sept. 3, 2015.

51. J. Clement, "Number of Video Gamers Worldwide 2021, by Region," *Statista,* Oct. 25, 2022.

52. "Gaming: The Next Super Platform," *Accenture,* April 27, 2021.

53. Sarah Cascone, "The Average Person Spends 27 Seconds Looking at a Work of Art. Now, 166 Museums Are Joining Forces to Ask You to Slow Down," *Artnet News,* April 4, 2019.

Chapter 3: Cray Cray Crap

1. Mike Winkelmann, *Ocean Front,* Nifty Gateway, purchased by Justin Sun for $6 million on March 20, 2021.

2. Seth Price and Michelle Kuo, "What NFTs Mean for Contemporary Art," *MoMA Magazine,* April 29, 2021.
3. Jim Tankersley and Michael Crowley, "Here Are the Highlights of Biden's $1.9 Trillion 'American Rescue Plan,'" *New York Times,* Jan. 14, 2021.
4. Katherine Wiles, "Fed Chair: Rise in Inflation Not 'Particularly Large' from $1.9 Trillion Rescue Package," *Marketplace,* March 23, 2021.
5. James Surowiecki, "How Did They Get Inflation So Wrong?," *Atlantic,* June 10, 2022.
6. "Nearly 1 in 10 Americans Have Used Stimulus Checks to Invest in Crypto," *Harris Poll,* March 17, 2021.
7. Pandemic Oversight, "Three Rounds of Stimulus Checks Went Out and for How Much," *Pandemic Oversight,* Feb. 17, 2022.
8. Chris Dixon, "Why Decentralization Matters," on his personal blog, Feb. 18, 2018.
9. Kevin Kelly, "1,000 True Fans," *Technium,* March 4, 2008; republished 2016.
10. Marie Fazio, "The World Knows Her as 'Disaster Girl.' She Just Made $500,000 Off the Meme," *New York Times,* April 29, 2021.
11. Sophie Haigney, "Does the Metaverse Need a Zoning Board?," *Curbed,* April 15, 2021.
12. Samantha Hissong, "The NFT Art World Wouldn't Be the Same Without This Woman's 'Wide-Awake Hallucinations,'" *Rolling Stone,* Jan. 6, 2022.
13. Jessica Klein, "Planet of the Bored Apes: Inside the NFT World's Biggest Success Story," *Input,* Aug. 3, 2022.
14. "Conviction Upheld in Slaying of Florida Boatbuilder," *Trade Only,* Dec. 8, 2010.
15. Simon Abrams, "Speed Kills," *Roger Ebert,* Nov. 17, 2018.
16. Klein, "Planet of the Bored Apes."
17. Ibid.
18. Kyle Chayka, "Why Bored Ape Avatars Are Taking Over Twitter," *New Yorker,* July 30, 2021.
19. Nicole Muniz, "Bored Apes Founders Doxxed: CEO Speaks Out," interview with Laurie Segal, Feb. 16, 2022, YouTube.
20. Derek E. Bambauer, "Privacy Versus Security," *Journal of Criminal Law and Criminology* 103, no. 3 (2013).

21. John Kenneth Galbraith, *The Great Crash of 1929* (New York: Penguin Classics, 2021), p. 118

22. Crypto Citizens (@Crypto_Citizens), Twitter post, Aug. 11, 2021, 10:20 a.m.

23. Andrew Warner, "The Guy Who Sold a Company for $56M Explains the Secret of Raising Money," in *Mixergy,* March 5, 2014.

24. Matthew Leising, "The Betrayal of Bright Moments, Part 2," *DeCential,* Nov. 12, 2021.

25. Kevin Roose, "They Love Crypto. They're Trying to Buy the Constitution," *New York Times,* Nov. 17, 2021.

26. Joseph Fuller and William Kerr, "The Great Resignation Didn't Start with the Pandemic," *Harvard Business Review,* March 23, 2022.

27. Matthew Leising, "The Betrayal of Bright Moments, Part 3," *DeCential,* Nov. 19, 2021.

28. Ibid.

29. Brian McCullough, "A Revealing Look at the Dot-Com Bubble of 2000—and How It Shapes Our Lives Today," *Ted,* Dec. 4, 2018.

30. Roger Lowenstein, *Origins of the Crash: The Great Bubble and Its Undoing* (New York: Penguin, 2004), pp. 218–19.

31. Fred Wilson, "Bright Moments DAO," *Union Square Ventures,* Aug. 25, 2021.

Chapter 4: A Gilded Void

1. Edward Chancellor, *Devil Take the Hindmost: A History of Financial Speculation* (London: Farrar, Straus and Giroux, 1999), p. 27.

2. Jean Baudrillard, *Simulations* (Los Angeles: Semiotext(e), 1983).

3. Jeanna Smialek, "Consumer Prices Jump Again Presenting a Dilemma for Washington," *New York Times,* Oct. 13, 2021.

4. Bloomberg Quicktake (@Quicktake), Justin Sun interview, Twitter post, Sept. 4, 2021, 5:07 a.m.

5. Brian P. Kelley, "How UTA's Lesley Silverman Went from Art Law to Helping Artists Launch Web3 Projects," *Artsy,* May 30, 2022.

6. Dana Thomas, "Dolce & Gabbana Just Set a $6 Million Record for Fashion NFTs," *New York Times,* Oct. 4, 2021.

7. Clone X blockchain data, hosted on Dune Dashboards, Aug. 1, 2021, https://dune.com/pet/CloneX.

8. Takashi Murakami, "Repainting the Canvas, One Pixel at a Time," *New York Times,* June 17, 2022.

9. Wyett Allgeier, "Takashi Murakami and RTFKT: An Arrow Through History," *Gagosian Quarterly,* Summer 2022.

10. Edward Ongweso Jr., "Court Filings Spark New Citadel-Robinhood GameStop Theories," *Vice,* Sept. 29, 2021.

11. John McCrank, "Citadel Securities Avoids Crypto Due to Regulatory Uncertainty—Founder," *Reuters,* Oct. 4, 2021.

12. Kelly Crow, "Ken Griffin on Why He Spent $43 Million to Buy the U.S. Constitution," *Wall Street Journal,* Aug. 9, 2022.

13. Ibid.

14. McCrank, "Citadel Securities."

15. Board of Governors, Federal Reserve System, "Joint Statement on Crypto-Asset Policy Sprint Initiative and Next Steps," *Office of the Comptroller of the Currency,* Nov. 23, 2021.

16. Emma Goldman, *Anarchism: What It Really Stands For* (1910), p. 3, https://pdcrodas.webs.ull.es/culturas/GoldmanAnarchismWhatIt ReallyStandsFor.pdf.

17. Franky Abbott, "The Homestead Strike," *Digital Public Library of America.*

18. NFT Market Overview blockchain data, hosted on Dune Dashboards, 2021, https://dune.com/hildobby/NFTs.

19. Paul Vigna, "NFT Sales Are Flatlining," *Wall Street Journal,* May 3, 2022.

20. Juliana Menasce Horowitz, Ruth Igielnik, and Rakesh Kochhar, "Trends in Income and Wealth Inequality," *Pew Research Center,* Jan. 9, 2020.

21. Max Haiven, *Art After Money, Money After Art* (London: Pluto Press, 2018), p. 185.

Chapter 5: Generation Moonshot

1. Wenjie Chen, Mico Mrkaic, and Malhar Nabar, "Lasting Effects: The Global Economic Recovery 10 Years After the Crisis," *International Monetary Fund,* Oct. 3, 2018.

2. "What Happens to Health During a Recession?," *American Nurses Association of Illinois,* Jan. 24, 2022.

3. Miriam K. Forbes and Robert F. Krueger, "The Great Recession and

Mental Health in the United States," *Association for Psychological Science* 7, no. 5 (July 19, 2019).

4. Sam Levin, "Millionaire Tells Millennials: If You Want a House, Stop Buying Avocado Toast," *Guardian,* May 15, 2017.

5. Morely Winograd and Michael D. Hais, "Millennial Generation Could Kill the NFL," *Christian Science Monitor,* Oct. 19, 2012.

6. Susanne Goldstein, "Here's How to Deal with Millennials Who Aren't Ready to Face Real Challenges," *Business Insider,* Aug. 17, 2012.

7. YiLi Chien and Paul Morris, "Accounting for Age: The Financial Health of Millennials," *Federal Reserve Bank of St. Louis,* May 16, 2018.

8. Timothy Noah, "America, the Gerontocracy," *Politico,* Sept. 3, 2019.

9. U.S. Bureau of Labor Statistics, "Older Workers: Labor Force Trends and Career Options," *U.S. Bureau of Labor Statistics,* May 2017.

10. Francesca Hughes, "Facilities for Correction," *E-Flux,* Dec. 2016.

11. USA Spending, https://www.usaspending.gov/.

12. Zachary Small, "After Pak and Beeple, What's Next for NFT Collectors? Art Made with a Paintbrush," *New York Times,* Feb. 12, 2022.

13. Ibid.

14. NFTfi.com (@NFTfi.com), in a Twitter post, Jan. 7, 2021, 12:57 p.m.

15. President's Letter, Holbrook Chamber of Commerce, June 2014.

16. Katie Stone, "Meet the Mesa: San Pedro Ceremonies in Peruvian Shamanism," *Psychable,* May 15, 2021.

17. Sam Wong, "Psychedelic," *New Scientist,* 2021.

18. Jo Lawson-Tancred, "Julie Pacino: Keepers of the Inn," *Public Offerings Ltd.,* April 29, 2022.

19. Sotheby's auction of Justin Aversano's *Twin Flames #49, Alyson & Courtney Aliano,* June 10, 2021.

20. "Twin Flames #49," *Fractional.*

21. Justin Aversano, "Pixelated III," *SaveArtSpace,* July 5, 2021.

22. Justin Aversano, "Smoke and Mirrors," on his personal website.

23. Anna Brady, "Rolling with the Punches: How the Art Market Bounced Back," *Art Newspaper,* Sept. 4, 2018.

24. Melanie Gerlis, "Amy Cappellazza: 'I Feel Like I've Been in the Crypto Business for 20 Years,'" *Financial Times,* May 31, 2021.

25. Clare McAndrew, *The Art Market 2022* (Basel: UBS, 2022).

26. Nate Freeman, "How Damien Hirst's $200 Million Auction Became a Symbol of Pre-Recession Decadence," *Artsy,* Aug. 23, 2018.

27. Carol Vogel, "Hirst's Art Auction Attracts Plenty of Bidders, Despite Financial Turmoil," *New York Times,* Sept. 15, 2008.

28. FingerprintsDAO, "Should Fingerprints Incubate RAW DAO?," *FingerprintsDAO,* Sept. 2021.

29. Justin Aversano (@justinaversano), Twitter post, Feb. 15, 2022, 1:58 p.m.

30. Tyler Hobbs, "Randomness in the Composition of Artwork," on his personal blog, Sept. 7, 2014.

31. Yyctrader, "Three Arrows Founders and Mysterious Collector 'Vincent Van Dough' Launch $100M NFT Fund," in *Defiant,* Aug. 31, 2021.

32. Aleksander Gilbert, "NFT Fund Starry Night Goes Dark on SuperRare," *Defiant,* June 16, 2022.

33. Michael Tant (@MichaelTant3), Twitter post, Aug. 1, 2021, 1:28 p.m.

34. "3AC's NFT Spending Spree (Starry Night)" blockchain data, Dune Dashboards, July 2022.

35. Nansen (@nansen_ai), Twitter post, Oct. 4, 2022, 4:00 a.m.

36. Tyler Hobbs, "The Importance of Generative Art," on his personal blog, May 5, 2021.

37. Adam Tooze, *Crashed: How a Decade of Financial Crises Changed the World* (New York: Penguin, 2019), p. 48.

38. Richard K. Green and Susan M. Wachter, "The American Mortgage in Historical and International Context," *Journal of Economic Perspectives* 19, no. 4 (Autumn 2005).

39. Tooze, *Crashed,* p. 70.

40. Mauro F. Guillén, "The Global Economic & Financial Crisis: A Timeline," *Lauder Institute,* 2015.

41. Tooze, *Crashed,* p. 10.

42. Jeanna Smialek, "The Financial Crisis Cost Every American $70,000, Fed Study Says," *Bloomberg,* Aug. 13, 2018.

43. Hilary J. Allen, *Driverless Finance* (Oxford, U.K.: Oxford University Press, 2022).

44. Charlie Warzel, "Is Crypto Re-Creating the 2008 Financial Crisis?," *Atlantic,* April 6, 2022.

45. Ibid.

46. Gary B. Gorton and Jeffery Zhang, "Taming Wildcat Stablecoins," *University of Chicago Law Review* 90, no. 3 (2021).

47. Hester M. Peirce, "Lawless in Austin," speech at Texas Blockchain Summit, Oct. 8, 2021.

48. Andrew Hayward, "Republican Sen. Lummis: Democrat Senator Gillibrand Is Teaching Me About NFTs," *Decrypt,* July 7, 2022, https://decrypt.co/104629/republican-sen-lummis-democrat-sen -gillibrand-is-teaching-me-about-nfts.

Chapter 6: The Rug Pull

1. "The Role of Hawalas and Other Similar Service Providers in Money Laundering and Terrorist Financing," *Financial Action Task Force,* Oct. 2013.
2. Rob Portman and Tom Carper, "Bipartisan Report Reveals How Russian Oligarchs Use Secretive Art Industry to Evade U.S. Sanctions," *Homeland Security & Governmental Affairs,* July 29, 2020.
3. Tom Mashberg, "The Art of Money Laundering," *Finance & Development,* Sept. 2019.
4. Steve Volk, "The Curious Case of Nicky Isen," *Philadelphia Magazine,* Aug. 9, 2015.
5. Graham Bowley, "As Money Launderers Buy Dalís, U.S. Looks At Lifting the Veil on Art Sales," *New York Times,* June 19, 2021.
6. Angelica Villa, "New York Attorney General Expands Sotheby's Tax Fraud Investigation," *ARTnews,* Aug. 26, 2022.
7. Victor Reklaitis, "Crypto Industry's Lobbying on Track to Hit a New Annual Record, by This Metric," *MarketWatch,* July 22, 2022.
8. United Nations Office on Drugs and Crimes, *Practical Assistance Tool to Assist in the Implementation of the International Guidelines for Crime Prevention and Criminal Justice Responses with Respect to Trafficking in Cultural Property and Other Related Offences* (Vienna: United Nations, 2016).
9. United Kingdom Parliament, "The Problem of Illicit Trade," *Select Committee on Culture, Media and Sport Seventh Report* (London: Parliament, July 18, 2000).
10. Neil Brodie, Jenny Doole, and Peter Watson, *Stealing History: The Illicit Trade in Cultural Material* (London: ICOM UK and Museums Association, 2000).
11. Geraldine Norman, "Great Sale of the Centuries: Geraldine Norman Previews a Unique Auction of Greek and Roman Antiquities," *Independent,* Nov. 24, 1990.
12. Sotheby's Mei Moses Indices.

13. Brian Boucher, "Seven Key Takeaways from the 2022 Art Market Report," *Art Basel*, 2022.

14. Department of the Treasury, *Study of the Facilitation of Money Laundering and Terror Finance Through the Trade in Works of Art* (Washington, D.C.: Department of the Treasury, Feb. 2022), p. 16.

15. Laurie Kahle, "20 Minutes With: Dewey Burke, Founder & CEO of Luxury Asset Capital," *PENTA*, July 13, 2020.

16. Treasury, *Facilitation of Money Laundering*, p. 27.

17. Olga Kharif, "The Hottest NFT Marketplace Is Mostly Users Selling to Themselves," *Bloomberg*, April 5, 2022.

18. 0x650d (@0x650d), Twitter post, April 1, 2022, 5:47 a.m.

19. Department of Justice, "Deutsche Bank Agrees to Pay $7.2 Billion for Misleading Investors in Its Sale of Residential Mortgage-Backed Securities," *Office of Public Affairs*, Jan. 17, 2017.

20. Christie's, FAQs, https://www.christies.com/en/services/christies-art-finance/faqs.

21. Georgina Adam, "In Debt We Trust: The Rise of Art-Secured Lending," *Art Newspaper*, Dec. 6, 2018.

22. NFTfi, FAQ, https://www.nftfi.com/faq.

23. "U.S. CMBS 2021 Loan Default Study (Defaults Level Off Amid Pandemic Recovery)," *Fitch Ratings*, May 17, 2022.

24. Allen, Hilary J. "DeFi: Shadow Banking 2.0?," *William & Mary Law Review* 64, no. 4 (March 2023), https://scholarship.law.wm.edu/wmlr/vol64/iss4/2.

25. MetaStreet (@metastreetxyz), Twitter post, Sept. 20, 2022, 5:29 p.m.

Chapter 7: Clown Frowns

1. Hannah Murphy and Joshua Oliver, "How NFTs Became a $40bn Market in 2021," *Financial Times*, Dec. 31, 2021.

2. Emilia David, "VCs Stake Their Claims as the NFT Gold Rush Heats Up," *Venture Capital Journal*, March 1, 2022.

3. Katya Kazakina, " 'I've Never Ever Been to a Gallery Opening': NFT Star Beeple on Trading Pixels for Paintings in His First-Ever Gallery Show," *Artnet News*, March 3, 2022.

4. Mike Winkelmann, Press Release for Uncertain Future at Jack Hanley Gallery, March 3, 2022, https://www.jackhanley.com/exhibitions/beeple/selected-works?view=thumbnails.

5. Mike Winkelmann (@beepleP), Twitter post, March 4, 2022, 10:35 a.m.

6. Sharon Roznik, "Artist 'Beeple' Who Sold $69 Million Digital Artwork Hails from North Fond du Lac," *FDL Reporter,* March 15, 2021.

7. Gregory Crouch, "The Mining Millionaire Americans Couldn't Help but Love," *Smithsonian,* June 6, 2018.

8. Robert F. Helzer, *The Destruction of the California Indians* (Lincoln: University of Nebraska Press, 1974).

9. "Samuel Brannan: Gold Rush Entrepreneur," *PBS: American Experience.*

10. Dean Kissick, "The Downward Spiral: Popular Things," in *Spike Magazine,* Oct. 3, 2021.

11. M. H. Miller, "The Surprising Ascent of KAWS," *New York Times Magazine,* Feb. 9, 2021.

12. Lorcan Roche Kelly, "Five Things You Need to Know to Start Your Day," *Bloomberg,* Jan. 4, 2021.

13. Satoshi Nakamoto, "Bitcoin: A Peer-to-Peer Electronic Cash System," *Bitcoin,* 2008.

14. Tim Schneider, "The Gray Market: How a Brazen Hack of the $69 Million Beeple Revealed the True Vulnerability of the NFT Market (and Other Insights)," *Artnet News,* April 21, 2021.

Chapter 8: Transcendental Squiggle Meditations

1. Thomas Wilson, "How Marfa, Texas Got Its Name," *Journal of Big Bend Studies,* 2001.

2. Leslie Jamison, "The Minimalist Who Wasn't," *Atlantic,* Oct. 2020.

3. Randy Kennedy, "Donald Judd, Artist, Revealed as Philosopher-Critic by His Children," *New York Times,* Dec. 25, 2016.

4. Hal Foster, "Object Lessons," *Artforum,* May–June 2020.

5. Jim Lewis, "One Hundred Boxes," *Texas Monthly,* Oct. 2007.

6. Hilarie M. Sheets, "What Would Donald Judd Do?," *New York Times,* Aug. 12, 2022.

7. Donald Judd, *Donald Judd Interviews* (New York: Judd Foundation/David Zwirner Books, 2019), p. 55.

8. Druid, "Why Is Art Blocks in Marfa?," *Medium,* Oct. 10, 2021.

9. Rachel Monroe, "When N.F.T.s Invade an Art Town," *New Yorker,* Jan. 18, 2022.

10. Nate Freeman, "Wet Paint: Marfa May Have Quarantined Christopher Wool, Jerry Gagosian Lands a Gallery Job, and More Juicy Art-World Gossip," *Artnet News,* April 3, 2020.
11. Nirvana, "Shimmering 3D-Printed Sculptures: Meet Light Art Interactive," *Pop Shop America,* June 27, 2015.
12. Chromie Squiggles Explorer, https://chromie-squiggles.com/.
13. Mike Novogratz (@novogratz), Twitter post, Jan. 4, 2022, 8:17 p.m.
14. Do Kwon (@EncryptedPedro), Twitter post, May 11, 2022, 7:26 p.m.
15. Zeke Faux and Muyao Shen, "An $85bn Crypto Collapse Reveals a New Kind of Bank Run," *Financial Review,* May 25, 2022.
16. Scott Chipolina and George Steer, "The Terra/Luna Hall of Shame," *Financial Times,* May 25, 2022.
17. Do Kwon (@stablekwon), Twitter post, May 13, 2022, 6:15 p.m.
18. Paul Vigna, "NFT Sales Are Flatlining," *Wall Street Journal,* May 3, 2022.
19. Frances Yue, "Here's How Much Money You Would Have Lost If You Bought a Bored Ape Yacht Club NFT a Month Ago," *MarketWatch,* May 27, 2022.
20. Emily Flitter, "How Wall Street Escaped the Crypto Meltdown," *New York Times,* July 5, 2022.
21. Phil Rosen, "A New NFT Features Robert De Niro's Face Reacting to the Current Price of Ether," *Insider,* Jan. 10, 2022.
22. Taylore Scarabelli, "A Miami Conference Questions If Blockchain Technology Will Commodify or Democratize the World," *Vulture,* Dec. 7, 2018.
23. Tim Schneider, "A Miami Beach Conference United Art and Tech A-Listers to Make the Case for Blockchain—and Ended as an Allegory of Market Mayhem," *Artnet News,* Dec. 5, 2018.
24. Ibid.
25. Michael Shnayerson, "Billionaire Financier Adam Lindemann Tweaks the Neighbors with His Phallic Sculpture on the Bluffs of Montauk," *Vanity Fair,* Oct. 11, 2012.
26. Hannah Miller, "Bored Ape's New ApeCoin Puts NFTs' Power Problem on Display," *Bloomberg,* March 19, 2022.
27. Dane Bowler, "Beware the SPAC: How They Work and Why They Are Bad," *Seeking Alpha,* Jan. 5, 2021.
28. Allyson Versprille and Bill Allison, "Crypto Bosses Flex Political Muscle with 5,200% Surge in US Giving," *Bloomberg,* June 2, 2022.

29. Allyson Versprille and Yueqi Yang, "Crypto Giant FTX Ready with Billions of Dollars for Acquisitions," *Bloomberg,* May 27, 2022.
30. Jason Delgado, "Hackers Hijack Nikki Fried's Campaign Twitter Account," *Florida Politics,* March 20, 2022.
31. Maxwell Strachan, "OpenSea 'Sitting on Ticking Bomb' as Lawsuits Pile Up over Stolen Apes," *Vice,* April 6, 2022.
32. Matthew Gault, "The Digital Colonizers of 'Axie Infinity,'" *Vice,* April 6, 2022.
33. Edward Ongweso Jr., "The Metaverse Has Bosses Too. Meet the 'Managers' of Axie Infinity," *Vice,* April 4, 2022.
34. Choe Sang-Hun and David Yaffe-Bellany, "How North Korea Used Crypto to Hack Its Way Through the Pandemic," *New York Times,* June 30, 2022.
35. Ryan Weeks, "How a Fake Job Offer Took Down the World's Most Popular Crypto Game," *Block,* July 6, 2022.
36. Sarah Emerson, "Seth Green's Stolen Bored Ape Is Back Home," *BuzzFeed,* June 9, 2022.
37. God Parody Account (@thegoodgodabove), Twitter post, Feb. 18, 2022, 10:33 p.m.
38. Sheets, "What Would Donald Judd Do?"
39. Donald Judd, "Nie Wieder Krieg" ["No More War"], in *Donald Judd—Architektur, exhibition catalogue* (Vienna: Österreichisches Museum für angewandte Kunst, 1991).

Chapter 9: We're All Gonna Die

1. Ivana Mitrovic, "Goblintown NFT Marketing Analysis: SELL Your NFTs Despite the UGLY ARTWORK?," YouTube video, July 7, 2022.
2. Kevin Roose, "Crypto Is Cool. Now Get on the Yacht," *New York Times,* Nov. 5, 2021.
3. Asa Hiken, "'God Hates NFTs'—Behind the Hundreds' Staged Anti-Crypto Protest," *AdAge,* June 20, 2022.
4. Reza Monem, "The One.Tel Collapse: Lessons for Corporate Governance," *Australian Accounting Review,* Dec. 14, 2011.
5. Ibid.
6. Live Nation Entertainment, "Live Nation Unveils Live Stubs Digital Collectible NFT Ticket Stubs Minting First Ever Set for the Swedish House Mafia: Paradise Again Tour," press release, Oct. 29, 2021.

7. "At 9.3% CAGR, Global Electronic Health Records (HER) Market Size to Hit USD 52.98 Billion by 2027, Says Brandessence Market Research," *Brandessence Market Research*, May 6, 2022.

8. Chris Kerr, "Square Enix Won't Spend Cash from $300 Million Studio Sale on Blockchain Projects," *Game Developer*, June 7, 2022.

9. 1-800-HOT-NITE movie website.

10. "Chromie Squiggle—Art Blocks Curated," *NFT Price Floor*.

11. Gary Gensler, interview with Charles Forelle, *Wall Street Journal* (@WSJ), Twitter post, June 14, 2022, 1:21 p.m.

12. Andrew Hayward, "Republican Sen. Lummis: Democrat Senator Gillibrand Is Teaching Me About NFTs," *Decrypt*, July 7, 2022.

13. 0xZuwu (@0xZuwu), Twitter post, Sept. 14, 2021, 7:28 p.m.

14. Elizabeth Howcroft, "NFTs Worth $100 Million Stolen in Past Year, Elliptic Says," *Reuters*, Aug. 24, 2022.

15. U.S. Attorney's Office, Southern District of New York, "Former Employee of NFT Marketplace Charged in First Ever Digital Asset Insider Trading Scheme," *United States Department of Justice*, June 1, 2022.

16. Celsius Network, https://celsius.network/.

17. Katie Canales, "A Former Employee at Bankrupt Crypto-Lender Celsius Has Sued the Company, Calling It a 'Ponzi Scheme,'" *Insider*, July 14, 2022.

18. "State Securities Regulators Investigating Celsius Accounts Freeze," *Reuters*, June 16, 2022.

19. Elmer Morales (@elmerm), Twitter post, June 22, 2022, 11:58 p.m.

20. Cambridge Bitcoin Electricity Consumption Index, https://ccaf.io/cbeci/index/comparisons.

21. Hiroko Tabuchi, "NFTs Are Shaking Up the Art World. They May Be Warming the Planet Too," *New York Times*, April 16, 2021.

22. Olga Kharif and Bloomberg, "Bored Ape Yacht Club Creators Buy Up Rival Token Collections to Become an Even Bigger NFT Powerhouse," *Fortune*, March 11, 2022.

23. CryptoPunks Sales Volume Data, Graphs, and Charts, https://cryptoslam.io/cryptopunks/sales/summary/?month=2022-06.

24. Chainleft (@ChainLeftist), Twitter post, June 19, 2022, 3:44 p.m.

25. Gary Vaynerchuk (@garyvee), Twitter post, June 18, 2022, 7:51 p.m.

26. Justin Aversano (@justinaversanophotos), Instagram post, May 22, 2022.

Chapter 10: The Escape Plan

1. "Beeple Gets Real," *Christie's*.
2. Ryan Zurrer, "Why I Spent $29M on a Beeple," *CoinDesk*, Dec. 16, 2021.
3. Kelly Crow, "The Latest Sign That Beeple Has Truly Arrived: An Exhibit at an Italian Art Museum," *Wall Street Journal*, April 11, 2022.
4. Sebastian Smee, "Venice Takes a Surreal Turn, Not for the Better," *Washington Post*, April 29, 2022.
5. Siddhartha Mitter, "Documenta Was a Whole Vibe. Then a Scandal Killed the Buzz," *New York Times*, June 24, 2022.
6. *Claes Oldenberg: The Street and The Store / Mouse Museum and Ray Gun Wing*, exhibition, Museum of Modern Art, April 14–Aug. 5, 2013.
7. Claes Oldenburg, *Money (Used in "Ray Gun Spex")*, https://specificobject.com/objects/info.cfm?object_id=13565#.YxoWhOzMJ_A.
8. Hal Foster, "1961," in Foster et al., *Art Since 1900* (London: Thames & Hudson, 2004).
9. John F. Morrison, "Arts Patron Jack L. Wolgin, Gave City the Clothespin," *Philadelphia Inquirer*, January 27, 2010.
10. Whitney Museum of American Art, "Whitney Focus Presents Claes Oldenburg's 'Giant BLT,'" YouTube video, June 10, 2009.
11. Mike Winkelmann (@beeple), Twitter post, July 7, 2022, 10:19 p.m.
12. Devin Finzer (@dfinzer), Twitter post, July 14, 2022, 2:25 p.m.
13. Devin Finzer, "Why We Don't Mind the Dip(s)," *OpenSea Blog*, Sept. 13, 2022.
14. "Personal Saving Rate," *Economic Research—Federal Reserve Bank of St. Louis*.
15. David Canellis, "Sudoswap Erupts as NFT Traders Capitalize on Royalty-Free Sales," *Blockworks*, Aug. 17, 2022.
16. Anders Petterson and James Cocksey, "NFT Art Market Report," *ArtTactic*, Nov. 2021.

Chapter 11: Information-Processing Error

1. Tim Schneider, "Two Buzzy Hybrid Projects Have a Lot to Teach Us About the Uneasy Merger Between Crypto and Physical Art," *Artnet News*, Sept. 14, 2022.

2. Dade Hayes, "UTA and Former Backer Investcorp Form Venture to Invest in the Creator Economy, Web3 and Other Emerging Sectors," *Deadline,* Oct. 12, 2022.

3. Vicky Ge Huang, "Crypto Startup Mysten Labs Raises $300 Million in FTX-Led Round," *Wall Street Journal,* Sept. 8, 2022.

4. Paul Kiernan and Vicky Ge Huang, "Ether's New 'Staking' Model Could Draw SEC Attention," *Wall Street Journal,* Sept. 15, 2022.

5. Brayden Lindrea, "3 Cloud Provides Account for Over Two-Thirds of Ethereum Nodes Data," *Cointelegraph,* Aug. 18. 2022.

6. Brayden Lindrea, "SEC Lawsuit Claims Jurisdiction Because Nodes Are 'Clustered' in the US," *Cointelegraph,* Sept. 20, 2022.

7. Gary Gensler, United States Securities and Exchange Commission, YouTube video, Oct. 3, 2022.

8. Stefania Palma and Patrick Temple-West, "SEC Must Clarify Which NFTs Will Be Regulated, Says Commissioner," *Financial Times,* Oct. 7, 2022.

9. ApeCoin to USD Chart, https://coinmarketcap.com/currencies /apecoin-ape/.

10. Heidi (@blockchainchick), Twitter post, Oct. 11, 2022, 3:07 p.m.

11. Kelsey Piper, "Sam Bankman-Fried Tries to Explain Himself," *Vox,* Nov. 16, 2022.

12. Reed Albergotti, "Andreessen Passed on FTX, and Made a Killing Selling Tokens," *Semafor,* Nov. 16, 2022.

13. Tom Morton, "Damien Hirst's Bonfire of NFTs," *Frieze,* Oct. 24, 2022.

14. "Former Chairmen of Sotheby's and Christie's Auction Houses Indicted in International Price-Fixing Conspiracy," press release, May 2, 2001, United States Department of Justice.

Chapter 12: A Sleepless Night

1. Sophie Haigney, "Refik Anadol Trains AI to Dream of New York City," *Art in America,* Sept. 18, 2019.

2. James Tarmy, "The MoMA Has Taken a 'Chainsaw' to Its Staff, Budget, and Exhibitions," *Bloomberg,* May 6, 2020.

3. Zachary Small, "Even as NFTs Plummet, Digital Artists Find Museums Are Calling," *New York Times,* Oct. 31, 2022.

4. Shanti Escalante-De Mattei, "By Buying Frank Stella's New NFTs, You Get the Rights to 3D Print His Art," *ARTnews,* Aug. 17, 2022.

5. Scott Chipolina, "Crypto Winter Risks Turning Into Ice Age," *Financial Times,* Oct. 28, 2022.

6. Claire Silver (@ClaireSilver12), Twitter post, March 12, 2023, 10:54 a.m.

7. Ian Allison, "Divisions in Sam Bankman-Fried's Crypto Empire Blur on His Trading Titan Alameda's Balance Sheet," *CoinDesk,* Nov. 2, 2022.

8. Paul Kiernan, "SEC, DOJ Investigating Crypto Platform FTX," *Wall Street Journal,* Nov. 9, 2022.

9. Ryan Dezember and Deborah Acosta, "Miami Fights to Break Ties with FTX, as Arena Curse Striks Again," *Wall Street Journal,* Nov. 28, 2022.

10. Clare McAndrew, *A Survey of Global Collecting in 2022* (Basel: Art Basel & UBS, 2022).

11. Ornella Hernandez, "FTX Re-enables Withdrawals, but Only in Bahamas," *Blockworks,* Nov. 10, 2022.

12. Stephen Katte, "FTX Under 'Active' Civil and Criminal Investigation: Bahamas AG," *Cointelegraph,* Nov. 28, 2022.

13. OpenSea (@opensea), Twitter post, Dec. 8, 2022, 1:00 p.m.

14. Erick Calderon (@ArtonBlockchain), Twitter post, Dec. 8, 2022, 10:32 a.m.

15. Harriet Agnew, Laurence Fletcher, and Patrick Jenkins, "US Capitalism Is 'Breaking Down Before Our Very Eyes,' Says Ken Griffin," *Financial Times,* March 13, 2023.

INDEX

ILLUSTRATION CREDITS

A NOTE ABOUT THE AUTHOR

ZACHARY SMALL is an investigative reporter on the dynamics of power and privilege in the art world for *The New York Times*. Small has a master's degree from the Courtauld Institute of Art in London and a bachelor's degree in art history and political science from Columbia University. They live in Manhattan.

A NOTE ON THE TYPE

This book was set in Minion, a typeface produced by the Adobe Corporation specifically for the Macintosh personal computer and released in 1990. Designed by Robert Slimbach, Minion combines the classic characteristics of old-style faces with the full complement of weights required for modern typesetting.

Composed by North Market Street Graphics
Lancaster, Pennsylvania

Printed and bound by Berryville Graphics
Berryville, Virginia

Designed by Michael Collica